DCI|DP09

PALGRAVE STUDIES IN THEATRE AND PERFORMANCE HISTORY is a series devoted to the best of theatre/performance scholarship currently available, accessible, and free of jargon. It strives to include a wide range of topics, from the more traditional to those performance forms that in recent years have helped broaden the understanding of what theatre as a category might include (from variety forms as diverse as the circus and burlesque to street buskers, stage magic, and musical theatre, among many others). Although historical, critical, or analytical studies are of special interest, more theoretical projects, if not the dominant thrust of a study, but utilized as important underpinning or as a historiographical or analytical method of exploration, are also of interest. Textual studies of drama or other types of less traditional performance texts are also germane to the series if placed in their cultural, historical, social, or political and economic context. There is no geographical focus for this series, works of excellence of a diverse and international nature, including comparative studies, are sought.

The editor of the series is Don B. Wilmeth (Emeritus, Brown University), Ph.D., University of Illinois, who brings to the series over a dozen years as editor of a book series on American theatre and drama, in addition to his own extensive experience as an editor of books and journals. He is the author of several award-winning books and has received numerous career achievement awards, including one for sustained excellence in editing from the Association for Theatre in Higher Education.

Also in the series:

Directors and the New Musical Drama: British and American Musical Theatre in the 1980s and 90s by Miranda Lundskaer-Nielsen

Beyond the Golden Door: Jewish-American Drama and Jewish-American Experience by Julius Novick

American Puppet Modernism: Essays on the Material World in Performance by John Bell

On the Uses of the Fantastic in Modern Theatre: Cocteau, Oedipus, and the Monster by Irene Eynat-Confino

Staging Stigma: A Critical Examination of the American Freak Show by Michael M. Chemers, foreword by Jim Ferris

Performing Magic on the Western Stage: From the Eighteenth Century to the Present edited by Francesca Coppa, Lawrence Hass, and James Peck; foreword by Eugene Burger

Memory in Play: From Aeschylus to Sam Shepard by Attilio Favorini

Danjūrō's Girls: Women on the Kabuki Stage by Loren Edelson

Danjūrō's Girls

Women on the Kabuki Stage

Loren Edelson

DANJŪRŌ'S GIRLS
Copyright © Loren Edelson, 2009.

All rights reserved.

First published in 2009 by
PALGRAVE MACMILLAN®
in the United States—a division of St. Martin's Press LLC,
175 Fifth Avenue, New York, NY 10010.

Where this book is distributed in the UK, Europe and the rest of the world,
this is by Palgrave Macmillan, a division of Macmillan Publishers Limited,
registered in England, company number 785998, of Houndmills,
Basingstoke, Hampshire RG21 6XS.

Palgrave Macmillan is the global academic imprint of the above companies
and has companies and representatives throughout the world.

Palgrave® and Macmillan® are registered trademarks in the United States,
the United Kingdom, Europe and other countries.

ISBN-13: 978–0–230–60946–4
ISBN-10: 0–230–60946–5

Library of Congress Cataloging-in-Publication Data

Edelson, Loren.
 Danjuro's girls : women on the kabuki stage / Loren Edelson.
 p. cm.—(Palgrave studies in theatre and performance history)
 ISBN 0–230–60946–5 (alk. paper)
 1. Kabuki—History. 2. Actresses—Japan—Biography. 3. Ichikawa,
Danjuro, 1660–1704. I. Title.

PN2924.5.K3E33 2009
792.0952—dc22 2008027366

A catalogue record of the book is available from the British Library.

Design by Newgen Imaging Systems (P) Ltd., Chennai, India.

First edition: February 2009

10 9 8 7 6 5 4 3 2 1

Printed in the United States of America.

This book is dedicated to Ichikawa Ohka, the artistic leader of the Nagoya Musume Kabuki Troupe. She inspired this book when we were in Amsterdam for the World Music Theatre Festival in April 2002. She was performing with her company, and I was there to give introductory talks and help with backstage interpretation. As she was applying her makeup a few hours before curtain, I remarked that the piece she was presenting, The Mirror Lion, *was the same work that the great nineteenth-century actor, Ichikawa Danjūrō IX, had performed with his two daughters for their stage debut at Kabuki-za in 1893, one of the earliest recorded appearances of a kabuki actor with his daughters. Ohka put her makeup brush down, walked over to her suitcase, and retrieved a worn book. "Yes, I've been reading Suisen's* Mirror Lion," *she said, handing me a book edited by Ichikawa Danjūrō X that contains an extensive commentary on the play written by his wife Suisen, Danjūrō IX's eldest daughter.*[1]

It was then that I decided to explore the connections between Danjūrō IX's support of kabuki actresses in the nineteenth century and the sponsorship of women on the kabuki stage by the Naritaya house in the twentieth and twenty-first centuries. Thank you, Ohka.

[1] Ichikawa Suisen II, "Kagamijishi" [Mirror Lion], in *Kagamijishi* [The Mirror Lion], ed. Hukusabro Horikosi (*sic*, spelled elsewhere Fukusaburō Horikoshi) [Ichikawa Sanshō V] (Kyoto: Unsō Shuppanbu, 1948), 13–63.

Contents ✑

Illustrations ✑

Acknowledgments ❧

This book began as a series of articles on the topic of women in Japanese traditional performing arts, which I wrote for the *Japan Times* in 1997. I am grateful to Yamaguchi Yoshie, the arts and entertainment editor, for telling me about Nagoya Musume Kabuki, the contemporary all-female kabuki troupe. Little did I realize at the time that my article on the company would lead to my doctoral dissertation, which served as the basis for this book.[1] I am indebted to members of the troupe for permitting me to attend numerous performances, watch rehearsals, and explore the frenetic activity behind the scenes.

I wish to express my profound gratitude to the former actresses of the Ichikawa Girls' Kabuki Troupe who took time to speak with me: Ichikawa Baika, Ichikawa Baishō, Ichikawa Ebimaru, Ichikawa Emiko, Ichikawa Fukushō, Ichikawa Himeshō, Ichikawa Hisayo, Ichikawa Kiyomi, Ichikawa Kobeni, Ichikawa Kobotan, Ichikawa Masuyo, Ichikawa Misuji, Ichikawa Sanpuku, Ichikawa Suzume, Ichikawa Toshie, and Onoe Umeno. Likewise, I am grateful to members of Nagoya Musume Kabuki: Hayashi Midori, Ichikawa Hisago, Ichikawa Kishō, Ichikawa Ohka, Ichikawa Misuya, Ichikawa Mitsuji, Ichikawa Sakurako, Kikuchi Yukie, and Sumiya Rie. I am grateful to the Yagi family for hosting me on several occasions and to Tokiwazu Tsunao for sharing his expertise in Japanese music.

Financial support from the Japan Foundation, the Graduate Center of New York (under the auspices of the Mario Capelloni Fellowship) as well as the City College of New York enabled me to conduct research in Japan and focus on writing after I returned to New York. The Cohen-Lortel grant gave me the opportunity to attend the World Music Theatre Festival. I am also grateful to the Social Science Research Council for inviting me to the Japan Studies Doctoral Dissertation Workshop in December 2004. Special

[1] Loren Edelson, "Danjūrō's Girls: The Ichikawa Family and Women on the Kabuki Stage" (Ph.D. diss., The Graduate Center, City University of New York, 2006).

thanks to all the participants and the faculty mentors: Barbara Brooks, David Howell, Mariko Tamanoi, and Robert Uriu.

I would like to thank Scripps College of Claremont, California, Sakuragaoka Museum of Toyokawa, Japan, and the Tokyo Metropolitan Foundation for History and Culture Image Archives as well as the Edo-Tokyo Museum for allowing me to reprint photographs. I am particularly grateful to the staff of the Sakuragaoka Museum for opening their archives to me, allowing me to photocopy materials on the Ichikawa Girls' Kabuki Troupe, and arranging my first interview with a former troupe member. I wish to acknowledge my gratitude to Ichikawa Ohka, Ichikawa Danjūrō XII, and Ogawa Tomoko for the use of the photograph that appears on the book cover. My thanks to Martha Walsh and the editors of the *Journal of Japanese Studies* for allowing me to reprint part of my article "The Female Danjūrō: Revisiting the Acting Career of Ichikawa Kumehachi," which appeared in the winter 2008 edition.

Additional institutions provided the source materials on which this book is based. My thanks to the librarians of the C.V. Starr Library of Columbia University, Hamamatsu City Central Library, Misono-za Library, National Diet Library, National Theatre (Kokuritsu Gekijō) Library, Ōtani Shōchiku Library, Ōya Soichi Library, Tokyo Metropolitan Library, and Waseda University Theatre Arts Library.

I wish to thank my outstanding dissertation committee: my adviser, Samuel L. Leiter, Marvin Carlson, Judith Milhous, and David Savran, as well as Daniel Gerould, Frank Hentschker, Lynette Gibson, and Pamela Sheingorn. Warm thanks to my exceptional teachers of Japanese language, literature, and history: Steven Ericson, Fujii Chieko, Donald Keene, Haruo Shirane, Henry D. Smith II, and Alan Tansman. Thank you, too, to Celia Braxton, Nicole Cohen, Paula Lawrence, Heidi Steinmetz Lovette, Ellen Anthony-Moore, Betsey Nevins, Jennifer McAllister-Nevins, Michelle Sieff, Terry Stoller, Yoko Shioya, and to my students in my spring 2008 class in Japanese Theatre at City College, who reenacted the 1880s debate on women on the kabuki stage with finesse and enthusiasm.

Further assistance was provided by Janine Beichman, Kei Hibino, Kudō Chinatsu, Matsumoto Kahoru, Matsumoto Shinko, Morinaga Masako, Claudia Orenstein, Tamaki Yoko, Yoshida Setsuko. Horiuchi Fumitomo and Isoguchi Tomomi of the Japan Foundation introduced me to kabuki actors and invited me to share my research at the Tokyo Foundation headquarters. Hayashi Kyōhei helped me decipher the letters of Ichikawa Sanshō V, Kodama Ryuichi gave a series of informative lectures on the Ichikawa

Danjūrō line of actors, and Kondō Tamao answered many questions. For generous photo expertise, I owe thanks to Del Hawbaker. I would also like to thank my editors at Palgrave Macmillan: Farideh Koohi-Kamali, Kristy Lilas, Brigitte Shull, and Don Wilmeth. The Edelson and Katz families have been incredibly supportive from beginning to end. I am grateful to my in-laws, Nina and Eugene Katz, my parents, Judy and Richard Edelson, and my siblings, Rebecca and Eric. My 95-year-old grandfather, Max Edelson, deserves special thanks for reading and commenting on my dissertation. My son, Julian, arrived almost exactly ten months and ten days—as the Japanese would say—after I deposited my dissertation and has brought me happiness every day. Finally, I thank my husband, Jeremy Katz. Friends and colleagues assume (correctly) that Jeremy, as an information technology wizard, helps with computer-related problems but that is a tiny part of the massive role he has played in the completion of this book. He read numerous drafts, attended countless performances and conferences, listened to my ideas, shared his insights, transferred to work in Tokyo during my research year, took hundreds of pictures and reams of video footage, and learned how to play the *shamisen*. I thank him for his love, warmth, humor, passion, dedication, and all his help, big and small.

<div align="right">

Loren Edelson
New York
September 2008

</div>

Notes on Style 〜

- Japanese names are given with the surname listed first, followed by the private name, unless the individual has specified otherwise. Actors will generally be referred to by their stage names. In cases where actors have multiple stage names, I give the name by which the actor was called at that point in my narrative. In other words, there are several cases where one individual, over the course of his or her lifetime, possesses several different stage names.
- Unless otherwise indicated, all translations from Japanese articles, books, and texts are mine.
- The English title of plays are used in the text. A list of corresponding Japanese translations is available in the appendix.
- With the exception of Japanese words that have become part of the English lexicon, Japanese words are italicized. Generally, I have provided English translations on the first reference.
- I have transliterated Japanese and Chinese names and terms following the modified Hepburn and pinyin systems, which are the dominant romanization systems used in Japanese and Chinese studies, respectively. The one exception is when an individual has indicated a preference for an alternative spelling (i.e., Ichikawa Ohka, not Ōka).
- When possible, the birth and death dates of individuals are provided on the first reference.
- The reader will note that some titles of plays are in quotes, while others are in italics. This is done to differentiate the scenes or highlights of longer plays that are frequently performed independently from the full-length plays (*tōshi kyōgen*). Quotations will be used for single acts; full-length plays will be italicized. There are several cases where a scene, such as "Village School," is performed so frequently as an independent work that it arguably could have been italicized, but quotations are used in order to alert the reader that it was excerpted from a longer work (in this case, *Sugawara and the Secrets of Calligraphy*).

- Although it is standard in most endnotes to omit the author's first name, I have retained the first name in the myriad of cases where the surname is "Ichikawa."
- The following abbreviations will be used for works that are referenced several times in the notes section:
 - *EHD= Engeki hyakka daijiten* [Theatre Encyclopedia]
 - ISKK= "Ichikawa Shōjo Kabuki kōenkai [Symposium on the Ichikawa Girls' Kabuki]
 - *KJ= Kabuki jinsei* [A Kabuki Life]
- Unless otherwise stated, all letters are from Ichikawa Shōjo Kabuki collection. Sakuragaoka Museum, Toyokawa, Japan.
- All articles by Ichikawa Baika that appeared in the *Mainichi shinbun* were part of her 1993 series "Matsuba-botan no ki" [Journal of Miniature Peonies].
- All articles by Kurokawa Mitsuhiro that appeared in the *Chūnichi shinbun* were part of his 1984 series "Maboroshi no Ichikawa Shōjo Kabuki" [Phantom Ichikawa Girls' Kabuki].
- The word *"shinbun"* (newspaper) is generally omitted in the notes. The full names of the newspapers noted are *Asahi shinbun, Chūnichi shinbun, Chūbu Nihon shinbun, Enshyu* [*sic*] *shinbun, Kyōto shinbun, Mainichi shinbun, Ōsaka nichi nichi shinbun, Sangyō keizai shinbun, Shizuoka shinbun, Tōkyō nichi nichi shinbun, Tōkyō shinbun,* and *Yomiuri shinbun.*

Prologue: Danjūrō's Girls ∽

In 1997, I wrote an article on contemporary kabuki actresses for the *Japan Times*. To most Japanese, the phrase "female kabuki," let alone "kabuki actress," is oxymoronic: Women do not perform in the exclusively male theatre of kabuki. And, yet, paradoxically, this book tells the story of women who performed kabuki on some of Japan's most prestigious stages in recent times.

Over the years of research and writing, I encountered a mixture of bafflement and excitement in reaction to this project. My skeptics undoubtedly wondered whether I was the victim of a terrible cross-cultural misunderstanding. Many assumed that my research focuses on Izumo no Okuni, the alleged female founder of kabuki, or her successors, the early seventeenth-century actresses who performed kabuki before they were banned from the public stages. When I assured an esteemed professor at a prestigious Japanese university that I was writing about *contemporary* female kabuki, he advised me to change my topic since there was probably little information available.

My interlocutors on the other extreme, however, not only believed that I was researching kabuki actresses, but presumed that they were radical feminist performers. At conferences and talks, audience members frequently asked me to make connections between the Japanese Equal Rights Movement and the emergence of women on the kabuki stage. Several years ago, for example, I received an email from a woman calling herself "Aphra Behn," from the feminist theatre collective, the Guerrilla Girls on Tour. She expressed interest in arranging for her troupe to study with the contemporary all-female troupe Nagoya Musume Kabuki, which I had featured in my *Japan Times* article some years before, and, in particular, wanted to know how the Japanese actresses "were taking back the form" of kabuki from men.[1]

This book attempts to set both my skeptics and supporters straight. It does not survey all kabuki actresses, but focuses on "Danjūrō's Girls" (Danjūrō musume). The title of a popular kabuki dance piece from the 1950s, "Danjūrō's Girls" refers here to the dozens of actresses who have

been affiliated with the renowned Ichikawa Danjūrō kabuki dynasty, also known as the Naritaya house, from the 1880s to the present. As we shall see, many of them were indeed "girls" (*shōjo*), a phenomenon that is explored at length in subsequent chapters. Contrary to the expectations of contemporary feminists, none of the actresses documented here ever claimed to take back kabuki. In fact, these female players appropriated many of the same "feudalistic" ideals as male kabuki in an attempt to be recognized as "genuine" and become part of the establishment.

The Naritaya house comprises the prestigious Ichikawa Danjūrō line of actors. Customarily, the head of the Naritaya house has been the actor holding the name Ichikawa Danjūrō, a celebrated name that has been passed down from father to son—either biological or adopted—since the late seventeenth century.[2] The head (*iemoto*) is the most powerful member of the house; he decides who is admitted, oversees the repertory, guards the family's secrets, and represents the house in business and management decisions. One of the Naritaya house's most significant contributions to kabuki is the creation of the bravura (*aragoto*) acting in the seventeenth century by Danjūrō I (1660–1704). The *aragoto* style is associated with such favorite plays as *Just a Minute, Sukeroku* (character name), *Saint Narukami*, and *The Subscription List*, which have been canonized as the Naritaya house's "family" or "heirloom art" (*ie no gei*).[3] Of all the important acting dynasties that have earned a place in the contemporary kabuki theatre world, the Naritaya house continues to receive the greatest approbation, and, as we shall see, the outstanding reputation that the "girls" earned cannot be disassociated from this connection.

THE FEMALE PRECEDENT

Before delving into the history of these actresses, I must clarify a few points about the early history of women on the kabuki stage. Izumo no Okuni, a woman serving the gods (*miko*) from the great Izumo Shrine, is said to have been the first to present wildly original dances and skits, based on traditional ones, on the banks of the Kamo River in Kyoto in 1603, the year of the establishment of the Tokugawa military government (*bakufu*). Though there is some extant evidence regarding Okuni's career, much of what has been written about her is apocryphal.

The most credible support comes in the form of edicts promulgated by the *bakufu* as well as a painting that supposedly depicts Okuni. Only one of the many "kabuki edicts" compiled by historian Yoshida Setsuko actually mentions Okuni by name. It notes that she was given permission in 1603 to

perform on the "Kitanō plain" (*shibahara*) in Kyoto but later was required to move to the Kamo riverbank beneath the Gojō bridge, and then north to the bank beneath the Shijō bridge. The edict further notes that there has been talk of "men and women performing together," which violates public morals.[4] It thus appears that Okuni's troupe—and contemporaneous competing troupes of kabuki players— comprised men and women, a fact that historian Torigoe Bunzō calls "epoch making."[5]

Further evidence comes in the form of the painted six-panel "Okuni screen" (Okuni kabukizu byōbu). The festive screen, boasting a generous amount of gold leaf as well as mellow reds, greens, and blues, does not depict Okuni performing on the banks of the Kamo River, but at the Kitanō Shrine in Kyoto, sometime between 1596 and 1615. The anonymous artist paints her in a standing pose on a raised, outdoor stage evocative of that used in *nō*, an earlier theatre form that gained the support of the shogun in the late fourteenth century. She wears loose-fitting garments; over a floor-length white robe with colorful trim, she sports a wrapped blue vest. Her hair falls just below her shoulders, and she holds a vermillion sword in her left hand, just behind her head. The signifiers of her costume—the sword, the tousled hair, and the strong, kicking motion of her right foot—suggest that she is playing a male role.

Scholars have hypothesized that she is performing a skit entitled "Chaya asobi" (Visiting the Teahouse). She shares the stage with two *saruwaka* comedic performers. They are thought to be men playing female roles, since both cover their hair with white cloth, a feminine marker. The players are accompanied by a chorus and several instrumentalists who are shown holding a flute and three different kinds of drums: hip (*otsuzumi*), shoulder (*kotsuzumi*), and stick (*taikō*), while one of the *saruwaka* performers holds what looks like a gong. Spectators surround the stage on three sides. The majority wear long brocade robes and carry decorative fans or swords, indicating that they are from the wealthy, privileged class of warriors (*bushi*). Servants, including a palanquin bearer, also watch the show.

The screen is invaluable for revealing the arrangement of the stage, the composition of the audience, and the festive, albeit restrained, atmosphere of the performance. At the very least, it challenges the prominent idea that kabuki was only a kind of early street theatre performed for the masses. Kabuki's origins were diverse; performances appealed to a cross-section of society. Whether or not the painting's central figure is in fact the legendary Okuni is still subject to debate. Indeed, one commentator reminds us that opinion is divided between those who believe that the woman is Okuni and those who do not.[6]

The lack of hard evidence, however, has not prevented Okuni from being anointed as the accepted founder of kabuki. The legends of Okuni are given ample attention elsewhere, so here a brief outline will suffice. As the story of Okuni is told, her slightly askew, "queer" choreography excited spectators to the extent that her performances were called *kabuku*, offbeat and far out, which literally "tilted" in a new direction.[7] Her performance of the *nenbutsu odori*, a twist on the Buddhist prayer, became an overnight sensation, earning her a reputation as the "world's best dancer." Her alleged love affair with the dashing rebel Nagoya Sanza captivated the public's imagination. After he died, Okuni is said to have conjured his ghost in a parody of *nō* drama. Equally shocking, she supposedly danced with a crucifix, introduced by the Portuguese traders who had yet to be banished by the new Tokugawa government. Her performances were so successful that she was invited to dance before the shogun, and within a short time, more troupes comprising men and women formed, imitating and embellishing her once-famous dances. Paintings show these post-Okuni players dancing with the *shamisen*, the three-stringed lute that came to play a central role in kabuki music.

But Okuni's female successors were banned subsequently from the stage, ostensibly because of their licentious behavior as prostitute-performers (hence, the term "prostitutes" (*yujō*) kabuki). Tokugawa *bakufu* edicts, aiming to disperse women performers, were promulgated beginning in 1603 and continued with outright bans on women performers through the 1640s. While 1629 is often given as the definitive date for the ban, it is likely, as Donald Shively has suggested, that it "was not always strictly enforced," since it was repeatedly issued.[8] Although the *bakufu* edicts do not always provide the reasons why certain regulations were initiated, the ban on female performers appears to stem from two major reasons: the concern that kabuki was lowering social morals, because of its connection to prostitution and presentation of men and women performing together, and that it was the source of fighting among spectators, which included samurai and commoners and therefore violated the *bakufu*'s policy of class separation. It appears that as far as the government was concerned, women's kabuki had deteriorated to an erotic preview of the intimate relations between spectator and performer that could be consummated after the show.

During the latter part of the seventeenth century, all-male troupes, first known as young male (*wakashu*) kabuki and later called men's (*yarō*) kabuki, came to monopolize the commercial stage. With men playing both male and female parts, the convention of the male female-role player (*onnagata*) developed into an intricate art form. The new methods of playing a woman were drastically different from the rather crude attempts by the

male *saruwaka* members of Okuni's troupe. Using a variety of performative techniques designed to "kill" their own bodies and create new ones, from pulling their shoulder blades back and walking with their knees locked together to painting their faces and donning appropriate wigs and kimono, the *onnagata* performed a theatricalized femininity.

Meanwhile, theatre and prostitution—that is, male-male prostitution—remained closely aligned; indeed, the sexually titillating elements of kabuki that the *bakufu* hoped to eradicate with the banishment of women from the stage were never fully excised.[9] But while the theatre industry indirectly continued to advertise the post-performance sexual services offered by the performers, the content of the plays began to change. Over time, acting became more important than good looks and charm, and kabuki slowly evolved from a song-and-dance-based art to one that boasted theatrical and narrative-driven content. Calling such an amazing transformation "from gay to *gei*," Samuel L. Leiter explains that beginning in the 1660s "kabuki witnessed a transition from gay theatre to *gei* theatre, *gei* being Japanese for 'art,' including 'acting art.'"[10]

Numerous works have discussed how women influenced men's characterizations of femininity, but the actual "return" of the actress to the commercial stage in the nineteenth century has received little attention until recently.[11] After a centuries-long ban on female performers, women performed kabuki on the public stages possibly as early as the 1850s, apparently free of hortatory warnings and threats of punishment. A scroll by "Amano," the ninth-generation Tachibana Seisei, centers on the traveling actress, Okume. Painted between 1849 and 1862, the scroll depicts her playing *aragoto* roles. In one panel, she poses triumphantly as a warrior. Extending her muscular arms outward, she raises her scabbard over her head, while her sword hangs at her waist. Red makeup adorns her bare arms, legs, breasts, and, most prominently, her swollen, pregnant belly. Only her body from her hips to her knees is unexposed.[12]

Just how many other "traveling actresses" performed kabuki at this time is unknown, but it is clear that by the late 1860s there were several actresses earning their livelihood by performing kabuki plays in the city of Edo (later renamed Tokyo). They appeared in commercial theatres without any change in their legal status as performers. Many of these actresses had been *okyōgen-shi* (honorable theatre masters) during the late Tokugawa period. Employed by *daimyō* (feudal lords) and other members of the warrior class, they performed kabuki plays in private theatres, generally located in residential estates, or even, on occasion at the Edo castle for ladies of the shogun's inner court.[13] By 1862 with the unraveling of the *daimyō* hierarchy

and the demise of the alternate attendance system (*sankin kōtai*), however, the *okyōgen-shi* lost these private engagements. Amid the overthrow of the Tokugawa shogun and the advent of the Meiji period (1868–1912) several of these erstwhile honorable theatre masters transitioned to the public career of kabuki actress.[14] While these women generally were referred to as *onna yakusha* (female performers), they were, on occasion, also called *joyū* (actresses). Therefore, I, too, will refer to women who performed kabuki not only as "female performers" but as actresses.[15]

"MINOR" VERSUS "GRAND" KABUKI

The playhouses in which actresses performed were not the grand theatres (*ōshibai*), but the minor ones (*koshibai* or *shōgekijō*). Because of the salience of the minor theatres to women's kabuki, a brief overview of "grand/major" kabuki and "small/minor" kabuki is in order.

Almost all of the kabuki produced in major cities today is of the grand kabuki variety; with a handful of exceptions, kabuki has become streamlined into one monolithic, totalizing tradition that is monopolized by the Shōchiku Theatrical Corporation. Such a tradition prides itself on all-male uniqueness, exotic *onnagata*, and a canonical repertory. Grand kabuki troupes tour internationally and present kabuki to the world as Japan's national theatre. At home and abroad, the best seats are prohibitively expensive. Not surprisingly, grand kabuki productions are the ones broadcast on Nippon Hōsō Kyōkai or NHK (Japan Broadcasting Corporation) and the "Kabuki Channel" on Sky PerfecTV, simultaneously reaching larger audiences while showcasing a much more limited spectrum of kabuki than available in the past when the minor theatre flourished.

The legal distinction between major and minor theatres only emerged during the Meiji period; during the Tokugawa period, when kabuki developed as a new theatre form, theatres were either "licensed" or not recognized by the government. From 1714 on, Edo, which had become the base for the Tokugawa shogun, had three licensed theatres (the Edo *sanza*; *za*, theatre): the Ichimura-za, the Nakamura-za, and the Morita-za; in addition, many other "temporary" theatres operated on the grounds of shrines and temples during festivals and other occasions. Under the Meiji government, the number of licensed theatres in Tokyo grew to ten and came to be referred to more formally as "grand theatres." Meanwhile, the number of unlicensed theatres continued to increase and came to be called "small" or "minor" theatres. Movement between the two classes was discouraged; it was all but unheard of for a grand kabuki actor to perform at a minor house; however,

there were several cases of minor-league actors performing at a grand house, but generally for a limited run.

Moreover, in the cities of Osaka and Kyoto, there were at least three classes of licensed theatres (major [*ōshibai*], middle [*chūshibai*], and minor [*koshibai*]), and movement between them appears to have been more fluid.[16]

Minor theatres were not necessarily physically smaller than their grand theatre counterparts, but were required to abide by different requirements concerning theatre architecture, production schedule, geography, and management. Only major theatres were permitted to have a *hanamichi* (rampway), a revolving stage, and a drum tower (*yagura*) at the entrance, which signaled they were licensed. While the major theatres boasted a pull curtain (*hikimaku*), the minor theatres only were allowed a drop curtain (*donchō*). The legal distinction between the "grand" and "minor" theatres was repealed in 1895, but the social distinction between the two theatre classes did not fade, and the nonlegal usage of terms such as "minor" and "major" theatre remained. Even today small-town theatres and actors are referred to pejoratively as drop-curtain theatres (*donchō shibai*) or drop-curtain actors (*donchō yakusha*), respectively. Unfortunately, using such derogatory terms fails to encapsulate the spirit of this type of kabuki.

Indeed, before Japan's defeat in World War II and the subsequent Allied Occupation, the minor theatre was a viable alternative to the grand theatre. Tickets were cheaper, and the minor theatres had their own venerable stars. Many minor troupes included women and men. Small country towns and cities also boasted minor theatres. Although residential—amateur-type groups, such as the Manninkō Association discussed in chapter 2, might have played at these theatres—they were more often used by touring itinerant troupes. Ozu Yasujirō (1903–1963) captures the tribulations of one such troupe in his poignant 1934 silent film *Ukigusa monogatari* (A Story of Floating Weeds).[17] When actors began to reform grand kabuki in the late nineteenth century in order to attract elite audiences and appeal to western sensibilities, minor kabuki remained relatively impervious to such changes. It resisted the staid, high-class, exclusive affair that had become associated with an afternoon at the major theatres.

For our purposes, the minor theatre is important because women's kabuki grew out of this tradition; in fact, almost all of the Danjūrō's Girls discussed here had significant careers performing at the minors. The first woman affiliated with the Naritaya house was Ichikawa Kumehachi (1846?–1913). Referred to as the "female Danjūrō" both during and after her life, she performed at minor playhouses in Tokyo for more than twenty years before Danjūrō IX (1838–1903) adopted her as his disciple.[18]

Several decades later, the Ichikawa Girls' Kabuki Troupe (Ichikawa Shōjo Kabuki Gekidan) emerged as one of the last remaining minor troupes. The troupe was created initially as an all-girls' dance club in rural Toyokawa City, in Aichi Prefecture after Japan's defeat in World War II. A national sensation in Japan in the 1950s, it became a professional company after receiving official sponsorship from Ichikawa Sanshō V (1882–1956, later Ichikawa Danjūrō X) and subsequently Ichikawa Ebizō IX (1910–1965, later Ichikawa Danjūrō XI). These men were the respective heads of the Naritaya house at the time, even though they had yet to take the name Ichikawa Danjūrō. Sanshō V would be named Ichikawa Danjūrō X posthumously in 1956 and Ebizō IX took this name in 1962.

Danjūrō XII (b. 1946) continues the tradition of the Naritaya house sponsoring kabuki actresses. To date, ten members of the Nagoya Daughters' Kabuki Company (Nagoya Musume Kabuki) have received the "Ichikawa" name from Danjūrō XII. Over the years, he has offered the troupe artistic guidance and direction, and, in November 2007, he appeared with the leading member, Ichikawa Ohka (b. 1959, née Katō Emiko), for the first time onstage in a celebrated production of *The Barrier Gate* (see cover photo).

THE ICHIKAWA GIRLS' KABUKI TROUPE

The respective careers of Kumehachi and the actresses of Nagoya Musume Kabuki are important in their own right, but here, in this book, they serve to frame my discussion of the Ichikawa Girls' Kabuki Troupe. Indeed, while there could be separate full-length studies on all three periods of the Naritaya house's patronage of women, most of the extant material on female kabuki concerns the troupe from the 1950s. The pages that follow, therefore, detail the Ichikawa Girls' path to fame, documenting how it performed on almost every major city stage and in almost every prefecture. At its peak, the company boasted more than one hundred plays in its repertory, worked a year-round production schedule, and received popular and critical acclaim, briefly becoming part of the otherwise all-male kabuki establishment that continues to monopolize Japanese traditional theatre today.

Though the troupe's roots were avowedly "minor," it occupied a liminal position between the "minor" and "major" theatre traditions. As the troupe became famous, it attempted to disassociate itself from the minor-league tradition in order to operate in the grand theatre world. This development mirrored trends toward classicalization that were occurring simultaneously on a larger scale in grand kabuki in the postwar period.[19]

Despite its success, the Ichikawa Girls' Kabuki Troupe has been all but relegated to an historical footnote. Apart from brief mentions in a few reference books, no scholarly study about the troupe in English or Japanese ever has been published.[20] Commentary about the troupe was glaringly absent from the exhibitions, conferences, and performances celebrating kabuki's quadricentennial held throughout 2003–2004. The sweeping exhibition on "Kabuki's Four Hundred Years," for example, devoted ample space to Okuni and women's kabuki of the early seventeenth century, but failed to mention any of the contributions made by women in more recent years.[21] Ironically, while very little is actually known about Okuni and her successors, there is an abundance of extant material documenting the history of Ichikawa Girls' Kabuki. I could only conclude that the troupe was omitted from the exhibit because it was too much of an aberration from the dominant narrative of kabuki's evolution from low-class street performance to high-class theatre. Like most textbook accounts, the curators chose to chronicle kabuki as if women, once banned, had never made a comeback.

This book, therefore, "endeavors," in the words of Tracy Davis, "to recover data about women and fill in the 'female blanks' of history."[22] On one level, it examines the Ichikawa Girls' Kabuki Troupe in all of its complexity, from its formation as a provincial dance club in the wake of Japan's defeat in World War II through its meteoric rise as a professional kabuki company. Considering the troupe's outstanding and well-documented accomplishments, not the least of which was its connection to the Naritaya house, it deserves recognition in any comprehensive history of twentieth-century kabuki. Yet, on another level, this study offers a lens through which to view kabuki as a popular theatre form that encompassed not only grand theatre but the minor league as well.

By focusing on one generation of "Danjūrō's Girls," this book aims to revisit the question of women in kabuki and to document a story that has been forgotten. At the same time, it is a response to the de-historicized, essentialist refrain that kabuki is performed by only men, as well as to the sexist contention that women are inferior performers, who merely play themselves instead of creating roles.[23] Most scholarship on kabuki has been focused on professional male actors, and when attention is turned to women, it invariably involves studying female characters or focusing on the aesthetics of the *onnagata* and building a case that only an *onnagata*, rather than a "real" woman, can play a female role in kabuki. Virtually everyone who has written on the *onnagata* has dismissed categorically the notion of female kabuki without ever seriously discussing the valiant attempts of women to act in kabuki plays over the past 150 years.[24] The recently published *Transvestism*

and the Onnagata Traditions in Shakespeare and Kabuki, for example, offers excellent insights into the male kabuki tradition, but does not include any significant discussion of women on the kabuki stage.[25]

Theatre historians are not the only ones guilty of overlooking kabuki actresses. In their introduction to the recently published *Gendering Modern Japanese History*, the editors recapitulate a claim that has been proffered by many critics of the Japanese stage: "... it was acceptable, indeed it was art for men to act as women on stage in the kabuki theatre; some even said that female impersonators (*onnagata*) performed a more perfect femininity than could have been enacted by women had they been permitted to perform on the stage."[26]

This statement, which reads as axiomatic to anyone who has heard only about the all-male kabuki theatre, is used to support the contention that in early modern Japan "there was no necessary one-to-one correspondence between sex and sexuality, whether in male-female sexual relations or in same-sex liaisons."[27] Thus, in the fashion of innumerable gender theorists, the editors make the important claim that gender, as well as sex, is a social construct. While such theorizing is welcome, as it unquestionably opens up new vistas for thinking about gender and performance, it forecloses the possibility that women ever performed on the stage. It very well might have been the case that men performed one version of femininity—what Katherine Mezur calls "fictions of female-likeness"—better than women.[28] Yet, what cannot be overlooked is the condition "had they [women] been permitted to perform on the stage." By now it should be clear that women *did* perform on the kabuki stage, even during the time when they were not "permitted." Thus, this study seeks to add another dimension to the field of Japanese history, which will continue to benefit from engendered analyses of theatrical characters, both off and on the stage.

While researching *Danjūrō's Girls*, I drew on numerous neglected materials available at the Ōtani Shōchiku Library, Misono-za Theatre Library, Oya Soichi Library, Waseda Theatre Museum, Tokyo Metropolitan Library, National Diet Library, Hamamatsu Central Library, and the Sakuragaoka Museum in Toyokawa City, the troupe's hometown. My discovery of the latter was particularly fortuitous, since it serves as the troupe's archive and had sponsored an exhibition on the troupe in 1995. Among its holdings are programs, photographs, copies of handwritten letters from Sanshō V and Ebizō IX, and a transcript and tape recording of a lecture delivered by the troupe's local leader, Ichikawa Masujūrō (1913–1998).[29] Contemporary critical accounts of the troupe's engagements published in national and city newspapers (*Asahi shinbun, Mainichi shinbun, Yomiuri shinbun, Tōkyō*

shinbun, Ōsaka nichi nichi shinbun, etc.), and theatre magazines, such as *Engekikai* (Theatre World) and *Makuai* (Intermission), provide insight into how the troupe's performances were received in the 1950s and early 1960s. An eight-mm film produced by the troupe that has been preserved on VHS, available at the Misono-za Library and Sakuragaoka Museum, provides the best visual evidence of the troupe's performance style, and a collection of television footage, assembled by actress Ichikawa Baika (b. 1936, née Hikosaka Sachiko), offers further clues about the reception of the troupe. Moreover, published autobiographies by Ichikawa Masujūrō, Hamamatsu-za Theatre owner Ono Haruyoshi (1905–1981), and Ichikawa Baika, as well as journalist Kurokawa Mitsuhiro's twenty-article newspaper series on the troupe, figure prominently in my reconstruction of the troupe's genesis and subsequent development.[30] This body of work provides the foundation for my study, as it would be virtually impossible to obtain such accounts today, since so many of the writers and sources have since died. None of these works, however, presents an in-depth, comprehensive study of the troupe. The writings rarely describe what Ichikawa Girls' Kabuki looked like onstage, nor do they discuss how the troupe's efforts were perceived in the male-dominated kabuki world. Furthermore, additional context about the historical postwar period, kabuki, and competing all-female troupes is missing from these accounts.

I have supplemented this written archive with more than twenty taped interviews that I conducted with former troupe members as well as with several senior male kabuki actors, who, as young men in their teens and early twenties, saw the Ichikawa Girls perform. These discussions both confounded and clarified the written account. Perhaps the widest gulf between the extant written texts and oral testimonials concerns the alleged behavior of Ichikawa Masujūrō during his tenure as the troupe's local leader. Although the written accounts portray Masujūrō as an ambitious, occasionally lewd, and exceedingly strict teacher, none goes so far as to raise the taboo topic that he engaged in sexual relations with several actresses while they were members of the troupe.

This allegation initially came to my attention from a third-party source, who was not a member of the troupe, and while it took me months to muster up the courage to confront members with what I regarded as an odious charge, members, including one of Masujūrō's daughters, did not attempt to conceal what has been the troupe's "secret" for many years.[31] Yet, at the same time, members were quick to downplay what many have long regarded as part and parcel of membership in an all-female, touring performance troupe. While I accept the contention that Masujūrō's philandering

was not viewed as particularly unusual for the time in question, I think that continuing to bury old secrets fails to enhance our understanding of why the troupe ultimately did not become a permanent fixture on Japan's stage. I raise the issue here neither to sensationalize it nor to call attention to what some might see as muckraking, but to note that it was perhaps my most daunting challenge, as I attempted to track down former members and ask for interviews. A couple of actresses initially declined my requests, and while I, at first, could not comprehend why they would not want to discuss their association with the troupe, I now understand that the reason for some members' hesitation stemmed from their past relationship with Masujūrō. In the end, everyone whom I contacted spoke to me either in person or over the phone, and more often than not, provided me with the contact information for additional members.

ORGANIZATION

Chapter 1 sets the scene for the formation of the Ichikawa Girls' Kabuki Troupe by investigating the origins of the Naritaya house's patronage of actresses. I draw connections between the debates that occurred over the question of actresses replacing the *onnagata* and Ichikawa Danjūrō IX, who took action by adopting Kumehachi as his disciple, training his two daughters as actresses, and performing with a European actress on the grand Kabuki-za stage. Their respective careers, insofar as they related to Danjūrō IX, are explored.

The subsequent three chapters introduce the Ichikawa Girls' Kabuki Troupe. Chapter 2 shows how the troupe developed from the minor-theatre tradition that had flourished before Japan's defeat in World War II. Chapter 3 analyzes the steps it took to become a professional troupe licensed by the grand Naritaya house and owned by the newly built Hamamatsu-za Theatre, which gave it a home base and the financial capital to perform on Japan's first-class city stages. Chapter 4 explores the troupe's 1953 Tokyo debut, the critical response, as well as its engagements at grand theatres in Tokyo, Osaka, Kyoto, and Nagoya. Although reviews were overwhelmingly positive, they were never free from criticism. Drawing on Masujūrō's autobiography and letters from the troupe's great patron, Ichikawa Sanshō V, this chapter shows how the girls incorporated critical feedback to develop into a mature, professional troupe. The troupe's relationship with Sanshō is given special attention, as it is clear that, without his constant attention to its needs, "none of this would have come about."[32]

Chapters 5, 6, and 7 break from this chronological approach to reflect on the troupe's artistic direction, its reception in the press, and its offstage hierarchical structure. Of particular interest is the troupe's liminal character; members were in-between childhood and adulthood as well as in-between the "minor" and "major" traditions. Taken together, these chapters show how the troupe inverted kabuki tradition without ever truly subverting it. Chapters 8 and 9 chart the troupe's demise. The troupe was caught in a power struggle between the Naritaya house and the Hamamatsu-za, from which it was forced to break in 1959. Renamed the Ichikawa Actress Company (Ichikawa Joyū-za) in 1960, the troupe gradually came to lose the support of its fan base as well as the Naritaya house. Although the advent of television affected Japanese performing arts at all levels, I argue that the breakup of the troupe resulted more from clashing personalities, hard-line business tactics, and even the seemingly superficial name change.

In my concluding chapter, I reflect on what has prevented women from attaining the same professional standing on the kabuki stage as men today. While other once-exclusively male Asian traditional genres have permitted actresses to perform on the same stage as men, professional kabuki remains almost entirely male dominated. The epilogue explores why kabuki's gender traditions persist so strongly at the beginning of the twenty-first century and offers some thoughts on the future prospects for women in kabuki.

1. Danjūrō IX and the Actress Question 〜

It's a black day for an actor family when no one is left but women who know nothing about the world—the way it was with the house of Naritaya. It's a pity to think of such an illustrious family of artists gone to ruin.

—Nagai Kafū (1879–1959), *Udekurabe*[1]

As the nineteenth century drew to a close, the Naritaya house desperately needed an heir. The greatest actor of his generation and the head of the family line, Ichikawa Danjūrō IX, had turned fifty in 1888 and still did not know who would succeed him. His only son had died at birth, although he later had two daughters. Defenders of the all-male kabuki tradition could only agree with the novelist Nagai Kafū that the situation was dire for the kabuki world.

Like all kabuki acting dynasties in which a family name is traditionally handed down from father to son, the Naritaya house sought to ensure that the illustrious Ichikawa Danjūrō name would be carried into the twentieth century and beyond. The father of Danjūrō IX, Danjūrō VII (1791–1859, later Ichikawa Ebizō V), had ensured male succession of the line by procreating with six women (three wives and three mistresses), but such a solution was frowned upon in the Meiji period, which prided itself on a new era of "civilization and enlightenment" (*bunmei kaika*).[2] Familial succession was still prioritized, but it was an open secret that the bloodline of the Naritaya house had been broken by adoption a number of times. Taking on a boy from a rival house or family branch was an option. Danjūrō IX had adopted his deceased younger brother's son in the 1870s, but the boy died at the age of thirteen.[3] The following year, he became a biological father with the birth of his own son, but this too ended tragically, as the baby died before he was even given a name.

One can imagine that the births of Danjūrō's daughters, Jitsuko (1881–1944) and Fukiko (1883–1947), would have been greeted with a mixture

of joy and disappointment.[4] They were the wrong sex for grand kabuki. Performing at the minor theatres was out of the question—that was beneath a scion, male or female, of the Naritaya house. The timing of their respective births, however, was fortuitous. Just a few years later, the theatre establishment would begin to consider the idea of women performing with men. Such a change would enable actresses to perform on the grand kabuki stage. Had Danjūrō been blessed with one healthy boy instead of two girls, it is plausible that he would have sat on the sidelines of such a heady debate, but, as we shall see, it is just as likely that he lobbied for kabuki actresses for reasons that extended beyond any personal failure to produce a male heir.

The parameters of this public debate on women in kabuki in the late 1880s were set by the Society for Theatre Reform (Engeki Kairyō-kai). Established nearly twenty years after the fall of the Tokugawa *bakufu*, the society was a top-down organization, with the majority of its leaders drawn from the business and government elite. As its name implies, the goal of the society was to reform kabuki; what its name obfuscates is that its mission was dictated largely by the Meiji government, which aimed to use kabuki as a political tool to make Japan respectable in the eyes of the West.[5] The society's mission was to "overthrow the old customs" of the Tokugawa regime; more specifically, it pledged to commission better plays, professionalize theatre workers, and establish a theatre that would produce "reformed" drama. If kabuki were to earn the title of Japan's national theatre, it needed to adhere to the changing times and make significant changes. Precisely how the drama would be reformed was left vague, although it soon became clear that the changes in question reflected western theatre conventions with which several members had become familiar on trips to Europe and the United States. The society also hoped to make kabuki presentable to the emperor, a goal it realized in April 1887, two years before it disbanded.

Most significant for our purposes, the society championed training actresses to play female roles.[6] Members argued that the longtime theatrical practice of men playing women and women playing men was an "extremely bad" custom and "the object of foreign ridicule." The society, therefore, believed that the addition of actresses would enable kabuki— long considered a déclassé albeit popular entertainment—to become a respectable drama on a par with western theatre. Since women already had been performing both female and male roles in all-female productions at the minor theatres, the society promoted the new idea of women appearing in mixed productions with men (*danjō kongō engeki*). Men would continue to play the male roles, while women would replace the *onnagata* and perform the female ones.[7]

The society recognized that the custom of men playing female roles could be abandoned only if it was opposed from inside the system. Danjūrō was the society's first pick for an actor who could inaugurate this change. As the head of the Naritaya house of kabuki actors, Danjūrō occupied arguably the most powerful position in the actor hierarchy. He was not wedded to the traditions of the past; he aspired for kabuki to become an elite theatre form, one that would be "useful" for the nation.[8] Particularly appealing to the society was the fact that Danjūrō had demonstrated a sincere interest in kabuki reform. Since the early 1870s, he had advocated breaking with the "period piece" (*jidaimono*) conventions that blurred the historical "truths" of the past, often the result of government-imposed censorship. Dubbed sarcastically *katsureki-geki* or "living history plays," these new works experimented with storylines, staging, costumes, and language. It was a radical attempt to deflate the over-the-top bombastic exuberance of the kabuki stage, especially the histrionic *aragoto* bravado acting for which the Danjūrō line was famous. Although reformers might have appreciated his efforts, neither the actual plays nor the theatrical conventions associated with this movement gained a popular audience.

Such early experimentation with verisimilitude might have inspired him to support the society and the addition of actresses on the grand kabuki stage. Historian Matsumoto Shinko, in particular, believes that casting women in female parts was an extension of the *katsureki-geki* experiments and Danjūrō's "quest for realism."[9] The question is not that all characters, male and female, in the living history plays of the 1870s and 1880s were performed by men; what is important is that it was during this early period that Danjūrō began to sense the power of historical realism and psychological acting. It can be argued that this eventually led him to consider the possibility of women playing female parts. His history as a zealot for theatre reform and his friendship with the nation's elite, many of whom had been intrigued by women and men performing together abroad, further ensured that he would support the society. His views regarding actresses were also influenced by his being the father of two girls, who were already learning kabuki-style dance.

Danjūrō became the society's de facto actor representative in July 1888 when he publicly announced his intention not only to train his two daughters as kabuki actresses, but to adopt Iwai Kumehachi (later, Ichikawa Kumehachi) as a member of the Naritaya house. This was nothing less than a radical break with the all-male performance tradition of training only male heirs for the kabuki stage. Still, it was not entirely surprising since Takada Sanae had proposed that Danjūrō "marry"—that is, play opposite—her.[10]

Now, less than one year later, Danjūrō justified his actions to support kabuki actresses in a debate—covered in the *Tōkyō nichi nichi shinbun*—that took place at the home of the philosopher and educator Fukuzawa Yukichi (1835–1901), one of the society's most vocal opponents and an ardent advocate of retaining the *onnagata* convention.

There is no question that Danjūrō was influenced by European and American theatrical conventions. In his words, training actresses would "elevate" kabuki while enabling it to "compete with the spirit of the far-away western theatre that captures the truth."[11] Yet, the heart of his argument appealed to a purely Japanese matter: the extinction of the "pure" breed of *onnagata*. These were the male players of female roles who lived their lives off and on the stage as women. "Pure" *onnagata* included the legendary Yoshizawa Ayame (1673–1729), Segawa Kikunojō I (1693?–1749), and Nakamura Tomijūrō I (1719–1786). Legends of their brilliant performances had been passed down through the generations, and, in several cases, their words had been immortalized in their "art treatises" (*geidan*) that revealed their secret techniques of "becoming a woman." According to Danjūrō, these *onnagata* were ready to flee the scene in case of a fire "with their make-up mirror in hand," or, if experiencing physical discomfort, act as "if they were menstruating." Such reasoning resonates with Maki Isaka's thesis that *onnagata* relied on the direct imitation of femininity, as performed by "real" women of the Tokugawa period. Expanding on Judith Butler's work that theorizes gender as a construction that conceals its genesis, Isaka shows how *onnagata* and women of the Tokugawa period were caught up in an endless circle of citationality, so that it was impossible to distinguish the "original" from the "copy." She states, "*Onnagata* artistry was measured by the criterion of verisimilitude in everyday life. Being able to pass as a woman in places crowded with women, such as restaurants and bathhouses, was considered crucial to evaluating an actor's achievement as an *onnagata*." In this way, she raises the important point that the dichotomy between constructionism and essentialism is often ambiguous, arguing that although their performances were constructed, *onnagata* were also required to "pass naturally."[12]

Yet, as many male-role specialists, including Danjūrō IX, expanded their repertoire to include female characters in the nineteenth century, the number of female-role specialists who acted as women offstage declined. Versatility became more valued than specialization. Danjūrō thus concluded that there was a dearth of "pure" *onnagata* available. Although he occasionally played female roles, Danjūrō stated that the innate differences separating men from women prohibited them from playing the opposite

sex in a realistic manner, since this deviated from "the truth."[13] The gap between stage fiction and reality would close only by casting women in female roles. Actresses would impart the psychological truth that Danjūrō had been aspiring to capture throughout his artistic career.

The type of woman Danjūrō envisioned acting on the kabuki stage was not an ordinary woman, but one who "naturally" acted like an *onnagata*, as if such actions were indeed "natural" and not learned. Though he does not state this directly, he appears to have believed that a woman was infinitely closer to the female model exemplified by "pure *onnagata*"; she instinctively would know how to sit properly, to stand with her knees inward, to bend slightly so that she appeared smaller than her male partner, to behave modestly, and to paint her face with the perfect hue of milky-white cream. As Matsumoto Shinko suggests, Danjūrō could only envision an actress performing in the manner of an *onnagata*; in other words, like a woman playing a man as a woman.[14]

Danjūrō's essentialist ideology regarding actresses corresponds to Ayako Kano's thesis about how the definition of gender changed in Japan during the onset of the Meiji period. With the rise of scientific discourses (i.e., biology) in the early twentieth century, gender was no longer viewed, as it had been during the Tokugawa period, as a "theatrical accomplishment"; it was no longer defined based on how one performed the actions of everyday life, how one walked, talked, and dressed. Rather, gender became defined as an "innate" characteristic, naturally fixed in the body, which could not be constructed, rehearsed, and performed.[15] Building on Kano's work, Isaka posits, "In the late Meiji... when the 'return' of actresses was strongly associated with new, scientific discourses that grounded natural femininity in women's bodies alone, *onnagata* could no longer brag about their ability to suffer from gynecological disorders, a stage that they reached by *onnagata* training."[16] Instead of constructing their bodies so that they could "pass" as real women, both in everyday life and on the stage, Isaka suggests that *onnagata* were forced to redefine themselves as artificial: they were not performing real femininity so much as they were presenting the artistic essence of femininity. Therefore, she argues that the "*onnagata*'s artistic femininity became the exclusive property of male *onnagata*," which, in turn, resulted in the abjection of female actors (*onna yakusha*) from the stage.[17]

A close look at the historical situation, however, reveals that the *onnagata*'s artificiality validated the kabuki actress. Indeed, Danjūrō suggested that precisely because pure *onnagata* had ceased to exist, femininity should be performed onstage by women. At this juncture, his ideas regarding the performance of femininity corresponded with the changing definitions of

gender: sex should be aligned with gender, and, therefore, women should play female roles. Women would infuse kabuki with a dosage of "the truth." Danjūrō's vision of kabuki actresses opened up a space for women to act on the stage, but it was ultimately a restrictive space. He still expected the real woman, the new kabuki actress, to act as an *onnagata*, thus flattening, if not erasing, the actual experiences of ordinary women, including the very actresses playing the female roles in kabuki. It is no accident that for his new, female leading lady he pinned his hopes on Kumehachi. Her performances so closely imitated his performance style that she had become known as the "female Danjūrō" (*onna* Danshū).[18]

ICHIKAWA KUMEHACHI

By the time she became Danjūrō's disciple, Kumehachi was between forty and fifty-five years old. Long before she was welcomed into the Naritaya house, she had earned an excellent reputation playing at the minor theatres. Trained as an apprentice of an honorable theatre master (*okyōgen-shi*), Kumehachi had learned kabuki by watching private performances in the homes of feudal lords during the last years of the Tokugawa period. When the *daimyō* system collapsed, she began performing at commercial playhouses, modeling her acting style after well-known grand theatre actors. She mastered important male and female roles, including the loyal serving woman Masaoka (*Precious Incense and Autumn Flowers of Sendai*); Yaegaki, an important princess role (*Japan's Twenty-Four Paragons of Filial Piety*), the Genji warrior Kumagai (*Kumagai's Camp*), the samurai retainer Oishi Yuranosuke (*Treasury of Loyal Retainers*), and Hanako (*Maiden at Dōjō Temple*).

Like many performers, imitation was a fundamental component of how Kumehachi learned to act. She sought to play both male and female roles in the same way as professional male actors. In preparing to become a commercial actor, she formally left her *okyōgen-shi* master and joined the house of Iwai Hanshirō VIII (1829–1882), one of the last "pure" *onnagata*. After his death, she imitated the acting of Ichikawa Kodanji IV (1812–1866) and Sawamura Tanosuke III (1845–1878); only after they died, however, did she discover that Danjūrō's playing was congenial to her own style. By the early 1880s she was being regularly compared to him, and by 1884, she had attracted the attention of the critic, playwright, and scholar of Chinese literature Yoda Gakkai (1833–1909), who, it is said, was the first to call her the "female Danjūrō."

Looking back years later, Kumehachi remarked that the sobriquet "female Danjūrō" had caused her excessive embarrassment. "I felt it was above me," she confided.[19] By then, she had become a disciple of Danjūrō and the most renowned actress on the kabuki stage. She recalled that he had told her, "When you are in the process of launching your career, imitation is fine, but if you are to perform genuine plays, you must rely entirely on your own charms."[20] This might help to explain why one newspaper had reported that, before making her his disciple, Danjūrō "disliked" her and that he had "smiled bitterly" when he heard Kumehachi called the "female Danjūrō."[21] Yet, as we have seen, he accepted her into his acting house in 1888, believing that she could help him make the stage more "truthful" and palatable to western tastes.

There is no doubt that the society's position on women in theatre gently nudged Danjūrō to welcome Kumehachi into his all-male house, but he would not have done so if he did not believe that she had excellent potential. After all, the actor Bandō Matasaburō II (1854–1906) had imitated Danjūrō by doing low-priced curtain raisers, earning the nickname "Ni-sen Danshū" or "Twopenny Danjūrō," but no invitation to the Naritaya house had been issued.[22] Kumehachi was in a class by herself.

Notwithstanding the hype over Kumehachi's acceptance into the Naritaya house, there is no extant written record of Kumehachi ever becoming Danjūrō's leading lady. In fact, theatre historians Ihara Seiseien (1870–1941), Toita Yasuji (1915–1993), and Hasegawa Shigure (1879–1941) state that the two never performed together, while Okamoto Kidō (1872–1939) writes that he remembers hearing rumors that Kumehachi performed at the Kabuki-za (which opened in 1889) but does not know whether she actually did.[23] More definitively, Danjūrō, in *Danshū hyakuwa* (One Hundred Sayings by Danjūrō), records his regret that Kumehachi never performed at the Kabuki-za, but does not comment on whether they ever shared the stage elsewhere.[24] If Kumehachi actually had performed with him, however, someone would have mentioned it, most of all Kumehachi in one of her two autobiographical essays that appeared in *Engei gahō* much later in her life. The only real reason to pause to consider the possibility that Kumehachi did appear with Danjūrō is an extant woodblock print (*ukiyoe*) that depicts them together.

The 1888 print (see figure 1.1) is a triptych attributed to Utagawa Kunisada III (1848–1920).[25] From the characters' names, pose, and dress, it becomes clear that the print is a variation on the eighteenth-century play *Mirror Mountain: A Woman's Treasury of Loyalty*. The moment depicted is the famed fencing duel between the villainous Lady Iwafuji and the pious

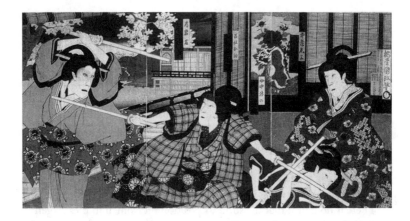

Figure 1.1 Woodblock triptych of *Mirror Mountain: A Woman's Treasury of Loyalty* at the Ichimura-za (Tokyo, 1888) by Utagawa Kunisada III. Actors include Iwai Matsunosuke IV as Ohatsu (center), Ichikawa Danjūrō as Iwafuji (left), Ichikawa Kumehachi as Masuno (right center), and Nakamura Fukusuke IV as Lady Onoe (right). Actual measurements: 13.75 in. × 27.5 in (34.93 cm × 69.85 cm). Courtesy Scripps College, Claremont, California.

servant, Ohatsu, fighting on behalf of her mistress, Lady Onoe. All the names of characters and actors are clearly decipherable. Iwai Matsunosuke IV (1857–1906) as Ohatsu occupies the center; he holds two swords outstretched, one aimed at the chest of Iwafuji (Danjūrō), the other restraining the maid Masuno, who is identified as Ichikawa Kumehachi. Meanwhile, Nakamura Fukusuke IV (the future Utaemon V, 1865–1940) as Lady Onoe watches passively as the scene unfolds.

The production that corresponds to this print in Ihara's *Kabuki nenpyō* (Kabuki Chronology) is *Goshozome of the Mirror Mountain Stage*, which took place at the Ichimura-za on 7 March 1888.[26] According to the cartouche, the print was produced on 23 February 1888, some twelve days before the performance, which accords with the standard practice of prints being published in advance. What is troubling is that Kumehachi is not listed in the *banzuke* (play program); there is no mention of who played the maid Masuno. Moreover, Ihara's *Kabuki nenpyō* notes only that Matsunosuke played Ohatsu; none of the other actors noted in the print are listed.[27] There is no extant written documentation that suggests that Kumehachi appeared in this production. Thus, we must ask whether the print can be considered reliable, factual information.

In many cases, especially when Ihara's *Kabuki nenpyō* and the *banzuke* record that a particular production occurred with the same actors noted in a print, the answer is definitely yes. Yet, it is also plausible that Kumehachi played the part, but was not billed; indeed, even Ihara fails to point out that the great Danjūrō played Iwafuji. We can only speculate that the management of the Ichimura-za, a grand kabuki theatre, permitted Kumehachi to perform as long as her name did not appear in the program. At the same time, an historian must always be aware of the possibility that the prints are not representations of what actually occurred onstage, but figments of the artist's imagination. There is an entire genre of "dream team prints" (*mitate*) in which artists depicted their ideal cast for a performance, even if those actors had never actually performed the roles in question. With all the excitement surrounding Kumehachi's membership into the exclusive Naritaya house, it would have been commercially advantageous for artists to paint her with Danjūrō. This print could arguably be one material trace of an imagined production.

Yet, it seems that if Kunisada III were going to go so far as to imagine Kumehachi and Danjūrō playing together he would have painted them by themselves, not with two other actors who were not even members of the Naritaya house, and he would have chosen a more fitting piece. While *Mirror Mountain* was certainly an excellent vehicle for performers, it is not a play that is associated with the Danjūrō line in general or Danjūrō IX in particular. Furthermore, had Kunisada really wanted to cause a sensation, as the dream-team prints invariably did, he at the very least would have depicted both Danjūrō and Kumehachi in major roles. To be sure, Danjūrō is playing the lead Iwafuji, but Kumehachi is saddled with a bit part, that of the obscure maid, who probably did not say more than a few lines. Although it would have been a major event for Kumehachi to perform with Danjūrō in any role, surely a dream-team print would imagine Kumehachi playing a major role opposite Danjūrō—either Onoe or Ohatsu—since she already had proven herself as a talented actor to Tokyo audiences. Thus, the print cannot easily be dismissed as false, nor can it simply be used as evidence that the two actors ever shared the stage together; rather, we can only be aware of the possibility that a joint performance might have taken place, despite the fact that several historians have all but ruled it out. Clearly, Kunisada believed that it was important to depict the great master and his female disciple together, whether or not an actual production ever occurred.

Credit, however, should be given to Kumehachi for the role she played in the promulgation of an 1890 Tokyo Metropolitan Police edict concerning actresses. Several scholars and critics have interpreted this proclamation

as overturning the Tokugawa ban on female actors and officially allowing women to perform on the stage. In actuality, the edict merely took a laissez-faire stance regarding women on the stage, stating quite simply that the police's policy will be "not to make an issue of it" (*fumon ni fusu*). Rather than permitting women to perform onstage—which they already were doing—the edict was concerned with men and women performing together. It announced that henceforth the police would neither prohibit nor promote such performances from taking place. All decisions concerning mixed casting would be at the discretion of theatre owners and actors.[28]

Kumehachi's wish to perform together with men appears to have been the impetus behind the edict. The text of the proclamation explains that the owner of the Azuma-za petitioned the Tokyo Metropolitan Police to permit mixed productions at the theatre. According to Matsumoto Shinko, Kumehachi's troupe had been performing at the Azuma-za at the time in question, so the Azuma-za owner was most likely asking for permission on Kumehachi's behalf. Matsumoto and Ōzasa Yoshio further relate that Yoda Gakkai, the acclaimed scholar and a strong supporter of the now-defunct Society for Theatre Reform, had planted the idea that Kumehachi's troupe perform with men, after which the Azuma-za theatre owner requested permission from the Tokyo police.[29] Instead of tailoring its response specifically to the Azuma-za, however, the edict noted that the police's decision would be applicable to all theatres. Thus the Azuma-za and, by extension, Kumehachi, had the green light to go ahead and produce mixed performances.

Contrary to expectations that the edict would facilitate joint performances between Danjūrō and Kumehachi, no productions appear to have taken place. In fact, the year following the promulgation of the edict, in 1891, Kumehachi was expelled from the Naritaya house for performing Benkei in *The Subscription List*, one of the Naritaya house's "Eighteen Favorites" (*jūhachiban*), without Danjūrō's permission. Codified and passed down by Danjūrō VII, these plays are considered heirloom art "owned" by the Naritaya house. Actors from other families may perform the plays, but protocol requires permission from the head of the family line.

Although not unheard of, expulsion (*hamon*) is rare in the kabuki world. Yet it was not beneath Danjūrō IX to flex his muscles and oust a member from his house if he felt that he had been betrayed. He had banished Ichikawa Ennosuke I (1855–1922) from his house in 1874, also for playing Benkei without permission, only to readmit him in 1886.[30] Kumehachi too was later readmitted but since it is unlikely that she had ever shared

the stage with Danjūrō previously, it was all the more improbable that they would perform together now, after such an imbroglio. As before, Kumehachi continued to perform at the minor theatres. She soon became the actor-manager of a new all-female troupe at the Misaki-za (later, Kanda Gekijō [Theatre]). In November 1893, her troupe performed *Viewing the Autumn Foliage*, with Kumehachi playing the lead, Princess Sarashina (in actuality, the demon of Mount Togakushi), the very same role that Danjūrō had enacted for the play's debut at the Shintomi-za in October 1887. A woodblock print of the production lists her as Ichikawa Kumehachi (粂八), which might indicate that by November 1893, she already had been readmitted to the Naritaya house.[31] Over the next year, she was invited to Osaka for the first time and also toured in Kyoto, Kobe, and Nagoya, returning to Tokyo only in May 1894.[32]

THE DEBUT OF THE DAUGHTERS

Meanwhile, Danjūrō continued to perform at the grand theatres in classics such as *Sukeroku* and in new plays by Fukuchi Ōchi (1841–1906). As for his interest in actresses, he became focused on the 1893 Kabuki-za debut of his daughters, Jitsuko and Fukiko. It is understandable that critics have assumed that this appearance marked the stage debut of the daughters since the event captured the attention of the press. In fact, they had made their respective stage debuts some four years earlier, in 1889, at a charity recital at the Shintomi-za hosted by the private Mimasu Society headed by Danjūrō. The eight-year-old Jitsuko performed a dance version of *Pinning Wind* and six-year-old Fukiko danced *The Wisteria Maiden*.[33]

Fittingly, Fukuchi, an advocate of kabuki actresses, wrote *Mirror Lion*, the piece they performed at the Kabuki-za. The play is classified as a dance-drama (*shosagoto*), but is reminiscent of the "pine-tree board plays" (*matsubame-mono*), the sub-genre that adapted plays from *nō* and *kyōgen* as part of the trend to reform and refine kabuki. The play is a vehicle for one actor to showcase technical skill and versatility. The actor first performs the challenging part of a dainty lady-in-waiting (Yayoi), who reveals herself in the second part of the play as the spirit of the lion. It demands graceful, light "feminine" steps in the first half and powerful, wild "masculine" movements in the second half. While this actor changes costume offstage, the butterflies enter and perform a short dance that sets the stage for the brilliant second half of the play. After the lion returns,

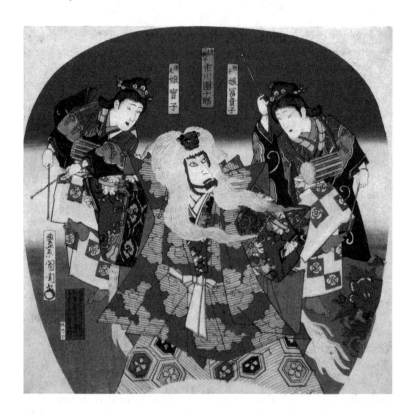

Figure 1.2 "Kyūsei Ichikawa Danjūrō no *Kagamijishi*" (Danjuro IX's *Mirror Lion*). Woodblock print of Ichikawa Danjūrō IX with his two daughters, Jitsuko and Fukiko, at the Kabuki-za (Tokyo, 1893) by Toyohara Kunichika. Courtesy Tokyo Metropolitan Foundation for History and Culture Image Archives.

the butterflies slip offstage only to reappear for the head-spinning climax. Danjūrō played the lady and lion, while his daughters played the twin roles of the butterfly spirits.[34]

The Kabuki-za went to some lengths to make the debut a memorable event. A commemorative fan featuring a woodblock print of Danjūrō and his daughters was either available for purchase or distributed to spectators (see figure 1.2). The artist, Toyohara Kunichika (1835–1900), depicted Danjūrō as the lion flanked by his daughters as the butterfly spirits. He seems to have taken some liberties with their costumes; in his print, they wear matching long-sleeve

kimono with angelic butterfly wings on their backs, but photographs do not show them wearing wings (see figure 1.2).[35] The reverse side appears to have included a haiku that Danjūrō composed in honor of his daughters:

> In the spring fields
> Resembling peonies
> Bamboo flowers[36]

The haiku was a beautiful tribute to Jitsuko and Fukiko. Their father compares them to bamboo flowers, which are rare, flowering only once every 100 years or so. Bamboo, furthermore, symbolizes an ideal manner in which to grow: straight, but flexible enough to bend. This alone would be a reasonable wish any father would have for his daughter, but Danjūrō went further, comparing the bamboo flowers to peonies, the symbol of the Ichikawa Danjūrō family line. In "resembling" peonies, the daughters were poised to inherit the acting heritage of their father. Yet, for the present time, they were closer to the bamboo flowers in their early spring, the very season in which they made their Kabuki-za debut.

In the grand kabuki world, actors participate in special ceremonies to celebrate taking a new stage name (*shūmei hiro*). Such formal "curtain speeches" are called *kōjō*, and ever since the 1950s, these ceremonies have become lavish affairs. The main members of the actor's house and close colleagues appear onstage dressed in Tokugawa-period costumes and wigs. Careful attention is paid to protocol: when the curtain opens, the actors are lined up in neat rows on the stage, kneeling *seiza* style, with their calves tucked under their thighs. Actors then take turns giving formal speeches from memory in which they extol the virtues of the performer receiving a new name and ask for the audience's support. Many actors bow their heads until it is their time to speak. Depending on the occasion, the remarks can be brief or lengthy.

It is possible that Danjūrō would have made some kind of announcement—with or without all the pomp and circumstance—from the stage to mark the felicitous occasion, but there is no evidence that a naming ceremony took place. Newspapers reporting on the event continued to refer to the girls as Danjūrō's daughters or by their private names, Jitsuko and Fukiko, as do the extant *ukiyoe* prints in honor of the occasion.[37] Sometime later, perhaps not until several years after their father's death, they took the stage names by which they would be known for the rest of their lives. Jitsuko, the eldest, became Suisen II (翠扇), after the pen name of Danjūrō II's wife, and Fukiko took the name Kyokubai (旭梅), the pen name of Danjūrō V's first wife.[38]

In light of his support for women to play female roles, Danjūrō's choice to have his daughters play the butterflies might have been strategic. It was unlikely to upset opponents since the butterflies have no explicit gender. The butterflies do not speak, and the fact that the girls appeared with their father for the majority of their onstage time might have mollified even the most obstinate critic. Only the most stubborn spectator would not have been moved by Danjūrō's new spin on the old tradition of a father performing with his offspring, the older generation appearing with the up-and-coming one. By making their respective debuts before adolescence, the girls gave spectators the opportunity to become lifelong fans. Indeed, kabuki aficionados embrace the opportunity to witness the debuts of scions of major kabuki families. They know that these young children will be groomed to inherit the great kabuki roles; watching their development over the years is considered to be a kind of insider sport. Beginning with this unique performance, fans could chart the growth of the daughters. Some of them might have envisioned the young girls one day performing with their own daughters.

Following their Kabuki-za debut, the girls performed in a new dance piece, *The Fulling Block*, probably an adaptation of the eponymous *nō* play, and, in September 1893 at the Kabuki-za, Jitsuko played Hitomaru and Fukiko played "the female Tomi" in *The Daughter of Kagekiyo*. Later the daughters, together with a girl named Reishi, appeared in *Ōkubo Hikozaemon* (character name) and played the child role Otsuru in *Naruto on the Straits of Awa* at an industrial promotion fair sponsored by the Meiji government.[39]

Jitsuko's and Fukiko's performance careers, however, were curtailed abruptly when they became ill. The *Yomiuri* reported that Danjūrō became so concerned that he considered retiring from the stage. Published after the girls had recovered, the article poked fun at the great actor for worrying excessively about his daughters. Jitsuko is quoted as saying, "If we had died and father had quit acting, and if there were financial concerns, why couldn't father take up the sport he loves and become a fisherman?" Apparently, Danjūrō was "too stumped" to respond.[40] For their comeback performance, the girls appeared in *The Daughter of Kagekiyo* once again with their father at Kabuki-za in May 1894.[41]

They subsequently took a break from performing in public. As Danjūrō and others later reported, the girls were never accepted as actors by their fellow male performers.[42] Neither one, however, totally abandoned the stage. Like other aspiring actresses at the beginning of the twentieth century, they turned their attention to *shingeki* (new theatre), which consisted mainly of European modern drama performed in Japanese.

Their big break was in *Benisu no shōnin*, Ichikawa Sadanji II's (1880–1940) adaptation of Shakespeare's *The Merchant of Venice*, in January 1908, at the Meiji-za.[43] It is unclear which role Jitsuko played, but Fukiko played Portia and danced *The Heron Maiden*—even in *shingeki*, she continued to perform kabuki. In curtain speeches, the sisters petitioned for a school devoted to training actresses. Their efforts probably contributed to the opening of the Teikoku Joyū Yōseijo (Imperial Actress Training Institute) under the direction of Kawakami Sadayakko (1871–1946) later that year. The school was the first of its kind to offer western and Japanese acting, dance, and musical training for women. Many of these actresses later appeared in the Teikoku Theatre's popular, albeit short-lived, series that cast men and women in kabuki plays.[44]

Jitsuko and Fukiko occasionally appeared together in dance pieces such as *Two Maidens at Dōjō Temple* but neither became the kabuki actresses that their father had envisioned back in the late 1880s. Sawamura Tanosuke VI (b. 1932), remembers Suisen II best as a dance teacher—indeed, after Danjūrō's death in 1903, she became the head of the Ichikawa dance school, which became a counterpart to the Naritaya acting house.[45] But the daughters struggled for performance opportunities. Writing about the thirty-one-year-old Suisen, the 1912 actress directory *Joyū kagami* (Actress Mirror), noted, "Nowadays many new actresses continue to perform, but we cannot forget that this is, no doubt, thanks partly to the courageous sacrifice made by this person."[46] It gently reminded readers that the acceptance of actresses in the early twentieth century was thanks to trailblazers such as Suisen. Indeed, when Kyokubai's (Fukiko's) daughter, Horikoshi Kikue (1913–1978, later Ichikawa Kōbai, Ichikawa Suisen III,), expressed interest in becoming an actress, her own mother discouraged her, so she turned to her Aunt Suisen for support.[47] Interestingly, the family member who would emerge to promote kabuki actresses most notably would be the husband of Suisen II, the banker Kamiyagi Fukusaburō (later, Ichikawa Sanshō V), whose story is told in subsequent chapters.

In the early 1890s, however, Danjūrō IX was still alive and interested in seeing women perform on the kabuki stage. The 1894 visit of Madame Théo would prove to be the perfect occasion for more experimentation.

DANJŪRŌ AND THÉO

In his biography of his father-in-law, Ichikawa Sanshō V wrote that it was "after" Danjūrō IX performed with Théo that he "developed a special interest in actresses."[48]

It should be clear, however, that Danjūrō had developed this interest long before Théo came on the scene, but thanks to Sanshō's biography, it is possible to trace how his position on actresses evolved. Precisely who Théo was remains somewhat of a mystery. The little information that is provided in Japanese accounts states that she was of Russian extraction and that she had spent time in France, as an actress with the French theatre (Furansu-za).[49] An entry for Madame Théo in Lyonnet's *Dictionnaire des Comédiens Français*, however, states that she was the daughter of Madame Piccolo, the director of "café concerts" on the Champs-Elysées, and that she made her stage debut in 1873, performed frequently at the Aux Bouffes and Aux Nouveautés theatres, and toured to North America in 1900–1901.[50] The photo of Théo that accompanies Lyonnet's entry resembles the actress pictured with Danjūrō in *Kabuki-za hyakunenshi* (One Hundred Years of Kabuki-za History), and the dates of her activities (the dates of her birth and death are not provided) correspond to Japanese accounts.[51] Unfortunately, Lyonnet did not mention her 1894 Japan visit, so it is possible, though not likely, that the two Théos were not the same person.

Danjūrō first made Théo's acquaintance through a Russian diplomat who invited him and Fukuchi to dine with the actress. Danjūrō was quoted subsequently as saying that Théo was around forty-two or forty-three (he would have been around fifty-six), and "still very beautiful," and that the two had met "many times" during her visit to Japan. Exactly how they communicated is unknown; Danjūrō spoke no French, she no Japanese, but that did not prevent them from spending time together. The *Yomiuri* reported that Danjūrō arranged demonstration performances especially for her, and that she "didn't blink," she was so enraptured.[52] At the end of the month, the two performers starred opposite each other in a joint three-day production at Kabuki-za, marking the first performance by an adult woman at the theatre.[53] Apparently, Théo's Occidental credentials were prioritized over Kumehachi's lifelong devotion to the kabuki theatre. Because Théo was a foreign European actress performing for a limited run, kabuki actors were not likely to feel that their jobs were threatened. She was not competing with the theatre establishment, but introducing European "high-class" drama to Japanese audiences.

In a preview article, the *Yomiuri* reported that Danjūrō and Théo planned to perform a comedy adapted by Fukuchi and others that "will show the essence of the [respective] French and Japanese theatres" and "show educated people about theatre in Europe."[54] The script was written in three languages: French, English, and Japanese; Danjūrō would speak

in Japanese, and Théo would speak in "a foreign language," presumably French (a French scholar would assist with translation). Short of extolling the cutting-edge theatrical experience, the *Yomiuri* commented, "It promises to be truly strange."[55]

Despite their linguistic challenges, both Danjūrō and Théo expressed mutual admiration for each other. For Théo, the problem was not with her partner, but with the "infantile" Japanese spectators. She stated, "If this had been Paris, spectators would have forgotten themselves and showered him with praise, but in Japan, the audience showed absolutely no interest. On the other hand, it applauded at the dull moments."[56] Danjūrō, likewise, came to believe that Théo was a brilliant performer. While acknowledging problems communicating, he believed that Théo's acting conveyed the elusive "truth" for which he had been searching: "I felt that she appeared real when she cried, showed surprise, and laughed," he is quoted as saying.[57]

He was so impressed that, according to Sanshō, Danjūrō proclaimed definitively, "From here on out, actresses must play female roles." Yet, now he distinguished between kabuki and the new, emerging genres of theatre. In "plays such as those that will be born henceforth and for dance dramas (*buyō geki*)," the actress was necessary and would play "a greater role in Japanese theatre," but he added, "This is not the case for the Japanese traditional kabuki."[58] It is true that Sanshō later noted that Danjūrō had "murmured" something about "having all the ladies in waiting (*koshimoto*) played by women," and that he was still trying to understand how a "woman's figure could harmonize with kabuki," but there is little doubt that Danjūrō's views on women in kabuki had changed from the time he had accepted Kumehachi as his disciple.

Théo showed him that there were many more possibilities for a woman than to play the conventional *onnagata*. Actresses could now enact modern women, whose voices, gestures, actions, and motivations differed from what had been presented heretofore on the kabuki stage. It therefore should not come as too much of a surprise to learn that just six months later, Kumehachi, too, would begin to expand her repertory of female-style roles, making a slow transition from the old school (*kyūha*), as kabuki was then called, to the new (*shinpa*), which showcased contemporary events onstage.

KUMEHACHI AS MORIZUMI GEKKA

Perhaps because Danjūrō and Kumehachi's "marriage" was never officially consummated onstage, there was no need for an official divorce.

Kumehachi never reported that she was going to discard her old name, but she did announce that she was going to take a new one.

As we have seen, the critic Yoda Gakkai had been a fan of Kumehachi for more than a decade, allegedly giving her the nickname the "Female Danjūrō" in the mid-1880s, but now he felt the time had come to give her a new name. In June 1890, after seeing her perform at the Azuma-za, he wrote a poem in *kanbun* (literary Chinese) in her honor. He explained that his poem meant that "Kumehachi was so beautiful that she could not be compared to the moon or to the flowers." She was the best under the sky. Kumehachi wrote that she treasured the poem; so smitten was she, in fact, that, in 1895, she took "Gekka" 月華 (moon and flower), the very word of praise that Gakkai had bestowed upon her, as her stage name for the *shinpa* plays in which she appeared, combining it not with the name Ichikawa, but with her married name, Morizumi, to become Morizumi Gekka.[59]

Why did Kumehachi, who had dedicated her life to perfecting the dance and acting style of kabuki, decide to act in *shinpa*? Most compelling, it appears that she was unhappy with how she was treated by male kabuki actors, what would be referred to today as gender discrimination. She never complained directly about this, but Yoda Gakkai implied that it was one of the reasons for her decision to try her hand in the new theatre. Kumehachi hoped, he stated, that she would be treated "as an actor, not as a woman" by actors involved in *shinpa* and *sōshi shibai*, a political theatre form that grew out of the People's Rights Movements in the later 1880s.[60] For just as Kumehachi had adapted to the commercial theatre after working in the private homes of *daimyō* in the early 1860s, she was prepared once again to make a career transition.

In her essays, Kumehachi clarifies that one of the primary reasons for appearing in *shinpa* was to get more practice in *sewamono* (domestic plays), which she, as a classically trained dancer and veteran performer of *jidaimono* (period pieces), believed to be her weakness. She believed that *shinpa*'s relative emphasis on realism, plot, and dialogue would help her to perform *katsureki*-type plays, which, as we have seen, were the attempts by Danjūrō to perform a more historically correct kabuki. From Kumehachi's perspective, both genres were committed to visual verisimilitude, textual innovation, and a more restrained acting style. It was also an excellent opportunity to experience something new and different. She was impressed by *shinpa*'s strict rehearsals and meritocratic system by which actors without family connections could play significant roles.[61]

At the same time, she was not thoroughly enamored with *shinpa*. While acknowledging that the genre was still in the process of formation, she was

unimpressed with the looseness of the plays. There was so much dialogue that actors did not know where to breathe, and plays that would have taken one day to rehearse in kabuki took three. "If you did that in the old theatre (*kyūgeki*), you would get fired," she wrote.[62] In short, *shinpa* was not as enthralling to her as kabuki, but it was more straightforward. "I might be boasting, but compared to the old theatre, *shinpa* is much easier; *shinpa* is not all that interesting," she stated, adding, "It is much easier to teach a lady-in-waiting *shinpa* than to teach her the old-school theatre." Still, she allowed that *shinpa* plays had improved, and once the blocking and breathing "become more set...something good might come about."[63] She even acknowledged that performing in the new genres had helped her own acting.

Her frustration can be gleaned between the lines, but she avoided stating what many commentators have since agreed: *shinpa* was not a good match for her. She excelled at the exaggerated *jidaimono* period pieces of kabuki, not the relatively more realistic style of *shinpa*. Historian Kamiyama Akira, moreover, quotes from a contemporary periodical that states that, while Kumehachi was on tour with the troupe of Kawakami Otojirō (1864–1911), she "loitered and sat in the corner during times when everyone would spend the night together."[64] The differences that *shinpa* presented were so acute that old-school performers, Kumehachi notwithstanding, could only have felt like water to *shinpa*'s oil, too strange to ever blend seamlessly.

She must have been relieved to be officially reinstated to the Naritaya house, probably around 1895, some four years after being ousted. Yet, performing at her old haunts, she realized even more poignantly that she had hit a "glass ceiling." Though she had been accepted with great fanfare into the Naritaya house, she was not made to feel at home. She could continue to perform at the minor theatres, but seldom at the grand ones. Like male actors who had been given the pejorative designation "drop-curtain actors" early in their careers, she never was able to make a clean break with her past acting career.

Danjūrō was unable to facilitate a vertical career move for her. Though he had acquired a reputation as an opponent of actors from the minor theatres, he does not appear to have held a bias against female actors let alone Kumehachi. One commentator later quoted Danjūrō as acknowledging that his wishes for women on the kabuki stage had been left unfulfilled. He expressed frustration that he was unable to realize "his firm desire to use actresses in grand kabuki" and to enable Kumehachi to perform at the Kabuki-za.[65] Following Danjūrō's example, several actors—Onoe Baikō VI (1870–1934), Ichikawa Sadanji II, Sawamura Gennosuke IV (1859–1936),

and Sawamura Sōjūrō VII (1875–1949), to name a few—began to admit women into their respective schools in the early twentieth century. Their approval of women in kabuki, however, came after Danjūrō's death in 1903. During his life, he allegedly commented, "In our country it seems that there cannot be actresses."[66] As Toita remarked, "No one, notwithstanding the emperor, had the type of power that Danjūrō wielded, and yet he felt it was his duty to stick to kabuki's conventions." Indeed, many of Danjūrō's contemporaries remember him saying, "If only Kumehachi had been born a man."[67] She was the wrong sex for a profession that otherwise fit her perfectly well.

By many accounts, Kumehachi, too, regretted her sex. Toita, Hasegawa, and Okamoto emphasize that one of her major disappointments was never being able to perform with Danjūrō. Leaving aside the question as to whether she ever did perform with him, what matters here is her sense of frustration at being a woman in a man's world. No matter how adeptly she transcended her female sex in performance, she remained a minority of one in the Naritaya house. The benefits she accrued from her association with Danjūrō bolstered her independent stage career, but did little to help her cross the dividing line between the minor and grand theatres.

The death of Danjūrō left her on even more unsteady ground within the Naritaya house. Up until this sad occasion, however, Kumehachi still played the role of a devoted disciple. According to one account, she had been performing in Kyoto when she received a telegram with the news that Danjūrō was in a critical state; wasting no time, she took the train back to Tokyo, going directly to his home in Tsukiji to sit by his bed and care for him through his last night. During the funeral, a rainy September day, she walked in straw sandals, a sign of her humility, next to the coffin. Yet, precisely for her devotion to her master, she was begrudged by his wife, who apparently was consumed with jealousy. Although it was considered requisite for a disciple of Kumehachi's standing to pay respects to Danjūrō's wife, Kumehachi decided to send one of her apprentices in her stead. She sensed that she was not wanted.[68]

Interestingly, though, she appeared at the Kabuki-za in a memorial production for Danjūrō in September 1905. Thus, it was after his death that she achieved one of her goals of performing at the renowned theatre. She played the old woman in *The Shogun Takatoki*, one of the more popular of Danjūrō's controversial *katsureki-geki*.[69] Compared to the plum roles that she had played in the past, it was not a remarkable part, but she could still take great pride in this belated debut at the prestigious Kabuki-za.

After Danjūrō's death, she collaborated with other "old-school actors" to perform at minor theatres as well as to tour the provinces and other cities. She performed occasionally with the troupe of Kawakami Otojirō, but had to play second fiddle to the troupe's new female star, Sadayakko, Otojirō's wife, who had become a household name after her tour to Europe and the United States.[70] She also taught "old-style acting" at the newly opened Imperial Actress Institute. Commentators suggest that her acting began to decline as early as 1905, when she was injured in a traffic accident (a bicycle crashed into her rickshaw). But she continued to perform, most notably at the Ashibe Club in Osaka, where she was paid an impressive sum of 1,000 yen for one month's work. Her final program in Tokyo at the Mikuni-za included *The Mountain Witch* and *Yasuna* (character's name), which she was scheduled to perform three times a day. But upon returning to her dressing room after the second evening's performance, she collapsed and lost consciousness. She died ten days later in the hospital on 24 July 1913.[71] Her name was later inscribed on the memorial plaque in the Naritaya gravesite in the Aoyama Cemetery in Tokyo as one of the chosen pupils of Danjūrō IX, the only woman to be listed. No matter how little Kumehachi interacted with Danjūrō IX, she would be remembered as the "female Danjūrō."

After her death, Kumehachi's all-female troupe continued to perform at the renamed Kanda Gekijō until the early Shōwa period (1926–1988). Their style of acting, however, was reportedly different from Kumehachi's. Nakamura Kasen (1889–1942) was said to have played female roles oozing with feminine sex appeal.[72] Such sexually titillating performances made critics wary of female actors, especially those who dared to perform kabuki. Kumehachi, too, would not escape a legacy of being sexually suspect. Nearly seventy years after her death, Toita Yasuji reprinted rumors that Kumehachi was a lesbian and that her female disciples coveted the cotton wrap that she had used to bind her breasts while playing male roles.[73] Just as it had been in the seventeenth century with Okuni and other actresses, sexual licentiousness was used as an excuse for why kabuki actresses failed to become permanent fixtures on the stage. Zoë Kincaid, the author of the first major English-language tome on kabuki, epitomized this thinking when she wrote in 1925: "The tendency of the theatre art in Japan is toward a separation of the sexes, and there is hope that in the future a women's theatre, free from the immoral influences that caused the downfall of the *Onna* Kabuki, will coexist with kabuki, the firmly established masculine stage."[74]

The next generation of Ichikawa kabuki actresses initially appeared to transcend sexual scrutiny. Comprising prepubescent girls, the Ichikawa

Girls' Kabuki Troupe impressed critics as safely asexual. "Young, innocent, naïve, and cute" were the words of praise lavished on the troupe during its early days. But such descriptions alone never would have ensured Naritaya house sponsorship. The troupe's artistic prowess, together with the precedent of Kumehachi, Suisen, and Kyokubai, would convince the next leader that Ichikawa kabuki actresses had a venerable past and a promising future.

2. The Formation of the Ichikawa Girls' Kabuki Troupe ᷓ

The Ichikawa Girls' Kabuki Troupe was born in 1948, some three years after Japan's defeat in World War II. Like a famous grand kabuki actor who takes different stage names over the course of his career, the troupe changed names several times before receiving the prestigious "Ichikawa" name from the Naritaya house. In the beginning, however, the troupe was nameless. It was just an after-school girls' club. There was no indication that it would become a professional company, let alone a famous one that would play to packed houses in Japan's premiere theatres.

The girls who eventually came to earn the "Ichikawa" name were not of kabuki lineage, nor had they ever seen a production of grand kabuki until after they had performed in a dozen or so plays of their own. Hailing from Toyokawa in the Mikawa district of Aichi Prefecture, they were unabashedly provincial. One member recalled that she did not know that kabuki was "all-male" until years after she had played starring roles in the troupe's plays.[1] The majority of members came from families that were intimately acquainted with minor kabuki and the tradition of men and women performing together.

In this respect, Toyokawa was perfectly positioned to produce a female theatre troupe after the war. Nestled in the countryside between the Mikawa-sanchi mountain range and the Toyokawa River, the city was somewhat sheltered from the hunger, poverty, and panic that characterized the immediate postwar experience for many urban Japanese. The area's expansive farmlands produced a respectable crop throughout World War II and the subsequent Allied Occupation, so that the majority of local residents were decently fed. They still had to forego the desired polished white rice in favor of barley and had to make do with *meri-ko* (A-*meri*-can wheat) in

their soup, but it was a luxury compared to the fate of many of their urban compatriots who were hard-pressed to come by even one adequate meal.[2] Before the war the town had been famous for its minor theatres. Many local folk could chant lines by heart from plays and imitate their favorite actor. According to one account, there had been more than 200 kabuki actors—ranging from amateur to professional—in the neighboring big city, Toyohashi.[3] Many locals belonged to an amateur theatre club called "Manninkō" (ten thousand plays) in which participants pooled their money, so that a select few could see kabuki at the grand theatres in Tokyo, Nagoya, Kyoto, or Osaka. In turn, Manninkō representatives were each responsible for a different aspect of production—dialogue, movement, costumes, scenery, props—so that upon returning to Toyokawa, they reported on every aspect of the performance, imitated the voices and movement of the actors, and applied their newfound knowledge to town festivals and amateur productions. The result was a fairly accurate reflection of what they had seen in the cities.

Concerning their choice of repertory, however, there was one vital difference. Grand theatre productions include a generous mix of different kinds of kabuki plays, but the majority of plays selected for Manninkō productions were adapted from the puppet theatre (*ningyō jōruri* or *bunraku* repertory).[4] A "balanced" production included "pure" plays written expressly for the kabuki theatre, dances (*shosagoto*), new kabuki plays (*shin* kabuki), as well as plays adapted from the puppet theatre. These latter plays are generally referred to as *maruhon-mono* (round books), due to the circular cursive style of the puppet chanter's scripts, or as *denden-mono*, an onomatopoeic term that mimics the sound of the plectrum striking the *shamisen*. *Denden-mono* are accompanied by *gidayū*, a musical-performance genre named after Takemoto Gidayū (1651–1714), a famous chanter of the *bunraku* puppet theatre. In *bunraku* productions, the *gidayū* chanter sings the narration and all the characters' lines, but in *denden-mono*, the kabuki adaptations of these plays, the *gidayū* chanter usually narrates the story, while actors generally recite the majority of their own lines. These plays are easy to distinguish from others in the kabuki repertory, since the *gidayū* chanter and *shamisen* player or players usually sit on stage left, considered the more important side of the stage, often in the raised "minister pillar" (*daijin-bashira*).

In the case of the Manninkō Association, the prevalence of *denden-mono* in the repertory reflected Toyokawa's proximity to Osaka, the city most commonly connected to the development of *bunraku*. Townspeople were more familiar with the plays of the puppet theatre than with other genres of kabuki. In addition, conventional wisdom suggests that the first plays many

actors learn are the ones adapted from the puppet theatre. Together with a solid background in kabuki-style dance (*nihon buyō*), *gidayū* chanting is considered one of the prerequisites for kabuki. Moreover, mastery of the puppets' predefined movements and corporeal patterns (*kata*) is thought to be the best training for performers, as the same forms can be applied to dozens of plays. Even though the plot and dialogue change from play to play, the exterior movements remain more or less the same, enabling actors in rotating repertory to remember their parts, especially when they are playing the same stock character over and over.

In addition to serving as the region's theatre hub, Toyokawa was known as the pleasure quarters of the Mikawa region.[5] According to local lore, the city was a destination for pilgrims who paid their respects to the gods at the Inari Shrine during the day and at night availed themselves of the many excellent restaurants and teahouses. These establishments offered an intimate setting to mingle with geisha, watch dances, and listen to *shamisen* ditties. As the war progressed, however, Toyokawa's riverfront was converted to navy dockyards, and, after an artillery storage facility was bombed, most residents evacuated to the outlying towns. Pilgrimages all but ceased, crippling the local economy. Luxuries such as artistic lessons came to a halt during 1945, the final year of the war.

One of the many casualties of the war was the closure of Yuki-san, a popular restaurant. Before the war, it had catered to the groups of visitors descending on Inari Shrine, thanks to its convenient location across the street from the Toyokawa train station. During the war, however, business had slowed, and it had become a "snack" house, serving appetizers and drinks; by the end of the war, it was out of business. The proprietor Ishiguro Tatsunosuke, however, hated to see such prime real estate go to waste. Instead of selling or leasing the space, he proposed that his young daughters and their friends use the restaurant's second-floor banquet room as a dance studio.[6]

Like many residents in the area, Ishiguro was a theatre aficionado and an amateur student of *gidayū*. He went to the theatre frequently and participated in several Manninkō productions. His most memorable moment onstage might have been when his wig fell off playing the comic villain Bannai in *The Treasury of Loyal Retainers*. Despite any embarrassment, he remained passionate about theatre. Even during the closing years of the war, he had ensured that his two youngest daughters, Ikuyo (b. 1938, later Ichikawa Masuyo), and Hiroe (b. 1936, later Ichikawa Misuji), learn *nihon buyō*, a prerequisite for kabuki acting. Thanks to his prodding, they participated in local dance recitals and won regional contests. Encouraged by their

success, he decided they should learn a kabuki play. Besides, he was tired of seeing them perform the same old *Heron Maiden* and *Dancing Footman*. He wanted his girls to do something different from their competitors; he wanted them to stand out. But he also imagined his daughters forming an all-girls' kabuki club. Far from wanting to profit commercially from their talents, he hoped to revive the now-stagnant prewar theatre scene that had been such an important part of his childhood. He wondered whether his daughters could help to fill the void.[7]

It is uncertain whether or not Ishiguro knew about past all-female troupes or even the kabuki actress Ichikawa Kumehachi. It is unlikely that he linked the formation of a girls' kabuki troupe to the Japanese feminist movement, or to the newly written constitution, promulgated on 3 May 1947, which gave women the same rights as men. It is also doubtful that he had seen a performance by a children's kabuki troupe, though he had seen girls play "child roles" (*koyaku*) in Manninkō productions. In thinking about an all-female kabuki club, he probably envisioned something akin to Takarazuka or the Shōchiku Revue (Shōchiku Kageki Dan, SKD), two popular all-female troupes.

The establishment of the Takarazuka Revue in 1913 followed by the foundation of SKD in 1921 presented girls with new opportunities to perform in public. Both troupes were commercial ventures run by male managers that capitalized on the charm of young girls. Takarazuka was founded by railroad tycoon Kobayashi Ichizō (1873–1957) to provide "wholesome family entertainment" at the hot-spring resort town, Takarazuka, which conveniently happened to be on Kobayashi's new railroad line just west of Osaka. Like the Shōchiku Revue, Takarazuka later would open another large theatre in Tokyo, securing a sizeable audience base in Japan's most heavily populated regions. By the 1940s, both female companies had become famous for their top stars, glitzy line dances, and showy musical numbers. Their respective repertoires featured some adaptations of kabuki plays, but they were better known for their Parisian-like revues and flashy dances.[8]

Perhaps due to the precedents of Takarazuka, SKD, and female participation in the town's minor-theatre productions, there was no opposition to the formation of a girls' kabuki club. Ishiguro, however, had difficulty finding a suitable teacher for his daughters. For a town with such an excellent reputation for amateur theatre, the pickings were surprisingly slim. Though Ishiguro hoped to enlist a kabuki actor for the job, he settled for a *gidayū* chanter who was volunteering as a makeup artist at nearby theatres. Furukawa Yoshiishi had some stage experience; before the war, he had performed as a *gidayū* narrator on the minor-theatre circuit and had studied

acting with a local star, Katsukawa Matazō. For his efforts, he had received two professional stage names Takemoto Nishiki-dayū and Katsukawa Matanojō from his teachers. Illness had forced him to retire from his work in his mid-forties, so he was available to teach the girls a kabuki play. Given his background as a *gidayū* narrator, Furukawa was comfortable only teaching the girls *denden-mono* pieces. He initially thought that they would just imitate kabuki dance as best they could while he chanted the narration and dialogue. He never envisioned them actually speaking and embodying the various characters in a convincing matter. Within a few weeks, however, he had taught them his favorite plays: "The Village School" and "Pulling the Carriage Apart" from *Sugawara and the Secrets of Calligraphy*, as well as short scenes from *Naruto on the Straits of Awa* and *The Miracle at Yaguchi Ferry*. He soon recognized that he had underestimated the girls: their energy was boundless and their gift for remembering new material was extraordinary. They needed a teacher who had worked as a kabuki actor, not only as a chanter and makeup artist.[9]

Ichikawa Dankichi II (later Ichikawa Masujūrō) fit this description. Unlike Furukawa, he was veteran actor of the minor circuit. It would be under his leadership that the girls would learn kabuki plays, tour the country, and become licensed by the Naritaya house. Indeed, while Ishiguro had planted the idea of an all-girls' troupe, Dankichi made it a reality. Of course, it is possible that another teacher could have shown the same interest and devotion as Dankichi, but it is just as likely that under different leadership, the girls—and the fledgling troupe—would have languished in Toyokawa.

Dankichi came to lead the troupe by sheer coincidence. As Furukawa told the story to journalist Kurokawa Mitsuhiro in 1984, he planned to ask his former teacher Matazō to take charge of the troupe. On the train trip to visit him, however, he bumped into Dankichi. Furukawa had worked with Dankichi when he was still known by his private name, Nakada Daiji, when he was a local student. Daiji had come to Furukawa seeking advice on how to get started in theatre, and they had performed together several times in amateur productions. But that had been in the late 1920s; in recent years, Dankichi had been running his own traveling kabuki troupe, the Ichikawa Dankichi Ichi-za, and for the ten years prior to that, he had been a member of other itinerant troupes. After Japan's defeat, however, he returned to the Mikawa region. He was now living nearby in Toyohashi City with his wife, Sumihachi, who had been a member of his troupe.

Forgetting that he was on his way to pay his teacher a visit, Furukawa blurted out his request: Would Dankichi teach the girls kabuki acting? Dankichi hesitated. He was not opposed to the idea of girls performing

kabuki per se, but teaching "little girls" was not on his agenda. Furukawa described how quickly the girls had absorbed his lessons and explained that he wanted to give them a real opportunity to excel. Dankichi would be the perfect teacher. The object of his pleas hesitated, but Furukawa somehow managed to extract a promise from him to watch a practice session later that week.[10]

STRIVING FOR THE MAJORS

It was only natural that Dankichi would shy away from such a job offer. He had been dreaming of performing in Tokyo on a grand stage for more than two decades. As he reveals in his autobiography, *Kabuki jinsei* (A Kabuki Life), Dankichi, then known as Daiji, graduated from the upper-level primary school in 1927 at age fourteen, after which he performed in several Manninkō productions.[11] His acting was complimented, especially his portrayal of Munetō in Act III of *Ōshū Adachigahara* (place name), and he was encouraged to try his luck on the rural minor-theatre circuit. His parents, both farmers, were opposed to him becoming an actor, but at fifteen, in 1928, he left home and joined an itinerant, male and female kabuki troupe run by the actress Ichikawa Beiju. According to Dankichi, Beiju had been a student of Ichikawa Kumehachi. This is possible—Kumehachi had many students—but there is no written record that can serve as evidence; one must accept his word. If he is correct, it would mean that Daiji became the disciple of a "direct disciple" of the Ichikawa Danjūrō family line.[12] Thus began his long devotion to the Naritaya house, and, in particular, to its head at the time, Ichikawa Sanshō V. Daiji's cousin Shizuka (his mother's eldest sister's daughter) had been a member of the troupe, which helped him strike a deal in which he became Beiju's live-in apprentice. In exchange for cleaning the bath, sweeping the house, and running errands, he received room, board, and the chance to learn the theatre from the inside out. Beiju was a strict teacher—Daiji later wrote that one in three of her senior disciples dropped out since the training was so rigorous. After a mere six months, he was allowed to tour with the company and even landed small but notable parts. Eventually, he took the stage name Ichikawa Kokaku (crimson crane). After five years with the troupe, it was time to move on. Beiju was growing older, and several of the women in the troupe had quit to get married or change careers. He believed that he had mastered the fundamentals of kabuki acting and now dreamed of finding success in Tokyo. He was keenly aware that if he were to make something of himself, now was the time to leave. Moreover,

as a live-in, he was privy to the constant bickering that went on between Beiju and her husband. Fed up, he left the company and returned to his hometown. He joined a local acting troupe, but had difficulty getting cast in any interesting parts.[13] Down on his luck, Kokaku sought out the actor Ichikawa Ebijūrō III (1874–1954). He had first met Ebijūrō at Beiju's house years before and had immediately recognized him as different from the run-of-the mill country performer. Formerly known as Ichikawa Misunojō, Ebijūrō had taken his current stage name in 1912 at the Teikoku Theatre and had gone on to star in several *rensageki* (linked drama) productions, a new hybrid theatrical genre that incorporated film into live theatre. After *rensageki* were banned by the Metropolitan Police as a fire hazard, Ebijūrō worked as a stage actor under contract to the Shōchiku Theatrical Corporation. But his alleged decision to appear in a film with the famous actress Tanaka Kinuyo (1909–1977) at a rival film company apparently upset Shōchiku so greatly that Ebijūrō was thereafter banned from working at a Shōchiku theatre in a major city. The story, as passed down by members of the Ichikawa Girls' Kabuki Troupe, is that Ebijūrō found work as an actor on the minor-theatre circuit. It was there that he met Kokaku, whom he advised to try his luck in the big city.[14]

For the next sequence of Kokaku's life, two rather different stories emerge. According to his 1983 autobiography, he became a popular actor on the minor-theatre traveling circuit in a troupe based near Tokyo. According to this self-aggrandizing account, everyone doted on him, and he even garnered the highly coveted roles of Jūjirō in *The Picture Book of the Taikō*, Kokingo in *Yoshitsune and the Thousand Cherry Trees*, and Shirai Gonpachi in "Suzugamori" (place name) not to mention another chance at Munetō, the role he had first played back in his hometown. He wrote that he was incredibly happy to be part of this troupe.[15]

Yet, in 1995, some twelve years after he published his autobiography, at a special symposium on the Ichikawa Girls' Kabuki Troupe, Kokaku (then known as Masujūrō) briefly touched on this period of his acting career. According to this more plausible account, after leaving Beiju's troupe, he traveled to Tokyo with Ebijūrō's letter of recommendation. While the letter opened doors to the closed kabuki world, he could not overcome the firmly entrenched hierarchy. "It was so much worse than the countryside. I spent a year running around carrying people's tea and sandals," he recalled.[16] In the eyes of the grand kabuki actors, who were licensed to perform on Shōchiku's grand stages, he was nothing more than a drop-curtain actor (*donchō yakusha*), the demeaning term still used for an actor outside the

major-league system, with no name lineage, who was only eligible to perform at the minor theatres.

Whichever of these two stories is closer to the truth, whether he was truly dissatisfied or whether he merely wanted yet another adventure—the reason he gives in his autobiography—Kokaku quit the troupe after two years. At his parents' request, he returned to his hometown and married a woman of their choosing. In 1936, their first daughter, Nakada Eriko, was born.[17] Kokaku, however, became a long-distance father (and husband), as he decided once again to join yet another itinerant troupe, the Ichikawa Dankichi Ichi-za.

He later recalled that he was eager to join this troupe because he shared the "Ichikawa" name with the leading actor, Dankichi I. But he learned the hard way that the troupe was neither associated with the Naritaya house nor was it a genuine kabuki company. The leader had given himself the stage name Ichikawa Dankichi without bothering to consult the Naritaya house of Ichikawa actors, and, to Kokaku's irritation, he performed a hodgepodge of three different genres: kabuki, *kengeki* (sword fighting), and *shinpa*, advertising his troupe as a "sanmen-geki" (literally, a three-faced theatre).[18] To Kokaku's distress, but to the audience's apparent delight, the same actor who played Kanpei in the kabuki play *Treasury of Loyal Retainers* played the prince in a *shinpa*-style play; even more distressing for the pure-kabuki trained Kokaku, the other actors seemed to think that all there was to kabuki was cutting a stylized *mie* pose at a climatic moment. Kokaku no doubt looked down on these unsophisticated "*kusai-gei*" (literally, smelly art) colleagues. He wrote that he spent time practicing alone, determined to make something of his career. Still, he attempted to look on the bright side. He wrote that it was during this time that he learned one of the most valuable lessons: the importance of performing "for 1,000 'seeing' spectators and 1,000 'blind' spectators"—in other words, the need to play to different kinds of audiences.[19] The troupe toured along the old Tōkaidō highway, which connected the Kantō and Kansai regions, and even to Kyushu. Conditions were poor, but as a young man in his twenties, he was not bothered.

Kokaku's touring was interrupted in 1943 when he was ordered to take a military communications course in Mishima City in Shizuoka Prefecture. Like all Japanese men, he took a formal army examination when he was twenty-one but received the second grade, which might explain why he was placed in the reserves.[20] When he finished the communications course later that year, he learned that Dankichi's troupe had disbanded. He, however, decided that this was an opportunity to try his hand at running a troupe. The retired Dankichi gave Kokaku permission to use his name, reasoning

that since he had thought of the name himself, no other actor would have a problem with him using it. Thus, with no further ado, Kokaku became Dankichi II and ushered in the second phase of the Dankichi troupe, renaming it the "Hanagata Kabuki Ichikawa Dankichi Ichi-za" (Star Ichikawa Dankichi Company) and striking the "three-faced theatre" slogan.[21] In addition to performing at local festivities, the troupe played at events for the imperial army and navy. Like all kabuki troupes during the war years, it was required to obey censorship regulations that favored plays promoting nationalism and wartime spirit.[22] But after a short time, he disbanded the troupe and became a freelance actor.

In Kyushu, he met Ichikawa Sumihachi, a young female kabuki actor who became his common-law wife and gave birth to his second daughter, Emiko. Born Takamatsu Tatsuko in Yamaguchi Prefecture to rural kabuki performers, Sumihachi had studied acting with the female actor Arashi Yachio in Osaka before the war heated up.[23] It had been rumored that she was a former disciple of Ichikawa Kumehachi, since both of their names shared the character 八 (*hachi*), but she denied this was the case.[24] Dankichi II and Sumihachi were in Kumamoto Prefecture in Kyushu on 15 August 1945 when news reached them of Japan's surrender. Shortly thereafter, the couple returned to eastern Aichi Prefecture and rented a house in Toyohashi, not far from Dankichi's hometown.

Dankichi tried to assemble a local troupe, but found the rapidly changing conditions facing the kabuki theatre insurmountable. In the name of democratizing Japan, General Douglas MacArthur, the Supreme Commander for the Allied Powers (SCAP), had issued strict theatre regulations banning plays that glorified war, revenge, feudalism, or the suppression of women, which just about covered the entire category of *gidayū* plays that emphasized obligation (*giri*) over personal feeling (*ninjō*). Given the small number of actors in Dankichi's troupe, he wrote that he felt he was left with performing dance plays such as the "Okaru Kanpei Michiyuki" scene from *Treasury of Loyal Retainers* (though not the play itself, as it was on the banned list) or *Miracle at Tsubosaka Temple*, the sweet love story of a wife and her blind husband whose sight is restored. But the plays failed to attract audiences. The minor-theatre circuit had come to a standstill. In its wake developed strip shows for Japanese men and GI soldiers and silly sing-along tunes such as "The Apple Song" (*ringo no uta*).[25] After struggling to lead his small hometown theatre company, he finally decided to disband it formally, probably sometime in late 1947.[26]

Dankichi longed to perform in Tokyo in a grand kabuki theatre. The Kabuki-za and other major metropolitan theatres had been bombed and

burned in 1945, but grand kabuki had been quick to rebound, with the 2,600-seat Tōkyō Gekijō (Tōgeki) offering numerous productions during the Occupation.[27] Ichikawa Sanshō, the head of the Naritaya house, had responded courteously to one of Dankichi's earlier letters, but did not go so far as to offer him work. By New Year's 1949, Dankichi had sunk into a depression. With no work and time on his hands, he had taken to hunting sparrows every day with his air gun. The meeting with his old friend Furukawa had cheered up him a bit, but the prospect of teaching elementary and junior high girls was too depressing for words. Here he fancied himself a Tokyo star actor, but the reality facing him was that of a school master trying to entertain girls in an extracurricular dance club.

COMPROMISED AMBITIONS

The disappointment—and embarrassment—of Furukawa's request was so overwhelming that Dankichi sent his wife in his place. Sumihachi, a student of the Fujima dance school, was the better dancer, after all, and what more were the girls going to learn besides a few dances, he figured. As he later recalled in his autobiography, Sumihachi, too, was not thrilled with the prospect of teaching "little girls," but after the first lesson, she changed her mind. "The girls were excellent. They could easily go pro," she raved to Dankichi. To top off the elation of teaching talented students, she was given a hearty portion of sweet broiled eel, presumably as payment, from the girls' parents. After days of eating sparrows and bulbuls, the eel was a welcome treat for the cash-strapped couple.

Despite her excitement, Sumihachi made it clear that she had introduced herself as Dankichi's "apprentice"; the girls were still waiting for the real teacher. When Dankichi showed no intention of going the next day, she returned to Yuki-san. But on the third day, she told her husband—Dankichi would recall years later—that he would be expected that afternoon. "We're going to finish [the piece] today. It will be something for you to see, and besides, you owe it to Furukawa."[28] Dankichi's sense of guilt—and gratitude to Furukawa for past favors—finally kicked in, and that afternoon, he took the train north to Toyokawa City.

The only written account of this first meeting with the girls is by Dankichi, and, similar to his descriptions of touring with his itinerant troupe, it is self-congratulatory. Considering that he was a local boy who had gone off to make his acting career elsewhere, he very well might have received a hero's welcome on the second floor of Yuki-san that day. More

than thirty years after the incident in question, he vividly recalled the proprietress introducing him to the girls as "the master."[29]

Upon climbing the stairs and entering the former banquet hall, he witnessed several girls rehearsing *The Hidaka River*, a dance drama based on the famous *Maiden at Dōjō Temple*, in which a beautiful maiden turns into an angry serpent when her passion for a celibate priest is unrequited. Adapted from a puppet play, the piece requires mastery of *ningyō buri* (doll movement), a fundamental, yet difficult, technique. Practitioners must act as if they are bereft of all life, responding only to the movement commands of a black-hooded puppet operator. In this way, each "puppet" character is seemingly manipulated by one or more "puppeteers."

Dankichi was impressed that in just three days, the girls had mastered the entire dance. They had technique, pose, and tremendous energy. He had not come with a lesson plan, but improvised a pep talk and taught the "Nozaki Village" scene from *The Balladeer's New Tale*. Years later, he stated, "I was shocked. They were too good. I felt humbled. I knew instantly they had what it takes. They could go pro."[30] He recalled that in an instant he had found his life's calling. It was not the bright lights of Tokyo, but it was a job, and the girls—and their parents—needed him.

In fact, it initially appeared to Dankichi that the parents were more excited about the kabuki club than the girls. Mothers watched eagerly as Dankichi instructed their daughters. Proprietress Ishiguro went to great lengths to tell Dankichi how she wanted her daughters to become "something."[31] Years later Sachiko Hikosaka (later Ichikawa Baika), one of the first members, recalled that she herself had little interest in kabuki and was somewhat resentful that now she would have to speak onstage—she had preferred the dances in which the *gidayū* narrator vocalized her lines. But her mother—who had become a kabuki fan after entertaining Onoe Kikugorō VI (1885–1949) and Sawamura Sōjūrō VII at her family's restaurant—insisted that Sachiko continue to participate in the kabuki club, even threatening to terminate her dance lessons if she quit. So enthusiastic was her mother that she carried Sachiko on the back of her bicycle to the daily rehearsals, often humming *gidayū* tunes the entire way.[32]

The memories of the girls—at this writing the "girls" are now in their early seventies—are somewhat fuzzy. Takatsu Keiko (b. 1937, later Ichikawa Baishō) recalled that the first day Master Dankichi came to Yuki-san, he was wearing a kimono and a hunting cap, a combination that struck her as rather odd. Sachiko could not remember anything remarkable about Dankichi that day as much as she recalled that it was the first day she began menstruating. "I was crying and when people asked me why, I couldn't say

anything. Finally, I told Fukushō (b. 1936, née Kobayashi Yoshiko, later Ichikawa Fukushō)," she said, laughing at the memory. "She was six months older and explained everything to me."[33] What everyone remembers is that Dankichi was a very different breed from Furukawa. He was stricter and more demanding, and, as the girls improved, his expectations grew exponentially. He was the boss. "It was no longer the case where we could say 'yes' or 'no,'" one member later wrote.[34] Dankichi had the final word on all artistic decisions.

Under Dankichi's tutelage, the girls were required to work until they achieved perfection. To him, they were the ideal receptacles—like "ink-blotting paper"—for his challenging instruction. "Criticizing them was like pissing on a frog's wet face," he wrote in his autobiography. "They didn't care in the least. They took criticism amazingly well. They were so focused; they would just practice again and again."[35] Years later, he boasted that the girls readily apologized for their mistakes and agreed with his criticism. But conversations with his protégées reveal that they did not think of themselves as wet frogs or blotting paper. In the short term, they threw themselves into practice, but over time, they came to see Dankichi as a frightening power figure.

The master's brash tactics, however, attracted girls—or their parents—with strong ambitions to excel. For the first month or so, eight girls showed up at Yuki-san, but within weeks, word got out that a "real" pro was teaching kabuki, and more parents brought their daughters to practice. At the core remained the original members who had rehearsed under Furukawa: Ishiguro Hiroe, Ishiguro Ikuyo, Takatsu Keiko, Hikosaka Sachiko, and Kobayashi Yoshiko. All of them had studied Japanese dance from a young age, and Sachiko had taken lessons from a teacher whose method incorporated ballet, tap, and Japanese dance. While many others would come and go, these five girls would become the troupe's leading players, to the extent that the troupe developed around them. Though other talented girls would join, it would prove difficult to eclipse the chief positions that Hiroe, Ikuyo, Sachiko, and Yoshiko had secured by virtue of being the troupe's founding members. Even Keiko, who had been part of the original group, would be relegated to the second tier of performers for taking a leave of absence during the troupe's formative years.

Though Dankichi and the girls were not thinking in such stratified terms in the late 1940s, in hindsight it is clear that grooming for stardom began in those early days. In grand kabuki, such preparation begins even earlier, often at toddler age, and the roles an actor performs are determined frequently by family lineage. For these select actors, their physical attributes

are generally less important than the past roles performed by their fathers. In contrast, the girls were cast based on their physical builds: Ikuyo, as the youngest and lightest, played the *musume* (daughter) roles; Sachiko, slightly taller, played mother roles; the slender and androgynous-looking Hiroe played the romantic male roles; Yoshiko, with her broader shoulders and hips, played the *aragoto* (bravura) roles. Through this intensive introduction, the girls became intimately acquainted with kabuki's various role types—*wagoto* (gentle man), *aragoto*, *jitsugoto* (noble man)—getting a sense of what felt comfortable and what did not. Sachiko, for example, recalled bursting into tears when she looked at herself made up as the villainous Shihei in "Pulling the Carriage Apart" at a local elementary school production. Though she later acknowledged that her hysterics "greatly upset everyone around her," her reaction effectively released her from playing evil characters for the duration of her stage career.[36]

The club presented its first public recital in April 1949 at the Shōwa-za, a minor theatre in Toyokawa, which had been built in 1928. The audience sat on tatami mats, the customary seating style in prewar theatres, while the girls performed four plays: *Hidaka River*, "Nozaki Village," "Ninokuchi Village" from *Message of Love from Yamato*, and the "Lord Ōkura" scene from *Kiichi Hōgen* (character name).[37] All of the pieces were from the puppet repertory and all of them, Dankichi was proud to boast, were genuine kabuki plays performed by professional male actors.

Dankichi and Sumihachi had hoped to offer free admission by soliciting donations from local organizations, but they were overruled by the parents. Not all the girls came from affluent families, and parents worried that they would be left to cover costs and be cornered into making contributions to support the group. They feared that their contributions would affect the casting. In the end, the troupe decided to charge 50 yen per person, a fraction of the cost of seeing Kikugorō VI, the grand kabuki star, at Nagoya's Misono-za that same year.[38] To Dankichi's surprise, 50 yen was no obstacle to attracting spectators. The house was sold out and the response was overwhelmingly positive. "It's 'genuine' theatre, not just some kids' theatre," was a constant refrain. Dankichi recalled that it was difficult to keep from crying. "This was the first time that we felt this much excitement and emotion," he wrote.[39] That neither he nor Sumihachi had gotten a full-night's sleep in days did not matter. At that moment, they felt like there was no greater reward than to see their young charges perform kabuki before a paying audience.

What Dankichi and the girls underestimated (but Ishiguro had predicted) was the pent-up nostalgia that spectators harbored for these plays.

For many spectators, the sight of young girls performing kabuki was much needed validation that the traditional values of Japan, which kabuki had come to embody, would not die out despite Japan's defeat, the deaths of loved ones, and the ongoing Occupation. Most of the middle-aged and older members in the audience had grown up attending festive kabuki productions and had missed them during the latter part of the war. It is unclear how many in the audience knew that kabuki was just beginning to recover from censorship that had been imposed during and immediately after the war, but there is no doubt that the performance conjured up memories of the past.[40] As Dankichi later recalled in 1995, even if the girls had been awful, the audience still would have been enraptured. "Of course, at that time, it had been right after the war, and people had fallen on hard times and had trouble finding enough to eat, so looking at these eight or nine kids perform made them incredibly happy."[41] He further suggested that the troupe's great success could be attributed to the postwar situation:

> Nowadays you have popular young actors like Tamasaburō [Bandō Tamasaburō V, b. 1950], but during the time of Ichikawa Girls' Kabuki, all the young kabuki actors had been called up and sent to the front; the only people left were the old ones. And so when twelve and thirteen-year-old kids started to perform kabuki, there was this sense of freshness, and that, I believe, led to their sudden popularity.[42]

Several grand kabuki actors did in fact serve in the army, but most of them survived the war; in fact, more senior actors died during the Occupation years than during the war.[43] As we have seen, the minor-theatre scene was also affected, with many troupes like Dankichi's disbanding during the final years of the war. For spectators, the performance connected them to the very plays with which they had grown up, and, furthermore, served as a form of psychological healing, an antidote to the postwar trauma. This was true not only for this first production, but for subsequent ones as well. Watching kabuki was one way for the older generation to find solace in their lives that had been ravaged by the war.

As for the girls, their public debut led to more performances. Most of the requests came from local organizations whose directors had seen the Shōwa-za performance, but others had heard of the troupe by word of mouth. Dankichi later recalled that at the time he did not have a "specific plan" for the troupe, but subsequently he undertook responsibility for artistic direction, Sumihachi managed the troupe's schedule, and Furukawa supervised the troupe's finances and performed as a *gidayū* chanter. Dankichi also resolved to charge admission for any future performances. The money

would cover expenses and Dankichi and Sumihachi's modest salary. They had moved into the Ishigoros' annex and now, for the first time, were able to pay the rent. Rehearsals took place daily in the early afternoon for three or four hours. Attendance was mandatory and long-distance commuters were discouraged. Amazingly, when the girls began to miss school, the principal refrained from asking Dankichi to limit the performances; instead, he suggested hiring a private tutor.[44] The girls were encouraged to devote their time and energy to kabuki. Not surprisingly, a couple of girls quit, choosing to prioritize their academic studies over the club, but the majority welcomed the opportunity to perform more frequently. In fact, several new girls joined after the recital. Among the new members was the eleven-year-old Suzuki Sachiko (b. 1937, later Ichikawa Suzume). She had appeared as a child-role actor in Manninkō productions over the past two years and was surprised to see plays in which all the characters were played by girls her age. "The performance made a huge impression on me," she recalled years later.[45] She remembered being moved by the love-triangle in "Nozaki Village," and the acting of Hikosaka Sachiko as Omitsu and Ishiguro Ikuyo as Osome. She also remembered previously seeing Dankichi perform in her village and being particularly struck by his eccentric habit of wearing a fluorescent ribbon over his kimono at night, presumably for safety. After attending the recital, she decided to join the troupe. Her father had worked backstage on several local productions and was keen to give his daughter the opportunity to perform, despite her mother's belief that acting was a "dirty" profession. Within the same week, Tanaka Keiko (b. 1940, later Ichikawa Himeshō) joined as well.

Sumihachi and Dankichi, therefore, started to think of teaching as their profession. "I made a 180 degree life-change. . . . I was thirty-seven years old, but that year, I turned one," he wrote, indicating a rebirth.[46] No one, at this point, was saying anything about becoming a professional troupe, but Dankichi began to think in these terms. The girls were performing almost every day off from school in and around Toyokawa. By the summer of 1950, Dankichi felt that the club was ready for a longer tour. Relying on contacts from his days on the road, he arranged for the girls to perform in many of the same rural theatres he had once frequented.

A NEW NAME

With a new mission, the club took on a name: the Toyokawa Girls' Kabuki Troupe (Toyokawa Shōjo Kabuki Gekidan). It was not a particularly creative

effort. Toyokawa, of course, designated the troupe's hometown, and *shōjo* (literally, "little female") had been used initially in the formal names of the all-female Takarazuka and the Shōchiku Revue.[47] Throughout the history of Japanese theatre, it has been the rule for female troupes to call attention to their sex. As Torigoe Bunzō states, "If they were done by women at all, the genre itself was determined by the term *onna*, 'female' like *onna mai*, *onna gaku, onna kusemai, onna dengaku, onna sarugaku*, etc. It was tacitly understood that all entertainment forms with no gender specified were performed by men."[48] In other words, a gender-specific term was all but requisite for the troupe.

The word *shōjo* covers the broad age range of girls between four and sixteen years old. More generally, the term was used to denote adolescence, from the onset of puberty through marriage. As Jennifer Robertson suggests, the term *shōjo* was created in the late nineteenth century "for unmarried girls and women and means, literally, a 'not-quite-female' female."[49] Many members, like Sachiko, would mark their entry into the troupe with their first menses, but, as we shall see, they would not be ready to leave upon reaching what was considered to be "marriageable age."

Interestingly, though, both Takarazuka and SKD eventually removed the word "*shōjo*"—Takarazuka, for example, excised it in 1940, largely to acknowledge the "more 'adult' content" of its productions and to enable older, unmarried women, in their late twenties or early thirties, to remain in the troupe.[50] Had Dankichi's troupe paid heed to the reasons why Takarazuka had cut "*shōjo*" from its name, it might have saved itself from any number of future headaches. Just like the Takarasiennes, the Toyokawa girls would age to the point that critics would question whether members were still *shōjo*. This debate would have serious repercussions, with the women eventually recognizing that they had outgrown their own name.

But for now, the name was a shield against sexuality. Similar to Takarazuka's motto "clean, pure, and beautiful," the girls were expected to be asexual and to exude a cute, innocent charm. By calling itself *shōjo*, the troupe erected a barrier between itself and past female performers. They distinguished themselves from the term "*onna yakusha*," "with its historical connotations of itinerant actresses who were associated with unlicensed prostitution," as well as from the newer term *joyū* (actress), which also conjured up loose sexual morals.[51] As Ayako Kano states, "An actress is valued in so far as she can distance herself from sex work, but...she is constantly suspected of being no different from those women who sell sexual performances."[52] Including the word *shōjo* in its name would help to deflect criticism that the troupe was similar to kabuki actresses of the past.

Before the girls embarked on their travels, Ebijūrō, Dankichi's mentor, advised them to change the company's name to the Tokyo Shōjo Kabuki Troupe. "You're doing real kabuki, so none of this Toyokawa Girls' Kabuki," he urged.[53] Putting the word "Tokyo" on the marquee would make a difference. If a potential spectator heard that the troupe was from some country town such as Toyokawa, he would likely pass on the performance; *shōjo* from Tokyo, however, would attract spectators. None of the members had ever been to the capital, let alone spoke with a Tokyo accent, but virtually overnight, the Toyokawa Girls' Kabuki Troupe became the Tokyo Girls' Kabuki Troupe.

At first, their tour went well. The girls were thrilled to participate in the famous Ine Village theatre festival in which all performances take place on boats. For many of them it was the first time they had been to the Japan Sea, and they remember receiving a small stipend. When they toured the Ise Peninsula later that summer, however, they had difficulty attracting an audience. "The theatres were empty; everywhere we went there was a lack of spectators," one member recalled.[54] Several girls attempted to drum up interest by going around the towns in a three-wheeled truck, yelling "hear ye, hear ye," but to no avail. Dankichi neglected to mention the tour in his autobiography, but when asked about it in 1984, he acknowledged, "Yes, well, there were times when only fifteen people showed up. What can I say? That circuit saw kabuki, *rōdoku* (readings), *iromono* (variety shows). Performers were coming through all the time, so audiences had gotten used to professionals. They looked down on us as a kids' troupe."[55] The girls were tired and hungry, but since the troupe was earning practically nothing, funds were limited. When Dankichi joked that they would not be able to afford train tickets home, several girls apparently began to sob, making it even more difficult for him to take charge of the situation.[56]

The troupe eventually returned to Toyokawa, but not without Sumihachi swearing that she would never take the girls on the road again. It had reminded her all too vividly of the unpleasantness of past years spent with an itinerant troupe. Dankichi, on the other hand, saw the experience as a way to dispose of the weaker, unfit girls. Using the metaphor of a sieve, he later boasted that the performers who stayed in the troupe were the ones who had not fallen through the cracks. Only the ones tough enough to survive this process of "natural selection" were fit for any troupe that he was leading.[57] Still, it must not have been reassuring to see so many of the young girls quit after he had put so much effort into training them.

Despite the Ise tour mishap, Dankichi continued to arrange for the troupe to perform outside of Toyokawa. His contacts from former years on the road were helpful, but he also worked through third-party producers in

order to receive invitations from the more exclusive theatres. He knew from experience that many producers were just out to exploit performers, but it often took several meetings with them to separate the wheat from the chaff. Such was the case with a Mr. Nakatsubo from Yokohama. He had asked to be kept abreast of the troupe's future performances, so Dankichi promptly notified him that the troupe planned to perform next at a local elementary school. Much to his delight, Dankichi discovered before the performance that Nakatsubo had sent a man called Nakano, a vice president of performing arts for Shōchiku. "I've heard about your troupe from Mr. Nakatsubo," Nakano told Dankichi as a way of introduction. "And, if I think it's appropriate, we'd like to have the troupe perform at the Tokiwa-za theatre in Tokyo. We'll be able to give you an immediate reply."[58] Dankichi was elated. The Tokiwa-za had opened in 1886 in the Asakusa district primarily as a venue for kabuki, but had become a popular venue for comedy and sword fighting. It was thrilling to imagine his troupe performing there; hardly able to contain his excitement, Dankichi broke the news to the girls.

But his enthusiasm only lasted as long as the show. Nakano was far from enthralled. An all-female troupe had interested him, but not one performing traditional kabuki in an innocent manner. He confessed that he was looking for a risqué entr'acte strip show. "Since the war, Asakusa has become something of a haven for cruder entertainment, something showier," he said apologetically. "Your troupe won't work."[59] After giving the girls an obligatory souvenir package of Asakusa's famous rice candy, he excused himself.

Dankichi recalled that he felt like throwing the entire box of sweets at him. He could only wonder, "Is this the reputation of my troupe?"[60] Little did he know at the time that the girls were on the verge of being discovered by another producer: Ono Haruyoshi would determine the troupe's future direction and create the conditions for its professional success.

3. Name Recognition ❧

Located almost exactly between Osaka and Tokyo on the old Tōkaidō highway, Hamamatsu City took on particular significance for kabuki aficionados after the playwright Kawatake Mokuami (1816–1893) immortalized it in his famous play *Benten the Thief,* in which chief bandit Nippon Daemon announces that he "was born at Hamamatsu in Enshū."[1] This play, and many others, could be seen at the city's Hamamatsu-za before the war. Like dozens of theatres, however, it was destroyed during the war and later renamed and rebuilt as a movie theatre. In 1950, under the new management of Ono Haruyoshi (1905–1981), the 700-seat theatre reverted to its prewar name and began to present live acts.[2]

Subsequent to becoming the president of the Hamamatsu-za, Haruyoshi was elected a Shizuoka Prefectural Diet representative and owned his own public relations firm, Ono Productions (Ono Kōgyōsha).[3] A natural leader, he had produced several important performers in Japanese entertainment history, including the Korean modern dancer Saishōki and the boxer "Piston" Horiguchi. He took credit for thinking of the stage name "Hibari" (skylark) for Misora Hibari (1937–1989), Japan's beloved postwar pop-star. He had suggested "Aoizora Hibari," but it was decided that "Misora" (beautiful sky) was softer and more fetching than the inflected "Aoizora" (blue sky). Thanks to these successes, he had become somewhat selective about whom to promote.[4]

Now, as the president of his own theatre, he was looking for new talent and investigating the possibility of owning a resident theatre troupe. He did not envision promoting or even owning a kabuki company, let alone an all-female one. He was familiar with the examples of Takarazuka (his niece later joined that troupe) and the Shōchiku Revue, but that did little to excite him about kabuki actresses. Indeed, his initial reaction to the troupe is not unlike the story of how Dankichi came to be the troupe's director and teacher. In the same way that Dankichi refused to believe that the girls were any good at kabuki, Ono Haruyoshi could not envision hiring teenagers for his theatre's main entertainment. Had the choice been made exclusively

by Haruyoshi, the Toyokawa club never would have been selected as the resident troupe of the Hamamatsu-za.

According to Haruyoshi's account, he first heard about the girls from his brother-in-law, Ono Kakutarō, the president of press relations for Ono Productions, probably in the spring of 1951. Kakutarō had organized a series of successful performances for the troupe in Shizuoka Prefecture in 1950 and had boasted to his brother-in-law, "You could put the troupe on any stage and you wouldn't be embarrassed."[5] Haruyoshi, however, remained skeptical that country girls could perform kabuki. "Even if people said they were good, there were limits," Haruyoshi recalled telling Kakutarō, as a way of terminating any discussion of bringing the troupe to Hamamatsu. He was ashamed that Japanese troupes fell below what he considered to be "international standards." How would a provincial all-female troupe be any different?[6]

Several days after this exchange, however, Kakutarō notified him that he had promised the troupe the chance to perform at an upcoming three-day private event at the theatre. Needless to say, Haruyoshi was furious and promptly rebuked him, "You just told me before about this amateur troupe. But we never decided on anything. Isn't it just an amateur kids' company? Don't you remember that [our patrons] have put their trust in us! This cannot be. Retract your promise."[7] In the end, however, it was Haruyoshi who reconsidered his position. Kakutarō was married to his younger sister, and they were exceptionally close friends. Moreover, he recognized that Kakutarō had a sterling reputation as a producer and would face unpleasant repercussions if he broke a promise, even to an obscure all-female kabuki troupe.

In actuality, the troupe had performed previously at the Hamamatsu-za, apparently unbeknownst to Haruyoshi, who made no mention of it in his autobiography. Indeed, the earliest record of the girls performing at the Hamamatsu-za is 21 October 1950. This date was recorded by a city resident, Saitō Sadaichirō, whose unpublished, handwritten scroll is an excellent source for theatre productions in Hamamatsu in the 1950s.[8] From around 1950 until the early 1960s, Saitō recorded all the kabuki productions he saw at the Kabuki-za and the Hamamatsu-za in Hamamatsu City. Unlike Samuel Pepys, the famous diary keeper of late seventeenth-century London who peppered his account of daily life with remarks about his theatregoing, Saitō recorded only theatre productions, paying no attention to how he spent his days in Hamamatsu. For each entry, he methodically noted the name of the theatre, the name of the company, the names of the company members, the performance dates, and the plays presented. In the

case of the Ichikawa Girls' Kabuki Troupe, Saitō recorded three engagements: the performance on 21 October 1950, the sixty-day summer run from 22 July to 20 September 1952, and a three-week engagement, from 13 August to 8 September 1957. Since there are no extant programs before 1953, Saitō's scroll occupies an important place in the troupe's early history. According to Saitō, the troupe's performance on 21 October consisted of three pieces: Act VII of *The Treasury of Loyal Retainers*, "Nozaki Village," and the "Waterfall" scene from *The Miracle at Hakone*. Admission was 50 yen, the same price charged at the 1949 public recital. A cast list is not included with this entry.[9]

Exactly what the troupe performed for the subsequent "three-day engagement" is difficult to discern from Haruyoshi's and Dankichi's respective accounts, and Saitō made no record of it on his scroll. Moreover, the dates are unclear—according to Sakuragaoka Museum documents culled from oral testimonials, the three-day production took place in June 1951.[10] Haruyoshi recalled that the performance was a private affair, yet, according to Dankichi, it was officially billed as a "Kabuki Class," but had all the trappings of a regular kabuki performance. Both men, however, agreed that the performance was an unequivocal success. Stunned by the droves of people lining up for tickets, Dankichi recalled, "I had to pinch myself. It wasn't a lie; it wasn't a dream—it was really happening."[11] Haruyoshi, too, wrote that he was astonished not only by the girls but by the spellbound audience:

> You could hear a pin drop, no one coughed, the spectators looked like they were eating a feast; everyone was so enchanted, you could hear only astonished voices. I was sitting in the last row in the auditorium watching these girls perform something that even adults could not match, watching in admiration— something that I will never forget. I believe it was the end of the act of "Pulling the Carriage Apart" when [the theatre's executive director] Kaneko Seiji came over to my side, brimming with excitement, "Who would have expected this? They're great. Look at this reaction. We can take them," he said, confirming my thoughts.[12]

Haruyoshi quickly admitted his poor judgment and conceded: "The result was proof that Kakutarō had a brilliant eye for discerning his audience's taste; while, I, in a gentlemanly way, acknowledged defeat."[13] He invited the girls to become the Hamamatsu-za's resident troupe.

Dankichi reacted with a mixture of shock and elation. In his autobiography, he recalled that Ono Haruyoshi had summoned him to his office after the performance and inquired about the troupe's future plans. He, in

turn, discussed his main goals: to arrange for the troupe to perform in major cities, to have the girls take the stage name "Ichikawa," and to direct the girls until they reached "marriageable age."[14] Kaneko, who was also present at the meeting, told him that the Hamamatsu-za would provide much-needed financial support. The troupe, Kaneko said, was brilliant, full of talent and promise. And with that, Haruyoshi said, "Okay, you'll belong to the Hamamatsu-za." In his customary hyperbole, Dankichi recalled, "To my ears, this was like a boat saving a drowning man. I had no money. All I could do was bow my head at the end of the table."[15] Haruyoshi, who remembered the story slightly differently, recalled asking Kakutarō to break the good news, noting that Dankichi was so overjoyed that he grabbed Kakutarō's hand and shouted, "Thank you. Truly thank you. This is thanks to you. There is nothing more to say. I leave everything up to you."[16] Fears that the troupe was doomed to a life of touring the minor circuit evaporated; for the first time, the future of the troupe was secure.

In those weeks following this performance, Dankichi must have sensed the transformation of his entire world. He knew that the troupe would be able to accomplish his ambitious goals only if it had a patron, but a sponsor in the form of a major theatre was more than he had expected. He had all but abandoned the idea of becoming recognized as a grand kabuki actor, but he was still eager to live his dream vicariously through his girls. As someone who had spent the bulk of his professional career on the minor-theatre circuit, he was particularly sensitive to the acute difference in status between the "drop-curtain" actors and grand-kabuki ones who appeared on the so-called cypress stages (*hinoki butai*), a code word for the premiere theatres of the big cities. He had bigger hopes for his girls; he envisioned them performing on Japan's major stages: Kabuki-za or Meiji-za (Tokyo), Minami-za (Kyoto), and Misono-za (Nagoya). For this to happen, he knew that the troupe needed not only financial capital—that would come, at least initially, from the Hamamatsu-za—but *social* capital, that is, someone or something that, by way of prestige and connectedness, would help the troupe overcome two potential disadvantages: their lack of direct kabuki lineage and their female sex.

The proper dosage of social capital would give the troupe the necessary gravitas to perform kabuki on a major city stage. For that reason, the idea of Dankichi, or even Ebijūrō, passing on the name "Ichikawa" to the girls, in the same manner that he had received his different stage names (Kokaku, Dankichi II), would not do. Dankichi was seasoned enough to grasp that in the closed, hereditary world of grand kabuki, a name, particularly a name that had been transmitted by a top actor from a top acting family,

would give the troupe intangible validity in the eyes of fellow performers and audiences. Social capital in the form of the Ichikawa name, officially mandated by the leader of the Ichikawa family line, would be precisely what would marshal the troupe into the limelight. Without waiting for the news to settle, Dankichi returned to Toyokawa, and, together with his old mentor Ebijūrō, drafted a letter to Ichikawa Sanshō V. Their request was nothing short of asking permission for the troupe to use the Naritaya house's illustrious name.

THE NARITAYA CONNECTION

Danjūrō IX had died without a designated heir. Though he had trained several actors, including his daughters, none of them were deemed worthy of succeeding him as the head of the Naritaya house. Kamiyagi Fukusaburō, his son-in-law, was certainly never considered a possibility. Fukusaburō, after all, hailed from a prosperous merchant family, and, as a career banker, he had never voiced any aspirations of becoming an actor, let alone a future head of the Ichikawa acting family, when he married Danjūrō's eldest daughter, Suisen II, and took her family name, Horikoshi, in 1901, a common practice when the wife's family did not have a male heir.

But some seven years after Danjūrō's death, in 1910, at twenty-eight, an age considered ridiculously late to become a kabuki actor, Fukusaburō decided to give the stage a try and to assume the role of the head of the Naritaya house. Looking back after his death, his niece, Suisen III, wrote: "It was not a matter of wanting to or not wanting to [become the head]. [My uncle] took the stance that he had to protect the important position of the Ichikawa family leader."[17] He considered it his duty to continue the artistic work begun by his father-in-law.

At the time, the Osaka star Nakamura Ganjirō I (1860–1935) agreed to cast him in a minor role on tour, and later that year at the Naka-za in Osaka, he made his official stage debut, using his married name, Horikoshi Fukusaburō. In 1919 he starred in one of the "eighteen favorite plays," *The Arrow Sharpener*, and took the stage name Ichikawa Sanshō V. Though the name had never been used as a stage name (*geimei*) by the head of the Naritaya house, it had been used as a pen name (*haimyō*) ever since the time of Danjūrō I. Kabuki fans would have recognized the name's importance. The name Sanshō shares the same Chinese characters (*kanji*) as *mimasu* (三升), the name of the Naritaya house crest. All kabuki acting houses have a crest (*mon*), and the Naritaya *mimasu* is depicted visually by three

square boxes stacked one inside the next, representing three wooden *sake* (rice wine) cup measures (*masu*).[18] It is unquestionably the most famous acting crest; affiliated actors and musicians accompanying members of the Naritaya house often wear the crest on their costumes as well.

Despite his determination, Sanshō never earned a particularly favorable reputation as an actor; his impersonations were considered weak and shallow—to be perfectly candid, he was called a "*daikon*" (white radish), the Japanese equivalent to a "ham" actor. One account even notes that spectators screamed "*ginkōin*" (banker!) when he appeared on stage.[19] If he had had no name backing, he would have been laughed out of the theatre; even if he were talented, chances are that he never would have passed the phase of carrying other people's tea and slippers. But because of his family backing, he was able not only to play leading roles, but to assume the enviable position of head of the Naritaya house.

In addition to managing the organizational duties incumbent on any important kabuki leader, he set to work on several major scholarly undertakings: a biography of Danjūrō IX, notes of flagship productions of Danjūrō IX, such as *Mirror Lion*, and the theatrical exercise of reviving the "eighteen favorite plays" that had been codified by Danjūrō VII. Many of these works had fallen out of the repertory entirely, and many of the scripts, costumes, and props were destroyed in the Great Kantō Earthquake of 1923. Together with his wife, Suisen II, Sanshō attempted not only to resurrect the scripts and stage business, but to produce these long-forgotten plays and scenes. During his lifetime he revived and starred in seven of the eighteen favorites. His poor acting notwithstanding, Sanshō was exceptionally well educated: learned in the Japanese classics, an adept poet, a skilled painter, and, according to one source, a student of the English language.[20] Thanks to his lifelong devotion to restoring the memory of his father-in-law, Danjūrō IX, he was granted the stage name Ichikawa Danjūrō X after his death in 1956, the first and only Danjūrō to receive that name posthumously. The name had been in abeyance for fifty-three years.

Given the skeptical reaction of Dankichi and Haruyoshi upon hearing about the girls, it would have been reasonable to expect that Sanshō would refuse to permit the girls to use the Ichikawa name. But, on the contrary, Sanshō replied to Dankichi that if Ebijūrō believed that the troupe was worthy of the Ichikawa name, it would be fine for the troupe to use it. In his letter, he expressed his hopes that the girls would not do anything to soil the house name, and that he would see them perform in the near future. Furthermore, he alluded to the possibility that one day the girls might even be worthy of receiving individual stage names.[21] Sanshō's readiness to

accede to Dankichi's request suggests how much power he wielded, but it also raises questions about such seemingly hallowed traditions of taking a revered stage name. Apparently, receiving such a prized name from a kabuki house was not a major obstacle for an ambitious and talented performer. As we shall see, however, Sanshō would have reservations about giving troupe members individual stage names.

Though the Sakuragaoka Museum documents indicate that the troupe changed its name to the Ichikawa Girls' Kabuki Troupe (Ichikawa Shōjo Kabuki Gekidan) at this time, it appears that Sanshō did not grant this name until the following year. Ichikawa Ebimaru (b. 1941, née Ikeda Masuyo), who would join the troupe two years later, remembered attending a special performance to commemorate this new name at the Shōwa-za in Toyokawa in the spring or fall of 1951. Sanshō, however, was not in attendance.[22]

During this period, the media referred to the troupe by several different names, including the "Katsukawa Ikuyo Company: Women and Children's Theatre" (Katsukawa Ikuyo Ichi-za: Onna Kodomo Shibai), after the younger Ishiguro sister; the "Katsukawa Hiroe Troupe" (Katsukawa Hiroe Ichi-za), as well as the "Ichikawa Hiroe Troupe" (Ichikawa Hiroe Ichi-za), after the elder Ishiguro sister.[23] Katsukawa refers to Katsukawa Matanojō, the stage name of the troupe's first teacher, Furukawa. It is perfectly plausible that Furukawa gave his stage name, Katsukawa, to the Ishiguro sisters, but neither they nor other members of the troupe have any recollection of the troupe ever going by this name. Moreover, some fifty-four years after the performance in question, the sisters said that they had no recollection of ever receiving Furukawa's stage name.[24] Nevertheless, it is clear that the Ishiguro sisters were the designated stars. Given the pivotal role that their father had played in the troupe's foundation, their prominence makes sense within the traditional nepotistic hierarchy of kabuki.

In order to formalize this arrangement, a contract was negotiated that brought the troupe under the aegis of the Hamamatsu-za. The date the contract was signed is unclear; though Dankichi and Haruyoshi discuss the troupe's relationship with the Hamamatsu-za at length in their respective autobiographies, neither specifies the date on which the formal contract was signed, and there is no extant copy.[25] Problems of dates aside, Haruyoshi wrote that it was a "gentleman's agreement," a euphemism for an ambiguously worded contract. It was decided that Dankichi would be paid as an employee of the Hamamatsu-za, but matters of the girls' salaries and how they were to be treated were left unstated.[26]

The education and future performance schedule of the actresses, however, were treated rather seriously. Parents questioned how their daughters

would complete their mandatory schooling—elementary school and three years of junior high—if they missed school on a regular basis. After many discussions, it was agreed that performances would take place mainly during school vacations, but it also was stipulated that if the girls were absent from school for more than one week, the troupe would hire a teacher, who would offer group lessons and individual tutorial sessions.[27] The troupe was therefore given greater control over its performance schedule.

The contract was highly unusual given that it prioritized the troupe's goals to tour the country. In one place it stated, "In addition to performing at the Hamamatsu-za, the Ichikawa Girls' Kabuki Troupe will *definitely* perform in Tokyo as well as on all the best stages of major cities during the period of this agreement." As Haruyoshi wrote in his autobiography, "I believe this contract contained some rare contents. If you looked all over Japan and through the world, I doubt you'd be able to find one like it."[28] It was one thing for the troupe to *wish* to perform in Tokyo, Kyoto, and Osaka, but it was another matter entirely to have this spelled out in the contract. But Dankichi had insisted on it. "Please, president, give us a helping hand here," Haruyoshi recalled him pleading. "Please make these country girls the best in Japan. Please help us."[29] Haruyoshi remembers Dankichi clapping his hands in supplication, as if he were praying at the Inari Shrine in Toyokawa. In the end, Haruyoshi relented; at best, he thought it would be fitting to show up Tokyo snobs who assumed that a provincial troupe would not be able to perform kabuki.

Dankichi, however, was not relying on Ono Haruyoshi alone to make his dream a reality; he wanted the blessing of the head of the Naritaya house, Sanshō V. In his mind, the girls needed the stage name (*geimei*) Ichikawa as a last name as well as individual first-name stage names. Up until this point, all members continued to appear in plays under their private first names, which Dankichi probably believed was inappropriate for rising stars. Professionals needed a first and last name *geimei*. He thus ventured to ask Sanshō whether he would bestow individual stage names upon each member of the troupe. Such an important request could not be conveyed by letter, so Dankichi, together with the Hamamatsu-za executive director Kaneko Seiji and troupe member Ishiguro Hiroe, traveled to Tokyo to petition Sanshō directly.[30]

According to Kurokawa's account, based on an interview with Kaneko, the meeting lasted six hours and did not produce the desired effect. Despite his warm initial response, Sanshō was skeptical about the troupe's ability to perform kabuki plays. "Children perform kabuki? I don't think so," Dankichi later recounted him saying. "You mean that they perform the

dances, right? They're not able to do kabuki."[31] Given the ease with which Sanshō had agreed to permit the girls' use of the Ichikawa name, it appears that he had misunderstood that the girls performed *nihon buyō* dance and that they were interested in becoming part of the Ichikawa Dance School, not part of the more exclusive, male acting house.

Looking back, the Hamamatsu-za representatives felt slighted by the grand kabuki actor at the Tokyo meeting. "He did not treat us as equals," Kaneko recalled.[32] Sanshō was not convinced that the girls were really performing kabuki plays; he had somehow become convinced that Kaneko's girlfriend was in the troupe, and that he was trying to do her a favor. But the threesome must have made an impression, because, shortly thereafter, Sanshō sent his clerk Hori Kurakichi to appraise the situation. "Master, you'll be surprised," he apparently told Sanshō upon his return to Tokyo. "They're not doing kids' stuff."[33] His recommendation persuaded the head of the Naritaya house to travel to Hamamatsu City to see the girls perform a full-length version of *The Treasury of Loyal Retainers* in December 1951.

Just as Dankichi and Haruyoshi had radically changed their thinking, Sanshō was persuaded that he should accept the girls into the Naritaya house. According to Kaneko, Sanshō's eyes never left the stage, and, when it was over, he is reported as saying, "I am in a state of shock."[34] Haruyoshi remembered Sanshō telling him, "I'm surprised. Or rather, I should say I'm deeply ashamed of myself. These girls are so much better than the young people today at Kabuki-za in Tokyo. That they can do this alone is so impressive. They are truly this era's miracle."[35] Nowhere does Haruyoshi state why Sanshō was ashamed, but it is likely that he felt badly that he had been so dismissive of Dankichi in Tokyo. Now that he had actually seen the troupe perform, he felt comfortable permitting the girls to use the Ichikawa name and giving select members first-name *geimei*. It is also remarkable that he compared the girls to their male counterparts at the Kabuki-za. He expressed his feelings more clearly to a Hamamatsu journalist during the summer of 1952:

> When I was first asked to teach them, I didn't think they would amount to much; half fearful of what I'd actually find, I went to watch one of their performances, but [there I discovered that] they didn't look like girls (*shōjo*); they were totally sound. On top of that, everyone was so enthusiastic, so pure, harmonious, and committed to getting along. So I was happy to consent to include them in my house.[36]

As we shall see, critics over the next decade would echo Sanshō's impressions of the troupe's acting, never failing to give their stamp of approval for

the troupe's "pure" and "harmonious" manner. These latter qualities, seemingly distinct from acting skills, would bolster the troupe's reputation and set it apart from the sexually suspect performances of past female troupes.

THE 1952 LONG RUN AT THE HAMAMATSU-ZA

The collective support of Ichikawa Sanshō and the Hamamatsu-za coalesced during the summer of 1952 when the troupe performed at the theatre for sixty days straight, from 22 July to 20 September, an unheard-of feat in the modern kabuki world where productions generally run for twenty-five days each month. It was on this occasion that the troupe officially took the name the "Ichikawa Girls' Kabuki Troupe" (Ichikawa Shōjo Kabuki Gekidan), the name it would use for the next eight years, and it was on this visit that Sanshō gave the so-called top four members of the troupe individual stage names.

Before looking in detail at Sanshō's relationship with the troupe, mention must be made of the extraordinary nature of this production. The repertory changed every five days, without any repeated pieces, so that, in total, forty-six (forty-seven including Sanshō's announcement) plays were performed over the sixty days.[37] The majority of the pieces—an astounding thirty-seven—were *denden-mono*, kabuki plays adapted from the puppet theatre repertory. Similar to the Manninkō Association in Toyokawa, the troupe's tendency to include these pieces reflected its geographic background, as well as the fact that it was still in the early stages of development. Furthermore, most of the plays performed were highlights (*midori*), the abridged famous sequences from the most popular plays. Barbara E. Thornbury has suggested that this approach is "more commercially appealing" to audiences than presenting the full play (*toshi kyōgen*), a trend that would resume with the establishment of Japan's Kokuritsu Gekijō (National Theatre) in 1966.[38] Moreover, it is likely that many of these highlights were further condensed for the young actresses. As noted earlier, the ideal format in grand kabuki was (and still is) to present a mixture of different kinds of kabuki plays on every program. At this stage, however, the troupe's program failed to achieve such balance. There were a handful of exceptions—so-called pure kabuki plays such as "The Inase River" scene of *Benten the Thief*, "Waterfall," from *The Miracle at Hakone*, and "Suzugamori" (place name), for example—but even these plays are heavily reliant on stylized movement. Arguably, the only play that did not emphasize dance was the *shin* kabuki play, *Tsuchiya*

Chikara (character name), which stressed the psychological dimensions of the characters.[39]

The sixty-day run was a hot ticket, perhaps because, at 50 yen, it was considerably cheaper than other kabuki performances. In his autobiography, Dankichi recalled that 70 percent of tickets were sold in advance and that every day people waited in line for the day's tickets to be released. Each performer received six tickets that were valid anytime throughout the summer, and, in turn, parents were expected to volunteer backstage. They were led by the mother of Hiroe and Ikuyo, the former proprietress of Yuki-san. Exactly what the girls thought of this situation is unclear. "It's better than home," Dankichi remembered them declaring. Sachiko, however, recalled that the theatre was not air-conditioned and that rehearsals began at 6 a.m.[40] The pressure to succeed was heightened by Sanshō's presence at the beginning of the run and by the responsibility incumbent on receiving the Ichikawa name.

Sanshō formally announced to the public that the troupe was a sanctioned part of the Naritaya house during the second week of the Hamamatsu-za engagement. In a move that the magazine *Shūkan sankei* stated was "wholly unprecedented," he made this announcement while appearing on stage with the girls in a special "*kōjō*" address.[41] Photographs show him sitting *seiza* style in the middle of the stage flanked by the troupe members, all of whom wore the stage uniform of the Naritaya house: stiff vests (*kamishimo*) imprinted with the *mimasu* crest. Sanshō stated the traditional lines: "Honored guests, please look upon this troupe with favor." It was the same perfunctory phrase used during all grand kabuki stage announcements, but journalist Uchiyama Tsuneo said he believed that the head of the Naritaya house was utterly sincere. "Sanshō desperately wanted the audience to support his girls. I could sense the strong connection between him and the troupe," he wrote.[42] It is possible that Sanshō departed from the conventional language of formal announcements and recited a haiku that he had written in honor of the troupe:

Are these young buds
miniature peonies
fighting to bloom?[43]

He compared the troupe members to *matsuba-botan*, rendered loosely in the haiku as "miniature peonies," which generally blossom in the summer when they are exposed to direct sunlight. Technically, the common translation of *matsuba-botan* is "sunglo-orchid," which is in fact not related to

芸名伝達式後宗家市川三升と

Figure 3.1 Members of the newly named "Ichikawa Girls' Kabuki Troupe" pose in front of the Takasagoya Inn on 27 July 1952. Seated, from left to right: Ichikawa Michiko, Ichikawa Baika, Ichikawa Misuji, Ichikawa Eriko, Ichikawa Masuyo, Ichikawa Mineko, Ichikawa Keiko (later, Himeshō), Ichikawa Matsuyo, Ichikawa Masako (later, Sanpuku), Ichikawa Sachiko (later, Suzume), Ichikawa Fukushō. Standing, from left to right: Ichikawa Sumihachi, Ichikawa Masujūrō, Ichikawa Sanshō, Kaneko Seiji, Hori Kurakichi, Furukawa Yoshiishi, Ono Haruyoshi, Ono Kakutarō. Courtesy Sakuragaoka Museum, Toyokawa, Japan.

the peony family. However, *botan* means "peony" in Japanese, so it is likely that Sanshō chose the flower *matsuba-botan* because of the word association with *botan*, the symbol of the Naritaya house. The flowers are tiny, grow close to each other, and come in an array of colors. Sanshō's haiku suggests that the troupe was on the verge of blossoming; the girls were still "fighting" to bloom as full-fledged performers. Not wanting to overdo the praise at the beginning of his tutelage, Sanshō hoped the girls would interpret the haiku as both a compliment and a challenge.

A private naming ceremony took place at the Takasagoya Inn on 27 July 1952 (see figure 3.1). The inn was probably chosen for its convenience—it

was located next to the theatre—and because Sanshō had been staying there for the ten days he was in town. Photographs from the day show all the girls wearing the same neatly pressed white midi blouse and knee-length skirt, while Sanshō, Masujūrō, Sumihachi, and Furukawa wore kimonos. Hori Kurakichi, who had convinced Sanshō to see the girls, offered congratulatory remarks, after which Sanshō handed each girl a certificate printed with her new Ichikawa name. Despite the solemnity of the occasion, the girls could not keep from laughing. "We were at the age that when a chopstick dropped, we would burst into laughter. We couldn't stop—it was awful," Ichikawa Sanpuku (b. 1938, née Kawakami Masako) recalled.[44] Therein lay the unbridgeable gulf between the obsequious Masujūrō, who had spent his adulthood seeking recognition from the grand kabuki world, and the girls, who, at this time, still had yet to understand the privilege of the Ichikawa name.

At this juncture, Sanshō decided to give all the actresses the name "Ichikawa" as a last name but reserved the privilege of special, first-name *geimei* for four actresses and Dankichi. He did not give Sumihachi a new stage name, but gave a new name to Dankichi: Masujūrō, a name that appears to be original. As for the top performers, Ishiguro Hiroe, Ishiguro Ikuyo, Hikosaka Sachiko, and Kobayashi Yoshiko became Misuji, Masuyo, Baika, and Fukushō, respectively. According to *Engekikai*, Sanshō took "two full days" to think of the stage names. It is almost certain that the Hamamatsu-za paid for the names, given that in later correspondence Sanshō wrote that he had received payment from Kaneko.[45] The precise amount of money exchanged for the names, however, is unknown. Reporters and reviewers never mentioned the financial details in their articles, probably because these requisite monetary gifts are such an ingrained part of the kabuki world that to comment on them would be to point out the obvious.

Like all Japanese names written in Chinese characters (*kanji*), the stage names imparted meaning. Direct disciples often receive the former stage names of their master. This is especially the case when the eldest son succeeds his father. For example, the name Ebizō has been passed onto the actor in line for the future Danjūrō name.[46] More prevalent, however, is the phenomenon by which a disciple's name will feature at least one of the characters of the master's name. In this way, Sanshō 三升 used the character 升, which can be pronounced either as *shō* (the Chinese reading) or *masu* (the Japanese reading) for the names Masujūrō 升十郎, Masuyo 升代, and Fukushō 福升.[47] The name Misuji 美寿次 did not borrow any of the characters from Sanshō's name, but from the Naritaya house actor,

Ichikawa Sumizō 寿美蔵. Baika's 梅香 name was given, in part, as a reflection of her relationship with Sanshō's niece, whose first *geimei* was Kōbai (紅梅, later Suisen III). According to Baika, Kōbai had taken a liking to her and had asked Sanshō to give her the "*bai*" 梅 character from her name.[48] With the exception of the name "Masuyo," none of these stage names had been used by past kabuki actors, but all of them served to reinforce their association with Ichikawa Sanshō and the Naritaya house of actors.[49]

Misuji, Baika, Fukushō, and Masuyo became known officially as the troupe's first division (*kanbu*), and, by virtue of their senior status, were virtually guaranteed the leading roles in all the productions. While other girls would come and go, this foursome would lead the troupe for the next decade. As Baika would explain rather modestly years later, it was not a matter of being superior actors; what mattered was that they were the troupe's original members and that Sanshō had seen them perform the leading roles. That, at least, is how she would explain away any potential jealousy some fifty years later.[50] Still, giving only four members *geimei* drove a wedge between the top performers and the rest of the troupe, a tension that is explored in more depth in chapter 7.

CRITICAL NOTICE

Happily for the troupe and Masujūrō, spectators and critics lauded the ambitious program. Saitō of Hamamatsu City wrote on his scroll, "May I say that they are prodigies? They are exceptional and do not look at all like young girls, performing pieces like *The Subscription List*, *Scarface Yosa*, *Benten the Thief*, and *Tied to a Pole*. They are truly a wonder."[51] He added that he had attended the troupe's performances many times over the course of the summer and that the house was sold out most days. Notably, Saitō's entry for the Ichikawa Girls is the only place in the entire scroll for which he used color: for all other entries, including grand kabuki engagements, he used black ink, but for the girls, he used black ink to record the play titles and outlined them in blue, as if to further emphasize the troupe's startling achievement.

Saitō's private accolades for the troupe were shared by one of the leading theatre critics of the day, Toshikura Yoshikazu, editor of the preeminent theatre periodical, *Engekikai*. Though the magazine would come to feature critical reviews of the troupe, its unflagging support and annual publicity gave the troupe national recognition. Toshikura was the first of many journalists to write about the troupe. In an article four years later, he revealed

that he had joked at the time of the Hamamatsu-za engagement that he planned "to hold onto this stock," and that now the value "has gone way up."[52] In his review, Toshikura wrote that he had seen the troupe perform four pieces: "Amagasaki" (place name), *Gappō at the Crossroads*, *Tsuchiya Chikara*, as well as a play about the lovers Osome and Hisamatsu. The house was "eighty-percent full," and the troupe had become "incredibly popular." The two-page *Engekikai* spread contained six photographs of the girls appearing onstage and off, a paragraph or so about the troupe's history, and unstinting praise. He wrote, "I was surprised when I saw the performance. They are excellent. The children's sensitivity is sharp, they have learned everything perfectly, and their stage manner is also good. There is no trace of anything bad, perhaps because [they exude] no sensuality (*iroke*) or desires."[53] Indeed, while most of the photos featured the troupe performing onstage, the magazine also included a photograph of the pretty foursome in their dressing room, eating something as banal as Japanese curry rice. Their innocent faces and impeccable manners were valued as much as their talent.

Toshikura also took the opportunity to praise their teachers, writing, "Sanshō has put great effort behind the troupe, often coming all the way to train them," and, regarding Masujūrō, he stated, "He is young, not yet forty years old, and some might say that he is a bit eccentric, but he is rather amazing for teaching the girls more than ninety plays."[54] Masujūrō would look back fondly on the editor's praise, so different from future critics who would peg him as a Tokyo outsider, a mere second-rate director who had failed as an actor.

The review in *Engekikai* created a buzz and led to more performance opportunities. New theatres were being built and renovated after the war, and producers were eager to display the troupe's talent. A month after the Hamamatsu-za sixty-day run, the troupe was invited to perform for seven days at the newly opened Shin Kabuki-za in Nagoya, which had recently featured the important grand actor Kataoka Nizaemon XIII (1903–1994) in the opening performance. Critical praise led to an additional engagement in December. This time the run lasted last fourteen days and included four pieces: "*Sake* Shop," "Suzugamori," "Village School," and "Ninoguchi Village." Conveniently, the troupe's performances overlapped with the grand kabuki production at Misono-za, where Sanshō was performing. During his free time, he would round up other actors and tell them that they had to see the female troupe. "You better perform well today or you'll lose to my girls at the Shin Kabuki-za," he was quoted as saying.[55] Among the luminaries to see Ichikawa Girls' Kabuki for the first time were the popular *shinpa* actor Kitamura Rokurō (1871–1961), the *shingeki* actresses

Tamura Akiko (1905–1983) and Sugimura Haruko (1906–1997), and the Misono-za theatre director Hasegawa Eiichi. Years later critic Ueno Senshu recalled that he was "stunned" by the girls. Their production had dignity, correct interpretation, and was genuine. As if he were a PR agent for the troupe, he wrote that he went around town telling anyone he met, "They're amazing. Go see them for yourself."[56]

Also in attendance were two theatre critics who would play a key role in publicizing the troupe in Tokyo: Ōe Ryōtarō of *Engekikai* and Kimura Kikutarō of *Makuai*. Their reviews were positive but also contained the first serious criticism directed at the troupe. Kimura took issue with some aspects of the staging and the musicians and advised the girls not to become slaves to the predefined stage patterns (*kata*) developed by grand kabuki actors but instead to rely on their own individual talent.[57] Meanwhile, Ōe criticized the mismatched sizes of the costumes and props, most of which had been rented from Shōchiku. Some props were scaled down to size, but many looked ridiculously large next to the girls, and though the costumes had been hemmed, they looked "awful" and "cheap." While ill-fitting costumes warrant critique, some of Ōe's comments were picayune. For example, he questioned the costume selection for the character Gonpachi (played by Masuyo): why was she wearing the light yellowish-green (*hiwa*) kimono used by the Otowaya [Nakamura Kichiemon I (1886–1954)] house instead of the black-patterned kimono worn by Iwai Hanshirō?[58] Such attention to detail is no doubt important, but here Ōe is flaunting his insider knowledge of kabuki more than offering a well-founded evaluation.

Because all the plays performed were *denden-mono*, the reviewers also likened the girls to puppets, which moved with precision and grace. As Ōe confessed, "To tell you the truth, when I heard about girls' kabuki, I had assumed that it would be a decadent sort of showy thing. But after seeing it, I realize it's not some corruption of kabuki, but truly elegant."[59] Kimura agreed, writing, "More than I had imagined, they perform their actions with perfection, but the troupe's greatest charm is its purity."[60] Both reviews emphasized that the troupe hoped to perform in Tokyo, an idea that Toshikura of *Engekikai* had planted earlier. Just how much impact these reviews had is unclear; but, by the time Ōe's article went to press, a Tokyo venue had been selected. The troupe would perform at the Mitsukoshi Theatre in February 1953. Masujūrō's dream had come true.

4. Cypress Stages ❧

The sixty-day *tour-de-force* Hamamatsu-za engagement foreshadowed the troupe's ambitious performance schedule over the next decade. The next test would be negotiating the pressures and privileges of a Tokyo debut. With the hype already created by articles in *Engekikai* and *Makuai*, the press continued to generate interest in the troupe before it even set foot in the capital.[1] One week before the troupe opened at the Mitsukoshi Theatre, the *Asahi* ran two eye-catching stories. The first recounted the troupe's origins and attested to its talent: "Though they are children, their sensitivity is sharp, and they memorize their lines perfectly. They have mastered more than sixty plays—a tremendous feat."[2] The second article included a picture that captured the troupe arriving at Tokyo Station, with all the members wearing identical one-piece jumpers and carrying matching black valises and winter overcoats.[3] Shōchiku, for its part, ran a full-page ad in the Kabuki-za program, calling attention to the "teenage kabuki production."[4]

Attracting further interest, a two-minute film about the troupe was broadcast in cinemas during the second week of January. Although it did not explicitly advertise the upcoming Tokyo production, it showed the troupe performing *The Precious Incense and Autumn Flowers of Sendai*, one of the scheduled pieces. The film made no reference to the troupe's Naritaya connection, but a viewer with a sharp eye might have been able to spot the "Ichikawa" name in the troupe's banner and on the nameplates fixed above the individual dressing areas. Entitling the clip "*Musume* kabuki" (girls' or daughters' kabuki), the film presented the troupe as an all-female itinerant kabuki company that played at regional minor theatres. Similar to newspaper critics, the film producer included several shots of the members practicing together and helping one another backstage. This emphasis placed on collaboration further contributed to the growing reputation of the girls as "sweet" and "harmonious."[5]

By all accounts, it was a coup for the troupe to perform at the Mitsukoshi Theatre. Built in 1927 on the sixth floor of the flagship Mitsukoshi

department store located in the fashionable Nihonbashi district of Tokyo, the theatre has the distinction of being the world's first department store theatre. Before the war, the theatre—then known as Mitsukoshi Hall— offered an intimate setting in which to see traditional Japanese dance and music concerts. After the war, however, it was renamed Mitsukoshi Theatre, and became an important place to see kabuki and modern drama (*shingeki*). One of the few theatres in Tokyo not destroyed by the American air raids, it initially served as an "understudy" theatre to give kabuki actors an opportunity to perform while the grand theatres were being rebuilt and renovated. Within a short time, famous actors graced the stage and productions were dubbed "Mitsukoshi kabuki."

The theatre also produced many new Japanese plays and several European classics in translation. More than being committed to any one genre, the 500-seat theatre aimed to attract "bourgeois customers who could afford to buy expensive merchandise at the department store."[6] With the subsequent reopenings of the Shinbashi Enbujō in 1948, Meiji-za in 1950, and Kabuki-za in 1951, kabuki productions became less frequent. Mitsukoshi was no longer Tokyo's sole producer of kabuki, but it had garnered clout in the immediate postwar period as a premiere theatre. Curiously, in thinking about how to market the production, no one seems to have thought of the old advertisement: "Today the Teikoku Theatre, Tomorrow the Mitsukoshi." A perfect twist for the girls' engagement would have been: "*Yesterday* the Teikoku, *Today* the Mitsukoshi," given that the Teikoku Theatre had been the place to see women perform kabuki before it was destroyed in the 1923 earthquake and now the Mitsukoshi was taking on the challenge.

In the days leading up to the opening performance, the girls rehearsed at the nearby PL (Peace and Liberty) Hall. Sanshō oversaw the rehearsals and called on his kabuki colleagues for assistance. Ebizō IX, for one, was reported to have spent time teaching the troupe on "his days off."[7] In-between rehearsals, the performers made the rounds to thank the executives and actors who had been instrumental in bringing them to Tokyo. At least one visit was paid to Shōchiku President Ōtani Takejirō (1877–1969) at his office in Tsukiji to thank him for his support; a photo printed in *Makuai* shows the elderly impresario presenting a bouquet of flowers to Misuji, who accepts them, with Fukushō, Baika, and Masuyo bowing their heads behind her.[8]

The debut engagement ran for twelve days, opening 3 February and closing on the fifteenth; only on the ninth was the theatre dark.[9] Like their grand kabuki colleagues, the actresses performed twice a day, at 11 a.m.

and at 2:30 p.m., and tended to showcase short highlights (*midori*) rather than perform the plays in their entirety. The program consisted of the troupe's most polished pieces: "Pulling the Carriage Apart," a scene from *The Precious Incense and Autumn Flowers of Sendai, Gappō,* the "inner quarters" scene from *The Tale of Lord Ichijō Ōkura,* "Moritsuna's Camp," and "Ninoguchi Village." But unlike grand kabuki, the entire repertory consisted of plays from the puppet repertory, which critics interpreted as a sign of amateurism.

Sixteen actresses, plus adult musicians, appeared in the six plays. Two members had quit, but five new girls had joined, including Eriko, Masujūrō's eldest daughter, Kumazawa Junko, Takatsu Keiko, and Ichikawa Ebimaru. Ebimaru had been Ebijūrō's apprentice and the only girl to join the troupe with a stage name in hand. Keiko had been one of the original members of the troupe, but had dropped out when the performance schedule became too rigorous. Junko (b. 1936, later Ichikawa Kobotan) was raised in Nagoya and had studied Japanese dance. She had attended the theatre frequently with her parents, but after their house was destroyed during the war, the family took refuge in a small town near Toyokawa. She subsequently resumed her dance lessons and began attending rehearsals at Yuki-san.[10] Both she and Keiko would be elevated to the elite second-tier division in 1954, after they received their respective stage names Kobotan and Baishō. Despite the small cast, the major roles were played by an even more select group: Misuji, Masuyo, and Fukushō were cast in leading parts in every piece, while Baika appeared as the main *onnagata* in every play with the exception of "Pulling the Carriage Apart," the piece in which she had made her kabuki debut as the villain Shihei some four years earlier.

Compared to previous performances when tickets cost around 50 yen, admission to the troupe's Mitsukoshi performance was relatively pricey at 240 yen a ticket. The house was reported to be sold out on most days, but critics also noted that many invitational tickets had been distributed, a well-known but underreported phenomenon that has persisted in grand kabuki as well.[11] The show had the potential to attract a cross-section of spectators, including those who might not ordinarily attend the theatre, but just happened to hear about the show while shopping at the department store. The daytime hours, however, probably limited the audience to housewives, students, and others with flexible schedules.

Because of the event's unusual nature, the theatre had commissioned several speakers to prepare the audience for what many must have figured would be a half-baked disaster. As Kawatake Shigetoshi (1889–1967), the Waseda University professor and renowned kabuki historian, wrote in

his program notes, "There are sure to be some rough spots in the day's performance."[12] *Shinpa* actor Kitamura Rokurō, however, took the opposite tactic. He had seen the troupe perform in Nagoya, and, according to the writer Kōsei, testified to the troupe's talent, telling the crowd that he had broken another engagement in order to see the performance. Kōsei stated, "Rokurō, a veteran theatregoer, rarely praised anyone but he unconditionally praised the troupe. It was at this point in the program that everyone in the audience realized this might be the 'real thing.'"[13]

Additional speeches were made by the current and future leaders of the Ichikawa line: Sanshō V and Ebizō IX. They most likely wore the official Naritaya house costume for such occasions: the persimmon-colored vest with the *mimasu* insignia and warrior-style wig. Their remarks would have been delivered in the formal style, in which they thanked spectators for their support and patronage. Perhaps Sanshō recited the haiku that he had penned and printed in the program in honor of the troupe's Tokyo debut:

> Look at the buds
> Of red plum blossoms
> Touched by the spring breeze[14]

In just a few words, Sanshō managed to connect the literal timing of the performance with the metaphorical phase of adolescence. According to the lunar calendar, the first and second months (which usually correspond to February) were traditionally considered the beginning of spring, precisely the time of the debut. He compared the girls to plums (*ume*) that blossom throughout Japan during this season. To further emphasize this point, he drew several branches of plum blossoms on the program cover. The haiku perhaps also symbolically asks for support. With the gentle "breeze" of the audience's applause, the troupe would thrive.

The program lists "Pulling the Carriage Apart" as the first play on the morning lineup, but Kōsei implied that *Autumn Flowers of Sendai* kicked off the day. She recounted,

> Before the audience had time to digest all these greetings from famous people, it was time for *Autumn Flowers of Sendai*. I was nervous before the curtain opened. I imagined the voice of a small cute girl, but the voice of the girl playing Masaoka [Baika] was truly that of kabuki. It harmonized perfectly with her gorgeous costume; her voice was rhythmical and came from her belly. Everyone in the audience was stunned.[15]

Regarding the climax in which Masaoka's own son, Senmatsu, is killed by Yashio, the villainous lady-in-waiting, Kōsei wrote that her handkerchief was "so wet" that she could squeeze it. She was moved beyond expectation. Years later Masujūrō recalled—albeit rather subjectively—what he remembered to be the audience's reaction:

> There was a thundering of applause after the performances....Master Ichikawa Sanshō was brimming with happiness. He came to the dressing room to encourage the girls. This happened every day. The [kabuki] houses of Otowaya, Harimaya [Onoe Baikō VII (1915–1995)], and Kagaya [Nakamura Tokizō IV (1927–1962)] sent gorgeous bouquets of flowers, and we received many gifts, along with a special congratulatory telegram. And I received so many calling cards.[16]

Guests who visited backstage included the *shinpa* actor Hanayagi Shōtarō, the painter Itō Shinsui (1898–1972), and the Tōei movie star (and former kabuki actor) Okawa Hashizō (1927–1984).[17] If anyone in the weeks immediately following the performance thought the girls were over-rated, they kept it to themselves.

Kōsei's and Masujūrō's personal testimonial reflected the strong critical response. Reviewers lauded the troupe with cries of "the more you teach, the more you remember," from Moritsuna's famous line in "Moritsuna's Camp," suggesting that the girls pulled off the challenge of performing six plays.[18] The *Tōkyō shinbun* pronounced the performance, "Amazing Girls' Success," while the *Nippon Times* declared, "Teen-Age Kabuki Troupe of Girls Is Making Hit."[19] The *Asahi's* headline "Puppet Plays without Operators" emphasized that the entire program consisted of kabuki plays adapted from the *bunraku* repertoire, but this was not seen as negative. Like all of the reviews, it complimented the talented performers.

Despite the overwhelmingly positive response, the troupe did not escape from harsh criticism. Miyake Shūtarō, the critic for the *Mainichi*, advised the troupe to scrap "Pulling the Carriage Apart," since it was "unsuitable" for girls and instructed it to receive "belly training" (*haragei*), often defined in English as "internal art." The troupe could not merely perfect kabuki's physical poses and movements (*kata*), but needed to study the psychological motivations behind every role. In what appears to be a sincere suggestion, Miyake recommended the establishment of a kabuki training school to help the girls perfect such techniques.[20] To what extent the girls actually comprehended the subtleties of character and ideology inherent in the plays would be debated in the coming years.

For the *Asahi*, the adult musicians, not the girls, were a problem. The poor quality of the *shamisen* and narrator had been expressed earlier by Ōe of *Engekikai*. "If they could only get a better *gidayū* narrator and *shamisen* player, the performance would be more enjoyable than *bunraku*, since there is no hindrance of the puppet operator," the *Asahi* critic wrote, unabashedly indicating his taste for kabuki over the puppet theatre.[21] The names of the musicians are unknown, but they were probably accustomed to performing in rural minor-theatres.

SANSHŌ'S PATRONAGE

Sanshō took great delight in the troupe. In an interview with the *Nippon Times*, he stated, "The girls never intended to do this professionally. The whole idea started merely from their interest in kabuki. The girls began studying the classic dances with me during the early part of the Occupation."[22] The fact that Sanshō did not become involved with the troupe until the late part of the Occupation is disregarded in his account—perhaps in the moment of the interview he could not help but take full credit for such an accomplishment. He must have felt that his decision to award the Ichikawa name to the girls had not been for naught. In a letter to Masujūrō, he wrote, "Mitsukoshi was highly praised, and I am quite pleased and full of pride."[23]

The letter is the second in a collection of copies of twenty-seven unpublished letters written to Masujūrō from Sanshō, preserved in the Sakuragaoka Museum archive in Toyokawa City. Unfortunately, I have not been able to locate Masujūrō's responses, and it is likely that more letters were exchanged between the two men before the Mitsukoshi engagement, but only the letters after March 1953 through Sanshō's death in 1956 are extant. Several of the letters were written by an unidentified third party, after Sanshō became too ill to write himself. Though Sanshō's handwriting is excruciatingly difficult to read, it is clear that he and Masujūrō carried on a warm correspondence and a close professional relationship. While the majority of the letters take a business tone to confirm a meeting time or reschedule a rehearsal, all of them contain valuable information about Sanshō's personal views on the troupe, his reaction to specific pieces, and his concerns regarding the health, well-being, and future of the girls. Interestingly, he almost never referred to the individual performers, but he frequently asked Masujūrō to relay his fond regards to the "children," cautioning them "not to drink too much water" and to take care of themselves. He regularly invited Masujūrō and the troupe to his house in Ninomiya in Kanagawa Prefecture, advised Masujūrō on

appropriate gifts to send to grand kabuki actors who had taught the troupe, and offered extensive advice on the troupe's programing. The only time he discussed the concept of *ie no gei* in his extant letters was at the end of the letter dated 10 February 1955, in which he wrote, "Please protect the Ichikawa heirloom art."[24] The letters also reveal the severity of Sanshō's illness during the final year of his life, a fact that his family must have worked to conceal from the media, since it was reported otherwise.[25] Though newspapers and magazines emphasized Sanshō's remarkable commitment to the troupe, the letters offer the best proof that this was truly the case.

Sanshō admired the troupe, but it is clear that he still saw it as separate from his grand kabuki house actors. He did not give permission for the troupe to use the Ichikawa symbol of the peony (*botan*) flower, and he created a new crest for the troupe: the character 女, representing women, inside the authentic Ichikawa family *mimasu* crest (see figure 4.1).[26] It resembled

Figure 4.1 The crest of the Ichikawa Girls' Kabuki Troupe. Courtesy Sakuragaoka Museum, Toyokawa, Japan.

the Ichikawa family's one, but it was not be the same. Furthermore, he gave the troupe the house name (*yagō*) "Mimasuya" ("house of three *sake* measures"), instead of the Ichikawa family's well-known "Naritaya" *yagō*. Though these moves may have appeared to distance the troupe from the Ichikawa line, they had the opposite effect of bringing it even closer. Kabuki aficionados understood from looking at the troupe's crest that it constituted the official Ichikawa female acting branch. And, as far as the new *yagō* was concerned, no one bothered to use it; fans continued to scream "Naritaya" at the troupe's programs. Baika recalled that Masujūrō apologized to Sanshō for the spectators' negligence, but that Sanshō had just laughed, saying it was fine.[27]

Sanshō also wrote a "troupe song" modeled after the Waseda University fight song. The lyrics went as follows:

> Long ago during the times of the gods
> When Uzume no Miko offered her dances
> In the Kagura Valley
> That still exists today
> Izumo no Okuni passed down the arts [with which]
> We are blessed. We honor her
> We work hard, while developing our mental and artistic ability
> Focusing straight ahead
> We give it all, for our kabuki
> Kabuki, kabuki, for our kabuki[28]

The song lacks the elegant finesse of the haiku—one critic suggested that it is downright "childish"—but what should not be overlooked is Sanshō's enthusiasm for the troupe.[29] Here the Naritaya leader included the troupe into what he viewed as the long lineage of Japanese female performers, from Uzume no Miko, the deity who is credited with creating the first dance in order to lure the sun goddess Amaterasu out of her cave, to Okuni, the female founder of kabuki. He recognized the troupe as descendents of traditional performers and as worthy of the same canonization. Around the same time he wrote the song, he told a Hamamatsu journalist, "It's likely that they are a ground-breaking, unprecedented case. After Okuni Kabuki, this troupe is a true miracle."[30] His unflagging support enabled the troupe to become recognized nationally. As Ichikawa Baika recalled, "We often say that if it wasn't for Master Sanshō none of this would have happened."[31]

Singing the troupe song was mandatory anytime Sanshō came to the dressing room. "It was like the emperor coming to visit," Baika remembered. "He would come and say, 'Okay, sing the song.' . . . We would sing it,

and then he would call out, 'Okay, makeup!' You know, we were so busy, and this was the one time we would all be assembled." After singing the song, Sanshō would have everyone shout three times "*mainichi shonichi*" (every day is the first day). This mantra was always prominently displayed on the wall in the dressing room area as a reminder that each performance was a new opportunity.[32] During the remainder of 1953 and the beginning of 1954, Sanshō became a familiar figure backstage and in the auditorium, taking much more than a casual interest in the troupe.

The Naritaya head, however, recognized his limitations as a performer and teacher of kabuki. Though he could advise the troupe and offer suggestions about which plays to perform, he understood that he was not necessarily the ideal teacher for the troupe. Instead, he used his influence to enlist other kabuki actors to instruct the troupe. Masujūrō recalled, "Sanshō would immediately write me a letter: Don't you think they can do 'The Kawashō Teahouse' [from Chikamatsu Monzaemon's *Love Suicides at Amijima*]. If so, they had better study with Narikomaya [Nakamura Ganjirō II]. If not, it'll be all wrong. And so, he would write letters of introduction."[33] With just one phone call or letter, Sanshō would connect the troupe to the top grand kabuki actors. For any Chikamatsu play, he would send the girls to Ganjirō II; for *shin*-kabuki plays such as *Love Suicides at Toribeyama*, to Ichikawa Jukai III (1886–1971); and for *shosagoto* or *matsubame* dances, to either Onoe Baikō VII or Onoe Shōroku III (1913–1989). Moreover, later he would introduce them to the well-known Fujima-school choreographer, dance teacher, and future Living National Treasure (*ningen kokuhō*) Fujima Fujiko (1907–1998). His patronage also connected the troupe with the acclaimed puppeteer masters Yoshida Bungorō (1869–1962) and Kiritake Monjūrō II (1900–1970), who helped individual members learn movement from *bunraku*.[34] Sanshō made all the arrangements, and actors were loath to refuse his requests. The girls were put in the enviable position of studying with some of the top performers of the day. On the whole, critics acknowledged the improvement that came with these special master classes, but the *Asahi* reviewer wondered aloud whether "too many cooks were spoiling the broth."[35]

THE MEIJI-ZA PRODUCTION

With glowing reviews published in major dailies, another Tokyo engagement was a certainty; the question was one of venue. The manager of Mitsukoshi Theatre, Tanaka Takashi, planned a follow-up performance

but it fell through. According to the historian Iwasaki Eiji, it was canceled because the president of the Mitsukoshi department store, Iwase Eiichirō, deemed that girls under age should not perform. There was some fallout over the engagement: Tanaka was subsequently transferred to the Kobe store branch, a demotion, apparently for engaging the troupe.[36]

Years later, journalist Kurokawa Mitsuhiro reported that the Mitsukoshi management was disappointed at losing the opportunity to host the troupe a second time. The involved parties apparently proposed that the troupe play at the Mitsukoshi in the near future, but it never performed there again.[37] In fact, after 1953, the Mitsukoshi stopped presenting performances other than *bunraku* and *rakugo* (stylized comedic storytelling). In recent years, the theatre has begun presenting kabuki once more, but the Ichikawa girls occupy a special place as the last kabuki troupe of the postwar generation to perform there.

In place of the Mitsukoshi, the Meiji-za was selected for the troupe's second Tokyo engagement in May 1953.[38] Formerly under the management of Shōchiku, the theatre became independent when it reopened in February 1950. It subsequently burned down in 1952 and was rebuilt once again, so the girls were performing in another new theatre. According to his letters from March and April 1953, Sanshō was most concerned with which pieces the troupe would perform. He reminded Masujūrō that the Meiji-za had certain "preferences" regarding the lineup and that he needed to be consulted about any repertory decisions.[39] As he would do for all major engagements, Sanshō made it his responsibility to oversee the overall structure of the program. According to Baika, "In figuring out the order, he always put difficult and challenging ones (*karai-mono*), then one that would appeal more to popular taste (*amai-mono*)."[40] Several of the pieces were the same ones presented at the Hamamatsu-za "homecoming" in March 1953, following the Mitsukoshi engagement, but this time, the program was more varied. Taking into consideration the criticism that *denden-mono* had dominated its previous programs, almost half of the plays on the program consisted of subgenres from outside the puppet play repertory: *Fishing for a Wife*, a dance piece derived from the *kyōgen* repertory; *A Little Song While Dreaming of Yoshiwara*, a domestic drama, apparently requested by Sanshō's niece, Ichikawa Kōbai (later Suisen III); and *The Love of Izayoi and Seishin*, a pure kabuki play. The four puppet plays were highlights from *Mirror Mountain*, "Village School," the "puppet movement" scene from *Hidaka River*, and the "Brazier" episode from *The Love Suicides at Amijima*.

Once again, Sanshō composed a haiku to honor the troupe:

From today
Butterflies in the green field
Stretch and fly.[41]

He compares the girls to butterflies in a wide field, where they are free to roam. In just two months since the Mitsukoshi engagement, the troupe had sprouted from tiny buds to blossoms, and now to butterflies soaring to new heights. Commensurate with their experience, Sanshō now commands the troupe to spread its wings and fly.

For Masujūrō, however, the problem was that this new "field" of a theatre was far too large for the current size of the troupe. Years later, he recounted the problem:

> Mitsukoshi didn't have that big of a stage, but the Meiji-za was huge, and with a cast of just fifteen or sixteen, we would look ridiculously small on stage. We needed some eight or so ladies-in-waiting (*koshimoto*), or else it wouldn't look good. So I told everyone I knew, "It doesn't matter who, but find some more people—of course, girls." We somehow scrambled together a cast of twenty-five. But, of course, all of those new girls were novices. They had never performed in a play before. I believe the play was *Autumn Flowers of Sendai*. How would we ever please our audience? How could I direct it in such a way so that it wouldn't be an eyesore or an obstacle to the production? I assigned a place to each of them and told them to fix their eyes on a certain spot, not to look up or down, and not to raise or lower their head. With that, the show went on. Boy, was the press excited when they saw all those ladies-in-waiting lined up. They wrote in their articles: "Those girls have such good manners; kabuki actors could also learn something from them!"[42]

I was unable to locate any reviews from this engagement that extolled the good manners of the actors playing ladies-in-waiting. However, future reviews of the troupe often noted such qualities of the supporting role players.[43] Several of these "novices" subsequently joined the troupe. Among them was Kobayashi Toshie, Fukushō's sister, who would remain a member for the duration of the troupe's existence.

Similar to the reviews published after the Mitsukoshi engagement, critics voiced their enthusiasm for the troupe. Akiyama Yasusaburō of the *Asahi*, who would cover the troupe's Tokyo productions for the next ten years, stated that the performers handled the Meiji-za's stage with skill; Miyake Shūtarō of the *Mainichi* wrote, "Many people are saying the troupe is great, and there are times when one even forgets the label girl (*shōjo*)"; the

popular monthly magazine *Bunka seigatsu* declared that the troupe was "A Topic to Hurl at the Theatre World"; and Robert A. Carson of the *Nippon Times* declared that the troupe's versatile program would "stagger a male troupe," presenting "an amazing display of style, technique, and ability to interpret the old classics." He also warmly praised the troupe's male-role actors, Misuji and Fukushō, and lauded Baika's Izayoi.⁴⁴ Meanwhile, the emperor's brother, Prince Takamatsu (1905–1987), and his wife, Princess Kikuko (1911–2004) lavished praise on the girls during a backstage visit. Baika recalled, "The Royal Highness greeted us with 'Oh, you're so young.' She was surprised, and the Prince said that he was impressed with a girl playing such a solemn man."⁴⁵ Such admiration from representatives of the imperial family made a huge impression on the young actresses.

Despite these accolades, the troupe was not immune from criticism. As might be gauged from the headline, "Sometimes 'Overdone' Acting," Akiyama (*Asahi*) wrote that several parts were overacted and smacked of rural technique. He called particular attention to places where the direction differed from that of grand kabuki, such as the decision to forgo the much-anticipated feature of a horse in *A Little Song While Dreaming of Yoshiwara*. He was also surprised that the troupe neglected to use a palanquin to carry the courtesan Komurasaki in the same play and the character Matsuō in "The Village School."⁴⁶ And, despite Masujūrō's remarks that reviewers lauded the female-role specialists, Carson (*Nippon Times*) wrote that the troupe's "weakest fault" was its female portrayals, which were "weak and shrill in contrast to the male impersonators." He acknowledged that all the plays "are enjoyable, with the girls excelling in the Chikamatsu [Monzaemon] and [Kawatake] Mokuami pieces," but he also stated unequivocally that its "unattractive offering" was "The Village School," "where their work is at times inspired, but generally erratic."⁴⁷

TOURING JAPAN, 1953–1955

Over the next eighteen months, the troupe performed at the Bunraku-za in Osaka three times, the Yachiyo in Kobe twice, and the Yasaka Kaikan in Kyoto three times, in addition to performing at the Hamamatsu-za and touring the countryside. In Osaka, the mayor attended a performance and congratulated the troupe in person, and in Kyoto, *maiko* (geisha apprentices) flocked to see girls. The reviews radiated sheer joy at the troupe's prowess. Like many of the reactions previously discussed, critics reflected on the preconceived notions that they held about a girls' kabuki troupe. Writing in *Kyōto shinbun*, one critic raved, "Until one actually

sees the troupe perform, no matter how much one says, it's difficult to believe.... Their acting is not at all disorderly; they displayed solid voices, clear preparation, and perfect staging."[48] And, almost one year later, the same critic gushed that the troupe was so "excellent that even adults could not match its artistry."[49] The *Ōsaka* was just as enthusiastic; in 1954, it ran five stories on the troupe in ten days.

By June 1954, the troupe had graduated to performing at Shōchiku's grand Minami-za in Kyoto, and in August, the troupe returned to Tokyo to play at the Meiji-za, in what was reported to be a "smash hit" and "the most popular show of the month."[50] Skeptics would be correct to point out that August is generally a slow month for theatre, but critics probably would have been just as enthusiastic had it been May or October. This engagement, however, also caused the troupe to go into debt. Financial records from the time are not extant, but Misuji recalled several years later that the troupe was severely rebuked for its financial disorganization, and future accounts were scrutinized more closely.[51] Unfortunately, Sanshō did not remark on this matter in his letters.

During the Meiji-za engagement, a short name-taking ceremony (*shūmei hiro*) was held during which Sanshō conferred professional stage names on five additional actresses: Kawakami Masako (Sanpuku), Suzuki Sachiko (Suzume), Takatsu Keiko (Baishō), Tanaka Keiko (Himeshō), and Kumazawa Junko (Kobotan). They had demonstrated tremendous promise and would come to play many of the leading roles, but never would surpass the original foursome: Baika, Fukushō, Masuyo, and Misuji. Critics expressed hope that the new names would have a lasting impact, insofar as all of these stage names would be given to future generations of Ichikawa Girls' Kabuki, just as male kabuki stage names, such as Danjūrō, Kikugorō, and Ganjirō, have been carried on by their respective sons or disciples.[52] It was hoped that the nine "named players" would be the first of many generations of the all-female kabuki troupe.

Once again, Sanshō wrote a haiku to honor the troupe:

In the moonlight, one mistakes
The maiden blossom
For the male flower[53]

By this, perhaps Sanshō meant that just as one could mistake the female flower for the male one, spectators had difficulty distinguishing the girls from their male contemporaries. Their female sex should not bar them from performing kabuki. In his eyes, the troupe was a valid addition to the

established male tradition of kabuki. He recognized a genuine historical precedent to women kabuki performers: Okuni was the founder of kabuki, and, in his own lifetime, he had witnessed kabuki *onna yakusha*, from Kumehachi to his own wife, Suisen II. He would have been pleased to read reviews that suggested the actresses would "stagger a male troupe."

As is the case with grand kabuki actors who take a new stage name, the troupe performed the naming ceremony in several major cities—Kyoto in September, Osaka in November, and Nagoya in December—in order to allow more spectators to witness the festivities. Dressed in matching costumes imprinted with the Naritaya crest, the girls gathered on stage and bowed to the audience, asking for its support as they assumed their new stage names. Since the new names had been printed in the program, there was never any element of surprise, but audience members must have been delighted by the fact that the girls were performing the same venerable ritual practiced in grand kabuki.

After this tour, the troupe returned to Tokyo in March 1955, but to a different theatre: Tōyoko Hall. Located on the ninth floor of the Tōyoko department store in Shibuya, it was Shōchiku's newest and most fashionable theatre. The theatre had opened in December 1954 and had quickly become a popular place for young kabuki actors, and, on occasion, more senior actors to receive more time in the spotlight.[54] It did not have the established prestige of the Kabuki-za, Meiji-za, or Shinbashi Enbujō, nor was it an ideal kabuki theatre (it lacked a conventional, full-length *hanamichi*) but, situated in the heart of Tokyo's "youth" district, it was deemed the perfect venue for the girls—one that Sanshō had personally endorsed. Writing in the program, Akiyama (*Asahi*) noted, "Now it feels like the troupe has found an appropriate stage. The first stage they performed on at Mitsukoshi was too small, the second, Meiji-za, was too big. The stage at Tōyoko Hall seems to fit the troupe."[55] With the capacity to seat 1,000 spectators, it was bigger than Mitsukoshi, but smaller than Meiji-za.

To commemorate the troupe's new Tokyo home, Sanshō wrote in the program:

Below the new eaves
Perfumed with fragrant cypress
The swallow's nest[56]

This time, Sanshō compares the troupe to the swallows who do not make Tokyo their permanent home, but migrate from one location to another. Cypress is a wood native to Japan, and, as noted earlier, is shorthand for

a "premiere stage." The troupe was performing at the very same theatres around the country as grand kabuki actors. Over the next four years, it would perform at Tōyoko Hall six times.

The troupe continued to receive excellent reviews, leading some critics to muse that it was performing a service to grand kabuki by expanding its potential audience base. Indeed, though kabuki continued to thrive during the postwar period, producers were anxious to attract new spectators. The *Kyōto shinbun* critic speculated that the Ichikawa Girls succeeded at drawing audiences not only by offering lower ticket prices, but by making the plays "more accessible" than mainstream troupes.[57] The *Ōsaka*, furthermore, suggested that the troupe attracted "young girls," particularly the fans of Takarazuka and the Ōsaka Revue (Ōsaka Shōchiku Kageki). This new, untapped audience was thought to comprise mainly young women, who were unfamiliar with kabuki, but would grow to appreciate it and begin to attend all-male productions as well. Therefore, the troupe was assisting grand kabuki by bringing new patrons to the theatre.

It is impossible to confirm whether using the troupe as bait to draw the non-kabuki theatregoer to grand kabuki theatres was part of Shōchiku's official strategy to cosponsor the troupe. The female troupe was occasionally commissioned to perform pedagogic "Kabuki Classroom Events," which grand kabuki troupes had offered since 1952, in an attempt to develop new audiences.[58] Cosponsored by Shōchiku and the local board of education, these monthly, early-morning programs were geared to junior high school students. For the troupe, however, these classroom programs generally took place at non-Shōchiku theatres, such as Misono-za, Hamamatsu-za, or rural theatres, where it was assumed that spectators had fewer opportunities to see kabuki. The only evidence that Shōchiku hoped to profit commercially from its association with the troupe is found in a program greeting written by President Ōtani Takejirō, in which he implored the girls' audience to attend performances at the newly opened Bunraku-za in Dōtonbori in Osaka.[59] Program notes for Shōchiku's mainstream male productions were never used to promote the actresses, but the troupe's engagements were generally advertised in grand kabuki programs, along with any other upcoming shows at Shōchiku-owned theatres.

A shift in the girls' touring schedule can be discerned at the beginning of 1955. For its first few years under the Hamamatsu-za, the troupe performed for various lengths of time: a week at Mitsukoshi, twenty-three days at Naka-za, ten days at Misono-za, not to mention its unprecedented sixty-day engagement at the Hamamatsu-za. Some months the girls performed

frequently, albeit at different theatres (in June 1953, the troupe performed in Osaka, Kobe, and Kyoto, and, in August, in Osaka and Kyoto). Yet, beginning in 1955, the average number of days at any one venue became longer, with several, such as the May 1955 Minami-za run, stretching to twenty-five days, the standard length of grand kabuki engagements. Every month was different; sometimes the run would begin on the first of the month, other times, the first part of the month was reserved for intensive rehearsals and dance lessons, and, occasionally, even a quick trip home to visit with family.

Taking into account its heavy travel schedule, the troupe applied for accident insurance for forty members—twenty-six performers and fourteen staffers—over the summer.[60] This was a "rare case," but a necessary measure since the troupe planned to spend more time traveling outside of Hamamatsu. Indeed, even though the Hamamatsu-za owned the troupe, the majority of the girls' engagements were scheduled elsewhere, just as Masujūrō had hoped.

The troupe's membership grew, and the repertory expanded to include a larger variety of pieces. According to cast lists printed in programs, the company averaged around twenty-four members during the years 1954 and 1955. Masujūrō must have thought this was a good number, because Sanshō had to persuade him to continue to recruit members. Sanshō wrote that he understood that it was "a bother" to take the time to audition new actresses but there were many girls who want to join the troupe. "There may be some who are talented, and so you will be able to choose good new additions."[61] Many girls with extensive dance experience had seen the troupe perform, and several, including Mori Mineko (b. 1937, later Ichikawa Kobeni), Kōchō, Nobuko, Mutsuko, and Sanae, auditioned and joined during this time.

The troupe's most pressing task was mastering more pure kabuki plays, domestic dramas, and dance pieces. Most of the plays in the troupe's active repertory continued to be adaptations from the puppet repertory (*dendenmono*), but as it matured, it began to tackle other genres. Notable additions were several dance pieces, including *The Ferry, The Felicitous Three-Person Sanbasō, Two Maidens at Dōjō Temple*, and *A Maiden at Dōjō Temple*; plays derived from *nō* and *kyōgen: Fishing for a Wife, Three Handicapped Servants, Earth Spider*, and *The Zen Substitute*; as well as *Love Suicides at Toribeyama* and *The Tale of Shuzenji*, two *shin* kabuki pieces by Okamoto Kidō, the most well-known playwright of the genre. The troupe also added *dendenmono* that it had never performed before, such as *Matahei the Stutterer, The Stone-Cutting Feat of Kajiwara*, and scenes from *Mount Imo and Mount Se*.

Nevertheless, many plays that the troupe had debuted back in the summer of 1952 at the Hamamatsu-za became part of the troupe's permanent repertory. The most popular were, in fact, *denden-mono*: *Autumn Flowers of Sendai*, "The Skylight," "Moritsuna's Camp," "The Sanemori Story," "Ninoguchi Village," "Nozaki Village," *Naruto on the Straits of Awa*, "Amagasaki," *Gappō*, "Village School," *Hidaka River, Love Suicides at Amijima, Miracle at Tsubosaka Temple, Miracle at Yaguchi Ferry*, and "The Sake Shop." Plays from the pure kabuki subgenre, such as *Benten the Thief*, "Suzugamori," and *Ise Dances*, also became staples. During the mid-1950s, at least one of these pieces invariably showed up on every program the troupe performed.

The most popular additions were undoubtedly *Saint Narukami, The Subscription List*, and *The Demon Ibaraki*, all of which had been featured at the Meiji-za in August 1954. Marveling at the number of splashy pieces on the program, the *Yomiuri* critic exclaimed, "It's like going to see the Dan-Kiku festival," referring to the annual May tribute at Kabuki-za in commemoration of the Meiji-period kabuki actors: Ichikawa Danjūrō IX and Onoe Kikugorō V (1844–1903).[62] *The Demon Ibaraki*, found in the Onoe Kikugorō heirloom collection, includes a spectacular finale in which a demon disguised as an old woman reveals itself and engages in a riveting fight scene—a new challenge for the performers Fukushō and Misuji.[63] *Narukami* and *The Subscription List*, however, held special significance for the troupe, since both were part of the "eighteen favorites."

Performing *The Subscription List* was a milestone for the girls. As discussed in chapter 1, Danjūrō IX had banished Ennosuke I and Kumehachi from the Naritaya house, after discovering that they had played the lead character Benkei in this play without permission. Although they were both readmitted years later, it would have been perilous for the troupe to perform the play without Sanshō's consent. As the *Asahi* wrote, "It is truly a rare event for the master to grant permission to perform *The Subscription List*....Doing *The Subscription List* was risky. As for a woman performing Benkei in the past, Kumehachi only performed it with the title *Atakagawa*."[64] The only time Sanshō discussed *The Subscription List* in his extant letters, however, was when he stated that he needed more time to decide whether or not the troupe should perform the piece at the upcoming August 1955 Meiji-za production.[65] It is highly probable that he gave the troupe his consent, since the play appeared on the program. What is puzzling is that the troupe already had performed *The Subscription List* four times previously: in June 1954 at the Minami-za, in August 1954 at the Meiji-za, in November 1954 at the Naka-za, and in December 1954 at the Misono-za. It is strange

that Sanshō did not refer to its previous performances when noting that he needed more time to make a decision. Surely he knew that the troupe had performed this important play before.

The Subscription List became the troupe's most frequently performed piece; over the next eight years, it was performed on sixteen different bills at major theatres, in addition to countless times on provincial tours. Critics warmly praised it; the *Yomiuri* declared, "*The Subscription List*, with Fukushō (as Benkei) and Misuji (as Togashi), is one of the troupe's gems."[66] Fukushō, in particular, made the piece her own, putting her own "girlish" spin on the final exit, "bowing to the audience on the left, in the center, and to the right, before executing a *roppō*—the six directional flying hop— down the *hanamichi*."[67]

WORKING WITH SANSHŌ FROM AFAR

Amid the troupe's growing success, news of an impending tragedy reached Masujūrō: Sanshō had become ill and was growing weaker; by January 1955, he was confined to his house in Ninomiya. At first, this did not appear to influence the troupe: Sanshō corresponded with Masujūrō through letters, watched several of the troupe's televised productions, and oversaw rehearsals when members visited him at home or during the summer when he was in remission at the seashore. It is clear from Sanshō's letters that he still wanted to be kept informed of the troupe's activities, becoming at times even more adamant about certain issues. He continued to propose plays and expected Masujūrō to notify him personally of the troupe's schedule, as he did not take well to hearing of the troupe's plans from a third party. In a letter dated 10 February 1955, for example, Sanshō gently scolded Masujūrō for missing an appointment they apparently had scheduled in advance and cautioned him against producing any new material without his consent. He wrote, "I heard that you are doing a real dance like *Two Maidens at Dōjō Temple*, but I will not feel at ease until I've seen you perform it first in front of me." Yet, in the same letter, he said he was "at ease" with the troupe doing *Gappō*, and he relented to the troupe performing "Ninoguchi Village," the very piece that several weeks earlier he had advised not doing, since it could be construed as "neck-movement theatre."[68] It appears, therefore, that Masujūrō was able to convince Sanshō to allow the troupe to perform pieces that he had initially opposed. At the same time, the Naritaya head continued to feel responsible for the troupe.

There were several times when Sanshō questioned why the troupe would want to perform certain plays. Regarding the pure-kabuki period piece *The*

Rebellion of the Brother of the Bellflower, which the troupe planned to perform at the Minami-za in May 1955, Sanshō wrote, "Since even when adult, grand kabuki actors perform this piece it isn't particularly good, who are you planning to have teach you? I fear it will smack of countryside overacting."[69] He also advised Masujūrō not to overstretch the troupe by performing too many new plays too quickly, due to the pressures of frequent appearances at the same commercial venues. At the same time, he warned the troupe not to become so confident at performing the same pieces that they became stale. Sanshō, furthermore, cautioned the troupe on such matters as the dangers of practicing to a record instead of live music, complimented Masujūrō on the troupe's televised performance of *Benten the Thief,* and admonished performers when he had heard poor reports, such as when Hori Kurakichi told him the actress playing Benkei (Fukushō) in *The Subscription List* looked "too much like a female actor (*onna yakusha*)."[70]

Nothing, however, irked him more than when he received word from a third party that the troupe was planning to perform the highly theatrical "Under the Floor" scene of *Autumn Flowers of Sendai.* Who, he wanted to know, would play the role of Otokonosuke? This is indeed curious, as the character, though significant, is only on stage for a few minutes during the scene in question. The answer lies not in the play time this character gets, but in the fact that with his bold lines of black-and-red *kumadori* makeup, fierce *mie* poses, and heroic posturing, Otokonosuke embodies *aragoto* acting, for which the Ichikawa Danjūrō line is famous. The role is not owned by the Naritaya house but is often associated with its members, since the actor playing it must be thoroughly versed in bravura acting and stylized fighting. For Sanshō, Masujūrō's alleged failure to notify him was a personal insult: he had played Otokonosuke recently, in February 1952, at the Kabuki-za, and considered himself to be an accurate, if not excellent, source for learning the role. Feeling betrayed, he rebuked Masujūrō sharply:

> I am not pleased that I have not yet seen this piece, since I could have taught it, and I am not at ease with you doing it. I wish you had told me of your plans. So, who is teaching the role of Otokonosuke? I will teach you Otokonosuke in the future. Why didn't you tell me of your plans to do this role? I am not at all at ease with your doing it.[71]

Just a few weeks later, Masujūrō received another letter, dictated by Sanshō to an amanuensis, possibly a niece or nephew:

> My uncle is very upset regarding the Otokonosuke matter. Why didn't you have the head [Sanshō] teach you the role of Otokonosuke? I fear the dialogue

will smack of regionalism. Dialogue is not something that can be taught in a letter.... Putting on "Under the Floor" in this manner would be a disgrace, so I am asking you not to do it.... In the future, please let me know. This is a very difficult position for me to be put in.[72]

With the performance just a week away, pulling the piece from the program was not a realistic option. Sanshō instead proposed a compromise, recommending that the actor playing Otokonosuke perform the role, not in the *aragoto* style of the Danjūrō line, but "in the style of [Nakamura] Shikan IV [1830–1899], who played the role of the sumo wrestler Kanamisanzaemon, who wears a grey-speckled vest."[73] In other words, he condoned the troupe performing the piece, but wanted it to call Otokonosuke by another name in order to avoid criticism that a troupe from the Naritaya house did not know how to perform *aragoto* properly.

The program, however, lists Fukushō, the troupe member most skilled in *aragoto* technique, as playing the role of "Otokonosuke," not Kanamisanzaemon; so it appears that Masujūrō did not follow Sanshō's instructions. Subsequent extant letters exchanged between Sanshō and Masujūrō do not refer to this topic, and it should be remembered, after all, that the head's harsh rebuke was atypical of the gentle style and warm demeanor that generally characterized his relationship with the troupe.

Looking back many years later, all the troupe members interviewed remembered Sanshō with complete fondness. He had nicknames for his favorite stars—Baika was Dechiri, Baishō was Oume—and he teased the girls about having a "unique odor."[74] Emiko, one of Masujūrō's daughters and the youngest member, recalled that Sanshō worried about her when she left a rehearsal to play at a nearby park and took a special interest in training her for child roles. She had been instructed by Masujūrō to cry with her palms away from her face; Sanshō, however, gave her instructions to the contrary, telling her to cry in a more realistic fashion with her palms toward her face. Thus, she recalled performing to please whoever was present: "Whenever Sanshō watched the performance, I would play with my hands toward my face, but when my father was watching, I would do it the other way around," she recalled.[75] Meanwhile, the older girls enjoyed introducing Sanshō to teenage culture. Baika remembered that one day instead of serving him his usual green tea, she gave him Ramune, a popular lemonade-flavored soft drink, famous for its bottles that contain a blue marble at the top. "The first time the blue marble really confused him—he didn't know how to drink the soda, so we had to show him," Baika remembered. "After that he always asked for Ramune."[76]

Sanshō, in return, dedicated himself to the girls. He recognized that several members were extraordinarily talented. He would not have given nine of the girls individual stage names if he did not think they were worthy of it, and he certainly would not have appeared on stage with them if he had not believed the entire ensemble was deserving of the Naritaya head's patronage. As we have seen, Danjūrō IX promoted kabuki actresses, and, it is likely that his musings on the topic planted the idea in Sanshō's head that women, too, could one day be full-fledged performers. But unlike Danjūrō IX, who was born and bred in the kabuki world, Sanshō was a kabuki outsider. Though he would have been required to navigate the old-boy network of kabuki, he also came to the art form with a fresh eye, which enabled him to support such an experimental scheme as an all-girls' kabuki troupe. To say that he had been raised in a world where women were considered men's equals would be an overstatement, but as the husband of a once-aspiring kabuki actress, he saw firsthand that women could hope to become performers. Finally, there is the practical reason behind Sanshō's devotion to the troupe. By the early 1950s, he was winding down his own performance schedule and had time to spare. With no children of his own, he probably thought of the girls as his own grandchildren.

The troupe's encounter with Sanshō was serendipitous. Had they met him years earlier, it is likely that his own performance career would have taken precedence; had they met him any later, he would have been too ill to commence a relationship. Sanshō's patronage of the troupe enabled it to cross the threshold between amateur and professional, rural and city, and child and adult. With his backing, doors opened, and the troupe was ushered into performance venues that Masujūrō had only dreamed of during his years on the minor-theatre circuit. What would happen without the support of Sanshō after his death the following year is the story to which we shall return in chapter 8.

5. Acting Like Men ❧

What exactly was girls' kabuki? As the troupe swept across the country, making the day and night transition from a touring company that played at minor theatres to one that performed on grand city stages, that was the question asked by critics and spectators alike. Long before becoming famous, the troupe had designated itself a "girls'" (*shōjo*) company, first calling itself the Toyokawa Girls' Kabuki Troupe, then the Tokyo Girls' Kabuki Troupe, only to be named later by the Naritaya head as the Ichikawa Girls' Kabuki Troupe. From the troupe's perspective, the term "girls" was an accurate reflection of its age and sex.

Despite calling itself a "girls'" company, the troupe strove to perform "genuine" kabuki. In doing so, it appropriated many of the same so-called feudalistic ideals inherent in the grand kabuki world. Even in postwar Japan, grand kabuki actors continued to perform plays and engage in hierarchical practices that can best be understood as "feudal." Although applying the term "feudal" (*hōken*) to Japan's situation is potentially problematic, it is a useful expression in characterizing values that are integral to many kabuki plays that American censors involved in theatre reform during the Occupation found distasteful and undemocratic. The term "feudal" was widely used by Japanese to critique their own society, and during the Occupation, U.S. policymakers used the term extensively when referring to values such as obligation to a superior, self-sacrifice, and vengeance for the family or clan's namesake.

As discussed in chapter 2, Occupation forces initially sought to ban "feudalistic" kabuki plays, including those in which women work as prostitutes to support their families, parents consent to see their child murdered in order to save their lord, or characters avenge the death of a superior. However, just as policies concerning military and economic goals vis-à-vis Japan changed throughout the course of the Occupation, so too did changes occur regarding kabuki policy. Plays that initially were censored or banned were reintroduced to the stage as early as 1946. Although Occupation censors encouraged Shōchiku to modernize the repertory and produce new plays, Shōchiku insisted on staging only the traditional repertory. As James R. Brandon

suggests, "SCAP [Supreme Commander for the Allied Powers] was unable to mount an effective program of change," and Shōchiku was allowed to construct a "fossil art."[1] Instead of responding to current events and social issues as it had throughout the war, kabuki became a classical theatre form divorced from modern realities, a theatre that had no bearing on the way Japanese lived their lives in the postwar period.[2] Grand kabuki troupes responded by performing plays, perfecting artistic techniques, and sustaining hierarchical organizational structures that perpetuated "feudal ideals."

At least one critic viewed the advent of the Ichikawa Girls' Kabuki Troupe as an attempt to "break the traditional feudalistic structure of kabuki."[3] By this, he meant that girls lacking family connection had penetrated kabuki's exclusively male world. What he overlooked was the fact that the Ichikawa Girls performed plays that reified kabuki's atavistic ideology. As we have seen, the majority of the plays in its repertory were *denden-mono*, which tended to emphasize the struggle between individual feeling (*ninjō*) and obligation (*giri*). Characters vacillated between their need to fulfill their obligation to a superior and their desire to act on personal emotions. Revenge and self-sacrifice were common themes. The actresses performed plays such as "The Village School," in which a child was murdered with the consent of his parents or enacted characters such as Moritsuna who requests that his very own mother kill his nephew (her grandson) in order "to protect" his brother. Like male kabuki players, they performed plays involving love suicides, clan rivalries, and blood revenge.

For its part, the troupe did not see itself as emulating feudal values but as carrying on the esteemed performance tradition of grand kabuki. The troupe approached kabuki from an aesthetic standpoint, one that did not analyze the ideas of the plays, but prioritized the mastery of stylized movement and dances. Responding to a question about the extent to which she and her fellow performers understood the feudal mentality emulated in the plays, Baika stated, "I'm reading many books in order to learn more, but I don't think about it too deeply.... We've learned kabuki through starting with the set patterns (*kata*), and I think that's fine."[4] Her comment suggests that the troupe had little interest in analyzing whether or not it was perpetuating feudalistic morals; performing to make a statement about kabuki's ideology, be it gender relations or hierarchical class structure, was not a goal of the troupe—an approach that resonates, on the whole, with that of male kabuki performers, especially ones who are in the early stages of their careers. By performing the same classics in the same style as mainstream troupes, the actresses participated in the process of making kabuki into a traditional performing art in the postwar period.

OWNERSHIP OF PARTS

The troupe signaled its "grand" approach to the kabuki theatre by appropriating the "ownership of parts" system. Like Restoration period and eighteenth-century English actors, kabuki performers were regularly given sides (*kakinuki*), which they would own, sometimes for the duration of their careers. Integral to the kabuki heirloom system (*ie no gei*), roles were handed down by the family patriarch; generally, if one's father had played a role, his son could assume that it would be his to learn and perform in the future.

Though there are a number of versatile actors who perform male (*tachi-yaku*) and female (*onnagata*) roles, the majority tend to specialize in one or the other. Within the two broad role-type divisions, roles are further subdivided. *Tachiyaku* roles include bravura male (*aragoto*), romantic male (*nimaime*), dignified male (*jitsugoto*), elder man (*oji*), and villain (*kataki*); female roles include daughter (*musume*), wife (*nyōbō*), aged woman (*rōjo*), princess (*hime*), and lady-in-waiting (*koshimoto*). There are male and female comical (*sanmaime*) characters and child (*koyaku*) roles as well. It is rare for an *onnagata* to play only daughter roles, but it would be equally strange for a star *onnagata* to play both princess and lady-in-waiting roles, since the latter are considered minor characters. In addition, there are a variety of roles, from the spirits of animals and plants to gods and monsters that are neither male nor female. Generally, the troupe leader in grand kabuki troupes was (and is) a *tachiyaku* who, together with the theatre manager, assigned all the roles.

Unlike the grand kabuki world, where the leading roles are distributed based largely on family lineage, the girls were cast based on the number of years they had been a member of the troupe and on body type. The nine actresses who had received personal stage names from Sanshō received the best parts; everyone else played supporting characters. Petite girls generally played the female roles, while taller and broader ones played the male roles. All roles were determined by Masujūrō, with input from Ebijūrō, Sanshō, and later, Ebizō IX. Auditions for specific roles were not held, and troupe members never questioned role assignments. Baika recounted, "We girls had no say in the matter. There was never any discussion of liking or disliking the role. We were encouraged to master all types of roles."[5] In actuality, a survey of the different kinds of roles played by the top actresses reveals that each one had a clearly demarcated line of business.

The four top-ranked actresses—Misuji, Baika, Fukushō, and Masuyo—garnered the principal roles and clocked significant stage time, but Misuji

was the troupe's most versatile performer. She wrote in 1958 that she had played "more than one hundred different roles," a statement that is easily supported by surveying the extant programs from this period.[6] Androgynous and slightly taller than her fellow members, she was dubbed a "beauty in male disguise" (*dansō no reijin*). She specialized primarily in romantic male leads (*nimaime*), such as Chūbei ("Ninoguchi Village") and Seishin (*Love of Izayoi and Seishin*), and dignified roles (*jitsugoto*), such as Moritsuna ("Moritsuna"), Yuranosuke (*Treasury*), and Kajiwara (*Feat of Kajiwara*). She even made her mark playing elderly roles, such as Gappō (*Gappō*) and Magoemon ("Ninoguchi Village"), leading the *Ōsaka* critic to remark, "Even without drawing wrinkles on her face, she plays the old characters well."[7] In addition, she played comical men, such as the wily servant Jirō Kaja in the humorous dance *Tied to a Pole*, and excelled at performing rough male characters such as Benten Kozō (*Benten the Thief*), Yosaburō (*Scarface Yosa*), and Igami no Gonta ("Sushi Shop"). As is the case in grand kabuki whereby male-role actors play "evil" women (*akuba*), Misuji played Yashio of *Autumn Flowers of Sendai* and Iwafuji of *Mirror Mountain*, and later, she played more *aragoto* roles such as the spider in *The Earth Spider*. However, it was generally presumed that Misuji played a much better man than woman. Indeed, even though Miyake (*Mainichi*) called her demon in *Ibaraki* "genius-like," he recommended that if she wanted to play characters that require a transformation from female to male-style acting, she should stick to the more aggressive lion role of *Mirror Lion*.[8] Misuji continually challenged herself to play new roles, and her energy was boundless; she generally appeared in every play in any given program.

Fukushō was the resident *aragoto* specialist. Critics were shocked at her ability "to pass" as a man on stage. As Baika recalled, "We absolutely could not tell if she was a man or woman when she performed."[9] Tomita (*Ōsaka*) further raved, "There is a special girl in the troupe, who is large, who can be mistaken for a man."[10] She was considered indispensable. While several troupe members played romantic male roles, no one could replace Fukushō. The parts she performed were almost identical to the ones owned by or associated with the name "Danjūrō" and the *aragoto* acting tradition. She was given special notice for her rendition of the consummate Naritaya role: Benkei (*Subscription List*). Writing what was otherwise a fairly critical review of the troupe's 1954 Meiji-za production, Miyake noted, "Fukushō's Benkei was splendid—it really suits her. Her eyes sparkle. It can be said that Ichikawa Girls' Kabuki is a troupe that has Fukushō's eyes and Misuji's aptitude."[11] On the other hand, her characterization of Watanabe Tsuna (*Ibaraki*) received poor reviews from at least one critic: Andō Tsuruo

simply said "it gave [him] a bad feeling."[12] Other frequent *aragoto*-type roles included Narukami; Umeōmaru ("Pulling the Carriage Apart"), Mitsuhide (*Picture Book of the Taikō*), Tonbei (*Yaguchi Ferry*), and the contentious Otokonosuke in "Under the Floor" (unfortunately, no critic appears to have commented on her ability to play this role).

Baika was the troupe's principal female lead (*tachi-oyama*). On occasion, she played opposite Misuji in romantic female parts, but she was lauded most for her wifely roles, such as Otoku (*Matahei the Stutterer*) and Misao (*Picture Book of the Taikō*); "motherly" roles, such as Shigenoi ("Separation from Nurse Shigenoi") and Masaoka (*Autumn Flowers of Sendai*); and grandmother-types, such as Mimyō ("Moritsuna"). From the *Ōsaka* critic she earned high praise as Shigenoi, "She shows us many beautiful things. Her line is never ugly... one thinks that adults are performing, with [Baika] playing in an elegant manner."[13] Her favorite role, though, was the one she had mastered first: Kiyohime in *Hidaka River*. Though primarily a female-role player, she also played "soft" male roles (*wagoto*), such as Yoshitsune (*Subscription List*), Yaosuke (aka Koremori, "Sushi Shop"), and Motome (*Mount Imo and Mount Se*).[14]

The youngest of the four leading players, Masuyo played mainly daughter, princess, and mother roles. Frequently lauded for her good looks and excellent form, she excelled at playing young, female lovers, including Omiwa (*Mount Imo and Mount Se*, see figure 5.1) and Umegawa ("Ninoguchi Village") as well as stronger, more daring women like the loyal servant Ohatsu (*Mirror Mountain*) and the duplicitous Taema (*Narukami*). She was paired with her older sister Misuji in pieces such as *Love Suicides at Sonezaki* in which she played Ohatsu to Misuji's Tokubei. She starred in many of the festive Sanbasō dances with other top-tiered members, and one of her favorite pieces was *Two Maidens at Dōjō Temple* in which she played Sakurako and Baika played Hanako. Unlike Baika, Masuyo almost never played male characters. Though she received plum roles, of which any low-ranking male kabuki *onnagata* would be envious, she remembered that she was the only principal member to play a bit part, that of a guard in *The Subscription List*. The role, she correctly pointed out, would never be performed by a top-ranked grand kabuki actor.[15]

To some extent, the second-ranking division members also had their own lines of business, though it was slightly more fluid, depending on the needs of the performance. Sanpuku, for example, specialized in grandmotherly and comic roles. She had started out playing more princess roles, until Himeshō took them over ("Hime" means "princess"). If Masuyo or Baika were already engaged, Himeshō played leading female characters as well.

Figure 5.1 Ichikawa Masuyo as the maiden Omiwa in *Mount Imo and Mount Se*. Courtesy Sakuragaoka Museum, Toyokawa, Japan.

She was viewed as one of the prettiest members of the troupe, and it is no wonder that she was given the role of the "beautiful woman" in *Fishing for a Wife* and other ingénue parts. She was generally paired with Suzume, who specialized in romantic male parts. Many of the roles that Misuji had played originally were eventually bequeathed to Suzume, partly to give Misuji a break, partly to allow her to continue to experiment with new roles.

Baishō carved out a special niche as the troupe's villain. With the exception of Iemon, which Misuji played in the troupe's sole production of *Ghost Stories at Yotsuya*, Baishō was the one chosen to play the scoundrels: Nangō (*Benten the Thief*), Kuheiji (*Love Suicides at Sonezaki*), Rokuzō (*Yaguchi Ferry*), and Iruka (*Mount Imo and Mount Se*). Cast in the challenging roles of the cub in *Two Lions* and Tarō Kaja in *Tied to a Pole*, she earned the reputation as one of the troupe's strongest dancers. She apparently thrived on the diversity of roles, as Tomita (*Ōsaka*) praised her ability to play each one in a unique manner.[16] Kobotan played an assortment of roles. It was rare for her to repeat the same role, though exceptions included Hayase ("Moritsuna"), Black Cloud (*Narukami*), and Ugenta (*Ibaraki*). She was generally cast in supporting roles, such as a lady-in-waiting or the store owner Kōbei in *Benten the Thief*.

For the first several years, critics made reference to the stark differences in ability between the four leading members and everyone else. The *Chūnichi* reviewer observed, for example, that Himeshō's performance of Shūrinosuke (*Matahei the Stutterer*) "was at the level of a girls' high school performance."[17] The gap between the first and second divisions never closed entirely, but critics would write more positively of the second-division tier over the next few years. Of all the second-tier performers, Kobotan would come to receive the most praise for her acting.[18]

Depending on the play, the second-tier actors and others would be assigned bit parts and grappler-type (*karami*) roles: ladies-in-waiting, policemen, firemen, soldiers, farmers, priests, or palanquin runners. As Akiyama wrote about a 1953 performance of "The Village School," "The troupe is short of actors, so as soon as the farmers are done, they race back to the dressing room for a quick change into soldiers. And just as [the character] Matsuō begins reciting dialogue, they are back on, which causes some laughter."[19] Years later, a former member would claim that second-ranking actors were merely used as supernumeraries—in her words, "bodies on the stage"—but critics lauded them for taking their roles, no matter how small, seriously.[20] It was unheard of for a new actor to receive a speaking part until she had been a member of the troupe for several months. Though they never were given leading roles at any of the major city productions,

many of the lower-ranked actors had an opportunity to play a starring role at least once at the periodic "study productions" held at the Hamamatsu-za.[21] *Koyaku* or children's roles were given to the youngest (and youngest-looking) members. Until Masujūrō's daughter, Emiko, was old enough to do the roles competently, Mineko (b. 1942) and Ebimaru, two of the younger members, played the children's parts.

Over time, the girls mastered roles and movements that they had avoided previously. As noted earlier, the troupe had been criticized for omitting the horse and palanquin from *A Little Song While Dreaming of Yoshiwara*, but the girls soon learned the small but ever-salient roles of palanquin bearers and horse's legs. This was not enough, however, to appease Masujūrō. He required the girls to learn how to perform flips, recognizing that such stunts would be appreciated by fans and praised by critics.[22] The actresses began learning how to flip under the guidance of Ebizō IX's apprentices during the troupe's run at Meiji-za in August 1955.[23] Every morning before the performances, they practiced over a sandy pit, wearing the requisite flesh-colored underwear. Similar to grand kabuki troupes, the principal actors rarely—if ever—performed flips; these feats became the domain of lower-ranking girls. By the end of the summer, five members—Kobeni, Toshie, Setsuko, Mieko, and Ebimaru—had learned how to perform forward flips, one of the many varieties of flips performed by grand kabuki actors. Their newfound talents were promptly displayed in plays such as "Mount Yoshino" and *Mount Imo and Mount Se*.[24]

Still, no one doing anything even as spectacular as a flying somersault could overshadow Misuji's performances. From the troupe's inception, she and Masuyo had been dubbed the sister stars of the troupe, but ultimately Misuji was the one to garner the most praise. Her acting, fellow troupe members remembered, was head and shoulders above everyone else. Kobotan recalled, "When Misuji performed, spectators screamed 'god of theatre' (*shibai no kami-san*)," an especially complimentary designation.[25] Critical response reflected popular sentiment. From the beginning, the press had commented on Misuji's "splendid" face, "somewhere in between Ichikawa Jukai and Nakamura Baishi [later Nakamura Tokizō IV]."[26] Headlines, ranging from "Looking at the Genius Misuji" to "Enchanted by Misuji," proclaimed her the troupe's top star.[27] Though Miyake of the *Mainichi* wrote that he wished she would research her parts more, he lavished praise on her versatility. Reviewing her performance of six different roles at the troupe's Tōyoko Hall debut, he wrote, "There is no other young kabuki actor who can match her skill."[28] This should be viewed as no less than an enthusiastic show of respect from one of Tokyo's top critics, since he

not only praised her, but compared her to young professional male kabuki actors. Tomita (*Ōsaka*) offered similar comments, asking rhetorically, "I would like to hear who among the young [male] kabuki actors today has the power to perform *The Subscription List* and *The Demon Ibaraki*," two plays that Misuji had mastered.[29]

Film star Tsukikata Ryūnosuke (1902–1970), moreover, wrote a heartfelt endorsement of the troupe in which he, too, called Misuji a "genius," who "even without a handicap [for being female], is among the first-ranked actors of the day." Most movingly, he discussed how he had admired her in the troupe's production of "Moritsuna":

> I played Moritsuna in a movie, and I had always wanted to do it on stage. The now-deceased Harimaya [Kichiemon I] taught me the role, but I never did it. Recently, I gave the "severed dummy head" [required for the head inspection scene], which I had held dear for some twenty years for the purpose of playing the role, to Misuji.[30]

Why, he implied, would he even think of playing the role onstage, since Misuji inevitably would perform it in such a superior fashion?

Many kabuki troupes, from Okuni's in the early seventeenth century to the independent Zenshin-za troupe today, have thrived largely because of a singular performer. Ichikawa Girls' Kabuki was no different. It comprised a core group of talented, handsome, and committed performers that revolved around the brightest star. In grand kabuki, that star is commonly born into his position; Ichikawa Misuji, however, assumed that title through her hard work, innate talent, and sheer performance charisma. It was due, in no small part, to her light that the troupe continued to shine through the 1950s.

TAKARAZUKA VERSUS ICHIKAWA GIRLS' KABUKI

The troupe's goal to be viewed as "genuine" differed from the approach taken by the Takarazuka Revue. For Ichikawa Girls' Kabuki, Takarazuka represented both its principal model and chief rival. Ichikawa Baika even remembered that a popular slogan was "Girls' Kabuki in the East; Takarazuka in the West," while another source reported that the troupe was nicknamed "Takarazuka Shōjo Kabuki."[31] The troupe modeled its kimono after Takarazuka's prewar uniform, and, according to Baika, some girls from the different troupes socialized together. Several of the troupe's new recruits from the Kansai region, furthermore, had attended

Takarazuka performances as children. Critics noted that both troupes faced similar issues. Akiyama, for example, observed that Ichikawa Girls' male-role specialists "have the same problem as the girls in the Shōchiku Revue (SKD) and Takarazuka when they take on male voices."[32] At the same time, the media exploited the differences of the two troupes, pegging them against each other. The troupes were rivals. Takarazuka, owned by Tōhō, was a direct competitor of Shōchiku, which cosponsored many of Ichikawa Girls' Kabuki's major productions. Both were seen as competing for the same young female demographic. One critic speculated that Ichikawa Girls drew a much broader audience thanks to its ability to "appeal to different classes."[33] The *Sandê mainichi* quoted a twenty-two-year-old student as saying, "[Ichikawa Girls' Kabuki members] are not like the Takarazuka performers who are popular because they have nice voices and are pretty. Ichikawa Girls' Kabuki has really got a grasp for kabuki, and both the leads and minor players have unified their hearts and minds. Due to their training, they have come a long way."[34] According to the article, the troupe had many fans, who were "intoxicated" with its art and seemingly preferred it over Takarazuka, which had legions of its own loyal fans.

Curiously, while references to Takarazuka abound in Ichikawa Girls' Kabuki critical reviews, essays, and performance notes, the troupe was not given much mention in the Takarazuka press. The more established Takarazuka is unlikely to have considered the female kabuki troupe a serious rival. As Miyakoji Noboru (b. 1936), a Takarasienne active in the 1950s stated, "I knew about Ichikawa Girls' Kabuki, but I never went to see them perform."[35] She expressed surprise that several newspaper articles had compared the two troupes, given that their histories are quite different. Just how frequently members of Ichikawa Girls' Kabuki attended Takarazuka productions is unknown, but that did not stop critics from comparing them to the Revue.

In terms of content, Takarazuka did not produce traditional kabuki, but flamboyant music-dance revues. Moreover, Takarazuka had a much more institutional approach to hiring and retention. All Takarasiennes were graduates of the two-year Takarazuka Music Academy (Takarazuka Ongaku Gakkō) where they were schooled not only in traditional Japanese arts, but in western musical instruments, dance, acting theory and techniques. Yet, Takarazuka, too, ever since the 1920s, if not earlier, had adapted kabuki plays and dances and required every member to undergo training in *nihon buyō*, the foundational dance of kabuki.[36]

Though Takarazuka sometimes referred to these pieces as "kabuki," they more frequently grouped them under the heading "*nihonmono*" (Japanese

things) in contrast with its "*yōmono*," or European and American-styled revue medleys. Many of its *nihonmono* were inspired by kabuki, but originally choreographed with western orchestration and dance features. Takarazuka, in fact, made a point of distancing itself from conventional kabuki. For example, its self-published *Fifty-Year History* described its 1926 production of *The Battles of Coxinga* and its 1935 production of *Benkei Aboard Ship* respectively as "a kabuki piece done the Takarazuka way"; its 1935 production of *Sanbasō*, a staple piece in kabuki, *nō*, and ritual puppet repertories, was entitled "Takarazuka Sanbasō"; and its *Mirror Lion*—a revue favorite performed frequently in the 1950s—was called an "elegant-styled dance." In its official histories, Takarazuka prided itself on setting productions apart from grand kabuki.[37]

Such self-conscious distancing contrasted with the approach taken by Ichikawa Girls' Kabuki. In a November 1954 roundtable discussion sponsored by the *Ōsaka nichi nichi shinbun*, the actresses distinguished their artistic approach from Takarzuka's. Ichikawa Baika, for one, was quoted as stating, "Even though we are an all-female troupe, we do not try for a Takarazuka kabuki revue-type atmosphere. In that way, we are not all-female kabuki. As for our staging, we perform kabuki in the same style as genuine kabuki."[38] There was nothing in her mind particularly "female" or "feminist" about the troupe, save for the fact that it was made up of girls. Although it called itself a "*shōjo* troupe," it strove to perform the same kabuki as men.

Later, in February 1955, two days after the troupe performed at Naka-za in Dōtonbori, Osaka, the *Ōsaka* invited Ichikawa Masujūrō and a Takarazuka director, Zeniya Nobuaki, to discuss the differences between their approaches to kabuki. Zeniya clarified that Takarazuka had no intention of performing conventional kabuki:

> Unlike Ichikawa Girls' Kabuki we cannot do genuine kabuki. I think that's fine. Takarazuka's aim is to not perform classical plays in the classical manner, but to make things fresh and new. Moreover, Takarazuka does not perform kabuki 365 days a year, but performs ballet, voice, and *nichibu* (Japanese classical dance). So, at the appropriate time, we master whatever style is necessary. We've mixed ballet technique with Japanese classical dance. This is the Takarazuka flavor. That is why the patterns (*kata*) of Amatsu Otome [1905–1980] and Kasugano [Kasugano Yachiyo, b. 1915] are fine. We go forward, making new creations out of conservative forms—this is Takarazuka's main goal. The other day at a research session, I directed *The Miracle at Hakone*. I experimented with the lighting during the transitions, taking the slow-tempo fight scenes at a quicker pace in *kengeki* fashion and covering for the sad lack

of flips. We are working hard to create a kabuki that fits Takarazuka. Our number one characteristic is a sophisticated kabuki.[39]

According to Miyakoji, Zeniya was one of several dance teachers at Takarazuka, not a spokesperson (or senior administrator), but that should not detract from his position as one of the Revue's representatives.[40] In many ways, his statement was more about Ichikawa Girls' Kabuki than Takarazuka. The former, he noted, is "genuine," while Takarazuka neither presented genuine kabuki nor cared to present kabuki in this manner. Its approach was experimental; it intentionally tried to deviate from kabuki.

Masujūrō, on the other hand, took the opportunity to explain why he believed his girls were in the purist kabuki camp:

> The girls are mirroring and performing the exact same style as the kabuki currently done on kabuki's grand stages. But at the moment they are not putting their own individual stamp on roles like [grand kabuki] actors today. While saying this, however, it is not mere imitation. After all, it is said that the power of expression passed down by mirroring is the power of the acting in classical kabuki.[41]

Masujūrō's stance was that the troupe was doing conventional kabuki. He distinguished mirroring (*utsushi*) from imitation (*monomane*). At first glance, the difference appears superficial, as the words can be viewed as synonyms. Ever since Zeami (1363?–1443) in the fifteenth century wrote about the imitative components of acting in his *nō* treatises and defined *monomane* as the "imitation of character," *monomane* has been a valued and accepted component of an actor's most fundamental techniques. In kabuki, the word *monomane* is often used to explain the manner in which children or junior actors acquire fundamental acting skills from their seniors. Masujūrō, however, consciously or not, inverts the terms. For him, *utsushi* (mirroring) was the process by which actors learned their technique; *monomane* indicated something closer to mimicry or aping in which an actor failed to internalize the role in a meaningful manner. In this way, he implied that the girls had a deeper understanding of kabuki, one that went beyond vapidly imitating forms.

Though Masujūrō's use of terminology was unorthodox, in hindsight it seems clear that he was responding to charges that the troupe was merely imitating kabuki. After all, the troupe's scripts, stage business, direction, music, theatre building, stage, teachers, and, often, backstage staff were the same as (or very similar to) grand kabuki's; the crucial difference was that its members were teenage girls, not boys and men. Masujūrō explained

that critics who dismissed the troupe as merely imitating kabuki failed to acknowledge that the art form, by its very nature as a classical theatre passed down from generation to generation, is a theatre of "mirroring." All kabuki actors must mirror, or, as theatre theorist Marvin Carlson would say, "ghost" past actors in order to perform any role, from the lowly messenger to the samurai warrior.[42] Kabuki actors are consciously aware of ghosting past—usually dead—actor's performances, since almost all the acting business and texts of classic kabuki plays are predetermined, and largely choreographed, similar to classical western ballet. As noted earlier, these fixed forms are called *kata*, and refer to everything from a subtle gesture to a speech pattern, from costume choice to set design to the choice of music.[43] *Kata* may be associated with an individual performer, an entire acting family, a particular role, or a group of plays. An action, gesture, or facial expression does not technically become a *kata* until it has been repeated a number of times, becomes recognized as a new entity, and is transmitted to the next generation of actors. One of the most important differences from most western theatre forms is that certain elements of these *kata* have been preserved, thanks to the father-son or master-disciple training system that requires imitation of corporeal movement and vocalization before innovation. In every generation, ghosts of the past reappear, a phenomenon that kabuki audiences anticipate, generally with pleasure. When Nakamura Kanzaburō XVIII (b. 1955) plays the rascal priest Hokaibō audiences recall the way in which his father played the same role, and when his sons perform this role in the future, aficionados undoubtedly will recall their father's performance and so on. Continuity from one generation to the next is a hallmark of kabuki acting. If a kabuki actor made up new stage business for a classic play as Takarazuka did, it would be considered a direct challenge to the grand kabuki tradition.

PLAYING WOMEN; PLAYING MEN

How the girls "mirrored" grand kabuki can be examined through the troupe's onstage performances of femininity and masculinity. These performances were regulated by the *kata*, the constructed forms of kabuki, which can be understood as "a detailed system of signifiers." Every choice, from the kimono pattern to the way in which a character moves, conveys meaning. Concerning the *onnagata*, Mitsuo Hirata explains:

> Meanings are decided, so that when a certain wig is worn, or certain make-up or kimono used, we know what kind of woman is being portrayed. All these things

carry their own semiotic meaning. When an *onnagata* wears a "*kokumochi*" kimono of yellowish green with white circles visible upon it, we know that she is a country girl. O-mitsu from *Nozaki* wears this kind of kimono. When the *kokumochi* is an auburn colour, we know the character is the wife of a masterless samurai such as Tonami in *Terakoya* ("Temple [Village] School").[44]

The smallest details matter: the mere shape of a woman's ornamental hair comb differentiates a courtesan from a townswoman. Similarly, when a *tachiyaku* wears two swords, the audience knows that he is, or is pretending to be, a samurai. When a male character paints his face white in period pieces (*jidaimono*), it is a sign that he is a young, gentle male character, perhaps of noble stock. The bold blue lines of the theatrical *kumadori* makeup denote ghosts of villains or other nonhuman creatures. Messengers, farmers, and *daimyō* have entirely different ways of walking, sitting, standing, and bowing. Indeed, every character type has a unique way of moving that is "codified semiotically."[45]

Writing specifically about the female characters, Hirata notes, "When these various codes or signifiers are collected together and attached to the male body, we have the basic form of the *onnagata*, and this, combined with an animating *gei* [art or artistry], forms the *onnagata* technique." Assuming that the *onnagata* character is always played by a man, he further comments that "the *onnagata* is something produced by a man employing these signifiers."[46] Yet, the same could be said for the Ichikawa girls; they too "employed" the patterns, techniques, vocabulary, and signifiers of grand kabuki. More than copying male actors, the actresses appropriated the individual *kata* building blocks developed to create the *onnagata* character.

Members who played the *onnagata* roles, or what Katherine Mezur aptly calls "fictions of female-likeness," were instructed to think of themselves as a neutral slate onto which they could refashion their bodies, movements, and gestures to conform with how men played women on the kabuki stage. Toward this end, they practiced what some have referred to as "killing the body" to describe the process they underwent in order to manipulate their bodies as female kabuki characters. After learning how to repress their so-called ordinary expressions, the actresses playing female roles mastered how to stand with their knees bent, their toes pointed inward. All hand and arm gestures were diligently controlled, with the hands kept close to the body. Head movement was small and precise. One of the challenges of becoming "fictions of female-likeness" was adopting the same artificial falsetto-like voice as their male *onnagata* counterparts. Female *onnagata* were therefore instructed "to kill their voices." "I would never permit them to do it in their

own natural voices," Masujūrō stated during his discussion with Zeniya, adding that the troupe aimed to perform "without damaging the special characteristic manner in which men have performed women in kabuki."[47] He understood that kabuki depended on the transmission of highly codified patterns from one actor to another, from one generation to the next.

Never were the girls encouraged to believe that playing the female roles in kabuki would be easy for them. In fact, as early as its Tokyo debut at the Mitsukoshi, the troupe acknowledged that even Kumehachi had suggested that performing female characters was potentially more of a challenge for women and girls than for men and boys.[48] Moreover, at the November 1954 roundtable sponsored by the *Ōsaka*, Baika, the troupe's leading *onnagata*, stressed that when playing female roles, the girls could not think of themselves as women.[49] Just because she was a woman did not mean that playing a woman was more natural than playing a male role. Femininity was a theatrical construct, which was neither the sole property of male or female bodies.

The same held true for the troupe's male-role specialists. Playing a man, the actresses reasoned, should not necessarily be more difficult for actresses than actors since the stylized acting resulted from a finite variety of fundamental patterns (*kata*) they had been trained to master. Once again, they grasped that playing men, or what we might call "fictions of male-likeness," transcended notions and expectations about contemporary masculinity. In order to create a kabuki theatricalized version of masculinity, they adopted a wider stance, used extra padding, and wore "masculine" wigs and costumes (see figure 5.2). Their range of motion was much larger; they were not as constrained by their clothing and were free to use a more vulgar form of speech. The troupe's male-role players also worked to deepen their voices, often speaking in a low register both off and onstage.[50] In addition, they relied on their *onnagata* partners to speak in a higher voice, so theirs would sound relatively lower. So convincing was the transformation that many believed they "passed" for the male performers who usually depicted such characters.

Just because they were girls did not preclude them from doing the same so-called unladylike *kata* as the boys. When Misuji, for example, played the role of the gender-bending Benten Kozō (who appears as a woman before revealing himself as a man), she too hiked up her kimono and stripped it off to reveal a bare chest, though like male actors, her chest would be wrapped with a skin-colored cloth. As we shall see, many critics found this akin to a vulgar female strip-show, but Misuji justified her controversial actions, stating, "I'm just immersing myself in the role."[51] For the troupe to omit this stage business was to perform something different from kabuki.

Figure 5.2 Ichikawa Misuji and Ichikawa Fukushō enact *tachiyaku* roles in *Chronicle of a Toyokawa Buddhist.* Courtesy Sakuragaoka Museum, Toyokawa, Japan.

For almost as long as women have performed in public, critics, in the words of Min Tian, have denied "actresses the possibility of acting stylistically or artistically because, supposedly, they are inclined to exploit their natural endowments."[52] The idea that a woman would perform femininity more "naturally" than a man has been used both to endorse kabuki actresses (by, e.g., Danjūrō IX) and to censure them (for not being sufficiently artistic). Ultimately, such criticism has been one of the many obstacles for women performing kabuki. The troupe tried to turn such criticism to its own advantage. The girls won praise for their depictions of ingénues and princesses. When the *Chūnichi* critic complimented Masuyo's Omiwa (*Mount Imo and Mount Se*), it was because "she played in a way that no adult could match. Her age fits this role perfectly" (see figure 5.1).[53] Yet, if it had been left up to the troupe, members would have preferred not to be seen as relying on their innate characteristics. Youth and beauty were undoubtedly on their side, but they sought to earn a reputation for playing roles other than themselves, whether they were samurai, geisha, or town dandies. Far

from wanting to challenge the way in which kabuki was performed, the troupe aspired to become part of the establishment.

By performing in this manner, the troupe reified gender roles as they had been constructed by male kabuki actors and passed down through the years to their sons and disciples. Notably, the Ichikawa Girls' Kabuki Troupe inserted itself into this process, with members learning many of their roles directly from male kabuki actors. While the actresses demonstrated their theatrical talent by "ghosting" professional male kabuki actors, such performances simultaneously served to perpetuate not only many feudal values, but also the so-called feudalistic ideal of how men and women should move, speak, and behave. Instead of experimenting with new work and contemporary dramaturgy, the troupe made its reputation performing the classics and "mirroring" the acting of grand kabuki. Despite naming themselves an all-female company, the Ichikawa Girls' Kabuki Troupe approached kabuki by acting like men.

6. The Critics Respond ↶

In the 1950s, the term *shōjo* (girl) conjured up overwhelmingly positive qualities. Judging from the media's use of the word, it suggested not only teenage girls, but young ladies who were sweet, pure, and pretty. From the perspective of the press, members of Ichikawa Girls' Kabuki perfectly embodied all of the *shōjo*'s ideals. The actresses, a *Mainichi gurafu* writer pronounced, were "old-fashioned" in the best sense, due to their kabuki training on and off the stage.[1] They were innocent, cute, and virginal; in short, the ultimate role models for how to be good girls.

Being good kabuki actresses was another question. Though troupe members believed that calling themselves "*shōjo*" and performing grand kabuki were not mutually exclusive, many critics felt that girls' kabuki was irreconcilable with "genuine" kabuki. While the press raved that the troupe was "the Shōwa Kumehachis" or "kabuki's Jeanne d'Arc" (a label for progressive women in Japan), it stopped short of calling it, plainly and simply, a kabuki company.[2] Critics rarely separated the onstage roles from the young performers playing them, which, in turn, prevented them from viewing the actresses in the same way as actors.

Of all the criticism the troupe received, the one review written by Toita Yasuji was the only one to question whether the girls were performing kabuki. His review appeared in the July 1953 issue of the highbrow *Geijutsu shinchō*, almost two months after the Meiji-za engagement and five months after the Mitsukoshi's, enough time to digest the media's (and the public's) views of the troupe.[3] Toita was thirty-seven years old when he penned this critique and would go on to become one of kabuki's most eminent critics.

Though Toita made some barbed remarks about the troupe, most of his critique was reserved for other members of the press. From Toita's perspective, the overarching reaction to the troupe's two Tokyo programs in the spring of 1953 had been one of sheer mesmerism and uncritical pandering to "Kabuki's Girl Prodigies." Wondering aloud about such seemingly gratuitous attention, he scolded readers for their "surprise" that contemporary women performed kabuki, given that past kabuki

actresses included Ichikawa Kumehachi, Matsumoto Kinshi (1854–?), and Nakamura Kasen. Times have changed so dramatically, he noted cynically, that women, wearing bean-specked headbands over permanent-waved hair, now perform the once-taboo custom of carrying the portable shrine (*mikoshi*) during festivals. "There is nothing to be surprised at," he further admonished, "we live in an age in which [pop-singer] Misora Hibari charges more admission than [*shinpa* actor] Kitamura Rokurō, and Kinkakuji [temple] is burned to the ground at the whim of a youth."[4] In such a topsy-turvy world, why should the addition of a girls' kabuki troupe elicit such a furor? The girls too, he mused, must wonder what all the fuss is over.

While acknowledging that the Mitsukoshi production (it is unclear whether or not he attended the Meiji-za program) was "magnificent," Toita suggested that the "glowing" press had nothing to do with the actual performances of the girls.[5] As discussed in chapter 4, however, the reviews were positive but hardly obsequious. Going to great lengths to set himself up as an objective critic, he wrote, "As for me, I don't in any way bear ill will against this troupe; more than [critics] treating the troupe's production with silent contempt or feeling bitter about it, this [positive] reaction is more pleasant."[6] Yet, a careful reading of Toita's article suggests that he would have preferred for the troupe not to have received such a rousing welcome in Tokyo. According to Toita, the troupe's unprecedented success in Tokyo stemmed from four factors that were entirely unrelated to the troupe's artistic talent: the advance publicity, the Mitsukoshi venue, the current state of grand kabuki, and Ichikawa Sanshō's patronage.

First and foremost, Toita believed that the advance publicity created an environment averse to criticism. Even before the girls arrived in Tokyo, journalists had endorsed them. Newspaper and magazine articles had predisposed the audience to favor the troupe without seriously evaluating the performances. At the same time, Toita paradoxically reasoned that spectators had enjoyed the show because their "expectations were so low."[7] Furthermore, critics had no standards by which to judge the troupe, since "never before in history has there been a girls' kabuki troupe." The performers' young age alone had enticed critics to see the shows, he wrote, implying that their *shōjo* status was an irresistible topic for reviewers and editors, who had granted "generous space" to the engagements. He warned against applying current critical standards that had been popular since the time of Ichikawa Danjūrō IX. One can surmise that he was referring to Miyake Shūtarō (*Mainichi*) for reprimanding the troupe for failing to convey "internal artistry" (*haragei*). Redefined as a quieter, more restrained, realistic acting style by Danjūrō IX,

this principle has been used by generations of succeeding kabuki actors and critics to evaluate an actor's performance.

According to Toita, the Mitsukoshi venue also factored into the troupe's success, since spectators automatically assumed that all of the theatre's productions were of high caliber. Moreover, he mused that audiences were eager for something new. They had become bored with grand kabuki, whose top actors "have lost their popularity" and "spill their family artistic secrets to reporters." Finally, he proposed that the troupe's success was wholly thanks to Sanshō. "Had the troupe just come from Aichi Prefecture and used their private names, it's unclear whether or not theatres would produce it."[8]

Toita conveniently failed to mention that grand kabuki performers, especially the scions of famous families, received, and continue to receive, all these advantages based on their birthright alone. They receive advance publicity, perform at the most prestigious theatres, and profit from the social capital of hereditary stage names. Take these so-called advantages away from the girls, and all that would remain on Toita's list was the current damaged state of grand kabuki, a somewhat contentious charge. Though a significant number of senior actors, including the esteemed "Rokudaime" (Onoe Kikugorō VI), had died recently, several junior actors such as Ebizō IX, Matsumoto Kōshirō VIII (1910–1982, later Matsumoto Hakuō), and Onoe Baikō VII were earning acclaim in new hits such as *The Tale of Genji* and in old favorites such as *Scarface Yosa*.

The crucial issue for Toita was that the troupe did not meet kabuki's artistic criteria. Though admitting that it was better than "student kabuki" (which he admitted left him "feeling cold"), the actresses were not any better than mechanical puppets. The troupe was merely calling itself kabuki, he argued, while in actuality doing "*kubi-furi shibai*" (neck-movement theatre). An important subgenre of children's kabuki, *kubi-furi shibai* was a popular Tokugawa-period theatre genre in which boys imitated puppets to the accompaniment of a *gidayū shamisen* player and narrator, who were visible throughout the performance.[9] The boy players rotated their necks side to side, mimicking stylized *mie* poses, and pantomimed the action, mastering the movement without reciting any of the dialogue, something that was expected of kabuki actors performing adaptations of puppet plays (*denden-mono*). Toita undoubtedly intended for the label "*kubi-furi*" to be an insult. He wrote, "The *Asahi*'s headline summed up [the troupe's performance] perfectly: 'Puppet Plays without Operators.'" A close reading of the *Asahi*'s review, however, reveals that this headline was intended to compliment the troupe's precise rendering of puppetlike movements; Toita, taking the headline out of context, made it sound like the newspaper had

meant it as criticism.[10] Even if one allows that the troupe at this stage was doing so-called elementary neck-movement theatre, however, Toita never acknowledged that such a convention was the norm for Tokugawa-period all-boy troupes.

At the heart of Toita's criticism raged the dialectic between *kata* (corporeal patterns) and *kokoro* (the heart), the warp and weft that are the basis for great acting in kabuki. With only the physical motions, the acting comes off as mechanical and empty; but with only psychological motivation, the foundational kabuki choreography is lost. At the beginning of an actor's training, emphasis is placed on mastery of the *kata*; only later, if ever, are the psychological components of acting taught. Indeed, it is widely believed that it takes at least ten years for an actor to master the *kata* "basics" before integrating the "*kokoro*." For Toita, only a performance that could fuse both of these elements was interesting. "When a cat sits on top of an electric piano an even more interesting sound emerges," he wrote, scolding the troupe for its so-called mechanical approach.[11]

As we have seen, earlier in his review Toita suggested that critics not judge the girls by the same standards to which grand kabuki actors were held. But here he expects the same level of psychological mastery demanded of a senior performer. Surely, competent understanding of the roles, one component of *kokoro*, should have been demonstrated by the girls even at this early stage, but to peg the girls as "neck-movement" performers seems unduly harsh. Ultimately, the troupe failed to move him. Toita charged that kabuki spectators like to get drunk on performances; without intoxication, the pleasures were few. The troupe was like a "fresh drink" in the kabuki world, but in his mind it was a decidedly nonalcoholic one.[12]

The troupe's reaction to this criticism is not recorded. Though Sanshō never referred to Toita personally, he did take up the topic of *kubi-furi shibai* in a letter to Masujūrō several months later. His request that the troupe avoid performing plays that would be interpreted as "neck-movement theatre" was probably more than just coincidental. If Masujūrō insisted on the troupe performing plays from the puppet repertory that relied heavily on pantomime, Sanshō recommended that they perform ones that had slightly more dialogue, such as Act VIII of *The Treasury of Loyal Retainers*, the second act of *Twenty-Four Paragons of Filial Piety*, and the *michiyuki* (travel dance) from *Mount Imo and Mount Se*. "But for a piece like 'Ninoguchi Village,' " he advised, "where the direction and dialogue is changed around [from that of grand kabuki], it smacks of *kubi-furi*, so it will be a minus."[13] In this respect, Toita's criticism probably served as a wake-up call that the troupe could not rest on its laurels. Just because members were particularly skilled

at performing the puppetlike movements from *bunraku*, they needed to expand their active repertory to include a more diverse selection of plays.

Similar to Toita, who showed how the troupe's work resonated with *kubi-furi shibai*, other critics took it upon themselves to describe, and to define, this new genre of "*shōjo* kabuki," often juxtaposing the Ichikawa Girls against other troupes and performers to show how it was different. As discussed in chapter 5, reviewers (and troupe members) went to great lengths to distinguish the troupe from Takarazuka. At the same time, critics proclaimed that the troupe was not a *nihon buyō* dance troupe, not a reincarnation of late nineteenth-century female kabuki, and not a derivation of "Genji Bushi," an all-female genre that emerged in the late nineteenth century.

Becoming like Genji Bushi elicited particular concern for critics, who could remember attending performances as children. A rival of the more established female *gidayū* companies, Genji Bushi troupes performed adaptations of kabuki plays, dances, and *shamisen* music. They were banned in 1905 by the Tokyo Metropolitan Police for sexual content, but vestiges of the genre could be seen until the early 1920s. Probably because of its lascivious reputation, Genji Bushi conjured up self-indulgent, unruly, and unpolished performances for Ōe Ryōtarō of *Engekikai* and Akiyama Yasusaburō of the *Asahi*. Even though Ōe admitted to admiring the all-female troupes in his youth, he cautioned the girls not to imitate their "decadent" style.[14] Akiyama was more concerned with the troupe emulating Genji Bushi's unpleasant aesthetic qualities. He wrote, "Whenever I hear [the troupe's gruff] voices, I am reminded of the once-popular Genji Bushi women's theatre, and I find myself listening to ugliness." He later warned, "It is essential that the troupe not force their voices, like they used to in the old Genji Bushi theatre."[15]

Likewise, critics were eager to distance the troupe from the mature female actors (*onna yakusha*) of the nineteenth and early twentieth centuries. These commentators emphasized how the girls needed to craft a separate identity, distinct from the questionably immoral female actors of the past. Reviewing the troupe for the first time, Miyake of the *Mainichi* sounded a sigh of relief that the members "have not been harmed by exposure to the adult environment" and cautioned the troupe not to learn "from past female actors."[16] Though there were certainly many *onna yakusha* who had played at the prestigious Teikoku Theatre, most had achieved only middling reputations as players on provincial stages. Akiyama wrote, "Those of us critics have one private worry about the troupe: With all the touring and praise, this troupe will become degenerate. That is, the time of the *shōjo* will expire, and it will

become a company of female actors."[17] His comments betrayed a bias not only against itinerant women's troupes, but also against players from the countryside.

The girls were also distinguished from Japanese classical (*nihon buyō*) dancers who specialized in the dance-drama (*shosagoto*) pieces of the kabuki repertory. Although women dominated (and dominate) Japanese dance schools, the majority did not make a living from their art, but practiced it as a serious hobby. Critics noted that amateur dancers spend longer periods rehearsing one piece and, generally, have only one opportunity to perform it before an audience. The girls, however, were not only dancers but actresses. They performed dances, plays, and dance-dramas in numerous venues and received payment for their work.[18]

CRITICAL OBSTACLES

Needless to say, critics had difficulty accepting the troupe on the same terms as men's grand kabuki. While they certainly compared it to male actors and judged it against the plays performed by grand kabuki troupes, they were loath to accept the girls doing the same thing as their male counterparts. Like other presentational theatre forms, kabuki prides itself on the technical skill and virtuosity of its actors. In turn, the audience is conscious of what Gary Schmidgall has termed the "Gemini factor," an awareness of the actor and character at the same time.[19] Although such attention to both the actor and the character is the norm in kabuki, this double vision led critics to hold the troupe to a double standard. Reviewers continued to highlight the obstacles that prevented them from seeing the troupe as the "real thing," criticizing the girls for their play selection, their inability to go beyond the forms (*kata*), and for their "minor-league" background.

For several critics, performing certain canonical plays was unacceptable. "Pulling the Carriage Apart," *Narukami*, "The Sushi Shop" scene from *Yoshitsune and the Thousand Cherry Trees*, and *Benten the Thief* were among those plays viewed as downright "impossible" for the girls.[20] As discussed earlier, critics were particularly wary of any "masculine" business appropriated by the girls that required them to bare their "skin," even if all they exposed was a flesh-colored cotton wrap. Not only was Benten Kozō's "strip" out of bounds, so was the moment in *Mount Imo and Mount Se* when Fukashichi throws off his trailing *nagabakama* trousers in a split-second costume change (*hikinuki*), the highlight of the scene. This was business that "*shōjo* should best avoid," wrote a critic for *Makuai*.[21] Similarly, another critic stated, "I fear that the evening's *Scarface Yosa* and 'The Hamamatsu

Shop' (*Benten the Thief*) fell to the level of an *onna kengeki* (female sword fighting) strip show. This is unacceptable."[22]

In addition to harboring anxiety about the girls showing skin, critics worried that certain roles were unbecoming to young ladies. One critic voiced his annoyance that Masuyo was cast as the jealous lover Omiwa. "The part should be played only by a mature...famous actor, not a girl who has not reached marriageable age," he wrote.[23] Perhaps he thought that audiences would actually mistake Masuyo for a jealous woman, which might harm her future prospects. If the actresses performed such odious characters they would lose their well-earned reputation as sweet girls. Furthermore, Andō (*Yomiuri*) was uncomfortable with company members crawling through each other's legs in a brief excerpt from *Sukeroku*. "This is detestable," he exclaimed. "In this regard, girls' kabuki has its limitations."[24] Thus critics imposed a double standard that dictated principles for the girls to follow that were quite different from their male colleagues.

When critics attempted to justify their double standard, they often relied on the essentialist argument that men were stronger, and, therefore, more capable of playing *aragoto*-type roles than women. Andō remarked: "Performing pieces like the *aragoto Narukami* and *Benten the Thief* was beyond the limitations of Girls' Kabuki; these pieces surpass the level of the girls. *Benten the Thief* in particular is absolutely not suited for children's theatre. It ends up taking away from the other pieces. It is a mistake to move in the direction of performing impossible pieces."[25] While admonishing the troupe to perform "suitable" plays, critics avoided stating which plays were acceptable. They refused to acknowledge that the very plays they were attempting to censure were in fact some of the most beloved plays in the repertory, and the ones that any "genuine" kabuki troupe would aspire to perform.

Critics also justified applying different standards to the girls because they evidently lacked the requisite erotic allure (*iroke*) to perform certain roles. Comprising two *kanji* ideographs for "color" (*iro*) and "spirit" (*ke*), *iroke* can be translated as beauty, sensual charm, or sex appeal. This has been a salient concept in kabuki dating back at least to Yoshizawa Ayame, the renowned eighteenth-century *onnagata*, who pronounced that "the essence of the *onnagata* is *iro*."[26] There is little doubt that most spectators (and critics) found the troupe members attractive, but no one wanted to admit (or believe) that the adolescent girls were capable of being erotic. Playing sexually provocative characters was anathema to the idea of a good girl. Yet, if what the critics said about the girls was correct, that they were truly innocent and sheltered from sexual experience and romantic love, how were they supposed to act in kabuki, which paradoxically required them to be erotic?

The troupe's solution was half-baked. It made no effort to avoid plays with more adult content, but the girls did not always comprehend the erotic insinuations, and Masujūrō apparently avoided uncomfortable explanations. He recalled his discomfort in directing Act VII of *The Treasury of Loyal Retainers*. In a scene replete with double entendre, Yuranosuke, feigning dissolution while standing on a ladder beneath her, makes sexual overtures to Okaru, who has been contracted to a brothel. "How do you teach that to young girls? I couldn't explain it. There are a lot of dirty words in kabuki. It was very difficult to make them say those sorts of things."[27] His reluctance to discuss sexuality on the stage, however, did not prevent the troupe from performing these kinds of scenes on a number of occasions.

The result was that just about every critic writing about Ichikawa Girls' Kabuki felt compelled to say something about whether troupe members did or did not possess *iroke*. One critic felt strongly that Masuyo lacked this vital ingredient when she played the courtesan Umegawa ("Ninoguchi Village"), while Ōe (*Engekikai*) wrote that her Umegawa "evoked sensuality and melancholy," which reminded him of Nakamura Utae's (dates unknown) legendary performance before the 1923 Great Kantō Earthquake.[28] Miyake (*Mainichi*), Andō (*Yomiuri*), and Fujima Shoju, a *nihon buyō* dancer, believed the girls lacked *iroke*, to the extent that they needed to avoid sensual roles that showed parts of the bare body.[29] Tomita (*Ōsaka*), on the other hand, agreed that the troupe lacked eroticism, but did not think that it detracted from its acting. Regarding Masuyo's Princess Taema in *Narukami*, he wrote, she "did not exude any *iroke*, but I must highly laud her performance as a young teenage girl who performs the *aragoto* piece of this great classic so well."[30] For him, there was no need to use *iroke* as a litmus test.

Unfortunately, critics never pushed the question further than to say that the troupe should avoid performing certain characters, like Benten Kozō, Narukami, and Princess Taema. The latter two characters, for example, engage in a "wet" scene (*nureba*) when Taema seduces Priest Narukami with her entrancing looks and plies him with alcohol. Miyake simply suggested that performing these characters adeptly depended on possessing "male instinct."[31] In other words, men had the monopoly on eroticism simply because they were men, an essentialist argument that holds up the male body as not only superior, but as the *only* body that can perform this role.

By this logic, Miyake also should have criticized the girls for performing the character Osato in "The Sushi Shop," whose playful sexual innuendo in trying to get Yaosuke (Koremori) into bed requires a fair helping of *iroke* as well. Yet he made no mention of this character when the troupe performed the play in August 1955. Initially, he even lauded Ichikawa Misuji

for her "braveness" in playing the uncouth Gonta ("Sushi Shop"), who, like Benten Kozō, bares his chest in a moment of masculine bravado. At the same time, Miyake recommended that instead of playing Gonta, Misuji should perform Kanpei in *The Treasury of Loyal Retainers*.[32] He did not explain his reasoning but he must have believed that Kanpei elicited more sympathy than Gonta, since Kanpei commits suicide mistakenly believing that he killed his father-in-law. Miyake later urged the troupe to stop performing "The Sushi Shop," altogether since the unsavory Gonta casts a shadow "on the excellent upbringing of the troupe."[33] The girls could best control their reputation as beautiful, pure, and naïve by depicting characters who embodied the same traits.

As discussed earlier, Toita implied that the girls had mastered the *kata* (forms) but were incapable of expressing the *kokoro* (heart or interior psychology). Miyake too had chided the troupe for emphasizing "form" at the expense of understanding the psychological dimensions of the plays. He commented, "All the girls have grown up, and on one level their acting has really improved; however, they are form actors.... I wish they would read acting treatises (*geidan*) and strengthen their knowledge of kabuki."[34] Toita had chastised the troupe's mechanical approach, while Andō (*Yomiuri*) had called the actresses "blotting paper," and Ōe (*Engekikai*) had commented, "They performed the roles just as they were taught, with great loyalty and with the correct *kata*. It was as if they were just following the conductor's baton or diligently concentrating on how to draw beautiful calligraphic brushstrokes."[35] These observations resonated with Masujūrō's remarks that the girls were "mirroring" kabuki. As we have seen, such comments were not meant as criticism, but in recognition of the troupe's intention to perform kabuki in the same manner as grand actors. Critics were undoubtedly impressed by the ability of the girls to enact a staggering variety of *kata* for so many plays.

Without clearly defined patterns on which to draw, the actresses were often stumped. One of the most famous (and amusing) troupe legends is one in which Kawarazaki Gonjūrō III (1918–1995) coached the sales clerks in *Benten the Thief*. According to Baika, he instructed the girls to "chat among themselves," using the onomatopoeic expression, "*gaya gaya gaya*," a sound that imitates people babbling on in conversation. When the actresses repeated the scene, they took his advice literally, saying to each other, "*gaya gaya gaya*" ("blah, blah, blah"). Gonjūrō, Baika noted, "had a great laugh over it," but ultimately ordered that the improvised dialogue be scripted for them. "As kids we couldn't always figure out an adult's mental state... it was difficult for us to do," she said.[36] The troupe initially tried to avoid

performing *shin*-kabuki plays that required new dialogue and depended less on acting forms and dance choreography. Eventually, it performed several plays in this genre, including Okamoto Kidō's *Love Suicides at Toribeyama, The Mansion of Broken Dishes at Banchō*, and *The Tale of Shuzenji*, but Baika stated that, "If you ask why we did it, it was because Ichikawa Jukai wanted to teach us these pieces."[37] Pragmatics, more than questions of moral cleanliness or psychological suitability, dictated the troupe's repertory. The girls learned the plays that grand kabuki actors wanted to teach them.

MINOR OR GRAND KABUKI?

Just as there was certain stage business that critics believed the troupe should not do, there was also business that they insisted the troupe should do. Specifically, critics charged that the troupe should perform standard grand kabuki *kata*. Now that the troupe was appearing on "cypress stages," *kata* from the minor-theatre circuit was deemed unacceptable.

Sanshō had voiced similar concerns regarding the troupe's engagements in rural towns. He wondered how the troupe would please aficionados if it played only for provincial, "minor-league" audiences. In another letter, he worried that the troupe needed to use the correct props for *The Love of Izayoi and Seishin*. The props (and, most likely, the scenery) that the troupe had used for past minor-theatre engagements were inappropriate for a Tokyo theatre and needed to be fixed. Thus, Sanshō wrote, "I've asked Fukunosuke [Ichikawa Fukunosuke III (1904–1990), Sanshō's disciple] to send a photo of the correct props."[38] Indeed, one of Sanshō's concerns that would surface occasionally and also become a major issue with the Tokyo press was the troupe's minor-theatre roots and itinerant lifestyle. Sanshō expressed his fear that the troupe's rural touring would ruin its artistry and reduce it to a low-class provincial traveling show. Writing to Masujūrō who was overseeing the troupe's production in Toyokawa, he warned, "You'll be performing for people who will not know how to appreciate your theatre."[39] He wanted the troupe to perform in the established city theatres, where they could be seen by what Sanshō perceived to be more sophisticated audiences.

It is clear that Sanshō felt some urgency in bringing the girls up to speed in grand kabuki techniques now that the troupe was performing in the very same theatre as professional male kabuki actors. He worried that the troupe had been exposed primarily to rural performance styles, which only could be corrected by increased exposure to mainstream male kabuki. Though he probably never meant to conceal the troupe's Toyokawa roots, he made

a point of telling journalists that the girls were based in Hamamatsu City, which "was a stopping-off place for the leading kabuki troupes on their way to and from Kyoto," making it easy for the girls to attend the theatre.[40] Under Sanshō's watch, the actresses made a concerted effort to see the very best that grand kabuki offered in the immediate postwar period. Sanshō encouraged them to take the opportunity to see kabuki whenever possible, even in middle of their own performance run (the girls had spent their one day off from Mitsukoshi to see Kikugorō's troupe perform), and during the years that he was alive, Shōchiku permitted the girls to see the shows for free. In his letters, Sanshō kept Masujūrō abreast of important productions (in December 1955, e.g., *The Treasury of Loyal Retainers* was a must-see). In another letter dated 28 February 1953, Sanshō requested that Masujūrō bring the girls to the March production of *Sukeroku* at the Kabuki-za, in which he was playing the villain Ikyū, and Ebizō, the future head of the Ichikawa line, was Sukeroku (Baikō VII played Agemaki and Nakamura Fukusuke VII [later, Shikan VII, b. 1928] took the role of Shiratama).[41] Writing in 1955, Akiyama (*Asahi*) stated that their presence was noticed:

So there they go—like female students wearing their uniform and makeup, they go to Kabuki-za, Shinbashi Enbujō, and Meiji-za to see grand kabuki. They are quite diligent about their theatregoing. So in that way they have become quite familiar with Tokyo. Get to know their faces well today, because next time you are at Kabuki-za, look around. In the seat next to you, you might find Misuji, and behind you Masuyo and Fukushō, watching the play enthusiastically. In this way, you will feel like they are your daughters or your younger sisters.[42]

Troupe members agreed that watching great actors at grand theatres was the best way to learn. "I always go to Kabuki-za first to watch genuine kabuki. More than anything else, watching good kabuki is the best study," Masuyo wrote in *Engekikai* in response to a fan letter, adding that she tried to visit Tokyo at least once every two months.[43] Years later, Ichikawa Sanpuku recalled taking notes on the acting whenever she attended productions at the grand theatres.[44] As far as the girls were concerned, their techniques and interpretations were faithful to professional, male actors.

Under Sanshō's direction, the majority of the troupe's plays were modeled on grand kabuki productions. Its "Village School," for example, incorporated staging originated by Nakamura Kichiemon I and Onoe Kikugorō VI. Moreover, the troupe was taught by top grand kabuki actors and their disciples, and it had spent many hours watching mainstream productions in Nagoya, Hamamatsu, Osaka, and Tokyo. Over time, more obscure

pieces, such as *The Diary of the Mito Clan* and *Sequel to the Treasury of Loyal Retainers*, were dropped. These little-known plays coincidentally were the ones performed almost exclusively at the minor theatres. In this way, the troupe slowly came to streamline its repertory so that it conformed to the kind of pieces presented by grand kabuki troupes.

Yet, there was no escaping the reality that the girls had been exposed to minor theatre. Masujūrō and Sumihachi, their regular teachers, were products of this tradition, so it was only natural that the troupe's repertory would reflect this bias. As Ichikawa Kobotan recalled years later, "Masujūrō had toured in the rural areas, so he was used to doing stunts (*keren*) and putting on lots of loud, colorful spectacle, but that was considered inelegant in grand kabuki, so conforming to such tastes was tough."[45] Some plays the troupe performed were confined to the minor kabuki repertory. Other pieces were performed by both the grand and minor actors, but exhibited special minor-theatre characteristics. For example, in the "minor" version of *The Miracle at Tsubosaka Temple*, a new gangster character, Gankurō, complicates the plot by attempting to woo Osato, the wife of the blind *shamisen* player, Sawaichi. Like most minor-theatre productions, one actress (Misuji) played both Sawaichi and Gankurō, toggling between the two characters in one quick change after another, giving her an excellent opportunity to exhibit her acting prowess.

Critics neither praised nor panned *Tsubosaka*, but they tended to find fault with plays that omitted favorite *kata* from grand kabuki. *Chūnichi* critic Fujino Yoshio, for example, voiced his annoyance that Tadanobu, Lady Shizuka's attendant in "Mount Yoshino," failed to perform the onstage instant costume change, in which he transforms from his human to his fox form. "In kabuki, it is a rule to change the entire outfit in making a transformation," he scolded, adding, "perhaps [the troupe performed] the way it was done in the minor theatre, but by omitting the instant costume change it is not interesting."[46] Miyake, writing much later in 1959, also chided the troupe for leaving out Fukashichi's messenger in *Mount Imo and Mount Se*.[47] Akiyama (*Asahi*) was distraught, not about the troupe cutting, but about adding business from the minor theatre. "In *The Earth Spider*, they swing their heads around like the *hiragana* 'no' (の) character, something that many believe is taboo in Tokyo."[48] Just like a girl stripping off her kimono, this choreography was best avoided.

Critics directed their complaints to Masujūrō. They never tired of treating him like a drop-curtain actor (*donchō yakusha*), who just happened to give birth to legitimate offspring. He was the troupe's fall guy. As Miyake (*Mainichi*) charged accusatorily, "Do not teach the old way of the minor

theatre to girls who do not know dirty ways."[49] Writing in *Engekikai*, Akiyama sneered that the troupe "reeks of minor theatre, which I have instructed it to fix." In the same article, he alleged that other critics were equally dismayed by Masujūrō's direction and could be overheard gossiping during intermission: "Who taught them that? They have not mastered the basics. They have made many mistakes. . . . Those kids who learned that are really to be pitied. Isn't it a pity for the children that they have an instructor like that?"[50] Though Akiyama wrote that other critics were the ones making these dismissive comments, his condescending tone suggests that he harbored similar thoughts. Masujūrō, not the girls, was the one to blame.

It is difficult to know how much of the criticism was truly due to Masujūrō's "minor theatre" style. Akiyama and Miyake appear to have taken a dislike to Masujūrō for personal reasons that, seemingly, had little to do with his "drop-curtain" background. Akiyama, for one, entitled his September 1955 review of the troupe, "The High-Nosed Ichikawa Girls' Kabuki Troupe," punning on the Japanese idiom "*hana takashi*" to mean both that the troupe's noses were literally "high," referring to plastic surgery recently undertaken by two troupe members in order to enlarge their noses, and to his belief that the troupe was actually "high" on itself—in other words, arrogant.[51] Even Sanshō, in a letter to Masujūrō, wrote, "There is a rumor circulating among critics that you are too self-assured." He further stated that if he had the opportunity to see the troupe perform, he would probably find fault with it, so Masujūrō should stop being smug.[52] Masujūrō's minor-league touring roots, together with what was perceived to be an egotistical personality, were loathsome to many people in the theatre world.

The troupe performed, however, not only for critics and city spectators accustomed to grand kabuki, but for audiences familiar with minor theatre. Many fans looked forward to acting business that was unique to this tradition. Seki Itsuo, for example, explained that he enjoyed the troupe's "minor" version of "Ninoguchi Village," precisely because it was overexaggerated and far-fetched.[53] He particularly liked the more dramatic ending in which the three main characters, Umegawa, Chūbei, and Magoemon, pose outside the curtain and perform a final tableau, a departure from the standard, grand kabuki *kata* in which Magoemon stands alone at the end of the play. Thus, although the troupe was reviewed by critics who were accustomed to grand kabuki staging, the actresses could never forget that one of their core constituencies were those spectators who anticipated the stage business of the minor theatres.

For the big city critics, more exasperating than the minor-theatre *kata* was the members' regional dialects. Their thick accents irked city reviewers to no end, and if the girls were cognizant of any one complaint, it was that every time they opened their mouths, out came the "Mikawa dialect." Ichikawa Sanpuku recalled, "We all spoke with the Mikawa dialect, and so when we went to Tokyo, our voices would always be a topic of conversation. Sanshō really wanted us to get rid of it."[54] The drawl of southeastern Aichi Prefecture, which can still be heard in cities such as Toyokawa and Toyohachi, differs from standard Japanese in that the ends of words are elongated in a more songlike manner, making the speakers sound, in the words of Andō, "like country bumpkins."[55] The accent, which "really hurt the ears," was a dead-giveaway that the troupe was from the provinces. Such problems needed to be cleaned up immediately. Once again, Masujūrō was pronounced the root of the problem. One critic charged, "Their troupe leader is also from the Mikawa region and is used to that way of speaking, so it seems that he is blind to this matter."[56] Such criticism was not entirely fair. Though Masujūrō spoke with an accent, he acknowledged that teaching the girls how to speak properly was his greatest challenge.[57]

Reviewers in Osaka, Kyoto, and Nagoya criticized the girls' accents, without sparing their feelings. Misuji's accent was considered the most conspicuous of the top-ranked performers, while Fukushō's was hardly noticeable. Worse, Misuji was frequently singled out. "Misuji has beautiful form, but because of her voice, she comes across as unsophisticated," one critic wrote.[58] Likewise the *Kyōto shinbun* noted, "If she could just get over the accent, her Tokubei (*Love Suicides at Sonezaki*) would be excellent."[59] She was taken to task for playing quintessential Edo characters such as Yosaburō and Benten Kozō, whose dialogue was intended to reflect the fast-paced city slang, with her Mikawa twang. The dialogue of Benten Kozō is especially challenging, since the actor must alter his voice from an attractive woman's to a vulgar gangster's. Advising Misuji not to perform this role, Andō wrote, "Since you have worked so hard to hide your accent, here it comes flying out, just like in the minor theatre."[60] Entitling his reviews "Concerns about the Poor Dialogue" and "Pleasures of the Dialogue are Scarce," Akiyama (*Asahi*) listed four problems with the girls' voices: they croak, are thick, squeaky, and shrill.[61] He also complained that it was difficult to hear the actresses, a criticism frequently hurled at male, grand kabuki actors. As noted earlier, the voices of the girls reminded Akiyama of the "gruff" and "unpleasant" sound of the all-female Genji Bushi troupe. He mused that the

speech defects "probably have something to do with the vocal cords." Yet, he allowed that it was not necessarily a female problem since certain girls, such as Kobotan and Sanpuku, did not force their voices.[62]

In order to standardize their speech, one critic advised the girls to limit their *gidayū* programs and to increase the number of *tokiwazu*-school pieces, since the former embodied the emotionalism and regionalism of the greater Osaka area. "Practice with Ichikawa Jukai, and in Tokyo with Ichikawa Ebizō and with other actors. Try to increase these interactions," he counseled.[63] Akiyama also suggested that the actresses spend more time studying with leading grand kabuki actors, but cautioned that the troupe had difficulty "learning new *kata* [and by extension, the proper dialogue], since they were so wedded to the way they were taught."[64] In time, several girls from Tokyo joined the troupe, which gave it in-house models for Edo speech. Meanwhile, girls from Osaka were invaluable in helping the other actresses perform plays by Chikamatsu, which called for the characters to speak in the dialect from the Kansai region.

CRITICAL ACCEPTANCE

Like everything subjective, there was no consensus regarding the troupe; some critics accepted it wholeheartedly, others did so begrudgingly. The voice of opposition, however, was never as harsh as Toita's review. If criticism was voiced, it was done behind closed doors or "relayed" in the press by critics who stated that they were not speaking for themselves, but for other critics or members of the audience. Goto Akira *(Kyōto)* for example, reported what he overheard other people saying:

> They have done the plays well, the dialogue is solid, but it would be a lie not to admit that there are critics who say that they are not the "real thing." To cut to the chase, the troupe lacks depth.... There is the physical problem of being a *shōjo* and the fact that the troupe has not been able to cultivate the charms of one who has spent many years in the kabuki world. They have not been able to engender this type of atmosphere. However, this is unavoidable for the girls. But the girls display their top level of performance. So, on this matter, they just have to go for it. We have great hope and expectations for the troupe, so if the troupe continues to do its best, it will be able to overcome the problems of tradition and physique.[65]

During the mid-1950s there was no question that the majority of critics were enthusiastic about the troupe. As Toita suggested, the Ichikawa Girls'

Kabuki Troupe was not ignored, but embraced.[66] This was very different indeed from the reception offered to female actors (*onna yakusha*) some four decades earlier. Not one review mentioned the "disharmony" of the members, perhaps the greatest criticism leveled at early twentieth-century female actors, who performed with male kabuki actors at the Teikoku Theatre.

Ichikawa Girls' Kabuki was able to transcend such criticism for the simple reason that its members were not performing with male kabuki players, but with other girls, who were roughly the same age and size. As an all-female troupe, it did not have to worry about finding the right balance with men. Still, issues of physiognomy did arise. The actresses needed to transcend not only gender, but a range of physical characteristics. Like their predecessors, the girls were believed to be weaker and smaller than their male counterparts. But when Fukushō or Misuji played strong, masculine roles such as Benkei (*Subscription List*) and Watanabe Tsuna (*Ibaraki*), they received praise. Moreover, several critics compared the troupe to grand kabuki. As Tomita (*Ōsaka*) wrote, "In the current [male] kabuki world, the first-class members also have physical limitations, so in this regard I don't think that [Ichikawa Girls' Kabuki] is overshadowed by the big-name players.... If they can learn to develop more of a sense of timing, they'll be tremendous actors."[67] In Tomita's view, the troupe rivaled mainstream kabuki, and its members had a bright future.

The fact that critics came down strongly on the troupe indicates not only that they accepted it, but also that they took the troupe seriously enough to offer balanced, critical feedback. Some years later, the troupe faced more backlash, as reviewers wrote that earlier critics had provided the troupe a handicap by giving it good reviews as a girls' troupe. In the beginning, however, the refrain "good for a girl" was almost never heard. Tomita was perhaps the troupe's greatest advocate. He closed his stellar review of the November 1954 Naka-za performance as follows: "I am not writing sweetly [because it is a girls' troupe]. I am a critic who has been writing criticism for forty years, and I take responsibility for what I write. If anyone has something different to say, let me know."[68] Whether or not he received any mail in response to his verbal challenge, the point is clear: a senior kabuki critic was willing to stake his reputation on the actresses. Such a challenge, however, would have been unnecessary had the troupe not been the subject of disparaging gossip. But no matter how one defined the troupe, no one could overlook the fact that it had become a serious contender on the national stage. As veteran grand kabuki actor Sawamura

Tanosuke VI recalled, "I didn't think much of them, but I wanted to see what they were doing, since they had become so popular."[69] Despite his misgivings, he saw Ichikawa Girls' Kabuki perform no fewer than three times. By the beginning of 1955, critics were calling the rise of the troupe none other than the "*shōjo* boom." The leader of the Nagoya Pen Club Association explained:

> Lately, the phrase "Ichikawa Girls Kabuki boom" has appeared. Saying "boom" is an exaggeration if only people who saw the troupe feel this way. A boom occurs when people have the feeling of wanting to see it; it is when this feeling reaches so many people that we begin to understand that a boom has come about. This is the second time the troupe has performed at the Misono-za. Since the previous engagement, not even three months have passed. In that time, the troupe has performed in Tokyo, Osaka, and Kyoto. One can truly say that a "boom" has occurred. Something amazing has happened.[70]

An article in *Gendai no kabuki haiyū* (Contemporary Kabuki Actors) published by *Engekikai* in 1955 further established the credibility of the girls and indicated that they had been accepted into the otherwise impenetrable all-male kabuki establishment.[71] With the exception of the troupe, all the actors featured in the book were men and most were scions of grand kabuki families. Compared to the male actors, however, the troupe was treated differently. Each famous male actor received at least a page or half a page of commentary exclusively devoted to his performance record; the entire female troupe, on the other hand, was given three pages. Head-shots of the nine top-ranked actors and Masujūrō were included, and a short article recounted the troupe's path to fame. The main feature was a chart, noting the respective stage names of the actresses, their private names, date of birth, date of joining the troupe, height, weight, shoe size, and "things I like," and "things I don't like."

There were no charts for likes and dislikes of male kabuki actors, whose bios included a listing of plays and characters they had performed to date. No mention was paid to the girls' skill as performers. A cynical reader might conclude that the girls were treated in a demeaning manner, more appropriate for child idols than for respectable kabuki actors. Yet, to dismiss the coverage would be wrong; it is significant that the troupe was the subject of numerous reviews and features in the nation's

top publications. *Engekikai's* inclusion of Ichikawa Girls' Kabuki in its exclusive handbook suggests that the troupe, just two years after its Tokyo debut, was viewed as part of the regular performance calendar. Spectators and readers of the preeminent publication could assume that the girls were on their way to becoming a permanent fixture on the national stage.

7. Life Offstage ❧

The press took great pleasure in portraying the girls as one big happy family. Life in the troupe was made out to be an endless slumber party. Pictures in magazines such as *Shufu no tomo* (Housewife's Friend), *Bunka seigatsu* (Cultural Life), and *Asahi gurafu* (Asahi Graph) showed the girls tucked neatly into their futons in two straight rows, as if they were perfectly positioned to regale each other with ghost stories into the wee hours of the night.[1] Other pictures showed the actresses taking communal baths, rehearsing in the dressing room, or unpacking the props. The press even made the girls look like they were having fun washing clothes. At face value, company membership appeared like a girl's fantasy, where she instantly would acquire a couple dozen sisters with whom to do everything: travel the country, perform, practice, eat, sleep, and bathe. But, in actuality, the troupe had its share of tremors and quakes underneath the smooth facade the press presented. If it did in any way resemble a family, it was a dysfunctional one at best.

THE APPRENTICE SYSTEM

Just as the plays the troupe performed onstage reflected rigid feudalistic values, so did the offstage division of members reinforce firm lines of demarcation between veteran and novice members. As the *Mainichi gurafu* reported, "That the girls are part of the old-fashioned world of kabuki speaks for itself."[2] A strict hierarchy was the modus operandi; it was not based so much on age, but on the length of time each girl had been a member of the troupe. The nine members who had received stage names from Ichikawa Sanshō V comprised the top class (*kanbu*), which was actually divided into two subgroups: the top class, consisting of four members, and the junior top class (*jun kanbu*), consisting of five members. Next in line were the middle-ranking (*chū-kanbu*) or regular members, while the newest additions were the apprentices (*minarase*). They had the lowest standing and were called low-ranked children (*shita no ko*), a

pejorative term that corresponded to the third-floor dressing room (*sangai-san* or *ōbeya*) used for adult kabuki actors.[3] Names were listed by rank in the program, and the hierarchical arrangement determined the order in which the girls sat in the dressing room (and generally ate or bathed). Depending on the theatre, top members either received their own dressing rooms or shared with other similarly ranked girls. Though no one ever formally called this arrangement an "apprentice system" (*deshi-seido*), that is in effect what it amounted to, as each of the top members, in time, came to have their own "low-ranked child," who would perform whatever tasks they needed done.

This arrangement mirrored the divisions in the adult kabuki world. Every star grand kabuki actor has his own apprentice or apprentices, often referred to as "room child" (*heyago*), who do backstage chores in exchange for receiving lessons and the opportunity to perform. Depending on his relationship with the senior actor, the apprentice is expected to arrive at the dressing room early to prepare for the rehearsal or performance and stay late to clean up, often after everyone else has left. Onoe Umeno, who performed as a special guest with Ichikawa Girls' Kabuki in the early 1960s and appeared as a child actor with Onoe Baikō VII in the late 1940s and 1950s, recalled that when Baikō went to the toilet, two of his apprentices stood guard, waiting on him with a towel in hand.[4] An apprentice's rank, generally determined by family standing, influenced what kind of roles he played on stage. For most apprentices of grand kabuki, the prospect of one day performing famous roles is practically nil, as major roles are reserved for big-name players.[5] Low-ranked actors must settle for performing as actor assistants (*kōken*), who help with onstage costume changes and oversee the props. A *kōken* spends much of the rehearsal time seated *seiza* style with his calves tucked under his thighs, and it is from this (uncomfortable) perch that he is expected to learn his master's role. He prompts the lead actors when necessary, and during the rare instance when a star becomes ill during a performance, he might serve as an understudy.

Of course one of the major differences between Ichikawa Girls' Kabuki and grand kabuki is that none of the girls hailed from kabuki families; everyone was an outsider. As we have seen, however, Sanshō bestowed first-name stage names to nine of the girls, which gave them special privileges. At the very top was Misuji, who, as company leader, would have been the member most privy to administrative and financial matters. When interviewed, Misuji humbly denied that she had any special privileges as the company leader. All other members, however, spoke about how Misuji played a leadership role in the troupe's development.[6]

The first four players—Misuji, Baika, Fukushō, and Masuyo—comprised the first division, and the second five players—Sanpuku, Suzume, Baishō, Himeshō, and Kobotan—made up the second, or junior top class. Offstage, however, this division largely faded, as all of them were entitled to apprentices. Middle-ranking members, such as Ebimaru, Mineko, and Teruko, neither received an apprentice nor served as one. "We could concentrate on our own selves," recalled Ebimaru, who had received her stage name from Ichikawa Ebijūrō, not Sanshō.[7] What became awkward was that new, incoming members, who belonged to the apprentice class, were often older than the middle and top-ranked performers. Experience and troupe loyalty were privileged over age.

The only one who circumvented this arrangement was Masujūrō and Sumihachi's daughter, Emiko. Born in 1948, she was four years old when the troupe first performed at Mitsukoshi Theatre, and, in this sense, she was the only member to be heralded a kabuki actor at birth. Sanpuku recalled, "She was still awfully young, so she always stayed in the master's room, and wherever the master [Masujūrō] went, she went. So in that case everyone treated her differently."[8] Years later Emiko, laughing at the memory of being pampered by all of her "older sisters," acknowledged that she was the spoiled brat of the troupe.[9]

Members accepted the hierarchical arrangement; it was thought to be perfectly fair and reasonable. New members understood that they needed to prove themselves for the first couple of months by helping with the costumes and props. The apprentices were responsible for arriving before the top-ranked performers to ensure that everything was ready; they washed their "masters'" white slippers and undergarments and gave them massages after performances; they poured the tea and were last in line for meals and the bath.[10] When interviewed years later, most actresses acknowledged that there was a division between the upper and lower ranks, and some even used the term "apprentice system," but most downplayed it. "After a couple years, they adopted an apprentice system for us," Fukushō recalled, "but it wasn't the same as in the grand kabuki world. After all, we were all kids."[11] Moreover, Baika said that she does not remember the apprentices using honorifics when speaking to her, which certainly would have been expected of adult subordinates. But for new recruits, the difference was acute. Kiyomi, who joined the troupe in the late 1950s, recalled, "From running around doing errands, to sewing costumes, to helping everyone put on their costumes, the time when I was on stage was actually a relief for me." Still, she never questioned the system. "It was natural for those of us at the bottom to serve the top members," she said.[12]

Reflective of Japan's strong gift-giving culture, apprentices often gave their mentors small presents, but sometimes this strategy backfired. Kobeni, a member of the troupe from 1954 to 1956, remembered giving Baishō and Baika stylish bags that her parents had sent from their store. "I only had two, so I gave them to my favorite mentors," she recalled. But Misuji, she said, scolded her for exhibiting such favoritism, something that Misuji years later could not recall.[13]

In the best cases, apprentices were paired with veteran members who taught them their roles and familiarized them with the rules of the troupe. Hisayo, who was matched with Masuyo, said that she could not have found a more helpful mentor. But sometimes the pairings were doomed from the start. Kiyomi and Suzume were a poor match. Their body types were different; Suzume was tall, Kiyomi, petite, and they were assigned different roles: Suzume played the soft *nimaime* male roles, while Kiyomi, when she was given the opportunity to perform, played female roles, comic characters, and appeared in dance pieces. "It was frustrating. She didn't really teach me," Kiyomi confided.[14] Suzume was not to blame; the arrangement reflected the system that did not always serve the interests of newcomers. Sometimes, it was equally difficult for mentors. Sanpuku, for example, recalled being paired with a new girl who could not adapt to life on tour with the troupe. "She was just miserable, sobbing on the phone to her family every night, till it got to the point that I told her it was fine to quit."[15] The apprentice system, at its best, served as a buddy system, providing support to members who needed it the most.

At the same time, the hierarchical ranking spawned cliques. As was only natural, girls tended to bond more quickly with those who had joined the troupe at the same time. Misuji, Masuyo, and Baishō, the original threesome, remained close friends; Ebimaru and Mineko and Kiyomi and Hiromi, who joined at the same time, became best friends. When interviewed years later, most members downplayed the existence of factions within the troupe, but few denied that there were clear boundaries that impeded friendships. As Kiyomi recalled, "It was rare that anyone in the top rank would speak to me. They were all above me. Of all the top-ranked members, Kobotan spoke to me the most."[16] Not surprisingly, the apprentices more intensely felt the gap in treatment between the classes.

The girls' salary during the years 1952–1959 was paid by the Hamamatsu-za and reflected the hierarchy in place. Unfortunately there are no extant official documents pertaining to salary; all the information compiled here is based on articles from the 1950s and interviews with members that occurred some fifty years after the event in question. According

to *Shūkan sankei*, which quoted Hamamatsu-za executive director Kaneko Seiji, the four top members were paid fixed salaries, while all the other members were given "pocket money."[17] It seems fair to assume that after Baishō, Kobotan, Himeshō, Suzume, and Sanpuku earned junior top ranking in 1954, they too received "fixed salaries." Several years later, in 1958, the *Shūkan Tōkyō* noted that "everyone is paid monthly, but the top-ranked members' salary is similar to young actors in grand kabuki."[18] The writer stated that they made around 50,000 yen per month, out of which they were required to pay for their stage makeup, also expected of grand kabuki actors. It was a generous sum, considering that in 1954 first-year male college graduates averaged 14,567 yen a month during their first five years of white-collar employment.[19] Interviews with performers corroborate this data, with Misuji earning the highest sum, followed by Baika and Fukushō. Masuyo should have been paid a figure in that ballpark, though she recalled being paid considerably less.[20] The junior top-tier lead performers were probably paid close to 30,000 yen, the figure that Baishō remembered making during a good month. As for the lower-ranked "regular" members, the *Shūkan Tōkyō* estimated that they made between 14,000 and 15,000 yen per month.[21] In actuality, a middle-ranking member, such as Ebimaru, recalled making more like 8,000 yen per month, though she remembered occasions when she earned 10,000 yen.[22] Apprentices were paid around 2,000–3,000 yen a month, and, therefore, the magazine added, "When they need cash, they send a telegram home: 'send money.'"[23] Similarly, *Shūkan sankei* suggested that paying most troupe members "pocket cash," was not problematic, "since all the members come from mid-to-upper middle-class families."[24] It appears that the girls were paid only for the time they actually performed, which, for the years 1952–1959, averaged ten months of the year. Payment policy, however, was not transparent; the girls said that they never knew how much the others were making. This, no doubt, was the Hamamatsu-za's intention.

Members said that they do not recall the topic of salary ever being discussed, nor do they remember feeling particularly disgruntled over financial issues. "I didn't need the money for anything. All our needs were cared for. They gave us clothing, food, lodging, and transportation was always paid for," Kobeni recalled.[25] Baika agreed, noting, "There weren't many things to spend money on," and, more practically, they had no time to shop for things.[26] In fact, although the press wrote that the girls were sending telegrams requesting money, members attest to sending money to their families. Suzume said that her mother, who had adamantly opposed her participation in the troupe, confided to her that the money she sent home

helped her family during times of financial distress.[27] Still, others sensed that there was a gulf between what everyone earned. Kobotan of the junior top-class, for example, recalled that the top-ranked Misuji always treated her to the movies, since she knew that she was making more money.[28] But at the time, Kobotan said she and the other actresses were content to receive any remuneration for their efforts.

"FREE TIME"

To the public, Ichikawa Girls' Kabuki "performed during the day" and "studied at night": at least that was how one newspaper summarized its daily schedule.[29] Reporters questioned how their intensive performing schedule permitted the girls to fulfill their obligatory schooling requirements. Magazines that featured stage pictures of the troupe were certain to include backstage photos of the girls studying diligently in the dressing room "after the performance."[30] In actuality, the troupe performed during the day and during the night; and for the four top-tier members, there was rarely time for school or homework. After finishing a performance, the last thing the girls wanted to do was study for school. As Misuji noted, "We always finish performing around nine or ten o'clock in the evening. Afterwards, we return to our inn, and the first thing we do is take a bath. Everyone does as she likes—some watch television, others listen to records. I'm asleep by 1 a.m."[31] The late evening hours were the main time the lead performers had to themselves.

Prioritizing the theatre over a formal education was not such a problem, as most of the leads already had completed their compulsory schooling by the time the troupe commenced its heavy touring schedule.[32] For the girls who still needed to complete their elementary and junior high coursework, the Board of Education, as stipulated in the Hamamatsu-za contract, hired a fifty-one-year-old female tutor, Matsui Yo. Matsui toured with the troupe for six years and taught members for approximately two hours each day.[33] In 1953, she told the journalist for the *Sangyō keizai*, "They are behind in subjects like science and math, but for subjects that are related to the plays, like Japanese and history, they would surprise you by how much they remember."[34] In contrast to the hard-line disciplinary tactics of Masujūrō, Matsui-sensei was seen by the girls as gentle and nurturing. She understood the extraordinary circumstances under which the actresses were working and tried to be supportive. "When the girls didn't understand their studies," she was quoted as saying, "I would tell them, you can go out there and put on such an amazing performance. I couldn't do that. That alone is

proof that you are smart."[35] Lessons were squeezed between rehearsals and performances. Matsui said that she frequently witnessed actresses fall asleep with their textbook in their laps, a position she was inclined to leave them in. Fatigue, however, never exempted them from taking the exams that the Board of Education sent every few weeks. As Ichikawa Baika remembered, "We took the tests while consulting a book. Our teacher didn't mind. We had no time to study," she said, adding, "The girls playing the ladies-in-waiting or soldiers would just go on stage for a few minutes and then have lots of down time during which they could study, but those of us in the first tier never had any down time. We were always on."[36] The nontraditional arrangement served its purpose; the girls were able to prioritize their performance careers, and their parents and local bureaucrats were content that they were receiving an education comparable to what was being taught in the public schools.

Of course, it goes without saying that the girls were receiving an education in theatre that none of their counterparts at a conventional junior high or high school would ever get. In addition to training with Masujūrō and grand kabuki actors, the members were encouraged to take lessons in tea ceremony and flower arrangement and to study instruments central to kabuki such as *shamisen*, *tsuzumi*, and *taiko*. Most of their free time, however, was spent in rehearsal. Ichikawa Baika recalled that on top of their busy production schedule, finding time to rehearse was a challenge. "While we were on tour, our rehearsals would take place after the performance ended; during our [sixty-day run] at the Hamamatsu-za, we would wake up at 5 and practice until 8 a.m. Breakfast was until 9. Afterwards, the leads would rehearse. And then we would meet in the dressing room to prepare for our 12:30 p.m. performance."[37]

By the time the troupe came under the auspices of the Hamamatsu-za, the actresses were rehearsing or performing almost every day, with very little vacation. According to Masujūrō's autobiography, the girls had one day off every eleven days; however, in a 1955 *Engekikai* article he is quoted as saying that the girls were given four or five days of "unplanned vacation" between engagements.[38] Whether this was truly the case is unclear. Reporting on the troupe's 1956 Hokkaido tour, *Asahi gurafu* noted that despite the rigorous schedule, "the girls do not look particularly tired nor do they get sick."[39] Most actresses interviewed further commented along the lines of, "Sometimes I get a little sleepy, but it's exciting to see new sights. And when I've had a week's vacation, I really want to tour again."[40] Similarly, Ichikawa Suzume looked back fondly on the intense schedule, "We didn't have any vacations. We'd occasionally return home to see our families, but it was

more fun to be together with everyone. I'd go home and would quickly long to go back to the Hamamatsu-za or somewhere else."[41] For the core members, fellow actresses functioned as a family away from home; they relied on one another and shared experiences that other girls their own ages could not necessarily understand.

But there were also times when the rigid schedule forced the girls into making difficult decisions. Baika recalled that she learned her father was dying just after the troupe had opened at the Naka-za in Osaka. She was playing several leading roles and felt that the audience was counting on her. "Of all the difficulties I've encountered as a performer, this was the most difficult," she wrote.[42] She knew that she would not be able to visit her father and return to the theatre in time for the performance. Ironically, her dilemma resembled the conflict between public obligation (*giri*) and personal feeling (*ninjō*) that dominated the troupe's repertory. Though the peer pressure to perform was intense, the very plays the troupe enacted also contributed to teaching actresses to prioritize the group's needs over individual ones. Given this backdrop, it is not surprising that Baika decided to remain in Osaka with the troupe.

During the formative years of the troupe, rehearsals of new work commenced with a full reading of the play. The entire company would gather and sit *seiza* style on the floor, while Masujūrō read the play out loud. He was the only one who owned a script; the girls were expected to record their own lines, any necessary prompt cues, and stage directions in their own notebooks.[43] It was at this reading that most of the girls heard the play for the first time. Hearing the play recited out loud was thought to be easier for the girls to comprehend than reading it by themselves, since many of the younger members had yet to master enough *kanji* to read sufficiently.

After Masujūrō's reading, the troupe would begin "standing rehearsals" (*tachi-geiko*), in which the movement for an entire act would be taught. "It didn't matter if we understood or didn't understand our parts, it would still be a full run-through," Baika remembered. "That's how we would learn. We had to because we had so many plays to learn. It was never at an easygoing pace," she said.[44] Members learned the movement and dances with greater ease, since so many patterns (*kata*) were recycled from previous plays that they had already mastered. More challenging was memorizing the dialogue. Looking back a half-a-century later, Masuyo recalled that learning the part of Princess Taema (*Narukami*) was the most difficult. "I still associate the number 104 with that play," she said. "I had to learn 104 lines, and I remember learning it as quite an ordeal."[45] For Baika, the role of Otoku in *Matahei the Stutterer* caused her the most trouble, because she had to speak

both for herself and her speech-impaired husband.[46] There was no preferred method for learning lines. Time, though, was scarce, and private time was even rarer. "It's not a nice thing to say," Baika recalled, "but I would sometimes resort to learning my lines in the toilet."[47] Sanpuku shared that her worst experience was her last-minute substitution for a sick member. With no time to learn her lines, she hid them onstage, only for a *kōken* (actor assistant) to mistakenly take them away. "I was in a cold sweat, trying to remember what to say," she said. "I'm sure the audience had no idea what I was saying."[48] With more experience, the actresses grew increasingly confident with the dialogue, but, as discussed in chapter 6, their strong accents continued to plague them.

With limited time for rehearsals, the girls quickly learned the necessity of honing their skills during actual performances. Baika recalled:

> For our productions lasting one month at big theatres, our schedule would be as follows: on day one, we would arrive at the theatre and make the appropriate introductions, on the second day we would have a dress rehearsal, and on the third day we would open. The last day would be the twenty-third. For the remaining part of the week, we would travel to our next destination and repeat the schedule. When we were on tour, there would be times when we would perform for just one day. So though one might speak of a "national tour," all we knew was the station, theatre, and inn; we never toured the sights. If we had any free time, we tried to get a little bit of sleep.[49]

Sleep, though, had to be deferred until after Masujūrō's infamous critique sessions, which he explained as follows:

> I would take notes on every performance, so after we returned to our inn, I would give criticism, telling each and every one of them what they had done wrong that day. "Here's how you screwed up," I would say. That would take about an hour. Think about it, if you have a twenty-five-day run, that gives you twenty-five times to improve. And within a year's time, I guess, I really began to see improvement. So this became our custom.[50]

On the whole, the girls appear to have welcomed these sessions. The writer Kōsei reported attending one of the critique sessions that had focused on Act VI of *The Treasury of Loyal Retainers* in which Kanpei commits suicide after being wrongly accused of murdering his father-in-law. According to Kōsei Masujūrō gave the actresses playing Okaru and Kanpei a list of mistakes they had made before he noticed that one of the girls who had played a hunter was sobbing. "Masujūrō thought the girl might have developed a stomach ache, but, when he asked, she shook her head, replying, 'Master,

you gave Kanpei and Okaru seven or eight points on which they needed to work, but you only gave me two,'" Kōsei wrote, adding, "one can only smile at this situation."[51] When questioned by Kōsei, Masujūrō said he attempted to treat the leads and the bit players equally in order to mitigate any friction or crying fits.

THE GREEN BAMBOO POLE MASTER

Kōsei's tender impression of Masujūrō fails to resonate with how most of the actresses viewed him. In their eyes, he was all-powerful, intimidating, and demanding. As Baika recalled, "He was very strict. He was the son of a farmer. Very strict."[52] Even Sumihachi, his wife during this period, told *Engekikai*, "I cannot tell you how many times I've cried under the whip of my husband."[53] Likewise, his daughter, Emiko, admitted that she was scared of him and was afraid to make mistakes. "If I knew I had made mistakes, I would avoid him and not return to his room until I was certain that he had forgotten about it."[54] Kōsei's image of a concerned master asking a girl about her queasy stomach does not jibe with their descriptions. Although the actresses and many outsiders agreed that Masujūrō wanted nothing less than to make the girls into excellent performers, his means were draconian at times. Nothing frightened the actresses more than when he used "green bamboo poles." Ichikawa Baika recounted, "When rehearsals first began, our master would prepare three bamboo sticks.... Masujūrō would fling the bamboo pole at us. We were scared of that whipping sound, but if we cried in front of that teacher, he would scold us twice as much. And this would go on day after day. But I never thought of quitting."[55] Just about every member interviewed admitted that she was intimidated by Masujūrō, who quickly earned the nickname, the "green-bamboo master." Masujūrō avoided any discussion of this disciplinary tactic in his autobiography, but acknowledged later that he used bamboo poles at practice and on tours, in order to keep the girls in line (not that there were reports of anyone misbehaving). Years later, at the Sakuragaoka Museum symposium, he defended his actions:

It's often written that I've been called the green-bamboo master, and that I hit the girls hard with a green bamboo pole, but that is not the case. If I hit them with a bamboo pole, they'd die, so that's just not true. As everyone knows, if you scream at someone in a loud voice, you surprise them. So, in order to surprise the children, I would hold a bamboo pole and scream in an angry voice,

"What are you doing," and I would hit the ground with the pole. Things that they might have learned by doing them ten times, they learned in two.[56]

Masujūrō had great ambitions for his protégées. He expected nothing less than perfection. The end justified the means if it resulted in a superior result. "Art is not something that you sweetly teach," he was reported to have said, adding, "As far as art is concerned, you have to continue to scold. Everyone, after all, continued to follow me, because several days later, a real performance would take place."[57] Even Baika, who as an adult wrote about Masujūrō's use of the bamboo poles, acknowledged, "If it hadn't been for [those poles] I'm not sure we would have gone so far. Due to the master always stamping with that pole and correcting us, we received such great applause from the audiences, and that is something a child will always remember."[58] Surely compared to the corporal punishment traditionally used to discipline actors in Peking/Bejing Opera (*jingju*), Masujūrō's tactics were mild, but, to the girls, they were harsh.

For some girls, the stress of performing and being critiqued was unbearable. Many dropped through Masujūrō's infamous sieve, never to return to the troupe after being scolded one too many times. Others stayed and suffered quietly. Ichikawa Sanpuku recalled that she once became so distraught that she considered suicide. Despairing that the audience laughed at her whenever she played grandmother-type roles, she asked Masujūrō for advice. His response, indelibly stitched in Sanpuku's memory, was, "They laugh because you're a bad actor. If you did it correctly, they wouldn't laugh."[59] This rebuke made her feel like a failure, but she did not remember whether this led her to contemplate killing herself. She said her suicidal thoughts were prompted by an awful night of performing and some harsh words from Masujūrō. "I was in a slump," she said. "I went backstage [at the Bunraku-za in Osaka] after the performance and started to look at all the ropes to hang myself. But I got scared and ran back to the dressing room where everyone was sleeping."[60] She said she never told anyone in the troupe, but buried her worries by throwing herself into practice. Though none of the other members said they had similar experiences, most of the actresses agreed that psychological stress was an inevitable part of life in the troupe.

Troupe members were expected to approach every task with the utmost professionalism. In his autobiography, Masujūrō expressed his delight that the girls were so well behaved. Recalling their exemplary conduct during their first outing to a kabuki production at Misono-za in Nagoya, he

mused, "It was not I who had raised the troupe. Art had raised it."[61] He further suggested that a rigorous training regimen had instilled a strong sense of responsibility in each performer. The actresses always had been expected to follow the rules of the troupe, but these regulations became stricter as they aged. Justifying his authoritarian policies, Masujūrō explained:

> One of the most difficult things was traveling with the girls during their transition from adolescence to womanhood. They were a troupe of some twenty-five or twenty-six girls. When they were in elementary school, it was like going on a school trip, but when they grew up and began turning seventeen and eighteen, they started to become these attractive women, and suddenly we'd be taking the train somewhere and suddenly young men would start teasing them.[62]

In an attempt to take control of the situation, Masujūrō instituted a curfew and forbade the girls to go on solo dates and to speak to men backstage, including the crew, musicians, and office staff. The leading actresses were permitted to go out only in groups of four or more. In Masujūrō's defense, members have noted that he felt "responsible" for their safety, since parents had entrusted their daughters to him.[63] The policy, however, created an awkward environment in which Masujūrō was the only man with whom they had regular contact—a situation that would lead to a host of problems.

Most members accepted the rules, but a handful rebelled by sneaking out late at night after Masujūrō had made his rounds of the rooms to ensure that everyone was safely in bed. Baishō, who admittedly loved to outsmart Masujūrō, said she often fooled him by putting small props in her futon to make it look like she was sound asleep.[64] Baika, however, said she was not as lucky. On the one time that she says she sneaked out, she got caught. The troupe had been staying in Kyoto in the Minami-za's third-floor dressing rooms, which were only accessible by an elevator that stopped running at 10 p.m. Baika says she and the unnamed other members had gone bowling with some *maiko* (geisha apprentice) friends. They had used a ladder to climb out of the dressing room window and had planned to use the same ladder to get back inside. But on their way back up, Masujūrō spotted them and gave them a terrible scolding.[65]

On a different occasion, when Masujūrō learned that one of the members had poured a cup of *sake* for the film star Tsukikata Ryūnosuke in Kyoto, he reportedly was so upset he "changed colors." As recounted by Kurokawa, Masujūrō lined up all the girls when they returned to the Minami-za and screamed, "I recall teaching you how to act, not how to pour *sake*. Step

forward if you poured *sake!*" No one confessed, so Misuji, as the troupe leader, came forward and took the blame, receiving, in turn, a slap across her face. According to Kurokawa, it was the only time such a public scolding occurred.[66] Here a contrast can be drawn between Masujūrō and the founder of Takarazuka, Kobayashi Ichizō. As Jennifer Robertson suggests, Kobayashi "envisioned his Takarazuka as an appropriate site for the resocialization of (bourgeois) girls and women whose unconventional aspirations had led them to the Revue stage in the first place."[67] He was not interested merely in having his Takarasiennes perform in front of an audience, he wanted to prepare them for a future life off the stage as conventional mothers and wives. In playing the part of the *otokoyaku* (male roles), the actresses could learn "to understand and appreciate males and the masculine psyche," which would therefore make them "better able to perform as Good Wives, Wise Mothers, knowing exactly what their husbands expected of them."[68] Masujūrō's public behavior, however, indicated that he was not keen on teaching the girls how to service their future husbands. Though he had told the Hamamatsu-za management early on that he wanted to lead the troupe until members married, he did everything in his power to delay this eventuality, at least on the surface. "The troupe was never seen as a finishing school for marriage," Baika explained, noting that although she played exclusively female roles, she never was pressured to learn domestic skills such as cooking or sewing. (During our interview, she joked that she is still a lousy cook, but that Fukushō, who excelled at male roles, is a phenomenal chef.) She remembered that Masujūrō, after the *sake* incident, repeatedly drilled them to not think of themselves as geisha. "He didn't want us to think about being a woman. We should be performers. Masujūrō absolutely hated it when thoughts would turn to marriage and other womanly things," she added.[69] Teaching members to be a good wife and wise mother, an expression that refers to the nation's educational policy in the 1890s, was not on Masujūrō's agenda.

To the press, Masujūrō appeared to be considerably less concerned about the prospect of the actresses becoming girlfriends, wives, and mothers. The *Mainichi gurafu* devoted most of its 1955 article on the troupe to the following exchange:

One girl comes running into Masujūrō's dressing room all made up.
"Master, I received this letter."
[Masujūrō:] "It's a letter from a man. Do you know this person?"
[Troupe Member]: "No, not at all."

[Masujūrō:] "Well, go ahead and read it."
So the girl breaks the seal, and just like Benkei (from *The Subscription List*), she earnestly opens the letter. [The letter reads]:
" ... I love XX-san [name of troupe member]. You are like a dream that I cannot forget. Please, won't you become my friend?"
The girl's face does not change colors as she reads, and the master says he's heard enough.
[Masujūrō:] "Enough. Enough. Isn't it fine for you to become friends with him? If you become friends with him, he'll become a patron of the troupe."
The girl exits relieved.
To this Masujūrō says, "Every now and again, we get this type of fan letter. And all the kids bring the letters to me. It's not that I tell them what to do about it But to tell you the truth, I don't have any worries about them. If you want to call them innocent, call them innocent. If you want to say that it's old fashioned, call it old fashioned. The girls here are not particularly trendy. All the girls are really diligent."[70]

Once again, Masujūrō's public image does not resonate with the one described by the actresses some fifty years after the incident in question. Though it has been their longtime "secret," several women, when questioned, spoke of Masujūrō initiating and having sexual relations with troupe members.[71] Ichikawa Baishō remarked, "It is the shame of our troupe. Everyone [in the troupe] knows about it, but there is a tacit rule not to discuss it."[72] Journalist Kurokawa Mitsuhiro said he became aware of such allegations against Masujūrō when he was writing his newspaper series on the troupe in 1984, but decided not to print anything because of the delicate nature of the situation.[73] It is not surprising that Masujūrō, who died in 1998, never discussed this matter, though he did make a point of stating that he "always liked girls," when asked why he did not start an all-boys' kabuki troupe.[74] Furthermore, Kurokawa revealed that Masujūrō told him that "he loved gambling and women," and during the successful years of the troupe, he was "blessed with money and women."[75]
Various reasons were given for the girls' compliance with his sexual requests—competition for the best parts, the troupe's intimate atmosphere, their undivided loyalty to him. As Kurokawa remarked, "Masujūrō was the king."[76] Indeed, it is difficult to gauge whether there was resistance to Masujūrō's sexual advances, or whether it was just seen as "a normal

part" of life in an all-female troupe, troubling as that is to imagine in an age when such actions instantly would be labeled sexual harassment. From interviews with troupe members, it does not appear that anyone saw this behavior in such stark terms; no one used words such as rape, harassment, or even exploitation. Kobotan said she told her mother, who was "angry" because she believed the girls getting the best parts were those having sex with the master.[77] Although Kobotan said she did not have sexual relations with Masujūrō, she said that she believed that sex with the leader was an inevitable part of troupe life. To further complicate the situation, such flesh-relations were not always viewed as unrequited. Masujūrō's daughter, Emiko, said she was of elementary school age when it became clear to her that her father was having sex with troupe members, whom she believed were willing and eager partners. "Some were called [by Masujūrō] and some were not," she said implying that those who were not picked as consorts were envious. As the daughter of the troupe leader, she said, "I absolutely hated it. I hated what was going on." Confronting her father was out of the question: "He absolutely would not allow it."[78]

While some members overlooked Masujūrō's philandering, others were more visibly annoyed. Kobeni recalls him flirting with one member offstage, but was more irked by the two occasions he barged in on the naked girls while they were bathing. "He would open the door and scream at us, 'What do you think you're doing!'"[79] No one felt comfortable tipping the balance of power and asking him what he thought he was doing.

In time, Masujūrō's relations with members took its toll on the troupe. His wife Sumihachi left, and lower-ranked members began to drop out. Just how many quit because of Masujūrō's behavior is unknown. For Kobeni, it was not a difficult choice. "When I told my parents about this, they insisted that I leave, saying that they had put their trust in this troupe, and that type of behavior was unacceptable," she recalled.[80] Kobeni quit after the March 1956 engagement at Naka-za in Osaka, which probably means that Masujūrō had begun having sex with members by then. The situation remained unchanged by the early 1960s, when Onoe Umeno made two guest appearances with the troupe. She remembered: "I was told by some members who had just come back from a rural tour what had happened. You know how on tour, everyone stays in the same room in the inn, and some of the girls were talking about how in the very same room, Masujūrō and [...] were doing it.... I had absolutely no interest in being part of that kind of troupe."[81] Masujūrō's behavior never impaired the troupe's collective ability to perform, but his actions exacerbated tensions among all actresses, regardless of their rank.

New and old members sensed that all was not well with the troupe's power dynamic, but there was no recourse other than to drop out. Many simply said that their first priority was the stage and to tattle on Masujūrō would jeopardize their career. If the press had any inkling of such illicit affairs, it kept mum. Writing in 1956 on how the troupe had changed since he first saw it perform at the Hamamatsu-za in 1952, a rather nostalgic Toshikura Yoshikazu, the editor of *Engekikai*, reported:

> Four years ago, I ate at the same table as Misuji, Fukushō, Baika, and Masuyo. When asked what they would like, they all ordered curry rice. They wore the type of all-white midi blouses worn by junior high students. I will never forget how cute they were, filling their cups with water and eating curry rice. Later when I met them in the hallway of the Kabuki-za—it was only my third time—I felt that their sense of frankness hadn't changed a bit. There's no way that the girls who have improved so much are still the same, but I feel that it was like yesterday that I saw the girls eating their curry rice. This girlishness is, in actuality, the key behind the charm of Ichikawa Girls' Kabuki.[82]

The sweet *shōjo* of yesteryear were still entertaining their admirers of today. The girls might have grown taller and acquired more aplomb, but they were still little girls, Toshikura assured his readers. In fact, the girls were such talented performers that their acting extended to real life, where they fooled the press, their fans, and, often, their families about their life off the stage. They might have looked cute and naïve, but they were much wiser in their years, whether or not they had been Masujūrō's sexual partners.

Looking back, the actresses would agree that Masujūrō's philandering was one of the reasons for the troupe's demise several years later. Had he not played favorites and broken the trust of so many of the girls, it is possible that Ichikawa Girls' Kabuki would have stayed afloat. But a host of other unrelated issues also contributed to the troupe's downfall. As we will see in chapter 8, the girls were not only victims of Masujūrō's warped sense of power and control, but of the historical circumstances, due to the change-over of the Naritaya house leadership.

8. Power Struggle ❧

On 1 February 1956, Ichikawa Sanshō V died. The tragic news reached the troupe by telegram that afternoon in Kyoto at the Minami-za where it had just begun a nineteen-day run. Over the past six months, the troupe had played at grand theatres, including the Naka-za, the Meiji-za, the Misono-za, toured the eastern part of the country, and performed at its home base, the Hamamatsu-za. Its popularity was soaring, and that very morning the girls had received a bouquet of flowers from *maiko* fans.[1] With Sanshō's death, however, the troupe suddenly found itself mourning the loss of its dearest patron and pondering its future.

Still, Sanshō's death was not unexpected. A letter dated 2 December 1955 from Sanshō to Masujūrō was followed by a postscript from a third-party, who identified herself as "Yoneko." She warned that her "uncle's" health was poor, and that if Masujūrō was planning to visit, he needed to do so quickly.[2] From his deathbed, Sanshō took time to write New Year's greeting cards and to compose a haiku in memory of a member of Ichikawa Girls' Kabuki who had died recently. Taking no chances, however, the troupe visited him in mid-January. They braced themselves for the worst.[3]

Now, three weeks later, after the final piece of the day, troupe members gathered on the stage around Masujūrō, who announced Sanshō's death, after which the actresses and the audience took a moment for silent prayer. "All of us were sobbing on stage," Ichikawa Emiko remembered.[4] That evening, Masujūrō departed for Odawara, where Sanshō's body was cremated, and, later in the week, he attended the funeral in Tokyo. The girls stayed in Kyoto; even with the death of the Naritaya head, the show would go on.

Sanshō's ashes were interred in the Aoyama Cemetery in Tokyo, adjacent to Danjūrō IX's grave. Though Sanshō's grave marker was dwarfed by the tomb of his father-in-law, his funeral was a grand affair, befitting the head of the esteemed Naritaya house. More than 1,000 people attended, and the ceremony, in a mark of continuity, was performed according to Shintō rites that had been observed at Danjūrō IX's funeral, not the conventional

Buddhist ones. Shōchiku president Ōtani Takejirō delivered the main eulogy. His remarks focused on what he believed were Sanshō's two major contributions: his work reviving several of the Naritaya house's "eighteen favorites" and his leadership of the all-female troupe. In an unprecedented move, Sanshō, at the urging of his successor, Ichikawa Ebizo IX, was posthumously named Ichikawa Danjūrō X.

It had been an open secret that Sanshō would be succeeded by Ebizō IX, the eldest son of Matsumoto Kōshirō VII (1870–1949), who had been an apprentice of Ichikawa Danjūrō IX. Indeed, largely due to this connection, Ebizō had been adopted in 1940 by Sanshō, who had no children of his own. Though Ebizō had never excelled as a child actor, he flourished in the postwar theatre world, playing starring roles such as Genji in the new kabuki adaptation *The Tale of Genji*, a part that earned him endearing cries of "Ebi-sama" (Sir Ebi) by female fans. It was rumored that Ebizō would marry Sanshō's niece, Ichikawa Kōbai (later, Suisen III), the only living descendent of Danjūrō IX (his grandniece) in order to produce a biological heir to the Danjūrō line, but this failed to transpire. Suisen III remained single until her death in 1978, contributing to yet another break in the bloodline of the Naritaya house.[5]

Before he died, Sanshō had instructed Ebizō to continue to teach and support Ichikawa Girls' Kabuki. Even Ichikawa Baika recalls Sanshō saying, "Haruo" (he called Ebizō by his private name), "you have got to look after this troupe."[6] The actresses had trained with Ebizō on several occasions while Sanshō was still alive, but, as far as Masujūrō was concerned, the troupe's future was now at risk. Recounting his personal connection to the Naritaya head, Masujūrō wrote, "Since I had such a deep relationship with Sanshō, his death for us meant that uncertain days were ahead."[7] Masujūrō's distress was not entirely unfounded; shortly after the funeral, he received the following letter from Yoneko:

> Thanks for coming so soon after the death of my uncle. The ten-day memorial service has ended, so I am getting back to myself. I did not know where to write to you, so I sent the letter to the Hamamatsu-za.
>
> Uncle Sanshō hoped that Ichikawa Girls' Kabuki would continue to prosper. If you are going to continue [to lead] Ichikawa Girls' Kabuki, I think it is best that you, Masujūrō, either go by yourself or, if possible, take the four lead performers, but do pay a call on Ebizō. I think you should ask the new head [Ebizō] for his teaching. Ebizō will not tell you to come, so I am playing the role of the intermediary and suggesting that you do this. Last week, this was a topic of conversation, so I am relaying this to you. If you do not pay your respects to him, he will not be pleased. So I am worried.

Haruo intends to take over all the work that Sanshō was doing for the troupe. I will assist in any way, and I will put in a good word for you. Please write to me about your intentions. I'm waiting for your reply.

If you like, I will go with you to Haruo's. Just let me know the date and time. Are the children and everyone well?[8]

Though Yoneko was sincere, if not kindly reassuring, regarding the role that Ebizō had promised to play as the troupe's new Naritaya sponsor, it is conceivable that Masujūrō would have felt uneasy hearing something akin to the king does not call upon his subjects, his subjects must call upon him. Clearly, Masujūrō needed to be the one to reach out to Ebizō, which, for whatever reasons, he had not yet done. Reading between the lines, Masujūrō sensed danger.

But, as if he had read his mind, Ebizō sent Masujūrō a handwritten letter, dated 23 February, six days later. In the politest language, he thanked Masujūrō for everything he had done to support "his father" [Sanshō] and promised to guide the troupe in the same manner.[9] It is unknown how Masujūrō responded to this letter, but just a few days later, Ebizō wrote yet again to Masujūrō requesting a complete list of the names and ages of all the actresses.[10] Despite the loss of Sanshō, it appeared that Masujūrō's fears were premature; the troupe still would be supported by the Naritaya house.

At first, all proceeded seamlessly. The troupe continued to perform in the grand venues to which it had become accustomed and maintained an exhausting touring schedule. The troupe performed in March at the Naka-za in Osaka; in May at Tōyoko Hall in Tokyo; in July in Tōhoku and Hokkaido; in August at Shinbun Hall in Kobe and the Misono-za in Nagoya; in September at the Minami-za; in October in Kyushu; in November back at Tōyoko Hall; and in December again at the Misono-za. Each engagement was several weeks long. Critic Tomita Yasuhiko (*Ōsaka*) wrote that there had been "an explosion of young women spectators" at the troupe's Osaka program and the *Asahi* reported that in Tokyo, its performances were at least 70 percent full and often sold out.[11] Regarding the Tōhoku/Hokkaido tour, the *Asahi gurafu* reported, "The troupe will visit twenty-two cities over twenty-nine days, performing twice a day, in the morning and evening, for a total of fifty-four times."[12] All told, the troupe played at a whopping seventy venues in 1956, its busiest year yet.

For the troupe's first Tokyo engagement after the death of Sanshō, Ebizō penned a special program greeting in which he formally announced his new role as the troupe's leader. To be sure, his greeting did not include a special haiku as Sanshō's invariably had, but that did not indicate that Ebizō

was any less committed to the troupe. Rather, he saw his main mission to continue to teach members; when the girls performed new work, they could count on Ebizō for instruction, though, like Sanshō, he occasionally requested the assistance of other actors (see figure 8.1).[13] Troupe members also learned firsthand that Ebizō could joke around backstage, but, on stage, he was serious and focused. "He was absolutely punctual, never late. He was always seated five minutes before rehearsals began," Ichikawa Baishō recalled. Kobotan further recalled that Ebizō was a strict teacher. "If we zoned out for a second, he would get angry."[14] Several members also remembered Ebizō to be quite severe concerning their theatregoing; while Sanshō had allowed and even encouraged the girls to attend Shōchiku productions free of charge, Ebizō reversed this policy. He reasoned that since the actresses were paid a salary, they should use their own money to pay for seats, just like everyone else. "When he learned that we were getting into the

Figure 8.1 Ichikawa Ebizō IX (later Danjūrō XI) with Ichikawa Masujūrō, Ichikawa Masuyo, Ichikawa Emiko, Ichikawa Baika, Ichikawa Fukushō, Ichikawa Misuji, and other members of Ichikawa Girls' Kabuki. Courtesy Sakuragaoka Museum, Toyokawa, Japan.

theatre for free, he revoked our privileges, telling us that if we didn't pay, we wouldn't be attentive," Baika recalled.[15] Apparently the new policy did not dampen the girls' appetites to see grand kabuki, though they now walked up four flights of stairs to sit in the cheapest seats.

Most memorably, Ebizō personally coached the actresses in *Ghost Stories at Yotsuya* for its Minami-za engagement in September 1956. He spent two days with the troupe before the production opened and stayed through the first day.[16] The October 1956 issue of *Makuai* printed several photographs of him speaking to the girls at the theatre. One shows him wearing a dark kimono, seated in the auditorium with the Minami-za president and a fan of the troupe, beaming at Fukushō. Another depicts him speaking to Baika, Baishō, and Misuji on the set of *Ghost Stories*; the third shows him dressed in a dapper white suit, standing in front of the stage and directing Misuji and Baishō.[17] His commitment to the troupe elicited praise, as the *Kyōto* attributed the performers' "lack of mistakes" to the new Naritaya head.[18]

Ebizō monitored the troupe's repertory and made casting recommendations. He saw tremendous potential, for example, in Kobotan, advising that she play Yuranosuke in the "Ichiriki Teahouse" scene (Act VII) of *The Treasury of Loyal Retainers* in November at Tōyoko Hall.[19] Furthermore, *Engekikai* commented that although Misuji, Fukushō, Baika, and Masuyo had been the troupe's top stars, actors from the second tier such as Kobotan and Baishō were starting to "push them out," a prediction that would come to naught.[20] Meanwhile, critic Miyake Shūtarō revealed that Ebizō had told him "how enthusiastic he was about teaching the girls"; he further commended the troupe's stellar improvement of *The Subscription List*, which he credited to Ebizō's guidance.[21]

But there was a downside to Ebizō's superstar teaching: he had difficulty making time for the troupe. This could only be expected. Unlike Sanshō, Ebizō was in the prime of his career, and there was mounting pressure on him to assume the Danjūrō name. His obligations were numerous. He was busy with his own rigorous production schedule, as well as with training his teenage son, the future Danjūrō XII.

RECONSIDERING THE REPERTORY

Meanwhile, the troupe came under fire for trying too hard to broaden its repertory. For its early years it had focused on performing the *denden-mono*, kabuki plays adapted from *bunraku*, since these pieces are usually the easiest to learn. The girls had concentrated on learning kabuki movement; only later did they incorporate dialogue and investigate the psychological

aspects of character. In response to criticism, the troupe had added to its repertory *shin* (new) kabuki plays that lacked preordained patterns (*kata*) as well as dances, thanks, in part, to its training with the renowned *nihon buyō* instructor, Fujima Fujiko.

Yet now members faced backlash that they had overstretched themselves. The *Makuai* critic warned that the troupe was "in danger of being a jack of all trades and master of none."[22] He explained that the troupe had become popular performing *denden-mono* such as *Treasury of Loyal Retainers*, "Village School," "Moritsuna," *Tsubosaka*, and *Gappō*. Since this was undoubtedly the troupe's strength, why did it need to venture into uncharted land where there were no preordained patterns at its disposal? "In kabuki," he advised, "the same pieces appear over and over again. Instead of reaching broad and shallow, study the narrow and deep adaptations of puppet plays. This is the road on which Girls' Kabuki will excel."[23]

To some extent, the troupe followed such suggestions. The obscure dance pieces were cut, and over the next year its program emphasized the *denden-mono* on which it had built its reputation, and, for a while at least, it performed fewer *shin*-kabuki plays. The decision to return to these seemingly "easier-to-learn" staples might have been motivated in part by the addition of several new performers, which brought the troupe's roster to twenty-nine members for the August 1957 Hamamatsu-za engagement.

The troupe's performance schedule in 1957 surpassed that of 1956, as it toured almost nonstop for twelve months. Vacations were scarce; between the Osaka and Nagoya productions in July, the troupe had a one-day break, which they spent in transit. Furthermore, during the June and July performances, the troupe took the opportunity to make a celebratory announcement (*kōjō*) from the stage in honor of its eight-year anniversary. When the troupe performed in Tokyo in November, Shōchiku President Ōtani Takejirō personally congratulated the troupe on its achievements, and Andō Tsuruo of the *Yomiuri* called attention to the dazzling lineup of pieces (*Tied to a Pole, Munechika: The Little Swordsmith, Maiden at Dōjō Temple*, "Numazu" [place name], and *Benten the Thief*), exclaiming, "This is something that could not be done by the ranks of junior male kabuki actors (*wakate kabuki*)," yet another golden endorsement.[24]

The troupe's full-length *Treasury of Loyal Retainers* at the Misono-za in December 1957 capped off the stellar year. Mirroring the grand kabuki custom, the production showcased the troupe's stars in a number of different roles. Fukushō had returned to playing Ōboshi Yuranosuke (she also played the villainous Kō no Moronao and Ono Sadakurō); Misuji rotated between Wakanosuke, Kanpei, and Honzō; Baika played Enya Hangan,

Okaru's mother, and Tonase; while Masuyo took the roles of Kaoyo and Okaru. Second-division members performed important roles as well: Sanpuku played the comical Bannai, Himeshō played Konami, Baishō played Honzō (when Misuji was playing other roles), and Suzume played Rikiya. Kobotan played Ono Kudayū, which was surely a comedown after playing Yuranosuke the previous year.

If there was one thorn in the company's side, it was the open letter to Misuji by Kusakabe Chitomeko, published in *Engekikai* in December 1957. Although the letter began in a complimentary fashion, Kusakabe told her in so many words that her acting was still amateurish. Trying to take the sting out of her comments, Kusakabe suggested that such a scolding inevitably comes too late, and therefore she was taking the liberty of warning Misuji while it was still early enough to correct any lingering problems.[25]

Despite this criticism, *Engekikai* published several flattering fan letters in the very same issue.[26] Questions included how the troupe had transitioned from a dance (*nihon buyō*) club to a kabuki troupe; where the troupe performed when it was not in Tokyo; what members thought of current fashion; and how they coped with being so far away from their respective families. Responses were penned (or at least signed) by Baika, Fukushō, Misuji, and Masuyo, whose candid photos accompanied their remarks.[27] From this exchange, readers also learned that the troupe had opened an office in Tokyo near Ueno Park, and that, on occasion, even members of Ichikawa Girls' Kabuki wore Western-style clothes: Masuyo always dressed in feminine attire or kimono, while her older sister, Misuji, "wears slacks," and "when she wears kimono it is in the male style." Not unlike Tokugawa-period *onnagata*, Misuji took to dressing her part onstage and off.

What none of the members admitted to knowing was that the troupe's foundation was beginning to erode. Little did they realize that the Hamamatsu-za management was reconsidering the direction of the troupe. There was no apparent change in the troupe's performance record; sales continued to be strong, and reviews, on the whole, were positive. But by the beginning of 1958, the management informed Masujūrō that the troupe needed to expand its repertory to include works that were not necessarily considered kabuki.[28]

The question of repertory and genre had surfaced earlier in 1957 when several troupe members appeared in the feature film *Rival Performances: The Transformation of Yukinojō* (*Kyōen Yukinojō henge*). The lavish historical drama starred the actress-idol Misora Hibari, who, at twenty, was roughly the same age as the leading performers of Ichikawa Girls' Kabuki (see figure 8.2).[29]

Figure 8.2 Ichikawa Misuji (left) and Misora Hibari (right) pose on the set of *Rival Performances: The Transformation of Yukinojō* (Tōei, 1957). Courtesy Sakuragaoka Museum, Toyokawa, Japan.

A revenge melodrama based on a novel serialized in the *Asahi* in 1931, the film revolves around the story of a fictitious Tokugawa-period *onnagata*, Nakamura Yukinojō. Invoking the kabuki convention of *yatsushi* (concealed identity), Yukinojō is actually a woman disguised as a male *onnagata* actor. Twelve years earlier, as a young girl, she—then named Yuki—had witnessed her mother's murder and the demise of her father's business and his subsequent death. As a result, she vows to take revenge on the individuals responsible. She is adopted by a kabuki actor, Nakamura Kikunojō, who, while coaching her to become a star *onnagata*, teaches her the art of sword fighting so that she can defend herself against her enemies offstage. The film was a remake of *Yukinojō henge*, released in 1935–1936, which starred the twenty-seven-year-old Hasegawa Kazuo (1908–1984), who played both Yukinojō and Yamitarō, Yukinojō's sidekick and self-appointed bodyguard. Misora Hibari's version went one step further; typical of her transformative style, she played both characters, plus that of Yukinojō's mother, Oen.[30]

Members of the Ichikawa Girls' Kabuki Troupe played supporting roles as kabuki actors in the scenes set in the re-created Nakamura-za, one of the

three licensed grand theatres (*sanza*) in Edo. Misuji had the largest of these cameo roles, as she played Kanpei opposite Hibari's Okaru in the *michiyuki* dance sequence of *Treasury of Loyal Retainers.* Fukushō, Suzume, Baishō, Himeshō, and Sanpuku also appeared onstage as kabuki characters in other brief excerpts, including one from the famous extortion scene of *Benten the Thief.* Since the film was a vehicle to showcase Hibari's versatility, she played the leading role of Benten Kozō. With the exception of Himeshō, all the troupe members who appeared in the film played male characters, which helps to explain why the troupe's leading *onnagata*, Baika and Masuyo, were not featured. Although all the roles played by the girls were small, the film offers one of the best extant performance documents of the troupe.

The film plays with gender norms. It is set during the Tokugawa period when only men would have been permitted to perform at the grand Nakamura-za. To complicate the situation, Misora, a woman, plays the role of a woman (Yukinojō), who plays a male kabuki actor, who performs as an *onnagata*. Reference is made to her constant gender-bending, as hordes of women become attracted to "him," thinking that she is a man who has an uncanny ability to pass as a woman both off- and onstage. Yukinojō's acting is so convincing, in fact, that her enemy's daughter falls hopelessly in love with her and dies convinced that she is a man. Likewise, the role of Benten Kozō requires Misora to shift between masculine and feminine genders, while for the roles of Yamitarō and Oen, she plays a straight male and female, respectively.

Notwithstanding the glamour of appearing with the pop-star on celluloid, members of Ichikawa Girls' Kabuki shrugged off the moment. In response to a fan letter, Baika stated that her fellow members never had any desire to perform in films, and that the troupe planned to continue to perform theatre. She emphasized that Hibari's agents had invited the troupe to appear in the film, partly, she disclosed, thanks to the long-standing relationship between Hibari's producers and the Hamamatsu-za. "As stage performers, we inhabit a totally different world from Misora Hibari who until now has worked in film . . . and among my acquaintances it seems that no one is a fan of Hibari," she stated. As if to separate herself one step further from any dealings with the movie industry and Misora Hibari, she noted that she herself "was frankly indifferent to the film."[31]

But the troupe's cameo appearance in *Rival Performances* was precisely the type of direction and publicity sought by the Hamamatsu-za management. When the well-known producer and playwright Kikuta Kazuo (1908–1973) inquired about the troupe performing a staged version of Takeuchi Tsunauchi's (1922–1987) hit *manga* cartoon *The Red-Barreled*

Suzunosuke (*Akadō Suzunosuke*), the Hamamatsu-za management was delighted. Kikuta and Kaneko Seiji of the Hamamatsu-za, in fact, went ahead and made arrangements for the troupe to perform at the Koma Gekijō in Tokyo. Moreover, the Hamamatsu-za proposed holding a joint performance—possibly performances—with the Shōchiku Revue.[32] The plan would move forward pending Master Ebizō's approval.

GROWING PAINS

Meanwhile, the troupe was under pressure to change its name. As discussed in previous chapters, the term *shōjo* most commonly refers to adolescent girls; in Japan, when a girl or boy turns twenty, she or he officially becomes an adult (*seijin*), which is commemorated with a special "coming of age day" annually held on 15 January. While the term "*shōjo*" could be stretched to include youthful-looking women, it had become apparent that the troupe's stars could no longer deny that they were growing up, and that the troupe's spectators, in turn, were finding it more difficult to accept these young women as adolescent girls. Fukushō, the eldest member, turned twenty-one in February 1957, and Misuji, Baika, and Kobotan followed later in the year. Masujūrō relented on the question of members over twenty wearing makeup, and, as mentioned earlier, Fukushō and Himeshō underwent plastic surgery in order to enhance their noses.[33] The leading girls were no longer girls.

Ever since the star members turned twenty, the media had begun to inquire directly about their respective plans for courtship and marriage. Or, rather, as *Shūkan Tōkyō* pointed out, it had become a topic of interest ever since "the girls' chests had started to swell."[34] The actresses, however, appeared even more annoyed with these questions than with the pressure to change their troupe's name. "We have no time for falling in love (laugh)," Baika joked, with Misuji adding, "I truly haven't given marriage any thought."[35] Fukushō was even more direct: "When I see those people pushing baby carriages, I'm kind of disgusted." The writer, in turn, surmised that for them "marriage was only a daydream."[36] Still, many of the third-tier members were leaving the troupe, purportedly to marry and start families, so the media continued to press the leads for their plans as well.

While many of the top newspapers that reviewed Ichikawa Girls' Kabuki steered clear of the members' private lives, they could not resist telling the troupe that its name had become dated. In the eyes of critics, any name with the word "girl" was no longer suitable for the maturing troupe. It had become a masquerade. Akiyama of the *Asahi* was the most

vocal critic, proposing, as early as 1956, that the troupe change its name to "Onna (women's) Kabuki." A *Kyōto* critic agreed, noting, "Members of Ichikawa Girls' Kabuki have gotten so much bigger, one cannot really call them *shōjo* anymore." The same year, the *Sandê mainichi* declared that the *shōjo* of Ichikawa Girls' Kabuki "had become adults." The company had, in the words of a *Makuai* critic, "reached a turning point." To be sure, some reviewers, such as Toshikura Yoshikazu of *Engekikai*, voiced frustration with critics who were constantly calling attention to the girls' female sex and name choice. "Can we please try to overlook the *shōjo* and the *onna* part of its name, and just let [the troupe] develop?" he pleaded.[37]

Long before 1956, Masujūrō had been forced to confront the inevitability of the girls growing up, but he took a wait-and-see approach as far as deciding whether to promote new members to the top tier. When asked by Akiyama Yasusaburō (*Asahi*) in 1955 about his plans for the troupe, Masujūrō told him that Sanshō believed that it should stick to being a "girls' kabuki company," in that the current stars should be replaced and given the responsibility of training the new members. However, he was quick to add, "The current stars love to perform, so it looks like we will become a women's theatre (*onna shibai*) troupe after all."[38] In 1956, when asked more directly about how the troupe felt about a name change, Masujūrō responded:

> That will be up to the troupe members—that is essential. It depends on how long they will remain in the troupe, but sooner or later, we will have to change the name. But in [grand] kabuki, there are forty-year-olds who are still considered young, and the oldest one in our troupe is only twenty. But calling a thirty-year-old a *shōjo* is really strange. Even when one turns twenty-four or twenty-five, she might feel rather embarrassed [about the name], so this would be a problem down the line some four or five years from now. The troupe members also do not see this problem as particularly urgent.[39]

Instead of offering his own personal opinion, Masujūrō skirted the issue by deferring to the supposed views of troupe members. Only much later, in 1995, did he frankly address why he had not replaced the top members with new recruits:

> We already had a firm foundation of nine top actors, and it was unusual for [the good] parts to circulate to the others. Just because one is given a role doesn't mean that she can do it well. So there were many who didn't like this policy and quit. [Painter] Itō Shinsui was a great fan of Girls' Kabuki, and he once warned me, "If you want to keep the troupe going in the future, you need to rotate the top performers to the rank of teachers and train new girls to take the lead roles. If you don't do that, Girls' Kabuki will disappear;

[rotate the players] in the same way that Takarazuka does." At the time, even though I agreed, I didn't have a response. The reason is that it had taken so many years for the top players to reach that point. Audiences came to see us perform because of those players. It was not so easy to replace these people. Maybe easy in other genres, but not kabuki. Now that I think back, perhaps Itō was wiser. If we had done that at the time, perhaps we would have lasted longer. But, after all, it would not be easy all of a sudden to tell a child who had worked so hard, "You are being transferred to the rank of teacher," that she was no longer needed. Maybe you can tell that to a grandmother at sixty, but you don't tell that to a twenty-year-old. They were at the height of their popularity. But maybe as a result, that is why there are no remains of the troupe.[40]

On the surface, these remarks sound like Masujūrō valued the interests of the top-ranked actresses. It makes sense that he preferred to retain the current members than hire new ones. Under his direct watch, Ichikawa Girls' Kabuki had achieved national recognition, and it would have been natural for him to want to reap the rewards of its success. But it is impossible to evaluate his inaction vis-à-vis reorganizing the troupe without taking into consideration his use of these very same individuals for his alleged sexual gratification. While it is unclear to what extent these relations influenced his decision to maintain the status quo, he was clearly attached to the leading members and did not wish to see them go.

For their part, the top performers defended their desire to remain members and to keep the term *shōjo* in the troupe's name. Fukushō told the *Makuai* critic, "If you look at our ages, I suppose we're not *shōjo* anymore, but though I've been in the troupe for some ten years, we only really became active after the Mitsukoshi Theatre production, so in that way we really still are *shōjo*."[41] Baika chimed in, "The oldest one in our troupe is twenty, but the average age in our troupe is seventeen or eighteen, so we can still keep the name until [the average] becomes twenty."[42] Fukushō also pointed out that if the troupe changed its name to "Onna Kabuki," the expectations would be much higher. Audiences would "come to expect true adult kabuki and that would be frightening," she said, internalizing the opinion that the troupe was inherently different from grand kabuki.[43] When pressed about the idea of replacing the older members with new recruits, in the same way as Takarazuka or SKD, the girls vacillated. *Makuai*'s critic could only conclude that the troupe had begun to do this by recruiting younger members and holding study productions a number of times a year at the Hamamatsu-za, but, as previously discussed, these newer members rarely played leading roles.

By 1957, the troupe's inaction over changing its name had begun to infuriate Akiyama. He wrote stingingly, "The troupe is comprised of twenty-five *shōjo*; there are members who are twenty-two, and one girl who is eleven joined the troupe recently. We tease them that this move is to lower the average age of the troupe. This is the troupe's problem."[44] For him, the troupe needed to take immediate action: either to change its name to "Onna Kabuki" or hire younger members to replace the leading members. The same year *Kyōto shinbun* complained that the "charm and freshness of the *shōjo* had diminished."[45] Even Professor Kawatake Shigetoshi agreed that the "*shōjo*" modifier was no longer appropriate and endorsed "Onna Kabuki" as a new name.[46]

By then, Masujūrō appeared to be contemplating a change, although he might have been humoring the media. Pressed on the matter in July 1957, he responded, "How about taking away the '*shōjo*' and just making it, 'Ichikawa Kabuki'? That's what I'm thinking."[47] The prospect of actually changing the troupe's name appeared to be too heavy a psychological burden; the members had been called "*shōjo*" for the past ten years of their lives and were not ready to discard it for a new name. The actresses could not accept the reality that the troupe's name no longer accurately represented its membership.

The issue remained a matter of concern, but the troupe avoided making any changes until the summer of 1958. The *Shūkan Tōkyō* was the first publication to announce that the troupe's June engagement at the seaside resort of Atami might be "the last chance" to see it perform as the Ichikawa Girls' Kabuki Troupe. The likely new name would be the "Ichikawa (Onna) Women's Kabuki Troupe," the very name that had been proposed by Akiyama Yasusaburō (*Asahi*) some years earlier.[48] By this point, according to Baika, even the Hamamatsu-za had begun advocating a new name.[49] All but confirming the inevitable name change, Executive Director Kaneko Seiji attributed the management's desire to rename the troupe to the demands of theatregoers at the Tokiwa-za in Tokyo's Asakusa district, where the troupe would play next. "Asakusa fans are something else," he stated. "With the name 'Girls' Kabuki,' some audience members might think that it's a children's theatre troupe and laugh—there's the fear that they won't respect the troupe, and so we're doing away with [the term] '*shōjo*' and replacing it with something else. I hope that it will be '*onna*' (women)."[50] By holding Asakusa audiences accountable for the troupe's new name, Kaneko effectively absolved the Hamamatsu-za from taking responsibility for the change, even though this is precisely what the management had wanted.

But in the weeks leading up to this Tokyo engagement, the actresses voiced their reluctance to change the troupe's name. *Shūkan Tōkyō* stated that Baika and Fukushō "won't say anything, but everyone seems to feel that taking away the '*shōjo*' and renaming the troupe 'Onna Kabuki' doesn't quite do it."[51] It quoted Misuji as saying, "Much has been said about our name. . . . We're all still very young, and we had always intended to be *shōjo*, and we'll continue working hard and performing plays."[52] The troupe was attached to its name and did not want to embrace a new one prematurely.

Then, without any regard for what it had just told reporters, the troupe announced that it would become the "Ichikawa Onna Kabuki Company." All programs, materials, and banners for the Tokiwa-za engagement were prepared with the troupe's new name. But then, just as suddenly, the Naritaya head unilaterally decided that the new name was inappropriate. Baika recalled, "The Hamamatsu-za thought that there was value in changing the name, but Ebizō did not want to change our name."[53] In addition to censuring the new name, he ordered any publicity materials bearing the new name recalled and destroyed. As Misuji later stated, "We had three days to re-do everything that stated 'Onna Kabuki'—the banners, the lanterns, the programs, etc. It was as if all hell had broken loose; it caused quite a storm."[54]

The new programs did not leave any trace of the "Onna Kabuki" name, but the *Asahi* did not let the incident rest. As a longtime proponent of a name change, critic Akiyama Yasusaburō did not remain quiet about what he believed was a mistake. He made the naming debacle public, disclosing that Ebizō had ordered the reversion to the old name "at the last minute." "Everyone in the troupe had gotten taller," he wrote, "they looked like 'regular women.' There is nothing strange about calling the performers 'women.'"[55] After years of urging the troupe to change its name, only to see it dispose of his advice at the eleventh hour, Akiyama was clearly disappointed.

The incident provides insight into the degenerating relations between the troupe and Ebizō. Why the head of the Naritaya house waited until the last moment to react to the name change remains unclear. He must have known that the troupe was on the verge of a name change, and he must have been consulted. All that the actresses remember, however, is that he tried to talk Masujūrō out of the troupe performing at the Tokiwa-za, the same theatre that years before had sought to hire the girls for an entr'acte strip show. Misuji recalled, "We were practicing at the Fujiya Inn on the Dōgenzaka slope in Shibuya where we often stayed. Ebizō came to watch the rehearsal, and I remember him saying, 'You don't need to perform at the Tokiwa-za.'"[56] The new Naritaya head probably believed the theatre was too déclassé for a troupe boasting the venerable Ichikawa name.

Ebizō's attitude might have been difficult for Masujūrō to discern because the troupe had progressively less contact with him in the months leading up to this engagement. Writing in the Tōyoko Hall Program in April 1958, Baika commented on his absences, stating, "It is truly a pity that the [Naritaya] head has not been able to see the troupe perform frequently."[57] He had been worried about the troupe spending three months on the road and was relieved to see that everyone was well, she wrote. "Just hearing his voice made the cold diminish instantly."[58] The actresses still looked upon Ebizō as their head leader; for the troupe's April production at Tōyoko Hall, he had penned a note of greeting in the program, reiterating that he was committed to training the troupe that his "deceased father," Sanshō, had raised.[59] Yet, if the channels of communication had been open, the Naritaya head and the troupe would have been able to solve matters amicably in a private, discreet manner.

Ebizō, unfortunately, left no public record as to why he felt so strongly about retaining the name Ichikawa Girls' Kabuki at this point in time. Perhaps he simply saw the performers as *shōjo*, not in age but in skill, or perhaps he still was hoping that the older members would make way for new ones. Or, perhaps he made the decision on behalf of the actresses, who had made it clear that they were not in favor of any name but Ichikawa Girls' Kabuki. It is also highly likely that he was sensitive to the connotations of the term "*onna* kabuki," which conceivably conjured up images of the actress-prostitutes of the early seventeenth century. Whatever the case, his decision was final: the troupe would remain Ichikawa Girls' Kabuki.

The troupe took the head's decision in stride. What part it had in destroying programs and flyers is unclear, but members spent the day before the official opening taking part in the Tokugawa-period custom of arriving at the theatre by boat (*funa norikomi*), sailing from the Tsukiji River to the Sumidagawa River, to the Azuma Bridge in Asakusa. Decked out in their persimmon and black, stiff, sleeveless vests (*kamishimo*) imprinted with the Naritaya *mimasu* crest, and male-style wigs, the actresses waved to onlookers.[60]

Some spectators might have assumed that the actresses took the boat ride as a consolation, but it seems that they agreed with the head's decision. In September 1958, three months later, Misuji wrote that not only was Ebizō opposed to the name, but "all of us members had strong desires, so our name reverted to what it had been." She further stated,

> While it's true that I have passed the legal age, it's not as if I'm really so old. I truly hope that we can continue to bring to the stage our good manners and

our girlish purity that we have always possessed. Although the name "Onna Kabuki" was thrust upon us, I don't believe that we have lost the beauty that we have cultivated up until now.[61]

Yet, she also implied that the troupe could not perform under the name "*shōjo*" forever; the question would be revisited.

A TAXING DILEMMA

Despite Ebizō's disregard for the Tokiwa-za, some critics deemed it the perfect venue. *Engekikai* wrote, "It's been a mystery to me why [the troupe] has not performed in Asakusa up until now, because there is no other troupe that fits Asakusa so well."[62] But save for the troupe's light-hearted dance *Sanbasō*, the reviews of the actual pieces were far from glowing. Critics dealt the harshest blow to the program's *shin*-kabuki piece, *The Downtrodden Chap*.[63] Surprisingly little was said about the troupe's tribute to the Naritaya master: *Danjūrō's Girls*. Adapted and rewritten by Kunieda Kanji (1892–1956) in 1950 for the Nishikawa school of dancers, the piece is set in Asakusa—the very Tokyo neighborhood in which the Tokiwa-za was located—and revolves around "Danjūrō's Girls," who have become smitten with the great kabuki actor.[64] They imitate him playing the amorous hero Sukeroku as well as his nineteenth-century counterpart, the gang leader Banzui Chōbei—quintessential Naritya house roles—and call out, "Japan's Number One Naritaya" (*Nihon ichi no Naritaya*). Though the troupe had planned to perform this piece at the Tokiwa-za long before the naming mishap, it served as additional proof that members wanted to retain their status, quite literally, as "Danjūrō's girls."

In agreeing to retain its name, the troupe hoped that its relationship with Ebizō would be strengthened and that the erstwhile incident would be forgotten. Such optimism, however, would soon be exchanged for a more pessimistic stance. In a face-saving gesture, Masujūrō told Kurokawa years later, "I learned that Ichikawa Ebizō was angry that the [troupe's] name had changed from Ichikawa Shōjo Kabuki to Ichikawa Onna Kabuki. Ultimately, we returned to the name Shōjo Kabuki, but from that point on, relations worsened with the Ichikawa leader."[65] In fact, it was not only the troupe's name that concerned Ebizō. He soon let it be known that he opposed the Hamamatsu-za's idea of broadening the troupe's repertory. Naritaya heirloom pieces such as *The Subscription List* were not to be performed on the same stage as juvenile cartoons, such as the popular *Red-Barreled Suzunosuke*. He felt so strongly that the troupe needed to reject the Hamamatsu-za's

position to incorporate contemporary work that he threatened to expel the troupe from the Naritaya house. "If you do that, you will have to return the name Ichikawa," Masujūrō recalled Ebizō threatening him.[66] Once again, only Masujūrō publicized his account of what transpired. But whether or not the story unfolded in this precise manner, the troupe's relationship with the head had become strained to the point of stalemate.

The seemingly superficial issue of the troupe's name exacerbated what, in the two and half years since Sanshō's death, had become a difficult situation. Tensions flared between the Naritaya house and the Hamamatsu-za. The incident made it excruciatingly clear to Ono Haruyoshi, president of the Hamamatsu-za, that he was merely the troupe's financier, who de facto was required to cede all artistic control to Ebizō, who had his own ideas about the troupe's future. Writing some twenty years after the naming incident, Ono stated, "I do not intend to blame others for what happened, but, as the owner, I did not understand the need to protect the traditional kabuki framework. Moreover, I don't understand the value of the [*iemoto*] system. It was very difficult, but I keenly came to realize that I was far outside the world of kabuki."[67] In Ono's mind, Ebizō had won.

After the Tokiwa-za engagement, the troupe played at the Hamamatsu-za from 28 July to 31 July, an unusually short run. It appears that at this point the Hamamatsu-za management decided that it would not negotiate with Ebizō. Instead Ono Haruyoshi gave Masujūrō an ultimatum: In order for the troupe to remain under the auspices of the Hamamatsu-za, the troupe would need to sever ties with the house of Naritaya.[68]

This was a daunting dilemma for Masujūrō, who acknowledged that the troupe was stuck between two greater forces. On the one hand, there was the Hamamatsu-za. Ono Haruyoshi, Ono Kakutarō, and Kaneko Seiji had been loyal and trusting financial backers of the troupe. It was thanks to this management team that the troupe had toured the country and become a professional company. But now the Hamamatsu-za team worried increasingly about the troupe's profitability, especially with the advent of home television—to be discussed in chapter 9—as well as with what they perceived to be increased competition from SKD and Takarazuka. Ebizō, on the other hand, while not giving the troupe financial capital, lent the troupe the priceless Ichikawa name.

Looking back on this double-ultimatum some twenty-five years later, Masujūrō wrote that he tried to convince both sides to compromise. Representing himself as the victim, Masujūrō stressed that he took it upon himself to meet with Ōtani Takejirō in secret at Shōchiku's headquarters to explain the troupe's position, while continuing to plead with Kaneko of the

Hamamatsu-za to rethink the theatre's plan. "I became absolutely panicked, negotiating among the head of the Ichikawa family, Danjūrō XI [Ebizō IX], the Hamamatsu-za, which had raised the troupe, and Ōtani Takejirō of Shōchiku," he wrote.[69] Yet, no one would relinquish his position, so Masujūrō was forced to take sides. After six years, the troupe decided to break from the Hamamatsu-za and become an independent company. In turn, it could keep the Ichikawa name and hope that relations with Ebizō would heal.

Ono Haruyoshi decided not to replace Ichikawa Girls' Kabuki with another performing troupe at the Hamamatsu-za. Apparently, he had had enough of show business. Predicting that live entertainment would no longer be lucrative, he ordered 800 *pachinko* game machines and turned the Hamamatsu-za into a hall for Japan's favorite new pastime.[70]

9. The Final Years ❧

In many respects, the troupe's newfound independence placed it squarely back where it had been before being discovered by the Hamamatsu-za. No longer did it have the luxury to concentrate exclusively on rehearsing and touring; now all members were required to help with the behind-the-scenes work that the theatre had managed so adeptly for six years. Surprisingly perhaps, only a handful of girls quit the troupe in the aftermath of the breakup. Most members chose to stay and perform in a three-month tour through Tōhoku and Hokkaido from August to October 1958 and at the Misono-za (Nagoya) in December. If the actresses recognized the precariousness of their situation, they did a good job of hiding it from the press; in interviews, they greeted their change in status with excitement and optimism.[1]

In what today would be called spin control, Misuji quickly published an article in the September 1958 edition of *Fujin gahō* (Ladies Illustrated), stating that the actresses were committed to performing for the long term.[2] While comparing her fellow troupe members to famous female actors (*onna yakusha*) of the past, Misuji also attempted to create some distance from them. Noting that Ichikawa Kumehachi's and Nakamura Kasen's respective performance careers had petered out, Misuji expressed her hope that the troupe would be spared the same fate. The actresses wanted to continue to perform as adults. Yet, she also acknowledged that the troupe needed to overcome the challenges of independence and find a new performance "style." Misuji's article was noteworthy for what it did not mention. She never once stated explicitly that the troupe had severed ties from the Hamamatsu-za. In hindsight, one can grasp that her statement "in the future, we will not be able to rely on other people's assistance" indirectly referred to the fact that the troupe had become independent from its financial sponsor and would have to forge a new means of survival.

Taking the first step to control its management destiny, members decided to become officially incorporated as the "Ichikawa Girls' Kabuki

Troupe, Inc." (Kabushiki-gaisha Shōjo Kabuki Gekidan). Just as its acting hierarchy had mirrored a grand kabuki company's, its organizational structure reflected that of a Japanese corporation. Each member assumed a managerial role: Misuji became the president, Baika executive director, and Masuyo and Fukushō were appointed executives; all the second-division members—Baishō, Sanpuku, Suzume, Himeshō, and Kobotan—were appointed department heads; the managing director was Masujūrō. All the other positions were filled by women, an attempt to overcome the hurdles of working in a male chauvinist culture. Misuji was quoted as stating that "in most Japanese companies, all women can do is grumble about how they don't like to serve tea; here is a chance to really try to combat male tyranny."³ Women were cordially invited to join the troupe, not as performers but as office administrators (for which serving tea was presumably not a requirement). It is unclear how much decision-making power they wielded, but the media depicted them as liberal feminist pioneers. With its commitment to finding ways of overcoming gender inequality in the workplace, the troupe became an all-female corporation, an arrangement that many considered to be unprecedented in Japan in the late 1950s.

Loyal fans appeared to welcome the troupe's newfound independence. One spectator called out, "President" (*shachō*) when Misuji appeared onstage.⁴ Writing in *Engekikai*, Enomoto Shigetami joked that he "did not know whether or not the troupe has a union, but this kind of cooperation between employees and management is in fashion."⁵ Making reference to the labor riots that had beset large Japanese companies since the end of the war, he jested, "Since all the leading actors are playing managerial roles, there probably will never be a strike."⁶ Still, Enomoto questioned how the troupe would survive as an independent entity.

Initially, the troupe maintained its demanding performance schedule. As in the previous year, the actresses began 1959 with a regional tour. This time they toured through central Honshū, Japan's main island. The troupe was invited back to Tōyoko Hall in Tokyo in March, and, similar to the previous year, it toured in the spring. During August, it divided its time between Nagoya (Misono-za) and Kyoto (Minami-za), demonstrating that it was still much in demand. Yet, for the second year in a row, the troupe did not perform in Osaka and spent more time in the countryside, an early indicator that it was experiencing problems. Moreover, its annual December run at the Misono-za had been reduced to six days (in 1956, it had been fifteen). For December 1959, the troupe shuttled between Nagoya and Tokyo, where it played at the Shinjuku Daiichi Gekijō, a new venue for the girls. For both of the troupe's Tokyo productions in 1959, the customary note of

greeting from the Naritaya head was missing from the program, a sign that relations between Ebizō and the troupe were not healthy.[7] The troupe made the best of the situation by continuing to perform new plays and trying to jumpstart its repertory. Critics were delighted that the actresses staged *Yosa and the Moon's Boxwood Comb*, a work that had not been performed since 1922.[8] A *shin*-kabuki sequel to *Scarface Yosa*, the play depicts the scarred Yosaburō's whereabouts after his first reunion with his lover, Otomi. As it had done before, the troupe also attempted to branch out by adding showier pieces. Some plays, such as *Dancing Doll of the Capital*, were jazzed up, as several members, instead of the customary solo dancer, performed the roles of the dolls. Another new piece *Paragon of Amusements*, a popular *shingeki* play, featured the actresses sporting an array of fancy hairstyles. Miyake and Andō wrote that they understood why the troupe wanted to perform flashier pieces in the fashion of Takarazuka and SKD, but Akiyama voiced opposition. "This new play is quite vulgar. This is not a proper play for young girls who will continue to grow," he scolded.[9] Other spectators, such as Fujima Rankei (b. 1929), the daughter of Fujima Fujiko, the troupe's dance teacher and choreographer, recalled that the problem was not its so-called vulgarity, but the fact that it was a play from outside the classical kabuki repertory.[10] Such dipping into the new genres upset the purists.

Meanwhile, Akiyama and Andō continued to complain about the voices and dialects of the performers, but Miyake praised the troupe's acting, gushing that the "entire [March 1959] program exudes enthusiasm." Calling the troupe's *Love Suicides at Sonezaki* a "masterpiece," he wrote, "The scene [the troupe] performed is not particularly charming, but Misuji made it work.... She wouldn't lose even to Ganjirō [Nakamura Ganjirō II]," who, in fact, had directed the piece.[11] Fukushō's Benkei (*Subscription List*) also earned stellar praise from the *Kyōto* critic, who wrote, "We could not expect such a Benkei from other actors of the same age in [grand] kabuki."[12] Such warm encouragement must have validated the troupe's difficult choice to break from the Hamamatsu-za.

By the end of 1959, its first year as an independent company, the actresses appeared to be in good shape. Membership was strong, if not stable. In a show of strength, five new members were listed in the troupe's December 1959 Misono-za program, and one new name was added to the roster for the troupe's engagement in Tokyo later that month. The performers were once again included in *Engekikai*'s December 1959 issue of *Kabuki haiyū hyakka* (Directory of Kabuki Actors), a listing of professional kabuki actors, all of whom, with the exception of Ichikawa Girls' Kabuki, were male. This

listing was another coup for the troupe, but the accompanying article suggested that its future was not entirely secure and appealed to readers to offer support.[13] More troubling to some was the recognition that hiring standards had become increasingly relaxed. In the past, potential members auditioned before Masujūrō and the Hamamatsu-za managers, but now a simple introduction and greeting could land a girl a place in the troupe, especially if she demonstrated that she would receive financial support from her family. Ichikawa Kiyomi, who joined the troupe after the March 1959 Tōyoko Hall production, recalled that she was hired on the spot, without any investigation of her talents or training.[14] It should be noted, though, that she had extensive music and dance experience before joining the troupe, but, as previously discussed, the new recruits were seldom permitted to perform. They worked their way through the ranks, first helping with backstage chores and playing extras, before receiving a significant role.

As the year drew to a close, critics once again began to complain about the troupe's ill-fitting name. Just because they continued to praise the troupe's productions did not mean they were willing to overlook the inappropriate "*shōjo*" (girl) modifier. Akiyama had momentarily let the issue slide when he observed in December, "The troupe has not changed. ... They are baby-faced, innocent, and have not lost their cuteness."[15] After grumbling for years about the word "*shōjo*" in the troupe's name, he seemed to suggest that the girls were girls. Yet now other critics began to lobby for the troupe to call itself the "Ichikawa Onna (Women's) Kabuki Company," the name that had been proscribed by Ebizō in 1958.[16] Their wishes were partially granted. In March 1960, from the stage of the Shinjuku Daiichi Gekijō in Tokyo, the troupe announced its new name: the "Ichikawa Actress Company" (Ichikawa Joyū-za).[17]

THE ICHIKAWA ACTRESS COMPANY

The origin of the troupe's new name is a bit of a mystery. It is generally attributed to Shōchiku president Ōtani Takejirō.[18] But, to complicate the situation, Hamamatsu-za president Ono Haruyoshi wrote in his autobiography that Ōtani, in fact, had proposed a different name: Ichikawa Musume Kabuki. Similar to the word "*shōjo*," *musume* means "girl" or "daughter"; in theory, the latter is a name that one never outgrows; no matter how old a girl becomes, she is always someone's daughter. The proposed name aside, what is confusing about Ono's account is that, according to other sources, neither he nor the other Hamamatsu-za managers participated in the negotiations at this stage in the troupe's career; they had been out of

the picture since August 1958. Yet, in his autobiography, Ono states that the Hamamatsu-za was involved in the negotiations over the new name. Indeed, he wrote that he sent Kaneko Seiji to Tokyo to meet with Ōtani, but "before the discussions with Shōchiku took place, Ichikawa Danjūrō XI [Ebizō IX] sent Masujūrō a sealed letter requesting that the troupe change its name to 'Ichikawa Actress Company.' All public indicators suggested that 'Daughters' (Musume) Kabuki' sounded fresher," he added, "but Danjūrō XI had the strong opinion of not allowing anything other than 'Actress Company' "[19] Ono Haruyoshi neglected to provide a date when such negotiations occurred, but he implies that he still was involved in discussions regarding the troupe in 1960. This, however, is highly unlikely, considering that the press documented a clear break between the Hamamatsu-za and the troupe in August 1958. With no one alive to clarify Ono's account, precisely what happened during the talks with Shōchiku remains unclear.

Meanwhile, Ebizō—who would not officially take the name Danjūrō XI until 1962—remained in the background. It was Ōtani Takejirō who wrote the program's requisite "greeting" for the troupe's Tokyo engagement, the first of four "Celebratory Shows" that subsequently took place in Nagoya, Kyoto, and Osaka. In his note, he duly recounted the troupe's patronage by Ichikawa Sanshō, writing that "today they have developed into splendid adult actresses," and that "Head Ichikawa Ebizō has given his consent for the troupe to change its name to the Ichikawa Actress Company."[20] Notably, though, there was no comment from Ebizō himself. As if to detract from the awkwardness of the situation, the program published a photograph of the minister of education, a professed "fan of Misuji and the other stars," giving the troupe a wooden plaque engraved with its new name.[21]

Also featured in the program was a commemorative photograph of the newly minted Ichikawa actresses. In what appears to have been a strategic choice, they posed on the grand staircase of Ginza's chic Matsuzakaya Department store in front of a poster commemorating the birth of Prince Naruhito (b. 23 February 1960), the future emperor (see figure 9.1). The occasion was celebrated throughout the country, and by associating themselves with the imperial family, the actresses added an auspicious quality and an air of establishment to the photo. Signifying her status as the troupe's leading male-role player, Misuji sported slacks and a sweater over a button-down plaid shirt. All the other actresses, however, wore skirts or dresses, stockings, and pumps, and Himeshō and Baishō completed their outfits with stylish hats. Decked out in the latest fashions, they looked happy enough to be the recipients of a new name. Missing from the photograph is Sanpuku,

Figure 9.1 Leading members of the newly named Ichikawa Actress Company pose. From bottom: Ichikawa Himeshō, Ichikawa Masuyo, Ichikawa Misuji, Ichikawa Baika, Ichikawa Fukushō, Ichikawa Kobotan, Ichikawa Baishō, Ichikawa Suzume. Courtesy Sakuragaoka Museum, Toyokawa, Japan.

who had left for financial reasons before the troupe's debut at the Shinjuku Daiichi Gekijō.[22] Such concerns of salary and future prospects were not far from the thoughts of the remaining eight leading members, but these worries would have been difficult to detect from the elegant photograph.

Critics who had been pressing for a name change for years praised the troupe for taking a name that suited the ages of the performers. *Engekikai* noted that Takarazuka and SKD notwithstanding, the troupe occupied a special place as one of the few all-female troupes in Japan's history.[23] Others, however, warned members that changing too quickly would lead to the troupe's demise. Maeda Mitsuho, for example, entreated the troupe to maintain its girlishness (*shōjo-rashisa*) and to "never forget the beginner's mind," as the great founder of *nō*, Zeami, had advised. Thus he cautioned the girls never to forget the memory of their first performances and the time before they had become a nationally renowned company.[24]

In contrast to the advice the troupe had received in its early years to broaden its repertory, critics now admonished it not to become overextended. "Let me be perfectly clear," Toshikura Yoshikazu of *Engekikai* warned, "performing a [*shingeki*] piece like *Paragon of Amusements*, of course, is a direction that you must take in order to attract spectators, but your real duty is to kabuki."[25] Similarly, Maeda warned, "When you move outside a stylized theatre form to realism, the limitations of having only women [performers] is a great handicap. If you continue to perform classics, there is no problem. ... It really comes down to choosing pieces that display the charms of an all-female troupe."[26] Maeda's argument pointed to the key differences between kabuki and *shingeki*. In the more realistic genres, roles were cast according to the players' sex: women were cast as women and expected to showcase seemingly innate female characteristics and men were cast as men and expected to embody innate masculine characteristics.[27] Yet, based on Maeda's comments, spectators recognized that in kabuki, gender had the potential to transcend sex: men had performed the female-like *onnagata* roles for centuries and now young women were playing the parts of men and women. While there were certainly fixed role types for men and women, the performance of these kinds of roles entailed a kind of virtuosic performance for any actor on the kabuki stage. Even a character such as Benten Kozō, who strips off his kimono, was never in fact naked; the body was always concealed in some fashion and every performance was constructed through borrowing the prescribed patterns (*kata*) handed down through the generations. Through mirroring these techniques and patterns, the actresses could perform both male and female roles in kabuki, while in *shingeki*, which prized realism, such gender-bending was more implausible.

For all four celebratory name-taking engagements, the troupe made a conscious effort to perform both kabuki classics and new, jazzier pieces. In Tokyo, the troupe once again performed the controversial *Paragon of Amusements*, but did so alongside traditional favorites such as *The Felicitous*

Soga Encounter, Love Suicides at Amijima, and *Autumn Flowers of Sendai.* In both Nagoya and Osaka, the troupe performed excerpts from *Yoshitsune and the Thousand Cherry Trees,* and for all three engagements, it performed Fujima Fujiko's colorful version of *Wisteria Maiden,* with seven dancers, instead of the customary one, as well as Okamoto Kidō's romantic Chinese fairytale *Commencement of the Drinking Fest.* In Kyoto, the troupe performed the classic Naritaya house play, *The Subscription List.*[28] That piece had been honed to perfection, together with so many of the other pieces the troupe had been performing since the early 1950s.

Critics responded enthusiastically, though Akiyama continued to harp on the performers' voices, and the *Chūo Nihon* critic echoed concerns of other reviewers that the troupe was overstretching itself. Entitling his review, "The New Pieces Are Still Weak," he admonished, "If the girls do not harness their artistry, there is the fear that they will slip into doing something in a *shingeki* manner. ... I want them to improve but if they go this route they will lose both their initial investment and any profit."[29] He encouraged the troupe to continue to perform dances and the *denden-mono* pieces from the *bunraku* repertory. Similarly, Tomita Yasuhiko (*Ōsaka*) complimented the troupe's dance pieces and lavished praise on Masuyo.[30]

Despite the overall positive reviews, the troupe's performance schedule came to an abrupt standstill after the initial celebratory engagements. When asked about their future plans, the actresses denied that anything had really changed. "It will be the same that it has been up until now," Masuyo told a reporter. "We always give it our all, and since President Ōtani gave us the name 'Actress Company' (Joyū-za) it wouldn't be right to soil it."[31] Still, some members recalled that around the time the troupe changed its name, Masujūrō formed the "Second Girls' Kabuki Company" (Daini Shōjo Kabuki), which featured younger members such as Ebimaru, Mineko, and his daughter, Emiko, who appeared under the stage name Suzuhachi. Though successful at first, it never came close to attracting the attention of the first Ichikawa Girls' Kabuki Troupe.[32]

In lieu of live performances, the Ichikawa Actress Company made the prescient decision to record several of its productions on film, a project that became known as "the kabuki play series." Masujūrō was credited as the codirector, but whose idea it was to make the films is not clear, nor is it known whether the films were intended to be broadcast on television or in a theatre. It is unlikely they were made for commercial distribution since they were never shown publicly. Judging from the notes on the scripts stored in the Sakuragaoka Museum, it appears that the troupe had planned to film seven or eight plays, but, in the end, only four were produced: *Naruto on*

the Straits of Awa, Mirror Mountain: A Woman's Treasury of Loyalty, Miracle at Tsubosaka Temple, and *The Love Messenger from Yamato: The Courtesan Umegawa and Her Lover, Chūbei,* all *denden-mono.*[33] The four plays were longtime favorites of the troupe. This time, however, they were heavily adapted for the screen; while each performance opened and closed with the conventional pulling of the tri-colored, striped kabuki curtain, there was no *hanamichi* and no live audience. Close-up shots of the performers and quick cuts to new scenes further indicate that the performers were directed as if they were in a movie, not in a play.

In some cases, the plays were adapted extensively to make them more appropriate for the screen. The film version of *Love Messenger,* for example, differs from the troupe's stage version, which always was performed on separate bills as two different acts: "Breaking the Seal" and "Ninoguchi Village." In the film, the acts are fused together. It begins with a shot of Magoemon learning that his son, Chūbei, has absconded with funds in order to purchase the contract of his lover, the courtesan Umegawa. Only after this newly added introduction does the film then cut to the "Breaking the Seal" scene, in which Chūbei "breaks the seal" on the packaged coins and redeems Umegawa. This dramatic sequence is followed by Magoemon receiving the bad news that his son is a thief, and only then do the actors perform an abbreviated version of "Ninoguchi Village," in which the lovers flee to Chūbei's hometown and meet his father one last time before succumbing to their captors. On the other hand, the piece *Tsubosaka* remained faithful to the troupe's stage version, complete with the minor-theatre addition of the character Gankurō (discussed in chapter 6). In this regard, the majority of the film's *kata* (forms) are the same as those used for the stage productions, but the dialogue is heavily cut and the pace is swifter. Each piece is approximately twenty-seven minutes.

The same performers who had played the parts for the stage usually landed the same roles for the films. As always, lead roles went to the top foursome, Misuji, Masuyo, Baika, and Fukushō, but Suzume, Baishō, and Himeshō also received several plum parts. Sanpuku was the only longtime member who did not appear in any of the films, due to her resignation earlier in the year.

THE CHALLENGES OF THE 1960S

Grand kabuki actors bolstered their growing stature at home by making their first tour to the United States during the summer of 1960. In contrast, the troupe's performance schedule waned. Save for a six-day run at

the Mainichi Hall in Osaka, the actresses limited their productions in 1961 to a smattering of one-day affairs in or around Toyokawa, the hometown of the original members. The retirement of several key members—to be discussed later—had taken a toll, and booking a venue had become increasingly difficult given the troupe's depleted financial reserve. A general state of inertia characterized the troupe during this year, but if it had avoided performing altogether, it might never have been resuscitated.

The next major engagement took place in 1962 at Tōyoko Hall—its first major performance in thirteen months. It would have been difficult for spectators to know that the troupe was falling apart. Under the direction of Enjōji Kiyoomi and with the sponsorship of the Shōchiku Corporation, the troupe went to great lengths to create a theatrical atmosphere that evoked an earlier age when kabuki had flourished as a popular theatre. The small lobby was decorated with festive billboards by the esteemed Torii house of kabuki artists that included the names of performers and drawings of characters in the plays. It also featured a tall tower (*yagura*), which served to designate a licensed theatre during the Tokugawa period. The tower housed a drum that was beaten to announce the opening and closing of the day's performance, a ritual that was reenacted during the troupe's programs. Spectators, furthermore, received a colorful program booklet that contained imitations of Tokugawa-period woodblock prints (*ukiyoe*) of the plays on the program with the text drawn in the old-fashioned calligraphy style. The auditorium featured two *hanamichi* that were decorated with festive lanterns bearing the names of the actresses. Among the players were seven new members, including Onoe Umeno, who enjoyed the pedigree of having been a child actor in Onoe Baikō VII's company.[34] With a whopping nine pieces on the program, the troupe showed off its strengths in movement and dance. Not surprisingly, three of the plays were *denden-mono*: "Amagasaki," "Numazu," and *Gappō*; and four were dances: *The Wisteria Maiden*, *Mirror Lion*, *Tied to a Pole*, and *Fishing for Love at the Ebisu Shrine*. *Osen the Cooper's Wife* was the only *shin*-kabuki play.

Aside from Akiyama's stinging remarks about the "unpolished" *Osen*, the reviews were positive. In an unusual move for a Tokyo critic, Miyake Shūtarō of the *Mainichi* actually praised the troupe for resurrecting the minor theatre's "old business" of using a candle for parts of "Numazu," and he commended Fukushō and Misuji. Most effusive in his praise was Andō of the *Yomiuri*, who stated, "Of all the troupes playing here in February, this was the most enjoyable."[35] Perhaps because of the warmhearted remarks, the troupe was invited back to the Tōyoko Hall for a short run in June.

The actresses performed in Tokyo again a short three months later, in September 1962, this time at Yomiuri Hall. Missing from this production

was Masuyo, who had quit after the performances at Tōyoko Hall—a big disappointment to fellow members and fans.[36] Easing the troupe's concerns was the return of Kobotan after a three year hiatus. Her picture was displayed in the program, and the *Asahi* review explained that because she had been working as a waitress at a restaurant near the National Diet Assembly, she had received many bouquets from politicians.[37]

The program contained no hints that this would be the troupe's last major engagement. As was usually the case, there was a mix of reliable staples—*The Demon Ibaraki*, *Narukami*, "Moritsuna," *Ise Dances*, and "Ninoguchi Village"—as well as new and more challenging work, such as a rarely performed act from *The Genji and Heike at the Nunobiki Waterfall*. The precursor to "The Sanemori Story," it had been performed last by Kataoka Nizaemon XII (1882–1946) twenty years earlier in 1943, and, for that reason, Andō commented, "This is an extremely difficult scene so that is one reason why actors stopped doing it. So, I applaud the troupe's courage."[38] Enjōji's specially commissioned *The Drum at the Waterfall*, a legend about a waterfall, was the other new piece. It did not go over as well as *The Genji and Heike*. Andō, for one, charged, "I expected it to be more fantasy-like. The finale, more so than being a revue, was like a third-rate geisha recital."[39] Additional feedback came from Miyake, who criticized Umeno's and Kobotan's "poor performances" in *Ise Dances*, and Andō complained that the troupe was still making mistakes in comprehension. "They are spending time on superfluous parts, and it still reeks of rural touring," he wrote. Even after performing countless times in the big cities, the troupe was faulted for failing to overcome its provincial roots. Nevertheless, not one critic insinuated that Yomiuri Hall might be the troupe's last major Tokyo production. Even the actresses apparently did not fully realize that this would be their last major engagement together.[40]

There were growing hints, however, that the troupe was having difficulty. A scheduled tour to Hawaii, which had been announced in the program and the *Yomiuri*, was subsequently canceled, more members quit, and audience numbers plummeted. Thinking back to this time period, Misuji recalled, "During the show, I looked out and saw that two-thirds of the seats were empty. I realized that so many things had gone wrong."[41] Previously loyal spectators had deserted them.

Writing in the *Yomiuri*, Andō Tsuruo surmised that attendance at a troupe engagement had been low because of competing kabuki companies, while Enomoto of *Engekikai* suggested that the troupe's problems stemmed from "a *shingeki*-complex." Masujūrō, in fact, was quoted as saying that a regional cultural association had canceled an upcoming production of the girls in order to

accommodate a *shingeki* troupe. In turn, Enomoto mused that young people were no longer interested in anything smacking of tradition, but were embracing the "new theatre." "They see [kabuki] as an amusement for the aged. Young people are rejecting traditional culture that has been passed down."[42] What was even more troubling for the troupe, Enomoto added, was that in some parts of the countryside, kabuki still had the reputation of being a low form of entertainment that was not necessarily suitable for children. Another new challenge came from the so-called little theatre movement (*shōgekijō*), in which playwrights and theatre companies were offering experimental alternatives to both traditional theatre and mainstream *shingeki*.

In hindsight, the burgeoning popularity of color television would be offered as yet another reason for the troupe's troubles in the early 1960s. Almost overnight, newspaper listings of television programs appeared in the very places once reserved for theatre events. Audiences previously eager to attend shows could enjoy the very same plays on television, since many live performances, including those of Ichikawa Girls' Kabuki, were televised during this period. Yet, whether television helped or hurt the troupe is unclear. Only 30 percent of households owned black-and-white television sets in the early 1960s; it was not until the 1964 Tokyo Olympics that Japanese began to own color televisions en masse.[43] Moreover, productions of Ichikawa Girls' Kabuki had been broadcast since the mid-1950s, which, paradoxically, might have contributed to its national popularity. Thus it is unlikely that television stole the troupe's core audience. While television might have had an adverse effect, there were other major issues that also played a role in the troupe's demise.

Another reason offered for the troupe's decline in popularity was the new name, the Actress Company. With the word "kabuki" now omitted, some members believed that it was unclear that the company was, in fact, a kabuki troupe. Several women argued that "*joyū*" (actress) conjured up the image of a contemporary theatre troupe, since the word had come to be associated with the modern plays of *shingeki*, while the term "*onna yakusha*" (female actor) was associated with women performing in kabuki plays.[44] The term *joyū* is the inverse of *haiyū* (actor), a term that was used frequently for male *shingeki* actors. It is likely that many potential spectators associated the Ichikawa Actress Troupe with the Haiyū-za (Actors' Theatre), one of the leading *shingeki* companies formed in the postwar period. As Matsushita Kahoru, a longtime employee of Fuji Terebi (Television), who worked as the commentator for an Ichikawa Girls' Kabuki broadcast, noted, "It's not that [Ichikawa Actress Company] has a negative nuance... but it no longer sounds like a classical performing company."[45] The new name was yet another excuse for the troupe's demise.

Declining audiences translated into low, if not nonexistent, paychecks for the actresses. As discussed in chapter 7, many girls had taken their salary for granted during the troupe's years under the Hamamatsu-za. With their daily living expenses paid for, the girls could send money home to their families; on tour, extra cash was not a necessity. Yet, now, as young women, the loss of a regular paycheck became a source of concern. Fukushō recalled, "That was around 1959 or 1960; it was always, 'This is it for this month; try to be patient.'"[46] After years of playing in grand theatres, such a precipitous decline in standards must have been depressing for the veteran members. Baika recalled that she and her colleagues bought a pot and staple ingredients so that they could cook in their dressing rooms, a state of affairs that was not so different from the early years of touring.[47]

The exodus of performers had started in the spring of 1960 when Himeshō, Kobotan, and Ebimaru had quit. At that time, Masuyo had also declared her intention to resign, but was persuaded to appear in the performances at Tōyoko Hall. Himeshō and Ebimaru had left for good, but, as we have seen, Kobotan returned for the Yomiuri Hall engagement. In later years, the members discussed their particular reasons for resigning. Many simply felt they did not have a future with a troupe that had difficulty attracting audiences and staying afloat financially. "It was such a difficult situation, but we had no guarantor," said Ebimaru, who left the troupe after the 1960 Shinjuku production to pursue an arranged marriage, a common means of finding a spouse.[48] Similarly, Himeshō said she resigned because she was "thinking about the future," and "as a woman," thought it best to leave; likewise, Masuyo told Kurokawa Mitsuhiro of the *Chūnichi*, "I came to understand a lot of things about adult society, and I didn't like it. I told them honestly that I was leaving and it was a huge relief."[49] As discussed in chapter 7, several members believed that Masujūrō's extramarital philandering had a negative impact on the troupe, but no one viewed his behavior as the sole factor for the troupe's demise. "It was one factor, but the main reason was money," Baishō stated.[50] Kurokawa, too, spoke of Masujūrō gambling away the troupe's profits, and Baishō further remembered that Masujūrō had approached her "wealthy" boyfriend about giving the troupe a loan to keep it financially solvent. "There was absolutely no guarantee that he [Masujūrō] would re-pay it," she stated.[51] Placed in such an awkward position, Baishō also decided to quit.

Meanwhile, what had come of Ebizō and the troupe's relationship with him? As expected, he was promoted to the name Ichikawa Danjūrō XI. Celebratory performances began in April 1962, just a month before the Ichikawa Actress Company's engagement at Tōyoko Hall. Tellingly, there

was no reference to this historic event in the troupe's program. Danjūrō XI was probably too busy with his own performance schedule to attend one of the troupe's Tokyo performances, but he or a member of his staff could have taken the time to write the customary note for the program.

As the Ichikawa Actress Company, the troupe continued to use the crest that had been approved by Sanshō, which featured the character for woman written inside the Naritaya *mimasu* crest, but such symbolism had become devoid of meaning. Indeed, it appears that despite Danjūrō XI's tacit acceptance of the troupe's new name, relations never healed between him and Masujūrō. Since the 1958 Tokiwa-za naming fiasco, communication between them had come to a grinding halt. Referring to Danjūrō XI's attempt to convince the troupe not to perform at the Tokiwa-za in Asakusa, Ichikawa Misuji recalled, "I have no recollection of ever meeting Danjūrō [XI] again after that time in Shibuya."[52]

Sadly for the troupe, Danjūrō XI's and Masujūrō's personalities clashed. Explaining that the former was "super polite" and a "perfectionist," Fujima Rankei, the *nihon buyō* dancer, noted, "This was the absolute opposite of Masujūrō. Their personalities were totally opposite."[53] So many of Danjūrō XI's positive traits—his methodic, punctual, and exacting approach—were viewed as problematic by Masujūrō. In his autobiography, Masujūrō revealed that he regretted his decision to follow Danjūrō XI, "The more I think about it, the more I don't understand why I became so worn down in the battle with the head of the Ichikawa family [Danjuro XI], who was useless at answering any questions."[54]

Masujūrō was not the only one to have difficulty working with Ebizō. Beneath his elegant stage persona, Ebizō was said to have a terrible temper, exacerbated by illness, which took his life just a few years later in 1965. He and playwright Osaragi Jirō (1897–1973) had a messy falling out, which was publicized in the 1960s, and he acquired a reputation for sparring with Shōchiku over such practices as requiring actors to appear in both afternoon and evening productions.[55] Unfortunately for the actresses, he appears to have taken a dislike to Masujūrō, and so, instead of using his power to boost the troupe, as Sanshō had done, he abandoned it mid-course, just as it was trying to forge a new identity. Of all the troupe members, Ichikawa Emiko, Masujūrō's daughter, spoke most openly about the strained relationship between Ebizō and the troupe. "He did not like Ichikawa Girls' Kabuki," she stated.[56] Before the troupe had time to make proper amends, the Naritaya leader became seriously ill and died.

BIDDING FAREWELL

Despite performers dropping out, despite the loss of its major financial sponsor, and despite no longer playing at first-rate theatres, the remaining members refused to face the reality that the troupe's days were numbered. Their tenacity is clear in an article that *Engekikai* ran in 1964, two years after the troupe had last appeared in Tokyo:

> The phrase "Ichikawa Girls' Kabuki" has virtually disappeared in today's media. The troupe was active for about ten years, becoming an incorporated company, but recently a rumor has started to circulate that the troupe has disbanded. Thinking about the age of the lead actor, Ichikawa Misuji, who was born in 1936, that is not necessarily a false report. Many people are apt to believe it, since Ichikawa Baika and Ichikawa Suzume have opened a drinking establishment near Toyohashi Station. So we decided to ask what was happening by calling long distance.
>
> "Broken up? Absolutely not," Suzume answered. "We opened Kabuki Teahouse (Kabuki chaya), but of course we perform whenever we have engagements. Many [venues] are old age homes and are memorial-type affairs, but I think we've been quite busy playing in Kyushu, Nagoya, and Tokyo. Misuji is living in an apartment in Nagoya and is active in a dance circle; Fukushō helps out at her family's candy shop, and everyone else is scattered about, but whenever we have a show, people come together. Many members are younger and are still commuting to school and cannot take a holiday, so frequently we'll perform with only fifteen members. Altogether we have around twenty members," she responded.
>
> The members who were once *shōjo* have become mature women today. They are not performing at regular theatres, and it is unknown how much their skills have improved, but it is clear they are doing well. The popular Ichikawa Girls' Kabuki has been a bit sad recently, but it appears that the troupe has not thrown away its dream to perform. The troupe's office is in Toyohashi City, the same address as Baika and Suzume's Kabuki Teahouse. We will continue to bring you news about the troupe as always in order to pacify worried fans.[57]

Needless to say, it was the final time *Engekikai* carried a story exclusively about the troupe.

But the lack of coverage in the major publications can be misleading. Even after the larger kabuki world had buried it, the troupe refused to die. For years after the so-called last engagement, the troupe, in a drastically reduced version of its former self, soldiered on, performing at civic centers and rural theatres.

An undated documentary about the troupe, probably from 1964, reveals that Misuji, Baika, Fukushō, and Suzume—who had replaced Masuyo as the troupe's fourth lead—continued to perform after other members had quit. Though Baika admitted that many of the scenes of the documentary had been "staged" by the film crew, it offers invaluable evidence about the state of the troupe in its declining years.[58]

The documentary primarily focuses on Baika, who begins by recalling the days when the troupe practiced tirelessly in Toyokawa, which laid the groundwork for it to perform at the Meiji-za, Minami-za, and Misono-za. The narrator then reveals that the troupe has been reduced to four members—Baika, Misuji, Fukushō, and Suzume—who occasionally performed together. Indeed, the first couple of sequences clarify that even these leading ladies have developed other interests and hobbies. The film shows Baika and Suzume serving *sake* to male customers at their Kabuki Teahouse while a weathered-looking Masujūrō drinks with a couple of men. In the next shot, Misuji and Fukushō try their luck at *pachinko*. The halcyon days of touring the country have passed.

One of the many poignant scenes shows Baika and Suzume watching Misuji and Fukushō enact the fight scene finale of *The Demon Ibaraki*, which, the narrator states, they have played some 400 times. Now, they perform it once again at a "Health Center" in Mie prefecture, a far cry from the grand theatres of Tokyo, Kyoto, and Osaka. Baika watches them intently, looking deeply saddened to see her talented colleagues wasting away in such lowly surroundings. The camera follows her as she walks away from the venue, stating, "I don't think your [Misuji's and Fukushō's] art has declined in the least, but something is missing." She proceeds to write a letter to former members, beseeching them to appear in a special production, which, at the very least, will reinvigorate the foursome. She is then shown paying a house call to a former member, who opens the door, with her baby in hand—the image starkly reminding the viewer why so many members had left the troupe.

Baika's strategy apparently works, as some twelve former members journey to Nagoya for a three-day engagement. The documentary captures Baika sewing a costume and gazing nostalgically at her co-performers. In the background, she states, "It's not as though everyone has forgotten how to perform. People married...and because of finances our troupe broke up.... But everyone loves the stage." The group rehearses and then Misuji recites a formal announcement onstage. Though she introduces herself as Ichikawa Misuji, she says nothing about being connected to the Naritaya house, nor does she wear the *mimasu* crest, which previously had been

visible on the troupe's costume. There is a brief shot of the troupe performing *Autumn Flowers of Sendai*, and then the camera revisits the dressing room, where Baika studies herself in the mirror and slowly wipes away her makeup. Another chapter has ended.

The next sequence takes place at the train station where the foursome take leave of the departing members, who are returning home after the last performance. The camera zooms up on one member who boards the train, accompanied by her husband and their babies. The train doors shut, and the passengers—the former actresses, their husbands, and their small children—furiously wave goodbye to Baika, Misuji, Fukushō, and Suzume. As they slowly walk from the station, Baika states, "Can I live as an actress? Can I live as a woman? Until today, my twenty-eighth year, while continuing to worry, I have come this far."

The four leading actresses retreat to an *okonomiyaki* restaurant where they take up the issue that constantly haunts them: to quit or to persevere. Misuji speaks first, proposing that they disband, arguing that they cannot continue given their present financial situation. "We must think of another road," she advises. Fukushō chimes in that she has been worried and is considering marriage. Verging on tears, Baika then reveals that she has been waiting for Misuji and Fukushō to say they wanted to quit. "If everyone says they are going to quit, there is nothing that can be done," she says. Looking utterly glum, they confer silently.

The mood then becomes festive; upbeat music plays while the foursome boards a train to Shizuoka prefecture, where they will perform for a girls' club. On the train, they laugh, smile, and act like they are having a wonderful time with their best friends. In Shizuoka, they perform "Ninoguchi Village," an old favorite, and the camera focuses on a male spectator who sheds a tear at the short-lived reunion of the characters Magoemon and Chūbei. After the performance, the actresses are treated to a feast, and, once again, they look like they are enjoying every moment.

But the next scene returns yet again to a solemn mood. Over braised eel and beer, Misuji, Baika, Fukushō, and Suzume plead with Masujūrō to keep the troupe afloat. This time, Baika breaks down, sobbing that theatre has always been what she wanted to do. "We put so much work into it as children, practicing, as you," she says addressing Masujūrō, "hit the bamboo pole." In a marked change from the earlier scene, the actresses insist that they want to continue to perform.

The subsequent scene shows the foursome training a younger generation in the roles they once performed. Suzume and Fukushō show a girl how to dance with a fan; Misuji demonstrates how to play the evil Yashio in *Autumn*

Flowers of Sendai; Baika illustrates the proper way to do a *mie*. "Do it again; do it again; again; again, again," she instructs. As she recites the lines of Masaoka, the camera fades out. In this way, the troupe reinvented itself as a senior company that was passing kabuki onto the next generation.

Yet, even after its official breakup—and despite Kurokawa's, Baika's, and Masujūrō's respective accounts that the troupe's final production took place at Yomiuri Hall in 1962, the troupe went on to perform numerous times throughout the 1960s, 1970s, 1980s, and even into the 1990s, at civic centers and sometimes at the old minor theatres, when they could find one still operable. These productions were never reviewed, and there was no concerted effort to maintain a collection of the programs. The extant programs, however, indicate that the troupe did not end suddenly, but petered out very slowly, after a long struggle. Even Masujūrō acknowledged that he "does not have any recollection of the troupe's lamp being extinguished."[59] As if in one final attempt to be recognized as part of the establishment, the troupe explicitly advertised itself as a "grand kabuki company" for a 1962 production at the Kitazawa Kaikan in Nagano Prefecture. The troupe, however, would be hard-pressed to ever again perform in the posh, grand kabuki venues that it had once enjoyed. In retrospect, Masujūrō wondered whether his ambitions had overtaxed the troupe. He wrote that he wished that he had not been so enamored by the grand kabuki theatre, which fueled his desire to be part of the Naritaya house. He further regretted not considering the interests of the troupe, and perhaps, even forming something akin to Suzuki Tadashi's theatre festival in rural Toyama Prefecture. "Why is it that I never thought of building a kabuki town, for everyone to come and see?" he asked.[60] Eschewing the minor-theatre tradition, Masujūrō had insisted that the troupe become a grand company, licensed by the Naritaya house. In the end, however, it had become an unequivocally "minor" troupe, performing in theatres not unlike those that Masujūrō had frequented as a young actor in the 1930s and 1940s.

As we have seen, there are numerous reasons for why the troupe ultimately disbanded: the women's age, societal pressures to marry and bear children, waning finances, problems with the new Naritaya head, competition engendered by Masujūrō's philandering habit, and the growing popularity of television. Perhaps if the troupe truly had fit comfortably in the grand kabuki world, it would have succeeded, but it faded like the minor-theatre tradition that slowly vanished after the war.

What should not be denied is that during the 1950s and early 1960s, the actresses mastered kabuki's fundamentals and delighted spectators throughout the country. For the most part, the core members remained dedicated

and, in the end, more than one hundred girls and women performed with the troupe over the course of its existence. Critics compared the troupe to "young men's kabuki" (*wakate kabuki*), and one can only assume that had it been given the opportunity to continue to develop as a collective group under the leadership of the Naritaya house, the Ichikawa Actress Company would have been compared to adult male kabuki as well.

Because of the troupe's relatively short-lived existence, it is easy to dismiss it as some professional male kabuki performers have done today. Sawamura Tanosuke VI, for example, said he thought it was overrated. Nakamura Jakuemon IV (b. 1920), moreover, said that he never saw the troupe perform because he was "against women performing kabuki."[61] Yet, many others who saw the troupe perform in the 1950s, including esteemed critics who also reported on men's grand kabuki, believed that the troupe was a valid addition to the kabuki theatre world and even predicted, if not hoped, that it would continue to develop as adults. Matsushita Kahoru, who worked as the commentator for an Ichikawa Girls' Kabuki broadcast, stated that the troupe performed "orthodox kabuki": "More than *shōjo*, they really had a sophisticated air about them. It wasn't an amateur troupe; they really practiced hard, and it was splendid theatre. There was no place in which I might have said, 'What was that?' ... They were brilliant and did terrific theatre."[62] As their first teacher Furukawa Yoshiishi told Kurokawa, "Their rise was quick, and their fall was quick. I learned from them that it had absolutely nothing to do with their artistic skill waning, but with their decline in popularity."[63]

It is not surprising that the statue memorializing the troupe in Toyokawa is of a young girl, not a woman. If members had a choice, they would prefer to recall the early years of their respective careers under Sanshō instead of the years struggling as adult actresses with receding emotional and financial support. Still, as the documentary from the 1960s foreshadowed, members also would be remembered as adult teachers. Indeed, some twenty-eight years after the Yomiuri Hall engagement, the troupe passed on the reins to the next generation of Ichikawa kabuki actresses. This was not strategic, but wholly accidental. As Ichikawa Baika tells the story, in the early 1980s she was approached at a party by three young women who inquired whether she would teach them kabuki.[64] In this way, the troupe's successor, the next generation of "Danjūrō's Girls," was born.

Epilogue: Kabuki as Invented Tradition ✧

In Japan today there is no longer a debate about women's place on the kabuki stage. Kabuki has become a traditional theatre (*dentō geinō*) that prides itself on performing classics of the past in the manner they were performed during its heyday in the Tokugawa period. To be sure, there have been changes—the house seating, lighting, and theatre technology are considerably different, and, on a more dramaturgically experimental level, some actors have reinvigorated old forms with new tools. Despite the common perception that kabuki is timeless, it is not entirely frozen in the distant past. New traditions are being invented.[1]

Yet, such innovating has stopped short at the prospect of replacing female bodies for the male ones that inhabit the stage. There is, of course, the notable exception of permitting the young daughters of kabuki actors— who are generally under the age of eighteen (*shōjo*, in their own right)—to make cameo appearances in plays, an invented tradition inaugurated by Danjūrō IX. While his daughters aspired to become actresses, daughters of more recent generations of actors are cognizant from a young age that their future does not entail acting on the kabuki stage. This point was best made in an interview with the five grandchildren of Nakamura Shikan VII, published in a 2004 Kabuki-za program. In response to the question "What is your future dream?" the four grandsons stated that they aspired to become kabuki actors; tellingly, only granddaughter Kana, then eight years old, responded differently: she wanted to become a bookseller.[2] While she arguably has a myriad of professions from which to choose, it is clear that the aspirations of her brothers are off-limits. Similarly, the only daughter of Danjūrō XII, Ichikawa Botan III (b. 1981), as well as his sister Ichikawa Kōbai II (b. 1950), have excelled in the world of *nihon buyō*, but have refrained from pursuing careers as kabuki actors. Kōbai, in fact, is an assistant director of the Ichikawa school of dance, and she has choreographed several cutting-edge productions, including an opera version of the kabuki

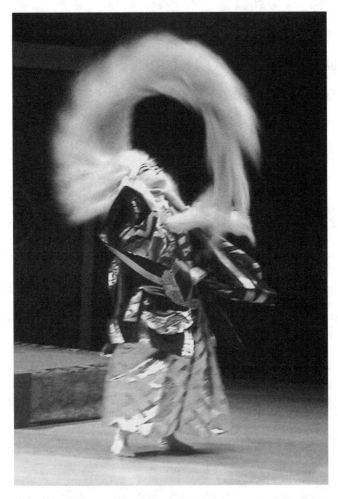

Figure E.1 Ichikawa Ohka in *Mirror Lion* at the World Music Theatre Festival, Amsterdam, April 2002. Photo by Jeremy A. Katz.

play *Saint Narukami* and an adaptation of *The Tale of Genji*. As far as gender roles are concerned, the world of kabuki acting remains entrenched in an all-male hierarchy. Female representation in professional kabuki is limited to the brief window of opportunity when women are *shōjo*. The social conditioning, not to mention training, begins at a young age when girls are taught that their calling lies outside the world of the kabuki stage. With

few exceptions, male actors have not attempted to integrate women into kabuki productions.[3] In recent years, the gender wars on which the media has focused attention concern women mounting the sacred sumo arena (*doma*) and whether or not Princess Aiko (Toshi no Miya, b. 2001) will be eligible to become the empress. But on the issue of women in kabuki, the debate has subsided.

The only notable exception to this is the Nagoya Musume (Daughter's) Kabuki Company, the heir to the Ichikawa Girls' Kabuki Troupe, under the indefatigable leadership of Ichikawa Ohka (see figure E.1). Established in 1983, the all-female troupe is still active today, defying its own self-anointed label of *musume* (girl or daughter). In the invented tradition of his ancestors, Ichikawa Danjūrō XII has given ten members the prestigious "Ichikawa" acting name, thus lending Nagoya Musume Kabuki intangible social capital from which its predecessor also benefited.

The troupe was guided initially by Ichikawa Sumihachi and then, for some ten years, by Ichikawa Baika, who taught the troupe the fundamentals of kabuki that she had learned as a member of Ichikawa Girls' Kabuki.[4] Several grand kabuki actors, including Sawamura Tōjūrō II (b. 1943), Ichikawa Ennosuke III, Bandō Yajūrō (b. 1956), and, most prominently, Danjūrō XII, have taught and directed productions. In addition, several actresses train under Fujima Rankei, the daughter of Fujima Fumiko, who taught members of the Ichikawa Girls'. The actresses have been exposed to a variety of acting styles both from the major and minor traditions. When Tōjūrō coached them in *The Miracle at Yaguchi Ferry*, he stated, "These girls have incorporated acting business taught to them by Baika, which is rarely used today. I learned something from them."[5] On some levels, the troupe is a repository of acting from the minor stage.

Nagoya Musume Kabuki generally sponsors its own annual or semiannual productions, which run for two or three days. In addition, it has been commissioned to perform at different theatres throughout Japan. Over the years, the troupe has expanded its repertory to include more than forty plays, engaged in outreach projects with the Nagoya community, established a fan club, and formed a teen troupe that trains junior high and high school students. The troupe's membership has fluctuated over the years, so an ongoing effort is made to recruit new members. Women with an interest in traditional performing arts are encouraged to contact the troupe.

In 2002, the troupe performed in the Netherlands and Belgium at the invitation of the World Music Theatre Festival. Most performances were sold out and the troupe received standing ovations at every performance. In 2003, it earned status as a nonprofit organization so that it can receive

tax-deductible contributions. The troupe also was prominently featured in the 400-year anniversary celebrations in honor of Izumo no Okuni sponsored by Taisha City in Shimane Prefecture. Moreover, every play that the troupe performed in 2003 and 2004 was advertised with the troupe's own slogan "Okuni runessansu" (Okuni Renaissance); from the troupe's perspective, it is the heir to Okuni's legacy. More recently, in response to requests from Aphra Behn of the Guerrilla Girls to learn more about kabuki technique, Ohka invited two members of the New York-based troupe to perform with Nagoya Musume in honor of its twenty-fifth anniversary.

The troupe's relationship with Danjūrō has grown stronger over the years. He has stated publicly his support for the actresses and declared that he considers members his disciples (*deshi*). He made more than a symbolic gesture when he performed the last act of *The Barrier Gate* with Ohka in November 2007 at the Nagoya Nō Gakudō (see cover photo).[6] This was one of the most significant productions in the history of kabuki actresses. While we can imagine that Danjūrō IX and Kumehachi performed together, this is the only performance featuring the Naritaya house leader and one of his female disciples that we definitely know took place. Danjūrō and Ohka had planned to perform together again in November 2008, but the performance was postponed until June 2009, due to lack of sufficient preparation and Danjūrō's poor health. In May 2004, Danjūrō was diagnosed with leukemia, but he made a triumphant recovery, even journeying to Paris later that year for performances in honor of his son taking the name Ichikawa Ebizō XI (b. 1977). Yet, he was later diagnosed with anemia for which he received a bone marrow transplant from his sister in July 2008. Kabuki fans are monitoring his health and praying for his recovery as this book goes to press.

In *The Barrier Gate*, Danjūrō eschewed the conventional kabuki costume, wig, and makeup for the *aragoto* character Sekibei. Instead he wore a plain green kimono, over a blue one, which was revealed during the climactic finale when he exposed himself as the villainous Ōtomo Kuronoshi. Ohka, who has played the role of Sumizome several times, dressed in the traditional flamboyant costume, but much of the "set" choreography was reworked to fit the new constraints of the *nō* stage. Instead of making her initial appearance from the cherry tree—the standard set piece for *Barrier Gate*—Ohka entered along the *hashikagari* bridgeway, walking in the sliding style of a *nō* performer. Danjūrō, for his part, delighted spectators by deviating from the standard tableau at the close of the play to perform his signature "*roppō*" flying exit down the *hashikagari*. As he stated in the program, "This is slightly different from today's kabuki since a man and woman are performing on the same stage and since we wanted somewhat different choreography."[7]

He justified his decision to perform with Ohka as a continuation of the Naritaya's house's support of kabuki actresses: Danjūrō IX's acceptance of Kumehachi in the nineteenth century and Danjūrō X and Danjūrō XI's patronage of the Ichikawa Girls' Kabuki Troupe in the mid-twentieth century. Danjūrō XII genuinely respects the troupe's perseverance and artistic accomplishments, commenting, "The troupe, under the direction of Ichikawa Ohka, has overcome many difficult hurdles, so we can support its twenty-fifth anniversary."[8] It is likely that his son, Ebizō XI, will assume a similar role when he takes his father's place as the head of the Naritaya house. *The Guardian* quoted him as saying, "When I have a daughter of my own, I want her to follow me onto the stage."[9] One hopes that he will support Nagoya Musume Kabuki as well.

Although the troupe approaches kabuki with utmost professionalism, critics have suggested that its collective management and production style mark it as amateurish. Reviewing the troupe in 1992, Kurokawa wrote: "First there's the question as to whether the troupe is 'professional' or 'amateur.' Being that they are allowed to use the Ichikawa name lends proof to their professionalism, but at the same time, the troupe's foundation is weak."[10] With the exception of its cofounder, Ichikawa Ohka, who earns a living from teaching *nihon buyō* and has transformed her grandmother's *tokiwazu* music school into the practice studio for the troupe, all the members hold jobs unrelated to kabuki and are often required to prioritize their paid work over performing. Partly because of its inability to make a full-time commitment, the troupe has not been commercially viable, nor is it well known outside of its home city, Nagoya. It flourishes thanks to a dedicated corps of volunteers and the fact that all the actresses play multiple roles; in addition to performing, they oversee every facet of production.

When the troupe was in its nascent stages, several actresses considered applying to the government-subsidized three-year (in the past, it was a two-year) National Training School (*yōseijo*), located on the grounds of the Kokuritsu Gekijō (National Theatre). The school has a decidedly sex-specific policy: it accepts only men between the ages of fifteen and twenty-five. But after further deliberation, the actresses resolved not to seek admission. Similar to the example set by the Ichikawa Girls', Nagoya Musume Kabuki has decided that it is more advantageous to secure the patronage and social capital of the Naritaya house than to try to compete with it. The payoff has been access to some of grand kabuki's finest performers as well as the artistic freedom to experiment with kabuki—by performing on a *nō* stage, changing otherwise "set" choreography, sharing the stage with American actors—in

ways that most actors under the management of Shōchiku never could. The downside is that the troupe has never become a professional contender.

By way of conclusion, then, perhaps it is appropriate to revisit the question as to why women have never succeeded at becoming professional kabuki actresses. As discussed in the introduction, women, post-Okuni, had their first opportunity to ascend the public kabuki stage during the Meiji period when theatregoers and management became receptive to the idea of kabuki actresses replacing the *onnagata*. The other great opportunity for women to perform on the kabuki stage came after World War II, when the feudalistic ideology fostered by the imperial system came heavily under attack. Recall Ichikawa Masujūrō's statement that Japan's defeat enabled the development of Ichikawa Girls' Kabuki.[11] While this was certainly one factor, it is worth considering that a macro revolution in kabuki could have occurred had Occupation censors been effective at modernizing the kabuki repertory. Throughout the early twentieth century and even during the war, kabuki continued to produce new plays that responded to contemporary social issues. After the war, however, Shōchiku insisted that it become a classical theatre form with a set, canonical repertory that did not reflect Japanese concerns in the postwar period. As Brandon remarks, "Despite paying lip service to a new, democratic Japan, Shōchiku never wavered from its aim of performing the traditional, feudal repertory in all its grotesque glory."[12] In becoming a classical theatre form, kabuki purged itself of any desire to become modern, and, by extension, absolved itself of the need to train actresses to play female roles.

In actuality, this was not the only direction that kabuki could have taken on the path to modernity. This can best be understood by looking briefly at the history of *jingju* (Peking/Beijing Opera). Like kabuki, *jingju* flourished in the eighteenth-, nineteenth-, and early twentieth centuries, is highly stylized, and was performed traditionally by all-male casts. Actresses were prohibited from the stage by Confucian-influenced imperial bans, most notably in 1772, after which male actors further developed the art of playing female roles. Similar to kabuki actresses during the Meiji period, women began performing publicly in *jingju* after the downfall of the Qing dynasty in 1911 and the establishment of the Republic of China.[13]

Yet, here the parallels come to an end. Unlike kabuki, professional actresses continue to this day to perform in *jingju* together with actors in mixed companies. With the support of Mei Lanfang (1894–1961), who is credited with training several women to learn the special techniques of the *dan* (male player of female roles in Chinese theatre), women became accepted gradually, to the extent that they are now seen as an inseparable component, and the tradition of the male *dan* has practically disappeared. This can be

traced to the communist government's use of *jingju* as a political tool to revolutionize thinking about social roles for men and women. While such politicking was most extreme during the Cultural Revolution (1966–1976) under the leadership of Jing Qing, Mao Zedong's wife and one of the notorious "gang of four," who sought to crush all feudal remnants of *jingju* and popularize the *yangbanxi* (revolutionary model plays), it has continued to this day. The government-subsidized Beijing Municipal Traditional Drama School (Beijingshi Xiqu Xuexiao) trains both women and men, and commentators, such as Min Tian, are optimistic that "in due course, traditional Chinese theatre will have its own Siddonses and Duses."[14]

In Japan, on the other hand, there are no such prospects. Kabuki is generally considered to be a mirror of the feudal past that must be preserved. Female kabuki is thought to be an aberration, if it is known at all. At the 1995 conference on "Traditions of Cross-Dressing and Cross-Gender Casting" (later published as *Transvestism and the Onnagata Traditions*), not one of the kabuki scholars present related the history of women on the modern kabuki stage. Ann Thompson, a scholar of Shakespeare, appeared somewhat baffled as to why women do not perform kabuki and questioned whether all-male theatre forms should be preserved:

> We are told that in most world dramas there has been a period, perhaps quite a long period, when drama has been exclusively something that men do. The assumption seems to be that this makes it all right, and I think that as a feminist, it is my role in this context to say I am not sure if it does. The appeal to history is a pretty problematic one for me, because it is also the case that in most real life societies women have been oppressed by men, and that, I think we would all now agree, does not make it all right. There is a problem about the preservation of these theatrical traditions.[15]

She further questioned why productions "could not reverse the genders the other way," so that there could be all-female casts for both kabuki and Shakespeare.

Of course, that is precisely what actresses, from Ichikawa Kumehachi to Ichikawa Ohka, have sought to create: an all-female kabuki. And, in rural Japan, it is still possible to see amateur productions in which women perform kabuki alongside men. Needless to say, my intention has not been to argue that kabuki should have endured something as traumatic as the Cultural Revolution and gone the way of *jingju*, nor is it my desire to advocate that women should replace men on the kabuki stage as a means of showcasing a "gender free" ideology. The female players discussed in this book did not act out of political conviction, and, as we have seen, merely

substituting female bodies for male ones does not "break" the feudalistic system. Yet, women must be supported in their efforts to perform kabuki. A small step in this direction would be providing access to the basic training that men are eligible to receive at the National Training School. Without this kind of support, women will have difficulty succeeding as professional players on the kabuki stage.

Danjūrō's Girls has offered a different narrative of kabuki that is largely forgotten today because of the need to preserve kabuki's image as an unchanging, frozen, and timeless theatre form. I have explored the history of the all-female Ichikawa Girls' Kabuki Troupe most extensively because it had the greatest potential to become a new invented tradition. While the troupe's own internal problems stunted its development as a professional adult company, it is also evident that it lacked the macro-social structure to succeed. The leading members, at least, quit not because they did not want to make a career in the kabuki theatre world, but because the socioeconomic support structure had receded. Financial backing from the Hamamatsu-za had ceased, and support from the Naritaya house had diminished. Without the sponsorship of these institutions, the troupe had no chance of succeeding, let alone retaining members for whom the prospect of marriage and raising children in lieu of a stage career proved to be a more appealing, if not practical, choice.

If history is any forecaster of the future, it will not be through the conventional route that women will become kabuki actors. It will be through the quirky nature of human relations by which a male player, perhaps one who has no biological children of his own (such as Ichikawa Danjūrō X) or has only daughters (such as Danjūrō IX), will train girls and women for long-term stage careers. For as we have seen, it only takes one powerful individual to change a tradition and invent a new one. The question is not whether women can perform kabuki, but whether social forces will enable them to do so.

Appendix: Play Titles
in Translation ✑

This list provides the Japanese titles of all the plays noted in the book. In the case when a play is known by multiple names, I have tried to call the play by the same titles the troupe used. When a play has been translated and published into English, I generally use that English-language title. As mentioned in the "Notes on Style," quotations are used for single acts while full-length plays are italicized.

Each play title is followed by its kabuki subgenre. Please note the following abbreviations: *nj=ningyō jōruri* (puppet repertory); *sho=shosagoto* (dance-drama); *ka*=kabuki (plays originally written for kabuki); *shin ka=shin kabuki* (new kabuki play); *matsu=matsubame* (derived from or inspired by *nō* and *kyōgen* theatre); *shin=shingeki* (new theatre).

"Amagasaki" (place name), from *Ehon taikōki* (*The Picture Book of the Taikō*), nj.

Arrow Sharpener, The (*Ya no ne*), ka.

Balladeer's New Tale, The (*Shinpan utazaimon*), nj.

Barrier Gate, The (*Seki no to*), sho.

Battles of Coxinga, The (*Kokusenya kassen*), nj.

Benkei Aboard Ship (*Funa Benkei*), matsu/sho.

Benten the Thief (*Benten Kozō*), also refers to *Shiranami gonin otoko* and *Gonin otoko*, ka.

"Brazier" ("Shigure no Kotatsu"), from *Shinjū ten no Amijima* (*Love Suicides at Amijima*), nj.

"Breaking the Seal" ("Fuingiri"), from *Koi no tayori Yamato ōrai* (*A Message of Love from Yamato*), nj.

Chronicle of a Toyokawa Buddhist (*Toyokawa risshoki*), ka.

Commencement of the Drinking Fest (*Sake no hajimari*), shin ka.

Dancing Doll of the Capital, The (*Kyō ningyō*), sho.

Dancing Footman, The (*Tomo yakko*), sho.

Danjūrō's Girls (*Danjūrō musume*), sho.

Daughter of Kagekiyo (Musume kagekiyo), sho.

Demon Ibaraki, The (Ibaraki), matsu/sho.

Diary of the Mito Clan (Mito kōmonki), genre unclear.

Downtrodden Chap, The (Wakashu kuzushi), shin ka.

Drum at the Waterfall, The (Tsuzumi ga taki), shin ka.

Earth Spider, The (Tsuchigumo), matsu/sho.

Felicitous Puppet Sanbasō, The (Kotobuki ayatsuri Sanbasō), also called *Ayatsuri Sanbasō, ka.*

Felicitous Sanbasō, The (Kotobuki Sanbasō), nj.

Felicitous Soga Encounter, The (Kotobuki soga no taimen), ka.

Felicitous Three-Person Sanbasō, The (Kotobuki sannin Sanbasō), nj.

Ferry, The (Noriabune), sho.

Fishing for Love at the Ebisu Shrine (Ebisu mōde koi no tsuribori), also called *Tsuri onna (Fishing for a Wife), matsu/sho.*

Fishing for a Wife (Tsuri Onna), also called *Ebisu mōde koi no tsuribori.*

Fulling Block, The (Kinuta), sho.

Gappō at the Crossroads (Sesshū Gappō ga tsuji), nj.

Genji and Heike at the Nunobiki Waterfall, The (Genpei nunobiki no taki), nj.

Ghost Stories at Yotsuya on the Tōkaidō Highway, The (Tōkaidō Yotsuya kaidan), ka.

"Gion's Ichiriki Teahouse" ("Gion no Ichirikiya"), from *Kanadehon chūshingura (The Treasury of Loyal Retainers), nj.*

Goshozome of the Mirror Mountain Stage (Kagamiyama butai no goshozome).

"Hamamatsu Shop, The" ("Hamamatsuya"), from *Benten Kozō (Benten the Thief), ka.*

Heron Maiden, The (Sagi musume), sho.

Hidaka River, The (Hidakagawa), nj.

Hill of the Bush Warbler, The (Uguisuzuka), nj.

"Inase River, The" ("Inasegawa"), from *Benten Kozō (Benten the Thief), ka.*

Ise Dances and Love's Dull Blade, The (Ise ondō koi no netaba), ka.

Japan's Twenty-Four Paragons of Filial Piety (Honchō nijūshikō), nj.

Just a Minute (Shibaraku), ka.

"Kawashō Teahouse, The" ("Kawashō"), from *Shinjū ten no amijima (Love Suicides at Amijima), nj.*

Kiichi Hōgen (character's name), also called *Ichijō Ōkura monogatari (The Tale of Lord Ichijō Ōkura), nj.*

"Kumagai's Camp" ("Kumagai jinya"), from *Ichinotani futaba gunki (Chronicle of the Battle of Ichinotani), ka.*

Little Song While Dreaming of Yoshiwara, A (Sono kouta yume no Yoshiwara), ka.

"Lord Ōkura" ("Ōkura-kyō"), from *Ichijō Ōkura monogatari (The Tale of Lord Ichijō Ōkura), nj.*

Love of Izayoi and Seishin, The (Izayoi seishin), ka.

Love Messenger from Yamato: The Courtesan Umegawa and Her Lover, Chūbei (Koi bikyaku Yamato ōrai: Umegawa Chūbei).

Love Suicides at Amijima, The (Shinjū ten no Amijima), nj.

Love Suicides at Sonezaki, The (Sonezaki shinjū), nj.

Love Suicides at Toribeyama, The (Toribeyama shinjū), shin ka.

Maiden at Dōjō Temple, A (Musume Dōjōji), sho.

Mansion of Broken Dishes at Banchō, The (Banchō sarayashiki), shin ka.

Matahei the Stutterer (Domo mata), from Keisei hangonkō (The Courtesan of the Hangon Incense), nj.

Message of Love from Yamato, A (Koi no tayori Yamato ōrai), nj.

Miracle at Hakone, The (Hakone reigenki), ka.

Miracle at Tsubosaka Temple, The (Tsubosaka reigenki), nj.

Miracle at Yaguchi Ferry, The (Shinrei yaguchi no watashi), nj.

Mirror Lion (Kagamijishi), sho.

Mirror Mountain: A Woman's Treasury of Loyalty (Kagamiyama kokyō no nishikie), nj.

"Moritsuna's Camp" ("Moritsuna jinya"), from *Ōmi Genji senjin yakata (The Genji Vanguard in Ōmi Province), nj.*

Mount Imo and Mount Se: An Exemplary Tale of Womanly Virtue (Imoseyama onna teikin), nj.

"Mount Yoshino" ("Yoshino Yama"), from *Yoshitsune senbon zakura (Yoshitsune and the Thousand Cherry Trees), nj.*

Mountain Witch, The (Yamauba).

Munechika: The Little Swordsmith (Kokaji), sho.

Naruto on the Straits of Awa (Awa no Naruto), nj.

"Ninokuchi Village" ("Ninokuchi Mura"), from *Koi no tayori yamato ōrai (A Message of Love from Yamato), nj.*

"Nozaki Village" ("Nozaki Mura"), from *Shinpan utazaimon (The Balladeer's New Tale) nj.*

"Numazu" (place name), from *Igagoe dōchū sugoroku (Through Iga Pass with the Tōkaidō Board Game), nj.*

Osen the Cooper's Wife (Taruya Osen), shin.

Ōshū Adachigahara (place name), *nj.*

Paragon of Amusements: The Dream Meeting (Oitotori monochō: Yume no taimen), shin.

Picture Book of the Taikō, The (Ehon taikōki), nj.

Pinning Wind (Hama matsukaze), sho.

Precious Incense and Autumn Flowers of Sendai, The (Meiboku Sendai hagi), nj.

Priest Roben, (Roben sugi no yurai), nj.

"Pulling the Carriage Apart" ("Kuruma biki"), from *Sugawara and the Secrets of Calligraphy (Sugawara denju tenarai kagami), nj.*

Rebellion of the Brother of the Bellflower, The (Toki wa ima kikyō no hata-age), ka.

Saint Narukami (Narukami fudō), ka.

"*Sake* Shop, The" ("Sakaya"), from *Hade sugata onna maiginu (The Lustrous Dancing Girl), nj.*

Sanemori Story, The ("Sanemori Monogatari"), from *Genpei nunobiki no taki, nj.*

Scarface Yosa (Kirare Yosa), ka.

"Separation from Nurse Shigenoi" ("Shigenoi kowakare"), from *Koi nyōbō somewake tazuna* (Multiple Colors of the Pack-Horse Driver and the Beloved Wife), *nj.*

Sequel to the Treasury of Loyal Retainers (Zōhō chūshingura), nj.

Shogun Takatoki, The (Takatoki), ka (katsugekireki).

"Skylight, The" ("Hikimado"), from *Futatsu chōchō kuruwa nikki (Chōgorō and Chōkichi: A Diary of Two Butterflies in the Pleasure Quarters), nj.*

"Soga Nakamura" (character name), from *Chōchidori Soga monogatari (The Butterfly and Plover Tale of the Soga Brothers), nj.*

Stone-Cutting Feat of Kajiwara, The (Kajiwara Heizō no ishikiri), nj.

Subscription List, The (Kanjinchō), ka.

Sugawara and the Secrets of Calligraphy (Sugawara denju tenarai kagami), nj.

Sukeroku: Flower of Edo (Sukeroku yukari no Edo zakura), ka.

Sumida River, The (Sumidagawa), sho.

"Sushi Shop, The" ("Sushiya"), from *Yoshitsune senbon zakura (Yoshitsune and the Thousand Cherry Trees), nj.*

"Suzugamori" (place name), from *Ukiyozuka hiyoku no inazuma (The Floating World's Pattern and Matching Lightning Bolts), ka.*

Tale of Genji, The (Genji monogatari), ka.

Tale of Lord Ichijō Ōkura, The (Ichijō Ōkura monogatari), also called *Kiichi Hōgen* (character's name), *nj.*

Tale of Shuzenji, The (Shuzenji monogatari), shin ka.

Three Handicapped Servants, The (Sannin katawa), sho.

Three Maidens at Dōjō Temple, The (Sannin Dōjōji), sho.

Three-Person Sanbasō (Sannin Sanbasō), also called *Kotobuki sannin Sanbasō (The Felicitous Three-Person Sanbasō), nj.*

Tied to a Pole (Bō shibari), sho/matsu.

Treasury of Loyal Retainers, The (Kanadehon chūshingura), nj.

Tsuchiya Chikara (character name), *shin ka.*

Two Lions (Renjishi), sho.

Two Maidens at Dōjō Temple (Ninin Dōjōji), sho.

"Under the Floor" ("Yuka no shita"), from *Meiboku sendai hagi (The Precious Incense and Autumn Flowers of Sendai) nj.*

Viewing the Autumn Foliage (Momijigari), sho.

"Village School, The" ("Terakoya"), from *Sugawara and the Secrets of Calligraphy (Sugawara denju tenarai kagami), nj.*

"Waterfall" ("Taki"), from *Hakone reigenki (The Miracle at Hakone), ka.*

Wisteria Maiden, The (Fuji musume), sho.

Yosa and the Moon's Boxwood Comb Late at Night (Fukeru yosa tsuki no yokogushi), ka.

Yoshitsune and the Thousand Cherry Trees (Yoshitsune senbon zakura), nj.

Zen Substitute, The (Migawari zazen), matsu/sho.

Notes ❧

PROLOGUE: DANJŪRŌ'S GIRLS

1. Aphra Behn, email correspondence to author, 13 September 2004.

2. Actors never perform under their private names, but are given stage names (*geimei*, literally "art names") that are usually inherited from senior actors in the acting family. Several top-rank names, such as Danjūrō, were repeated within families, and the recipient was also designated with an ordinal number marking his generation. Thus, Ichikawa (family name) Danjūrō (stage name) IX (ordinal). Since the time of Danjūrō IX, the private family name (*honmyō*) of holders of the Ichikawa Danjūrō stage name has been Horikoshi, which had been the private name of Ichikawa Danjūrō I. Hattori Yukio, *Ichikawa Danjūrō dai dai* [Generations of the Ichikawa Danjūrō Line] (Tokyo: Kodansha, 2002), 153.

3. It is considered proper for actors outside the Naritaya house to ask the head (*iemoto*) for permission to perform any of the Naritaya *ie no gei* pieces. All the plays listed are considered part of the "eighteen favorite plays" (*jūhachiban*) of the Ichikawa Danjūrō acting family.

4. Yoshida Setsuko, *Edo kabuki hōrei shūsei* [Collection of Edo Kabuki Ordinances] (Tokyo: Ōfūsha, 1997), 21.

5. Torigoe Bunzō, "A Note on the Genesis of *Onnagata*," in *Transvestism and the Onnagata Traditions in Shakespeare and Kabuki*, ed. Minoru Fujita and Michael Shapiro (Kent, CT: Global Oriental, 2006), 1.

6. See Kyōdō Tsushinsha, ed., *Kabuki yonhyakunen ten* [Exhibition on Kabuki's Four Hundred Years] (Tokyo: Kyōdō Tsushinsha, 2003), 28.

7. For a discussion of kabuki as queer theatre, see Ayako Kano, *Acting Like a Woman in Modern Japan: Theatre, Gender, and Nationalism* (New York: Palgrave, 2001), 58–60. The word kabuki is composed of three Chinese ideographs for song (歌), dance (舞), and skill (伎); before the Meiji period, the character for "prostitute" (妓) was used instead of "skill." During Okuni's time, however, the word kabuki was written in the hiragana script (かぶき). The verb *kabuku* can be translated as "to slant," though by the time of the Tokugawa period, it had become slang for unconventional manners of dress or anti-conformist modes of behavior. Benito Ortolani, *The Japanese Theatre: From Shamanistic Ritual to Contemporary Pluralism* rev. ed (Princeton: Princeton University Press, 1995), 164.

8. See Donald H. Shively, "*Bakufu* versus Kabuki," in *A Kabuki Reader: History and Performance*, ed. Samuel L. Leiter (Armonk, NY: M.E. Sharpe, 2002), 36. See also Yoshida, *Edo kabuki*.
9. Gregory M. Pflugfelder, *Cartographies of Desire: Male-Male Sexuality in Japanese Discourse, 1600–1950* (Berkeley: University of California Press, 1999), 77–80, 113–122; Donald H. Shively, "The Social Environment of Tokugawa Kabuki," in *Studies in Kabuki: Its Acting, Music, and Historical Context*, ed. James R. Brandon, William P. Malm, and Donald Shively (Honolulu: University of Hawaii Press, 1978), 10; Katherine Mezur, *Beautiful Boys/Outlaw Bodies: Devising Kabuki Female Likeness* (New York: Palgrave Macmillan, 2005), 54–57, 137–207.
10. Samuel L. Leiter, "From Gay to *Gei*: The *Onnagata* and the Creation of Kabuki's Female Characters," in *A Kabuki Reader: History and Performance*, ed. Samuel L. Leiter, 212.
11. Kano, *Acting Like a Woman*, 31–32; Maki Isaka [Morinaga], "Women *Onnagata* in the Porous Labyrinth of Femininity: On Ichikawa I," *U.S.-Japan Women's Journal* 30–31 (2006): 105–131; James R. Brandon, "Kabuki and Shakespeare: Balancing Yin and Yang," *The Drama Review* 43:2 (Summer 1999): 23–24; See my articles, "The Female Danjūrō: Revisiting the Acting Career of Ichikawa Kumehachi," *Journal of Japanese Studies* 34:1 (Winter 2008): 69–98 and Loren Edelson, "The Return of the Actress to the Public Stage," in *Gender and Law in Imperial Japan*, ed. Barbara Brooks and Susan Burns (submitted to Ann Arbor: University of Michigan, Japan Series).
12. See "Scenes in the Life of a Travelling Actress (after Kuniyoshi)," in Timothy Clark, *Ukiyo-e Paintings in the British Museum* (Washington, D.C.: Smithsonian Institution Press, 1992), 208.
13. Maki Isaka posits that their wealthy patrons "could not easily go to such vulgar places as playhouses due to their social status." Furthermore, many "were also bound by regulations such that they could not receive male visitors at their residences." "Women *Onnagata*," 108. Regarding the *okyōgen-shi*, see Norizuki Toshihiko, "Okyōgen-shi to iu Edo no joyū" [The Edo Period Actress Called Okyōgen-shi], *Geinō* [Performance] (September 1992): 10–16. This article appeared in a special issue of *Geinō* that was dedicated to "Women in the History of Kabuki" [Kabukishi no naka no onnatachi]. See also Andrew C. Gerstle, "Eighteenth-Century Kabuki and Its Patrons," in *A Kabuki Reader: History and Performance*, ed. Samuel L. Leiter, 2002 [1987], 101; Koike Shōtarō, "Daimyō nikki ga egaku aru Edo joyū" [An Edo Actress as Portrayed in a Daimyō's Diary], *Rekishi to jinbutsu* [History and Individuals] 10:11 (1980): 214–218; Waseda Daigaku Engeki Hakubutsukan, ed., *Engeki hyakka daijiten* [Theatre Encyclopedia] (Tokyo: Heibonsha, 1963), 1: 426.
14. Alternate attendance (*sankin kōtai*), instituted in 1634, required the nation's feudal lords to maintain residences in Edo where their families would remain hostages when they returned to their domains. For more on the *sankin kōtai* system, see Constantine N. Vaporis, "To Edo and Back: Alternate Attendance

and Japanese Culture in the Early Modern Period," *Journal of Japanese Studies* 23:1 (Winter 1997): 25–67. In 1868, the Meiji emperor was declared the sole ruler of Japan, and the seat of imperial authority was moved from Kyoto to Edo, renamed Tokyo (Eastern Capital).

15. See Edelson, "The Female Danjūrō," 76–77. For an alternative argument, see Kano, *Acting Like a Woman*, 32.

16. Brandon, "Kabuki and Shakespeare"; Miyake Saburō, *Koshibai no omoide* [Memories of Minor Theatre] (Tokyo: Kokuritsu Gekijō Geinō Chōsashitsu, 1981), 1–7.

17. In 1959 Ozu remade the film in color with different actors, including the grand kabuki star, Nakamura Ganjirō II (1902–1983).

18. For an in-depth study of Kumehachi in English, see Edelson, "The Female Danjūrō," 69–98. See also Isaka, "Women *Onnagata*," 105–131.

19. On classicalization in postwar kabuki, see James R. Brandon, "Myth and Reality: A Story of Kabuki during American Censorship, 1945–1949," *Asian Theatre Journal* 23:1 (Spring 2006): 1–110 and "Kabuki and the War of Greater East Asia, 1931–1945," *Mime Journal: Theatre East and West Revisited* 22 (2002–2003): 19–39. See also Samuel L. Leiter, "Kumagai's Battle Camp: Form and Tradition in Kabuki Acting," in *Frozen Moments: Writings on Kabuki, 1966–2001* (Ithaca, NY: Cornell East Asian Series, 2002), 157–182.

20. See Koike Shōtarō, "Okyōgen-shi," in *Kabuki jiten* [Kabuki Encyclopedia], ed. Hattori Yukio et al. rev. ed. (Tokyo: Heibonsha, 2000), 93; Samuel L. Leiter, *New Kabuki Encyclopedia: A Revised Adaptation of Kabuki Jiten* (Westport, CT: Greenwood, 1997), 198; Waseda, ed., *EHD*, 1: 169; Yamagawa Kazuo, "Ichikawa Shōjo Kabuki" [Ichikawa Girls' Kabuki], in *Sengō geinōshi monogatari* [Stories of Postwar Performance History] (Tokyo: Asahi Shinbun Gakugei-bu, 1987), 76–79; Shinhen Toyokawa-shi Henshū Iinkai, ed., *Toyokawa-shishi* [Toyokawa City History] (Toyokawa: Toyokawa-shi, 2001), 9: 1133–1134; "Ichikawa Shōjo Kabuki," http://www.naritaya.jp/learn/jiten/a.html#i01 (accessed 26 May 2008).

21. The Japanese title of the exhibition was "Kabuki yonhyakunen ten," and it was held during 9–28 July 2003 in Tokyo and Nagoya. The Nagoya exhibition was cosponsored by the Shōchiku Theatrical Corporation and the Geijutsu Bunka Shinkō kai (Society to Promote Artistic Culture) as well as by the *Chūnichi shinbun* and Kyōdō Tsushinsha. The omission of Ichikawa Girls' Kabuki was particularly disheartening, since the troupe had performed frequently in theatres owned by Shōchiku.

22. Tracy Davis, "Questions for a Feminist Methodology in Theatre History," in *Interpreting the Theatrical Past: Essays in the Historiography of Performance*, ed. Bruce McConachie and Thomas Postlewait (Iowa City: Iowa Press, 1989), 63.

23. Leslie Ferris, *Acting Women: Images of Women in Theatre* (New York: New York University Press, 1989), xi.

24. One important exception is Maki Isaka's recent article "Women *Onnagata*."

25. See, e.g., Tetsuo Kishi, chair, "Forum: Gender in Shakespeare and Kabuki," in *Transvestism and the Onnagata Traditions in Shakespeare and Kabuki*, ed. Minoru Fujita and Michael Shapiro, 195.
26. Barbara Molony and Kathleen Ueno, eds., *Gendering Modern Japanese History* (Cambridge: Harvard University Asia Center, 2005), 23.
27. Ibid.
28. Mezur, *Beautiful Boys*, 2.
29. Ichikawa Ebizō IX to Ichikawa Masujūrō, 23 February 1956, no. 26, Ichikawa Shōjo Kabuki collection. Sakuragaoka Museum, Toyokawa, Japan; Ichikawa Sanshō V to Ichikawa Masujūrō. Letters, 28 February 1953–6 January 1956, nos. 1–25, 28, 30, Ichikawa Shōjo Kabuki collection. Sakuragaoka Museum, Toyokawa, Japan; Sakuragaoka Museum, ed., "Ichikawa Shōjo Kabuki ten" [Exhibition on Ichikawa Girls' Kabuki] (pamphlet, Sakuragaoka Museum, Toyokawa, Japan, 28 April–28 May 1995). Ichikawa Masujūrō, "Ichikawa Shōjo Kabuki kōenkai: Ichikawa Shōjo Kabuki are kore" [Symposium on the Ichikawa Girls' Kabuki: Pondering Ichikawa Girls' Kabuki] (lecture, Sakuragaoka Museum, Toyokawa, Japan, 7 May 1995). Transcript courtesy Sakuragaoka Museum.
30. Ichikawa Masujūrō, *Kabuki jinsei* [A Kabuki Life] (Toyohashi: Hōbundō, 1983); Ono Haruyoshi, *Ono Haruyoshi jidenshō mizube danwa* [Autobiographical Discussions by Ono Haruyoshi] (Kyoto: Shirakawa Shoin, 1978); Ichikawa Baika, "Matsuba-botan no ki" [Journal of Miniature Peonies], *Mainichi*, 1993; Kurokawa Mitsuhiro, "Maboroshi no Ichikawa Shōjo Kabuki" [Phantom Ichikawa Girls' Kabuki], *Chūnichi*, 1984.
31. A fuller discussion of these allegations will be provided in chapter 7.
32. Ichikawa Baika, interview by author, 4 March 2004, Toyokawa, Japan.

1. DANJŪRŌ IX AND THE ACTRESS QUESTION

1. Kurt Meissner, trans., *Geisha in Rivalry* (Tokyo: Charles E. Tuttle, 1963), 124. Edward Seidensticker alternatively translates the title *A Test of Skills* in his *Low City, High City: Tokyo from Edo to the Earthquake* (New York: Alfred A. Knopf, 1983), 290.
2. The mother of Danjūrō IX was the mistress of Danjūrō VII, who bore four of the eight sons of Danjūrō VII. Hattori, *Ichikawa Danjūrō*, 153. See Sharon L. Sievers, *Flowers in Salt: The Beginnings of Feminist Consciousness in Modern Japan* (Stanford, CA: Stanford University Press, 1983), 10–25.
3. Danjūrō III and Danjūrō IV were the adopted sons of Danjūrō II; Danjūrō VI was the adopted son of Danjūrō V, and Danjūrō VII was the adopted son of Danjūrō VI. See Hattori, *Ichikawa Danjūrō*, 153. Danjūrō IX adopted his younger brother's son, Akabei (1864–1877), the biological son of Danjūrō VII's sixth son, Ichikawa Kōzo (d. 1875). See also Nojima Jusaburō, *Kabuki*

jinmei jiten [Biographical Dictionary of Kabuki], rev. ed. (Tokyo: Nichigai, 2002), 99; Ichikawa Suisen III, *Kudaime Danjūrō to watashi* [Danjūrō IX and Me] (Tokyo: Rikugei Shobo, 1966), 12.

4. For unknown reasons, a woodblock print by Toyohara Kunichika lists Jitsuko's name as Saneko. See James R. Brandon and Samuel L. Leiter, eds., *Kabuki Plays on Stage: Restoration and Reform, 1872–1905* (Honolulu: University of Hawaii Press, 2003), 347.

5. Kano, *Acting Like a Woman*, 6.

6. Ihara Seiseien, *Meiji engekishi* [History of Meiji-Period Theatre] (Tokyo: Kuresu Shuppan, 1933), 387.

7. See Kano, *Acting Like a Woman*, 15–24; Matsumoto Shinko, *Meiji engekironshi* [A History of Meiji Theatre Discussions] (Tokyo: Engeki Shuppansha, 1980), 153–162.

8. Kamiyama Akira, "Kindai ni okeru kabuki no henyō" [The Transition of Kabuki in Modernization], in *Kabuki: Changes and Prospects*, ed. International Symposium on the Conservation and Restoration of Cultural Properties (Tokyo: Tokyo National Research Institute of Cultural Properties, 1996), 159–169.

9. Matsumoto Shinko, *Meiji engekironshi*, 156.

10. *Yomiuri*, 10 September 1887. See Edelson, "The Return of the Actress to the Public Stage." See also *Tōkyō nichi nichi shinbun*, 11 July 1888.

11. Ibid.

12. Maki Isaka Morinaga, "The Gender of *Onnagata* as the Imitating Imitated: Its Historicity, Performativity, and Involvement in the Circulation of Femininity," *Positions: East Asia Cultures Critique* 10:2 (2002): 247–252; Isaka, "Women *Onnagata*," 107. See also Judith Butler, "Imitation and Gender Insubordination," in *Inside/Out: Lesbian Theories, Gay Theories*, ed. Diana Fuss (New York: Routledge, 1991), 312–313. See also Kano, *Acting Like a Woman*, 31.

13. *Tōkyō nichi nichi shinbun*, 11 July 1888. See also Edelson, "Return of the Actress"; Samuel L. Leiter, "Female-Role Specialization in Kabuki: How Real Is Real?" in *Frozen Moments: Writings on Kabuki, 1966–2001* (Ithaca, NY: Cornell East Asian Series, 2002), 150.

14. Matsumoto, *Meiji engekironshi*, 156.

15. Kano, *Acting Like a Woman*, 8; see also 9–11 and 27–32.

16. Isaka, "Women *Onnagata*," 119.

17. Ibid.

18. Danjūrō took the pen name "Danshū" in 1877 after playing the role of the loyalist samurai Saigō Takamori, who was nicknamed Nanshū. Toita Yasuji, "Ichikawa Kumehachi no sarashi momen" [Ichikawa Kumehachi's Cotton Wrap] *Naki dokoro jinbutsushi* [People Who Hit a Nerve] (Tokyo: Bungei Shunjū, 1987), 109.

19. Ichikawa Kumehachi, "Geidan hyakuwa" [One Hundred Sayings about Art], *Engei gahō* [Theatre Illustrated] (April 1907): 83–84. To my knowledge, the only other woman to be called the "female Danjūrō " was Ichikawa Botan

(1886–1943), a popular kabuki female actor who led her own all-female kabuki troupe ("Onna Kabuki no Ichikawa Botan Ichi-za") from 1912 until her death. See Nichigai Asoshietsu, ed., *Geinō jinbutsu jiten: Meiji Taishō Shōwa* [Dictionary of Performing Artists from the Meiji, Taishō, and Shōwa periods] (Tokyo: Nichigai Asoshietsu, 1998), 58.

20. Ichikawa Kumehachi, "Geidan hyakuwa," 84.

21. *Tōkyō nichi nichi shinbun*, 11 July 1888; Toita, "Sarashi momen,"109.

22. Toita, "Sarashi momen," 109. For a biographical sketch of Matasaburō, see Nojima, *Kabuki jinmei jiten*, 555–556.

23. Hasegawa Shigure, "Ichikawa Kumehachi," *Kindai bijin den* [Tales of Modern Beauties] (Tokyo: Sairensha, 1936), 193; Ihara, *Meiji engekishi*, 506–507; Okamoto Kidō *Ranpu no moto nite* [Under the Lamp: Discussions on Meiji Theatre] rev. ed. (Tokyo: Seiabō, 1965), 150; Toita, "Sarashi momen," 112–113. Ihara Seiseien's *Kabuki nenpyō* [Kabuki Chronology] (Tokyo: Iwanami Shoten, 1956–1963), the most comprehensive record of kabuki productions in Edo and Osaka, does not note any such performance by Danjūrō and Kumehachi.

24. Matsui Shōyō, *Danshū hyakuwa*, Kinsei bungei kenkyū sōsho series, rev. ed (Tokyo: Kuresu Shuppan, 1997), 30–31.

25. The print is part of the collection of the Ruth Chandler Williamson Gallery of Scripps College. The gallery's website notes that the print's date is 1889, but the cartouche clearly gives the date Meiji 21 (1888). See http://web-kiosk. scrippscollege.edu (accessed 14 May 2008).

26. Ihara, *Kabuki nenpyō*, 7:342.

27. Ibid.; Waseda University Theatre Museum collection, FA1–00387.

28. See, e.g., Ihara, *Meiji engekishi*, 700–701; Matsumoto, *Meiji engekironshi*, 156–158; Okamoto, *Ranpu no moto nite*, 146; See also, Brandon, "Shakespeare and Kabuki," 24.

29. Ōzasa Yoshio, *Nihon gendai engekishi* [History of Japanese Contemporary Theatre] (Tokyo: Hakusuisha, 1985), 1:61; Matsumoto, *Meiji engekironshi*, 156–158.

30. According to Faith Bach, this was the first time in history that an actor had been expelled over an artistic issue. Faith Bach, "The Contributions of Omodakaya to Kabuki" (Ph.D. diss., St Anthony College, University of Oxford, 1990), 31–50; Faith Bach, "Breaking the Kabuki Actors' Barriers: 1868–1900," in *A Kabuki Reader: History and Performance*, ed. Samuel L. Leiter, 158, 166.

31. See James R. Brandon and Samuel L. Leiter, eds., *Kabuki Plays On Stage*, 302–303.

32. *Yomiuri*, 1 August 1893; 5 December 1893; 9 December 1893; 11 December 1893; *Kabuki*, September 1913, quoted in Morizui Kenjiki, "Ichikawa Kumehachi debunki I: aru onna yakusha no kojitsu" [Rumors about Kumehachi: Things That Female Actor Said, Part I], *Jissen bungaku* [Practical Literature] (March 1971): 46; Okamoto, *Ranpu no moto nite*, 151; Nojima, *Kabuki jinmei jiten*, 77.

33. For a calendar of Danjūrō IX's productions, see Ihara Seiseien, *Ichikawa Danjūrō no dai dai* [The Generations of Ichikawa Danjūrō], rev. ed. (Tokyo: Kuresu Shuppan, 1997), 147–164. See also Nagayama Takeomi, ed., *Kabuki-za hyakunenshi* [One Hundred Years of Kabuki-za History] (Tokyo: Shōchiku Kabushiki Gaisha, 1993), 1:1: 79; *Yomiuri*, 7 March 1893; Sugiura Zenzō, *Joyū kagami* [Actress Mirror] (Tokyo: Sugiura Shuppanbu, 1912), 70–71; Engei Gahō, ed., *Nihon haiyū meikan* [Facebook of Japanese Actors] (Tokyo: Engei Gahō, 1910), 76.

34. *Yomiuri*, 7 March 1893. Ichikawa Suisen III gives a detailed account of the play in Ichikawa Sanshō, ed., *Kagamijishi*.

35. *Yomiuri*, 7 March 1893. The print is dated April 1893. See also Nagayama, *Kabuki-za hyakunenshi*, 1: 79.

36. *Yomiuri*, 7 March 1893. According to the *Yomiuri*, the haiku was written on a commemorative fan. The print that I have described is shaped as a fan, so it is likely that this haiku was printed on the reverse side.

37. Ibid. For another woodblock print of Jitsuko, Fukiko, and Danjūrō in *Mirror Mountain*, see Nagayama, *Kabuki-za hyakunenshi*, 1: front matter.

38. According to Sugiura, the daughters took part in an "actress ceremony" in 1909. This might have been the occasion on which they assumed their stage names (*Joyū kagami*, 70–71).

39. Ihara, *Meiji engekishi*, 506–507; Ihara, *Kabuki nenpyō*, 7: 413–414; Matsui, *Danshū hyakuwa*, 30–31.

40. *Yomiuri*, 2 April 1894. For a picture of Danjūrō fishing with his wife while his daughters look on, see Ihara Seiseien, *Ichikawa Danjūrō* rev. ed. (Tokyo: Kuresu Shuppan, 1997), 11.

41. Ihara, *Kabuki nenpyō*, 7: 431

42. Ihara notes that other actors were not in agreement with Danjūrō's view of actresses (*Meiji engekishi*, 506), an assessment that Danjūrō himself ultimately acknowledged. See Matsui, *Danshū hyakuwa*, 30–31; Zoë Kincaid, *Kabuki: The Popular Stage of Japan*, rev. ed. (New York: Benjamin Blom, 1965), 353.

43. Matsui Tōru, *Ichikawa Sadanji II* (Tokyo: Musashi Shobō, 1942), 117–118 and Appendix 3; Mine Takashi, *Teikoku Gekijō kaimaku: kyo wa Teigeki ashita wa Mitsukoshi* [The Opening of the Imperial Theatre: Today the Imperial, Tomorrow Mitsukoshi] (Tokyo: Chūkō Ronsha, 1996), 226.

44. Mine, *Teikoku Gekijō*, 221–226. Despite the objections of critics to the mixed kabuki productions in 1912, Mine notes that the upper middle-class audience welcomed the experiment. Unfortunately, he does not provide his source. See also Kano, *Acting Like a Woman*, 73–75.

45. Sawamura Tanosuke VI, interview with author, 18 August 2004, Tokyo.

46. Sugiura, *Joyū kagami*, 70.

47. Ōe Ryōtarō, "Shinpa no hitobito: Ichikawa Suisen no koto" [People in *Shinpa*: Things about Ichikawa Suisen], *Engekikai* (May 1962): 87.

48. Ichikawa Sanshō V, *Kyusei Danjūrō o kataru* [Talking about Danjūrō IX] (Kyoto: Suiko Shoin, 1950), 127.
49. *Yomiuri*, 23 July 1894. The *Jiji shinpō* states that she was Russian (12 July 1894).
50. Henry Lyonnet, *Dictionnaire des Comédiens Français* (Genève: Bibliothèque de la Revue Universelle Internationale Illustrée, 1901), 679.
51. Nagayama, *Kabuki-za hyakunenshi*, 1: 85.
52. *Yomiuri*, 8 July 1894.
53. Ihara, *Kabuki nenpyō*, 7: 437. According to the *Jiji shinpō*, it was a two-day program (12 July 1894).
54. *Yomiuri*, 23 July 1894.
55. Ibid.
56. Ichikawa Sanshō, *Kyusei Danjūrō*, 127.
57. Matsui, *Danshū hyakuwa*, 35.
58. Ibid.
59. Morizui, "Debunki I," 43; Ichikawa Kumehachi, "Meika shinsōroku," *Engei gahō* (September 1907): 116. Kumehachi's new stage name was announced in the *Yomiuri*, 12 February 1895. According to Ihara, this name was also announced at the Ichimura-za on 30 January 1895, in which she appeared in a play directed by Kawakami Otojirō. *Kabuki nenpyō*, 7: 447.
60. *Yomiuri*, 12 February 1895.
61. Ichikawa, "Meika shinsōroku," 116.
62. Ibid.
63. Ibid.
64. Kamiyama Akira, "Kumehachi no zanzō: onna yakusha to joyū no aidai," [Images of Kumehachi: Between Female Actor and Actress]. *Geinō* [Performing Arts] 34:9 (September 1992): 18.
65. Matsui, *Danshū hyakuwa*, 30–31.
66. Ibid.; See also *Tōkyō*, 11 July 1888; Sugiura, *Joyū kagami*.
67. Toita, "Sarashi momen," 113–114.
68. Morizui, "Debunki I," 43.
69. Ibid., 43–44; Toita, "Sarashi momen," 112; Ōzasa, *Nihon gendai engekishi*, 61.
70. See Ihara, *Kabuki nenpyō*, 8: 144, 244; Kano, *Acting Like a Woman*, 69; Toita, "Sarashi momen," 113; Ōzasa, *Nihon gendai engekishi*, 481; Morizui, "Debunki I," 44.
71. *Yomiuri*, 13 April 1905; Morizui, "Debunki I," 46; See also Toita, "Sarashi momen," 112–113; Nagayama, *Kabuki-za hyakunenshi*, 1: 217.
72. See Hasumi Seitarō, "Onna yakusha no hanashi" [Talk about Female Performers] *Gendai no kabuki haiyū* [Contemporary Kabuki Actors], special issue, *Engekikai* [Theatre World] (December 1955): 46–47; Toita, "Sarashi Momen," 107; see also Waseda, ed., *EHD*, 4: 239.
73. Toita, "Sarashi momen," 114.
74. Kincaid, *Kabuki*, 63.

2. THE FORMATION OF THE ICHIKAWA GIRLS' KABUKI TROUPE

1. Ichikawa Baika, interview.
2. Ibid.; John W. Dower, *Embracing Defeat: Japan in the Wake of World War II* (New York: W.W. Norton, 1999).
3. Ichikawa Masujūrō, "ISKK," 2. See also Noguchi Tatsuji, "Ichikawa Shōjo Kabuki no ayumi" [Development of Ichikawa Girls' Kabuki], in "Gendai no kabuki haiyū" [Contemporary Kabuki Actors], special issue, *Engekikai* (December 1955): 134–136. His article was later reprinted, without any attribution, in the *Tōkai tenpō* [Tōkai News] as "Hamamatsu de sodatta Ichikawa Shōjo Kabuki [Raised in Hamamatsu: Ichikawa Girls' Kabuki] (July 1956): 44–46.
4. See Ichikawa Masujūrō, *KJ*, 10–12. See also Kurokawa Mitsuhiro, "Musume no oya-tachi wa geisuki datta" [The Girls' Parents Liked Performing Arts], *Chūnichi*, 6 January 1984.
5. Noguchi, "Ichikawa Shōjo Kabuki," 134.
6. Ichikawa Masuyo, interview by author, 23 March 2004, Tokyo, Japan.
7. Ichikawa Misuji, "Shōjo kara onna e no nayami" [Concerns (about Going) from a Girl to a Woman], *Fujin gahō* [Ladies Illustrated] (September 1958): 232–234; Noguchi, "Ichikawa Shōjo Kabuki," 134. See also Tsuchiya Chikashi, "Shōjo kabuki no jūnen" [Girls' Kabuki's Ten Years], "Haiyū hyakka" [Directory of Kabuki Actors], special issue, *Engekikai* (December 1959): 172–173; Ichikawa Masuyo, interview; See Kurokawa, "Musume"; Ichikawa Masujūrō, "ISKK," 2.
8. Jennifer Robertson, *Takarazuka: Sexual Politics and Popular Culture in Modern Japan* (Berkeley: University of California Press, 1998). On the Shōchiku Revue, see Waseda, ed., *EHD*, 3: 211. Both troupes were called by other names, but I refer to them as Takarazuka and Shōchiku Revue (SKD).
9. See Noguchi, "Ichikawa Shōjo Kabuki," 134; Ichikawa Masuyo, interview.
10. Kurokawa Mitsuhiro, "Nomikomi no hayai onna no ko" [The Girls Who Learned Quickly], *Chūnichi*, 9 January 1984.
11. Ichikawa Masujūrō, *KJ*, 37–38, 43–50, 120–121, 189. In prewar Japan, students on a vocational track went to an upper primary school instead of middle school. Middle school corresponded roughly to the postwar high school and was mainly attended by college-bound men.
12. Ibid., 57, 59, 65, 189. Ichikawa Masujūrō, "ISKK," 2. He was not, however, a direct disciple of Ichikawa Danjūrō IX, which occasionally was reported in the press. See, e.g., "Otana ni natta shōjo kabuki" [Girls' Kabuki That Has Become Adult], *Sandê mainichi* [Sunday Mainichi], 10 June 1956, 39–41.
13. Ichikawa Masujūrō, *KJ*, 63–88, Ichikawa Masujūrō, "ISKK," 2.
14. Ichikawa Ebimaru, interview by author, 16, 28 April 2004, Toyokawa, Japan. Regarding Ebijūrō, see Ichikawa Masujūrō, "ISKK," 2; Kobayashi Katsunojō, "Wasurareta haiyū-tachi" [Forgotten Actors], *Engei gahō* (September 1940): 68; Nichigai Asoshietsu, ed., *Geinō jinbutsu jiten*, 47. Kurokawa Mitsuhiro,

"Dai ikkai happyōkai wa daiseiko" [The First Recital Is a Success], *Chūnichi*, 23 January 1984.

15. See Ichikawa Masujūrō, *KJ*, 98–100.
16. Ichikawa Masujūrō, "ISKK," 2.
17. Ichikawa Masujūrō, *KJ*, 101. Eriko subsequently became a member of Ichikawa Girls' Kabuki.
18. Ibid., 104.
19. Ibid., 105.
20. Ibid., 114.
21. Ibid., 107–108, 189; Ichikawa Masujūrō, "ISKK," 2.
22. Ichikawa Masujūrō, *KJ*, 115. On kabuki wartime regulations, see Brandon, "Myth and Reality" and "Kabuki and the War," 19–39; Marlene J. Mayo, "To Be or Not to Be: Kabuki and Cultural Politics in Occupied Japan," in *War, Occupation and Creativity: Japan and East Asia, 1920–1960*, ed. Marlene Mayo and J. Thomas Rimer (Honolulu: University of Hawaii, 2001), 272–275; Okamoto Shiro, *The Man Who Saved Kabuki: Faubion Bowers and Theatre Censorship in Occupied Japan*, trans. and adapt. Samuel L. Leiter (Honolulu: University of Hawaii, 2001).
23. Masujūrō does not discuss the fate of his first marriage in his autobiography, but according to his daughter, Ichikawa Emiko, he and his wife never officially divorced, and his marriage to Sumihachi was never registered in the Japanese National Family Registry (Ichikawa Emiko, interview by author, 2 June 2004, Toyohashi, Japan). She and Masujūrō later separated, and he married a third time, this time to Suzuki Sachiko, a member of the Ichikawa Girls' Kabuki Troupe. Ichikawa Suzume, interview by author, 5 April 2004, Toyohashi, Japan.
24. Ōe Ryōtarō, "Hamamatsu no Ichikawa Shōjo Kabuki" [Ichikawa Girls' Kabuki of Hamamatsu], *Engekikai* (December 1952): 76–78; Ichikawa Masujūrō, *KJ*, 117.
25. See Brandon, "Kabuki and the War," 30; Ichikawa Masujūrō, *KJ*, 117; for a discussion of "The Apple Song," see Dower, *Embracing Defeat*, 172–173 and Alan M. Tansman, "Mournful Tears and *Sake*: The Postwar Myth of Misora Hibari," in *Contemporary Japan and Popular Culture*, ed. John Whittier Treat (Honolulu: University of Hawaii, 1996), 103–133. For an alternate view on theatre troupes in the immediate postwar period, see Marilyn Ivy, *Discourses of the Vanishing* (Chicago: University of Chicago Press, 1995), 198.
26. Ichikawa Masujūrō, *KJ*, 117–118; Ichikawa Sanpuku, interview.
27. Samuel L. Leiter, "From Bombs to Booms: Kabuki's Revival in Tokyo during the Occupation," in *Rising from the Flames: The Rebirth of Theatre in Occupied Japan, 1945–1952*, ed. Samuel L. Leiter (Lexington Press, forthcoming).
28. Ichikawa Masujūrō, *KJ*, 121.
29. Ibid., 122.
30. Kurokawa Mitsuhiro, "Hatsu geiko de shishō mo zessan" [Praise Too from the Master at the First Practice], *Chūnichi*, 11 January 1984; Ichikawa Masujūrō, "ISKK," 2.

31. See Kurokawa, "Hatsu geiko."
32. Ichikawa Baika, interview; Ōki Yutaka, "Shishunki ni tasshita: Ichikawa Shōjo Kabuki" [Ichikawa Girls Kabuki Reaches Puberty], *Shūkan Tōkyō* [Tokyo Week], 5 July 1958, 82; Ichikawa Baika, "Ōatari, shōjo kabuki" [Smash Success, Girls' Kabuki], *Mainichi*, 11 January 1993.
33. Ichikawa Baishō, interview; Ichikawa Baika, interview.
34. Ichikawa Baika, "Honkaku gekijō de ronguran" [A Long Run in a Real Theatre], *Mainichi*, 18 January 1993.
35. Ichikawa Masujūrō, *KJ*, 125.
36. Noguchi, "Ichikawa Shōjo Kabuki," 134. See also Kurokawa Mitsuhiro, "Ryōriya no nikai de keiko" [Practice on the Second Floor of the Restaurant], *Chūnichi*, 7 January 1984; Kurokawa, "Nomikomi."
37. Toyokawa chihō no gekijō [Toyokawa Regional Theatres] (unpub. documents, Toyokawa: Sakuragaoka Museum, box 1). According to *Engekikai*, the troupe also performed "Pulling the Carriage Apart." Tsuchiya, "Shōjo Kabuki no jūnen," 172.
38. Kurokawa, "Dai ikkai happyōkai."
39. Ichikawa Masujūrō, *KJ*, 129, 133. See also Miyake Shūtarō, "Daigekijō ni deta shōjo kabuki" [Girls' Kabuki Appears on a Big Stage], *Mainichi* (evening), 4 May 1953; Noguchi, "Ichikawa Shōjo Kabuki," 134.
40. By the time of the 1949 performance, SCAP had relaxed its policy concerning kabuki censorship. See Brandon, "Myth and Reality," 14.
41. Ichikawa Masujūrō, "ISKK," 3.
42. Ibid. Note that the transcript differs in places from Masujūrō's recorded remarks, available on cassette tape. See Okamoto, *The Man Who Saved Kabuki*, 26.
43. Leiter, "From Bombs to Booms."
44. Ichikawa Masujūrō, *KJ*, 137.
45. Ichikawa Suzume, interview.
46. Ichikawa Masujūrō, *KJ*, 136.
47. Kobayashi Ichizō first called the troupe Takarazuka Shōkatai (Takarazuka Choir), but changed the name to Takarazuka Shōjo Kageki Yōseikai (Takarazuka Girls' Opera Training Association) five months later (Robertson, *Takarazuka*, 5). Shōchiku Revue was initially called Shōjo Kageki (Shōchiku Girls' Revue or SSK).
48. Torigoe, "A Note," 3.
49. Robertson, *Takarazuka*, 63–65.
50. Ibid., 63.
51. Ibid., 8.
52. Kano, *Acting Like a Woman*, 26.
53. Kurokawa Mitsuhiro, "Nojuku mo shita nagaki jungyō" [Also Spending the Night Outside on a Long Tour], *Chūnichi*, 24 January 1984.
54. Ibid.; Ichikawa Baika, "Gonan, yobikomi mimau aotake" [Difficulties, Being Screamed at and Hit with a Green Bamboo Pole], *Mainichi*, 25 January 1993.
55. Kurokawa, "Nojuku mo shita."

56. Kurokawa Mitsuhiro, "Ise jungyō wa sansan na kekka" [Disastrous Results for the Ise Tour], *Chūnichi*, 25 January 1984. Dankichi told Kurokawa that he was merely joking, but several years later, *Engekikai* reported that the troupe actually had been stranded in Ise since it did not have money for the train ride home. Noguchi, "Ichikawa Shōjo Kabuki," 135.

57. Ichikawa Masujūrō, *KJ*, 138; "Otona ni natta," 41.

58. Ichikawa Masujūrō, *KJ*, 149–150.

59. Ibid., 151.

60. Ibid.

3. NAME RECOGNITION

1. Uchiyama Tsuneo, "Hamamatsu to jūdaime Danjūrō: Ichikawa Shōjo Kabuki sodate no oya" [Hamamatsu and Danjūro X: The Parent Who Raised Ichikawa Girls' Kabuki], *Tōtōmi* [The Far Lake] 25 (March 2002): 9–18. Enshū is the former name for Shizuoka Prefecture where Hamamatsu City is located. Note that the play's Hamamatsuya dry goods shop is set in Kamakura.

2. Ono Haruyoshi, *Ono Haruyoshi jidenshō mizube danwa* [Autobiographical Discussions by Ono Haruyoshi] (Kyoto: Shirakawa Shoin, 1978), 146; *Tōkai tenpō* (February 1968): 80–83; see also Takasago En, ed., *Takasagoya: sōritsu sanjūnen kinen: sanjūnen no ayumi* [The Thirty-Year Anniversary of the Takasago Inn: A History of Thirty Years] (Hamamatsu: Oda Kogeisha, 1979). According to Ichikawa Kobotan, Ono was producing "strip shows" at the theatre (Interview by author, 29 April 2004, Gifu City).

3. Ichikawa Masujūrō, *KJ*, 137; Toshikura Yoshikazu, "Hamamatsu no shōjo kabuki" [Hamamatsu's Girls' Kabuki], *Engekikai* (October 1952): 34–35. Kaneko Seiji inherited the task of managing the Hamamatsu-za from his uncle, who had owned the theatre before the war. According to Ono Haruyoshi, Kaneko invited him to become the president and joint owner of the theatre. Kaneko became the theatre's executive director. See Ono, *Ono Haruyoshi*, 150–152.

4. Ono, *Ono Haruyoshi*, 148–149.

5. Ibid., 152; Ichikawa Masujūrō, *KJ*, 137.

6. Ono, *Ono Haruyoshi*, 153.

7. Ibid.

8. Saitō Sadaichirō, "Hamamatsu jōen kabuki shibai kiroku" [A Record of Kabuki Plays Performed at Hamamatsu] (unpub. scroll, Hamamatsu Chūō Toshokan [Hamamatsu Central Metropolitan Library], ref. no. 775: 29: K, 1960).

9. Ibid.

10. See Kurokawa Mitsuhiro, "Ōatari, Hamamatsu-za kōen" [Smash Hit, the Hamamatsu-za Production], *Chūnichi*, 28 January 1984; see also "Ichikawa

Shōjo Kabuki nenpu" [Ichikawa Girls' Kabuki Biographical Sketch] (unpub. documents, Toyokawa: Sakuragaoka Museum, 4 February 1995).

11. Ichikawa Masujūrō, *KJ*, 142.
12. Ono, *Ono Haruyoshi*, 154.
13. Ibid.
14. Ichikawa Masujūrō, *KJ*, 144.
15. Ibid., 144–145; Ichikawa Masujūrō, "ISKK," 3.
16. Ono, *Ono Haruyoshi*, 155.
17. Ichikawa Suisen III, *Kudaime*, 13.
18. Hattori, *Ichikawa Danjūrō*, 129–130. According to Kodama Ryuichi, the name Sanshō had been pronounced Sanjō by previous holders of this name. Lecture, May 2004, Tokyo, Asahi Cultural Center. The term "*masu*" is also used to describe the partitioned boxes in which spectators sat in Tokugawa-period theatres.
19. Seki Yōko, *Ebizō soshite Danjūrō* [Ebizō and then Danjūrō] (Tokyo: Bungei Shunjū, 2004), 24.
20. Hattori, *Ichikawa Danjūrō*, 129–132; Ichikawa Ebimaru said that she once overheard Sanshō speaking English to foreign visitors in Tokyo, but his degree of fluency is unknown. Ichikawa Ebimaru, interview.
21. Ichikawa Ebimaru, interview. See also Ichikawa Masujūrō, *KJ*, 146; Kurokawa Mitsuhiro, "Sōke ga Ichikawa no na o menkyo" [The Head Grants the Ichikawa Name], *Chūnichi*, 30 January 1984.
22. No written documentation of this performance exists, but Ichikawa Ebimaru said that she was in the audience and remembers this special production in honor of the troupe's new name. Ichikawa Ebimaru, interview.
23. See Ichikawa Misuji, "Shōjo kara," 232; Tsuchiya, "Shōjo Kabuki no jūnen,"172–173; Saitō, "Hamamatsu jōen."
24. Ichikawa Masuyo, interview.
25. There are differing accounts as to precisely when the contract was signed. See Ichikawa Misuji, "Shōjo kara," 233–234; Kurokawa, "Sōke."
26. It is possible that Furukawa also became a paid employee of the theatre, since he told Kurokawa in 1984 that he received a monthly salary from the Hamamatsu-za. Kurokawa, "Sōke."
27. Ono, *Ono Haruyoshi*, 156.
28. Ibid.
29. Ibid., 157.
30. Kurokawa, "Sōke." Ichikawa Misuji said she had no recollection of this meeting. Ichikawa Misuji, interview.
31. Kurokawa, "Sōke"; Ichikawa Masujūrō, "ISKK," 3.
32. Kurokawa, "Sōke."
33. Ibid.; Ichikawa Masujūrō, "ISKK," 3.
34. Kurokawa, "Sōke."
35. Ono, *Ono Haruyoshi*, 158.
36. Quoted in Uchiyama, "Hamamatsu to jūdaime," 16.

37. See Saitō, "Hamamatsu jōen"; Ichikawa Baika, "Honkaku gekijō"; Kurokawa, "Ōatari"; Toshikura, "Hamamatsu no Shōjo Kabuki," 34.
38. Barbara E. Thornbury, "Restoring an Imagined Past: The Kokuritsu Gekijō and the Question of Authenticity in Kabuki," *Asian Theatre Journal* 19:1 (Spring 2002): 173.
39. Ichikawa Baika, interview.
40. Ichikawa Masujūrō, *KJ*, 146; Kurokawa, "Ōatari."
41. Watanabe Saburō, "Shōjo bakari no kabuki" [All-Girls' Kabuki], *Shūkan sankei* [Industrial and Commerce Weekly], 22 February 1953, 56–57. Local press coverage included: "Koten no fukyū: Ichikawa Shōjo Kabuki ni tsuite" [The Popularization of the Classics: About Ichikawa Girls' Kabuki], *Hamamatsu minpō*, 24 July 1952; "Sanshō-shi Hamamatsu e" [Master Sanshō Comes to Hamamatsu], *Shizuoka*, 27 July 1952. See also Ichikawa Misuji, "Shōjo kara," 233.
42. Uchiyama, "Hamamatsu to jūdaime," 16. According to Saitō's scroll, the *kōjō* was performed as the third piece on a four-part program from 27 July to 31 July 1952.
43. There are at least two different versions of this haiku. See Ichikawa Misuji, "Shōjo kara," 233; Tsuchiya, "Shōjo kabuki no jūnen," 172; Uchiyama, "Hamamatsu to jūdaime," 16; Ichikawa Baika, "Ōatari."
44. Kurokawa, "Sōke."
45. Ichikawa Sanshō V to Ichikawa Masujūrō, 9 April 1955.
46. This has been the case with Danjūrō I, Danjūrō VI, Danjūrō VIII, Danjūrō XI, and Danjūrō XII. Danjūrō III, Danjūrō IV, and Danjūrō VII took the name Danjūrō *before* taking the name Ebizō, and Danjūrō II, Danjūrō V, Danjūrō IX, and Danjūrō X never held the name Ebizō (See Kabuki-za program, May 2004). It is expected that the current Ebizō (XI) will succeed to the name Danjūrō XIII.
47. These new stage names will be used henceforth for all of the performers. For example, the former Daiji, Kokaku, and Dankichi will be referred to as Masujūrō.
48. Ichikawa Baika, interview. In May 1957, Ichikawa Kōbai eventually took the stage name Ichikawa Suisen III.
49. Noguchi, "Ichikawa Shōjo Kabuki," 135.
50. Ichikawa Baika, interview.
51. Saitō, "Hamamatsu jōen."
52. Toshikura Yoshikazu, "Yonnen mae to" [Four Years Ago], Tōyoko Hall Program, May 1956
53. Toshikura, "Hamamatsu no Shōjo Kabuki," 34.
54. Ibid.
55. Ibid.
56. Ueno Senshu, "Ichikawa Shōjo Kabuki ni omou" [Thinking about Ichikawa Girls' Kabuki], Misono-za Program, February 1955, 27.

57. Kimura Kikutarō, "Seijun na Ichikawa Shōjo Kabuki" [The Pure Ichikawa Girls' Kabuki], *Makuai*, February 1953, 52.
58. Ōe Ryōtarō, "Hamamatsu no Ichikawa Shōjo Kabuki," 76–77.
59. Ibid.
60. Kimura, "Seijun na Ichikawa," 52.

4. CYPRESS STAGES

1. See, e.g., "Hamamatsu no musume kabuki: Ichikawa Shōjo Kabuki Gekidan o miru" [Hamamatsu's Girls' Kabuki: Watching Ichikawa Girls' Kabuki Troupe], *Shufu no tomo* [Housewive's Friend], January 1953, 42–43; "Tokyo de hatsu kōen: Ichikawa Shōjo Kabuki" [Tokyo Debut Production: Ichikawa Girls' Kabuki], *Shizuoka* (evening), 20 January 1953; "Seifuku de jungyō suru otome-tachi: hiru wa butai, yoru wa benkyō o tsuzukeru [The Girls Who Tour in Uniform: Stage in the Morning, Studies in the Evening], *Sangyō keizai*, 7 February 1953.
2. "Raigetsu hatsu no Tokyo kōen" [Tokyo Debut Next Month], *Asahi* (evening), 25 January 1953.
3. "Seifuku no 'shōjo kabuki dan' nyūkyo" [Dressed in Their Uniforms, "Girls' Kabuki Troupe" Enters the Capital], *Asahi*, 28 January 1953.
4. Kabuki-za Program, February 1953.
5. Mainichi News, undated footage, courtesy Ichikawa Baika (copy in author's collection).
6. Kei Hibino, "Re-Constructing Japanese Theatre after the War: Mitsukoshi Gekijō and Its Activities," in *Rising from the Flames*, ed. Samuel L. Leiter. See also Shino Yōdarō and Uchiyama Mikio, *Nihon koten geinō to genzai: bunraku kabuki* [Japanese Classical Theatre and the Present: *bunraku* and kabuki] (Tokyo: Iwanami Shōten, 1996), 194–196; Leiter, "From Bombs to Booms."
7. "Raigetsu hatsu no Tokyo kōen"; see also Watanabe, "Shōjo bakari," 56.
8. "Ichikawa Shōjo Kabuki" [Ichikawa Girls' Kabuki], *Makuai* (March 1953): 67. Also quoted in Ichikawa Masujūrō, *KJ*, 157–158.
9. Mitsukoshi Gekijō Program, February 1953. See also Nagayama, *Kabuki-za* 2: 124.
10. Ichikawa Kobotan, interview.
11. "Ningyō tsukai no inai ningyō geki" [Puppet Plays without Any Operators], *Asahi* (evening), 7 February 1953.
12. Kawatake Shigetoshi, "Sōshu o agete" [Offer Your Applause], Mitsukoshi Gekijō Program, February 1953, 10.
13. Kōsei, "Shōjo kabuki to wa" [What Is Girls' Kabuki?], Meiji-za Program, May 1953, 26.
14. Mitsukoshi Gekijō Program, February 1953.
15. Kōsei, "Shōjo kabuki," 26.

16. Ichikawa Masujūrō, *KJ*, 156.

17. Ichikawa Baika, "Shishō wa ichi-ryū mainichi shonichi" [The Master's Best: Every Day Is the First Day], *Mainichi*, 1 February 1993; Kurokawa Mitsuhiro, "Zessan o haku-shita Tokyo kōen" [Tokyo Production Receives Acclaim], *Chūnichi*, 3 February 1984.

18. See Andō Tsuruo, "Suitorigami no yosa, warusa" [The Good and Bad about Blotting Paper], *Yomiuri*, 6 August 1954; Tomita Yasuhiko, "Tadashii seichō ni kyōdan: hōkensei daha Ichikawa Shōjo Kabuki" [Amazed at the Proper Dignity: Ichikawa Girls' Kabuki Breaks the Feudal System], *Ōsaka*, 15 June 1953; Kawatake Shigetoshi, "Hisashiburi no Shōjo Kabuki" [Girls' Kabuki . after a Hiatus], Tōyoko Hall Program, 22 November 1957.

19. "Tassha na shōjo no karada atari gei" [The Amazing Girls' Success], *Tōkyō*, 7 February 1953; Robert A. Carson, "Teen-Age Kabuki Troupe of Girls Is Making Hit," *Nippon Times*, 13 February 1953. According to Masujūrō, other newspaper headlines included: "Kabuki's Wonder" (*Sangyō keizai*), "Something Refreshing in the World of Kabuki" (*Asahi*), and "Let This Be a Warning to Young Kabuki Actors" (*Tōkyō*) (Ichikawa Masujūrō, *KJ*, 156). However, he did not provide the dates of publication, and I was unable to locate them. Masujūrō wrote that the review that appeared in the *Tōkyō shinbun* was by Andō Tsuruo, but the one review that I found in that newspaper was anonymous. Andō was the theatre critic for the *Yomiuri*; he would begin to review the troupe's Tokyo productions starting in August 1954.

20. Miyake Shūtarō, " 'Hara' no shūren: Mitsukoshi Gekijō no Ichikawa Shōjo Kabuki" ["Belly" Training: Mitsukoshi Theatre's Ichikawa Girls' Kabuki], *Mainichi* (evening), 14 February 1953. See Leiter, *New Kabuki Encyclopedia*, 153.

21. "Ningyō tsukai no inai ningyō geki."

22. Carson, "Teen-Age Kabuki."

23. Ichikawa Sanshō V to Ichikawa Masujūrō, 23 March 1953.

24. Ibid., 10 February 1955.

25. See, e.g., Toshikura Yoshikazu, "Kinkyō hōkoku" [Report on How Things Are Going], *Engekikai* (October 1955): 49.

26. Ichikawa Baika, "Ōatari."

27. Ichikawa Baika, interview; Ichikawa Masuyo, interview.

28. Fujii Kōsei, "Sengo no Nagoya geinō kōshi: Ichikawa Shōjo Kabuki to Fuji Kabuki o chūshin ni" [Postwar Nagoya Minor Performance Movement: Focusing on Ichikawa Girls' Kabuki and Fuji Kabuki], *Nagoya geinō bunka* [Nagoya Performance Culture] 1 (1992): 4; Ichikawa Baika, interview.

29. Fujii, "Sengo no Nagoya," 4.

30. Uchiyama, "Hamamatsu to jūdaime," 16.

31. Ichikawa Baika, interview.

32. Ibid.; Ichikawa Baika, "Shishō."

33. Kurokawa Mitsuhiro, "Yoi shidōsha ni megumareru" [Blessed with Good Teachers], *Chūnichi*, 8 February 1984.

34. Ibid; Ichikawa Baika, "Shishō"; Ichikawa Baika, "Bunraku de haragei oshierare" [Being Taught Gut Acting from Bunraku], *Mainichi*, 1 March 1993.

35. Akiyama Yasusaburō, "Toki doki me ni fureru 'kusasa'" [Sometimes "Overdone" Acting], *Asahi* (evening), 4 May 1953.

36. Iwasaki Eiji, "Mitsukoshi Geikijō engekishi: shōwa 21 nen kara 28 nen made" [History of the Mitsukoshi Theatre: 1946–1953] (Mitsukoshi shiryō shitsu, Tokyo, 1990), 22; Hibino, "Re-Constructing Japanese Theatre."

37. Kurokawa, "Zessan"; Ichikawa Sanshō V to Ichikawa Masujūrō, 23 January 1954.

38. See "Raigetsu, hatsu no Tokyo kōen"; Waseda, ed., *EHD*, 5: 370.

39. Ichikawa Sanshō V to Ichikawa Masujūrō, 17 March 1953.

40. Ichikawa Baika, interview.

41. Meiji-za Program, May 1953.

42. According to the program, the play in question was actually *Mirror Mountain*. Meiji-za Program, May 1953; Ichikawa Masujūrō, "ISKK," 6.

43. See, e.g., "Misuji-san ni horebore, Masuyo no Dōjōji hyōjo wa mane dekinu" [Enchanted by Misuji; Cannot Imitate Masuyo's Expression in *Dōjō Temple*], *Ōsaka*, 7 July 1955.

44. Akiyama, "Toki doki"; Miyake Shūtarō, "Daigekijō ni deta shōjo kabuki" [Girls' Kabuki Appears on the Big Stage], *Mainichi* (evening), 4 May 1953; "Gekikai ni wadai o nageta: Ichikawa Shōjo Kabuki" [A Topic to Hurl at the Theatre World: Ichikawa Girls' Kabuki], *Bunka seigatsu* [Cultural Life], May 1953; Robert A. Carson, "*Onna* Kabuki Finishes Run at Meiji-za Today," *Nippon Times*, 7 May 1953.

45. Ichikawa Baika, "Shishō."

46. Akiyama, "Toki doki."

47. Carson, "*Onna* Kabuki."

48. Goto, first name?, "Hatsu no Minami-za kōen: Ichikawa Shōjo Kabuki" [Minami-za Debut: Ichikawa Girls' Kabuki], *Kyōto*, 16 June 1954.

49. Goto, Minami-za Program, January 1955.

50. Yuki Yamamoto, "All-Girl Kabuki Is a Smash Hit," *Nippon Times*, 17 August 1954; Akiyama Yasusaburō, "Natsu kare fukitobasu saikō no iri" [The Highest Attendance Figures Blow Away the Dead Season], *Asahi* (evening), 22 August 1954.

51. Ichikawa Misuji, "Shōjo kara," 233.

52. See, e.g., Katsurada Shigeharu, "Kiyō binbo e no kiken" [Danger of Being a Jack of All Trades and Master of None], *Makuai* (October 1956): 84.

53. Meiji-za Program, August 1954; Ichikawa Baika, "Suzume hyaku made odori wasurezu" [Never Forgetting the Customs that One Learned as a Child], *Mainichi*, 19 April 1993.

54. Shino and Uchiyama, *Nihon koten*, 256–260; Waseda, ed., *EHD*, 5: 369–370. In 1969, Tōyoko Ho-ru (hall) became Tōyoko Gekijō (theatre), before closing in 1985.

55. Tōyoko Hall Program, March 1955, 1.

56. On Sanshō's efforts to secure a Tokyo venue for the troupe, see Ichikawa Sanshō V to Ichikawa Masujūrō, 21 January 1955; no. 6, 23 January 1954; no. 20, 14 September 1955.

57. Minami-za Program, January 1955.

58. See, e.g., Fujii, "Sengo no Nagoya," 3–4; Leiter, "From Bombs to Booms," 25.

59. Ōtani Takejirō, "Minami-za no nigatsu to awasete minasama ni onegai no koto" [February at Minami-za, and a Special Request for Everyone], Minami-za Program, February 1956, 2. The new Dōtonbori Bunraku-za opened in January 1956 and was used for a variety of innovative *ningyō jōruri* productions. See Shino and Uchiyama, *Nihon koten*, 98.

60. "Shōjo Kabuki ichiryū ga rōsai hoken kanyū" [Girls' Kabuki Leading Members Apply for Worker's Accident Compensation Insurance], *Enshyu* [*sic*], 13 July 1955.

61. Ichikawa Sanshō V to Ichikawa Masujūrō, 4 February 1955.

62. Andō, "Suitorigami."

63. *The Earth Spider* and *The Zen Substitute*, two additional plays performed by the Ichikawa Girls' Kabuki Troupe, are included in the "Collection of Ten New and Old Plays" (*shinko engeki jūshu*) owned by the Onoe Kikugorō family.

64. Akiyama, "Natsu kare fukitobasu saikō no iri." I was unable to find any accounts of Kumehachi performing *The Subscription List* under the title of *Atakagawa*. *Ataka* is the *nō* play's usual title.

65. Ichikawa Sanshō V to Ichikawa Masujūrō, 30 May 1955.

66. Andō Tsuruo, "Tadashii tehon o ataeyo" [Give the Correct Patterns], *Yomiuri* (evening), 10 August 1955.

67. Akiyama, "Natsu kare."

68. Ichikawa Sanshō V to Ichikawa Masujūrō, 10 February 1955.

69. Ibid., 9 April 1955.

70. Ibid., 14 March 1955; Ibid., 2 December 1955; Ibid., 12 August 1955.

71. Ibid., 9 April 1955.

72. Ibid., 22 April 1955. The letter is written on stationery printed with the name 稲延 用箋, which can be read: Inanobu Yōsen. Though the writer refers to Sanshō as "uncle" (*ojisan*), there might not have been any familial relationship, since the word "*ojisan*" is frequently used in the kabuki world and Japanese society as a term of endearment for an older individual.

73. Ibid.

74. Ichikawa Baika, interview; Ichikawa Baishō, interview; Ichikawa Sanpuku, interview.

75. Ichikawa Emiko, interview.

76. Ichikawa Baika, interview; see also Kurokawa Mitsuhiro, "Sōke ga kyōryoku ni atooshi" [The Head Powerfully Supports], *Chūnichi*, 1 February 1984.

5. ACTING LIKE MEN

1. Brandon, "Myth and Reality," 78.
2. Ibid., 1–3, 78–83; See also Brandon, "Kabuki and the War," 19–39; Mayo, "To Be or Not to Be," 291–292; Okamoto, *The Man Who Saved Kabuki*.
3. Tomita, "Tadashii seichō." Likewise, the film star, Tsukikata Ryūnosuke, wrote, "I think the day is not far when you will show us your great success in breaking the precedent [that pronounced] 'Do not cultivate women's kabuki.' " "Fuan no kotoba" [A Word from a Fan], February 1955, Misono-za Program, 13.
4. "Suta o kakonde: Ichikawa Shōjo Kabuki to fuan" [Surrounding the Stars: Ichikawa Girls Kabuki and Its Fans], *Ōsaka*, 3 November 1954.
5. Ichikawa Baika, interview.
6. Ichikawa Misuji, "Shōjo kara," 234.
7. Tomita, "Tadashii seichō."
8. Miyake Shūtarō, "Hisa biza no Ichikawa Joyū-za: bunan na 'Numazu' " [It's Been a Long Time Ichikawa Actress Troupe: A Safe "Numazu"], *Mainichi*, 20 February 1962.
9. Ichikawa Baika, interview.
10. Tomita, "Tadashii seichō."
11. Miyake Shūtarō, "Misuji no soshitsu, Fukushō no me" [Misuji's Aptitude, Fukushō's Eyes], *Mainichi*, 9 August 1954.
12. Andō, "Suitorigami."
13. Tomita Yasuhiko, "Dōtonbori no kyōi: Ichikawa Shōjo Kabuki" [Dōtonbori's Miracle: Ichikawa Girls' Kabuki], *Ōsaka*, 7 November 1954.
14. Ichikawa Baika, "Bunraku de haragei."
15. Ichikawa Masuyo, interview.
16. Tomita Yasuhiko, "Tassai na kyōgen ni seichō shimesu" [Showing Growth in a Variety of Pieces], *Ōsaka*, 10 July 1955.
17. Fujino Yoshio, "Seichō miseta shōjo kabuki" [Girls' Kabuki Shows Improvement], *Chūbu Nihon*, 11 December 1955.
18. See Miyake Shūtarō, "Seiseiki karyō no 'Roben sugi' " [High Marks for "Priest Roben"], *Mainichi* (evening), 15 May 1956; Miyake Shūtarō, "Chikamatsu-mono no shūsaku" [Excelling with Chikamatsu Pieces], *Mainichi* (evening), 16 March 1959; Akiyama Yasusaburō, "Ushinawanu kawai-rashisa" [Not Lacking in Cuteness], *Asahi*, 19 December 1959.
19. Akiyama, "Toki doki."
20. Ichikawa Toshie, phone interview by author, 27 April 2004.
21. Ichikawa Kobotan, interview; Ichikawa Kobeni, interview by author, 4 May 2004, Yatomi Village.
22. Ichikawa Misuji, "Shōjo kara," 233.
23. See "Shōjo kabuki," 8. The article includes a photo of the girls practicing flips; Ichikawa Kobeni, interview.

24. Ichikawa Toshie, interview; Ichikawa Kobeni, interview; Fujino, "Seichō miseta shōjo kabuki."
25. Ichikawa Kobotan, interview.
26. Miyake, " 'Hara' no shūren."
27. Miyake Shūtarō, "Shūsai Misuji ni nozumu" [Looking at the Genius Misuji], *Mainichi*, 15 March 1955; Tomita, "Misuji-san ni horebore."
28. Miyake, "Shūsai Misuji ni nozumu."
29. Tomita, "Dōtonbori no kyōi."
30. Tsukikata Ryūnosuke, "Nobi yo shōjo kabuki" [Grow, Girls' Kabuki], *Ōsaka*, 9 November 1954.
31. Ōki, "Shishunki ni tasshita," 83; Ichikawa Baika, "Maiko-san to ikitō" [Hitting It Off with Geisha Apprentices], *Mainichi*, 22 February 1993. Takarazuka built its Tokyo theatre in 1934, so it was based in both the East and West. Concerning the nickname "Takarazuka Shōjo Kabuki" (Takarazuka Girls' Kabuki), see "Otona ni natta," 45.
32. Akiyama Yasusaburō, "Serifu no mazusa ga ki ni naru: Ichikawa Shōjo Kabuki" [Concerns about the Poor Dialogue: Ichikawa Girls' Kabuki], *Asahi* (evening), 15 May 1956; Ichikawa Kobeni, interview.
33. Fukushima Shuji, "Shōjo kabuki e no kitai to sunbyō" [Our Expectations, In Short, for Girls' Kabuki], Naka-za Program, July 1955. Katsurada Shigeharu, "Mezurashii 'Kagamiyama' tōshi" [A Rare Full-Length "Mirror Mountain"], Naka-za Program, March 1956.
34. "Otona ni natta," 42.
35. Miyakoji Noburu, interview by author, 17 September 2004, Tokyo.
36. Jennifer Robertson, *Takarazuka*, 10.
37. See Takarazuka Gekidan Shuppan-bu, ed., *Takarazuka Kageki gojūnenshi* [Takarazuka Revue's Fifty-Year History] (Takarazuka: Takarazuka Kagekidan Shuppan-bu, 1964), front matter, numbers 57, 103, and 110, in particular.
38. "Suta o kakonde."
39. "Musume bakari no kabuki" [All-Girls' Kabuki], *Ōsaka*, 6 February 1955.
40. Miyakoji Noburu, interview.
41. "Musume bakari."
42. Marvin Carlson, *The Haunted Stage: The Theatre as Memory Machine* (Ann Arbor: University of Michigan Press, 2001).
43. See Leiter, *New Kabuki Encyclopedia*, 288–289.
44. Mitsuo Hirata, "Forum: Gender in Shakespeare and Kabuki," in *Transvestism and the Onnagata Traditions in Shakespeare and Kabuki*, ed. Minoru Fujita and Michael Shapiro (Kent, CT: Global Oriental, 2006), 181–182; see also 176.
45. Ibid.
46. Ibid.
47. "Musume bakari"; Gunji Masakatsu, *Kabuki no bigaku* [Kabuki Aesthetics] (Tokyo: Engeki Shuppansha, 1963), 315. See also Mezur, *Beautiful Boys*, 2, 180.
48. "Meiboku sendai hagi" (*Precious Incense and Autumn Flowers of Sendai*), Mitsukoshi Program, February 1953, 7.

49. "Suta o kakonde."
50. See Carson, "*Onna* Kabuki."
51. "Suta o kakonde." The scene is often controversial even when performed by men.
52. Min Tian, "Male *Dan*: the Paradox of Sex, Acting, and Perception of Female Impersonation in Traditional Chinese Theatre," *Asian Theatre Journal* 17:1 (Spring 2000): 90.
53. Fujino, "Seichō miseta."

6. THE CRITICS RESPOND

1. "Shōjo kabuki" [Girls' Kabuki], *Mainichi gurafu* [Mainichi Chart], 14 September 1955, 8.
2. Shōwa refers to the reign of Emperor Hirohito, from 1926 to 1989. Toshikura Yoshikazu, "Ichikawa Shōjo Kabuki," Tōyoko Hall Program, March 1954; Noguchi, "Ichikawa Shōjo Kabuki," 134; Ōki, "Shishunki ni tasshita," 82. See also Vera Mackie, *Feminism in Modern Japan: Citizenship, Embodiment, and Sexuality* (Cambridge: Cambridge University Press, 2003), 28, 32. As noted earlier, the one notable exception was Noguchi Tatsuji, who reported that the troupe was performing "genuine kabuki." "Ichikawa Shōjo Kabuki," 134.
3. Toita Yasuji, "Ichikawa Shōjo Kabuki: kabuki no kuni no 'tensai shōjo' " [Ichikawa Girls' Kabuki: Kabuki World's "Girl Prodigies"], *Geijutsu shinchō* [Artistic New Tides] (July 1953): 70–72.
4. Ibid. In 1950, Kinkakuji (The Temple of the Golden Pavilion) was set on fire and destroyed.
5. Toita, "Ichikawa Shōjo Kabuki," 72.
6. Ibid., 71.
7. Ibid., 72.
8. Ibid.
9. Ihara, *Meiji engekishi*, 696.
10. Toita, "Ichikawa Shōjo Kabuki," 72.
11. Ibid.
12. Ibid.
13. Ichikawa Sanshō V to Ichikawa Masujūrō, 7 February 1954.
14. Ōe, "Hamamatsu no Ichikawa Shōjo Kabuki," 77; Waseda, ed., *EHD*, 2: 409.
15. Akiyama Yasusaburō, "Hanatakashi shōjo kabuki [The High-Nosed Girls' Kabuki], *Engekikai* (October 1955): 77; Akiyama Yasusaburō, "Seiketsu na Ichikawa Shōjo Kabuki" [The Pure Ichikawa Girls' Kabuki], *Asahi* (evening), 12 August 1955.
16. Miyake, " 'Hara' no shūren."
17. Akiyama Yasusaburō, "Ichikawa Shōjo Kabuki no tōjō" [The Entrance of Ichikawa Girls' Kabuki], Tōyoko Hall Program, March 1955, 2.
18. Tomita, "Misuji-san ni horebore."

19. Gary Schmidgall, *Shakespeare and Opera* (New York: Oxford, 1990), 188–203.

20. See Miyake, "'Hara' no shūren"; Miyake, "Misuji no soshitsu"; Miyake Shūtarō, "'Numazu' to odori: Tōyoko Hōru no Ichikawa Shōjo Kabuki" ["Numazu" and Dance: Ichikawa Girls' Kabuki at Tōyoko Hall], *Mainichi* (evening), 13 November 1957; Andō Tsuruo, "Sawayakana 'Kokaji' no Misuji" [A Fresh "Little Swordsmith's" Misuji], *Yomiuri* (evening), 8 November 1957.

21. Katsurada, "Kiyō binbo," 82. He clarified, however, that he was impressed that a girl (Fukushō) had performed the role so well. Meanwhile, the critic from *Chūbu Nihon* called Fukushō's performance "brilliant" and did not comment about her Fukashichi strip. Fujino, "Seichō miseta."

22. Masuya Jisaburō, "Ichikawa Shōjo Kabuki" [Ichikawa Girls' Kabuki], *Makuai* (August 1955): 91.

23. Katsurada, "Kiyō binbo," 82.

24. Andō Tsuruo, "Buyō ni shinpo: tassha na Ichikawa Shōjo Kabuki" [Improvement in Dance: The Amazing Ichikawa Girls' Kabuki], *Yomiuri* (evening edition), 11 March 1959.

25. Andō, "Suitorigami no yosa, warusa," *Yomiuri*, 6 August 1954.

26. Gunji Masakatsu, "Zeami no jotairon" [Zeami's Discourse on the Female Body], *Zeami no zuihitsu: Zeami seitan roppyaku nen ni* [Collected Writings on Zeami in Honor of His Six Hundredth Anniversary] (Tokyo: Hinoki Shōten, 1984), 18–19.

27. Ichikawa Masujūrō, "ISKK," 4.

28. "Shibai o satotteiru no ni kanshin" [Impressed by the Perceptive Staging], *Ōsaka*, 8 August 1953; Ōe, "Hamamatsu no Ichikawa Shōjo Kabuki," 76. Ōe further lauded Masuyo's ability to turn her *iroke* on or off as needed. "Her Tonami was a sexless school mistress," he wrote in reaction to the 1953 Shin Kabuki-za production, favorably noting the contrast with her Umegawa.

29. Miyake, "Misuji no soshitsu"; Andō Tsuruo, "Mō hitotsu migaki o: Tōyoko Horu no Ichikawa Shōjo Kabuki" [Polishing One More Thing: Ichikawa Girls' Kabuki at Tōyoko Hall], *Yomiuri* (evening), 12 November 1956; Tomita, "Misuji-san ni horebore."

30. Tomita, "Azayaka na 'Noriaibune'" [A Lively "Ferry"], *Ōsaka*, 5 February 1955.

31. Miyake, "Misuji no soshitsu."

32. Miyake Shūtarō, "Bunan na 'Shuzenji monogatari': Meiji-za no Ichikawa Shōjo Kabuki" [A Safe "Tale of Shuzenji": Ichikawa Girls' Kabuki at the Meiji-za], *Mainichi* (evening), 10 August 1955.

33. Miyake, "'Numazu' to odori."

34. Ibid.

35. Andō, "Suitorigami"; Ōe, "Hamamatsu no Ichikawa Shōjo Kabuki," 76.

36. Ichikawa Baika, interview.

37. Ibid.

38. Ichikawa Sanshō V to Ichikawa Masujūrō, 28 March 1953.

39. Ibid.
40. Carson, "Teen-Age Kabuki."
41. Ichikawa Sanshō V to Ichikawa Masujūrō, 28 February 1953. According to a later letter, Misuji, Baika, Masuyo, and Fukushō went to see this production. For a note on this production, see Nagayama, *Kabuki-za hyakunenshi*, 2: 126.
42. Akiyama, "Ichikawa Shōjo Kabuki tōjō."
43. "Dokusha kadai: Ichikawa Shōjo Kabuki ni kiku" [Reader's Issues: We Ask Ichikawa Girls' Kabuki], *Engekikai* (December 1957), 99.
44. Ichikawa Sanpuku, interview.
45. Ichikawa Kobotan, interview.
46. Fujino Yoshio, "Seichō miseta."
47. Miyake Shūtarō, "Shōjo kara onna e" [From Girl to Woman], *Mainichi*, 16 December 1959.
48. Akiyama, "Serifu no mazusa."
49. Miyake, "Seiseiki karyō."
50. Akiyama, "Hanatakashi," 77.
51. Ibid. The girls apparently felt their noses were too flat and that a larger one would enhance their looks.
52. Ichikawa Sanshō to Ichikawa Masujūrō, 12 August 1955.
53. Seki Itsuo, "Ichikawa Shōjo Kabuki ni tsuite" [About Ichikawa Girls' Kabuki], Minami-za Program, February 1957.
54. Ichikawa Sanpuku, interview.
55. See Andō, "Suitorigami"; Andō, "Buyō ni shinpo."
56. Ichigawa Tsutomu, "Ai suru otome-tachi" [The Girls I Love], Naka-za Program, March 1956, 6.
57. Ōe, "Hamamatsu no Ichikawa Shōjo Kabuki," 78.
58. Ibid.
59. "Shinkyō miseta Fukushō to Masuyo: Minami-za Ichikawa Shōjo Kabuki" [Fukushō and Masuyo Show Great Promise: Ichikawa Girls' Kabuki at Minami-za], *Kyōto*, 22 August 1959.
60. Andō, "Sawayakana."
61. Akiyama, "Serifu no mazusa"; Akiyama Yasusaburō, "Serifu ni kaikan ga tobashii" [Pleasures of the Dialogue are Scarce], *Asahi* (evening), 12 November 1956.
62. Akiyama, "Hanatakashi," 77.
63. Ichigawa, "Ai suru otome-tachi," 6.
64. Akiyama, "Serifu no mazusa."
65. Goto Akira, "Shōjo Kabuki no rikiryō" [Girls' Kabuki's Ability], Minami-za Program, January 1955, 7.
66. Toita, "Ichikawa Shōjo Kabuki," 72.
67. Tomita, "Tassai na kyōgen."
68. Tomita, "Dōtonbori no kyōi."
69. Sawamura Tanosuke VI, interview by author, 18 August 2004, Tokyo, Japan.

70. Shimizu Fue, "Shōjo Kabuki būmu," [Girls' Kabuki's Boom], Misono-za Program, February 1955, 16–17.
71. Noguchi, "Ichikawa Shōjo Kabuki," 134–136.

7. LIFE OFFSTAGE

1. "Hamamatsu no musume kabuki: Ichikawa Shōjo Kabuki gekidan o miru" [Hamamatsu's Girls' Kabuki: Watching Ichikawa Girls' Kabuki], *Shufu no tomo* [Housewife's Friend], January 1953: 42–43; Tsumori Kenji, "Ichikawa Shōjo Kabuki junen" [Ichikawa Girls' Kabuki Touring], *Asahi gurafu* [Asahi Graph]: 25 September 1956, 42–43; "Gekikai ni wadai o nageta," n.p.
2. "Shōjo kabuki," 8.
3. Ōki, "Shishunki ni tasshita," 83; Ichikawa Ebimaru, interview.
4. Onoe Umeno, interview.
5. The apprentice system has undergone change since the 1950s. Low-ranking apprentices are often given an opportunity to perform a major role at the Kokuritsu Gekijō's annual production, which features graduates of its training school. Moreover, the apprentices of Ichikawa Ennosuke III (b. 1939) are often given an opportunity to advance.
6. Ichikawa Misuji, interview.
7. Ichikawa Ebimaru, interview.
8. Ichikawa Sanpuku, interview
9. Ichikawa Emiko, interview.
10. Ichikawa Toshie, interview; Ichikawa Kiyomi, interview by author, 20 April 2004, Tokyo.
11. Ichikawa Fukushō, interview.
12. Ichikawa Kiyomi, interview.
13. Ichikawa Kobeni, interview; Ichikawa Misuji, interview.
14. Ichikawa Kiyomi, interview.
15. Ichikawa Sanpuku, interview.
16. Ichikawa Kiyomi, interview.
17. Watanabe, "Shōjo bakari," 56–57.
18. Ōki, "Shishunki ni tasshita," 83.
19. See "Wages by Educational Background, Age Groups, Industry and Duration of Service (1954)," in *Nihon tōkei nengan* [Japan Statistical Yearbook] (Tokyo: Bureau of Statistics, Office of Prime Minister: 1955–1956), 343.
20. Ichikawa Baika, interview; Ichikawa Masuyo, interview.
21. Ōki, "Shishunki ni tasshita," 83.
22. Ichikawa Ebimaru, interview.
23. Ōki, "Shishunki ni tasshita," 83.
24. Watanabe, "Shōjo bakari," 56–57.
25. Ichikawa Kobeni, interview.

26. Ichikawa Baika interview; Kurokawa Mitsuhiro, "Watashi seigatsu mo kibishiku kisei" [Private Life Also Strictly Regulated], *Chūnichi*, 7 February 1984.
27. Ichikawa Suzume, interview.
28. Ichikawa Kobotan, interview.
29. "Seifuku de jungyō."
30. See, e.g., "Gekikai ni wadai."
31. Ichikawa Misuji, "Shōjo kara," 234.
32. In 1956, the *Sandê mainichi* reported that all but three members had finished their school requirements. "Otona ni natta," 45.
33. Kurokawa Mitsuhiro, "Matsui sensei to no kōryū rokunen" [Six Years with Matsui-sensei], *Chūnichi*, 4 February 1984.
34. "Seifuku de jungyō." She is not identified by name in this article, but interviews confirmed that the teacher in question was Matsui.
35. Kurokawa, "Matsui sensei."
36. Ichikawa Baika, interview.
37. Ichikawa Baika, "Gonan, yobikomi, mimau aoitake" [Difficulties, Being Screamed at and Hit with a Green Bamboo Pole], *Mainichi*, 25 January 1994. See also Ichikawa Misuji, "Shōjo kara," 234.
38. Akiyama, "Hanatakashi," 76.
39. "Ichikawa Shōjo Kabuki junen," 42.
40. Ibid.
41. Ichikawa Suzume, quoted in Ichikawa Masujūrō, "ISKK," 8.
42. Ichikawa Baika, "Shoen geidai-chū ni chichi no shi" [My Father's Death in the Middle of the Opening Program], *Mainichi*, 8 February 1993.
43. Meiji-za Program, May 1953. See also Ichikawa Masujūrō, "ISKK," 4.
44. Ichikawa Baika, interview.
45. Ichikawa Masuyo, interview.
46. Ichikawa Baika, "Shoen geidai-chū."
47. Ichikawa Baika, interview.
48. Ichikawa Sanpuku, interview.
49. Ichikawa Baika, "Terebi fukyū, heru danin" [Advent of Television, Dropping Members], *Mainichi*, 8 March 1993. An examination of the troupe's programs shows that the troupe did not always perform for twenty days, opening on the third and closing on the twenty-third. Baika was using one engagement as an example.
50. Ichikawa Masujūrō, "ISKK," 4.
51. Kōsei, "Shōjo kabuki," 26.
52. Ichikawa Baika, interview.
53. Ōe, "Hamamatsu no Ichikawa Shōjo Kabuki," 77.
54. Ichikawa Emiko, interview.
55. Ichikawa Baika, "Gonan."
56. Ichikawa Masujūrō, "ISKK," 3.
57. Kurokawa Mitsuhiro, "Suparuta-shiki no mōgeiko" [Intense, Sparta-Like Training], *Chūnichi*, 6 February 1984.

58. Ichikawa Baika, quoted in Ichikawa Masujūrō, "ISKK," 8.
59. Ichikawa Sanpuku, quoted in Ichikawa Masujūrō, "ISKK," 9; Ichikawa Sanpuku, interview.
60. Kurokawa, "Suparuta-shiki"; Ichikawa Sanpuku, interview.
61. Ichikawa Masujūrō, *KJ*, 140.
62. Ichikawa Masujūrō, "ISKK," 4.
63. Ichikawa Baika, "Maiko-san"; Ichikawa Masuyo, interview.
64. Kurokawa, "Watashi seigatsu"; Ichikawa Baishō, interview.
65. Ichikawa Baika, "Maiko-san."
66. Kurokawa Mitsuhiro, "Yoi shidōsha ni megumareru" [Blessed with Good Teachers], *Chūnichi*, 8 February 1984; Ichikawa Baika, interview.
67. Robertson, *Takarazuka*, 67.
68. Ibid.
69. Ichikawa Baika, interview.
70. "Shōjo kabuki," 8.
71. Shortly after I embarked on this project, an off-the-record source revealed that Masujūrō had engaged in sexual relations with an unspecified number of the actresses while they were still members of the troupe. I was told that "many members were angry with what Masujūrō had written in *Kabuki jinsei*," and that it "didn't tell the full story as to why the troupe disbanded." When I began to interview members, however, I hesitated to confront them with such allegations. Finally, I confronted Ichikawa Baishō, who confirmed the information provided by the off-the-record source. I proceeded to question Ichikawa Kobotan, Ichikawa Kobeni, Ichikawa Emiko, Onoe Umeno, and Kurokawa Mitsuhiro, all of whom confirmed that they had been privy to information about Masujūrō's sexual relations. In the interest of preserving the trust of the troupe, I have refrained from naming individuals who allegedly had sexual relations with Masujūrō.
72. Ichikawa Baishō, interview.
73. Kurokawa Mitsuhiro, interview by author, 15 July 2004, Nagoya, Japan. He said that although he "researched the story one hundred percent, only thirty percent of it could be included in his columns."
74. Ichikawa Masujūrō, "ISKK." This remark can be heard on the tape of Masujūrō's lecture, but it was not transcribed on the hardcopy (see page 7).
75. Kurokawa, interview.
76. Ibid.
77. Ichikawa Kobotan, interview.
78. Ichikawa Emiko, interview.
79. Ichikawa Kobeni, interview.
80. Ibid.
81. Onoe Umeno, interview.
82. Toshikura, "Yonnen mae."

8. POWER STRUGGLE

1. Uchiyama, "Hamamatsu to jūdaime," 18.
2. Ichikawa Sanshō V to Ichikawa Masujūrō, 2 December 1955. Yoneko further warned Masujūrō not to tell anyone about Sanshō's illness. It is unclear whether Sanshō knew how severe his condition was at this point.
3. Ibid., 6 January 1956; "Yasashii otoosan deshita: Ichikawa sodatte kita 'Sanshō-dono'" [He Was a Sweet Father: "Mr. Sanshō" Who Raised Ichikawa Girls' Kabuki], *Kyōto* (evening), 3 February 1956.
4. Another troupe member interviewed seemed to recall that Misuji made the formal announcement, but Emiko said that she was certain that her father, Masujūrō, delivered the news to the audience. Ichikawa Emiko, interview.
5. Seki, *Ebizō soshite Danjūrō*, 114, 148; Samuel L. Leiter, "Ichikawa Danjūrō XI: A Life in Kabuki," in *Frozen Moments: Writings on Kabuki, 1966–2001* (Ithaca, NY: Cornell East Asia Series, 2002), 32–43.
6. Ichikawa Baika, interview; see also Uchiyama, "Hamamatsu to jūdaime," 18.
7. Ichikawa Masujūrō, *KJ*, 160.
8. Yoneko to Ichikawa Masujūrō, 17 February 1956.
9. Ichikawa Ebizō to Ichikawa Masujūrō, 23 February 1956.
10. Ibid., 1 March 1956. This letter is missing the year, but from the context it appears that it must have been written in 1956.
11. Tomita Yasuhiko, "Netsuen to kyōwa no kesshō: hikaru Misuji, Masuyo no 'Tsubosaka'" [Enthusiasm and Harmony's Crystallization: Shining Misuji, Masuyo's "Tsubosaka"], *Ōsaka*, 5 March 1956; Akiyama, "Serifu ni kaikan."
12. Tsumori, "Ichikawa Shōjo Kabuki junen," 42–43.
13. Ichikawa Ebizō, "Goaisatsu" [Greetings], Tōyoko Hall Program, May 1956. Akiyama, "Serifu no mazusa."
14. Ichikawa Baishō, interview; Ichikawa Kobotan, interview.
15. Ichikawa Baika interview.
16. Ibid.; "Sōke Ichikawa Ebizō-jō to Ichikawa Shōjo Kabuki" [Head Ebizō and Ichikawa Girls' Kabuki], *Makuai* (October 1956): n.p.
17. Ibid.
18. W., "Netsui ni wa kōkan" [Favorable Impressions Regarding the Enthusiasm], *Kyōto* (evening), 11 September 1956.
19. Ichikawa Kobotan, interview. Critic Miyake Shūtarō, however, criticized this casting. Miyake Shūtarō, "Mazu ichio no seiseki" [A Fine Grade], *Mainichi* (evening), 13 November 1956.
20. "Ichikawa Shōjo Kabuki Tōyoko Hōru" [Ichikawa Girls' Kabuki at Tōyoko Hall], *Engekikai* (December 1956): 43.
21. Miyake, "Mazu ichio"; See also Akiyama Yasusaburō, "Serifu ni kaikan ga tobashii," *Asahi*, 12 November 1956.
22. Katsurada, "Kiyō binbo," 82.
23. Ibid., 83.

24. "Gekirei no Ōtani Takejirō kaichō" [Encouragement from President Ōtani Takejirō], Misono-za Program, December 1957; Andō, "Sawayakana 'Kokaji' no Misuji."
25. Kusakabe Chitomeko [草壁知止子], "Seitake no nobita shōjo kabuki" [Girls' Kabuki That Has Grown Taller], *Engekikai* (December 1957): 58–60.
26. "Dokusha wadai," 98–100.
27. Ibid.
28. Kurokawa Mitsuhiro, "Mi o sutete na o toru" [Throwing Away the Fruit, Taking a Name], *Chūnichi*, 20 February 1984; Kurokawa Mitsuhiro, "Gei ka kekkon ka nayamu zain" [Troupe Members Worry: Art or Marriage], *Chūnichi*, 13 February 1984.
29. See Kurokawa, "Yoi shidōsha." The film was directed by Watanabe Kunio and produced by Shin Tōhō Eiga.
30. For a discussion of the history of *Yukinojō* films, see Donald Richie, *A Hundred Years of Japanese Film* (Tokyo: Kodansha, 2001), 156–157. Director Ichikawa Kon remade the film in 1963 with Daei productions, which once again starred Hasegawa Kazuo. Richie's account of the film's history omits the version starring Misora Hibari. See also Tansman, "Mournful Tears and *Sake*," 103–133.
31. See "Dokusha wadai," 98–100. For more on the relationship between Ono Haruyoshi and Hibari's producer, see chapter 3 in this book.
32. Kurokawa, "Mi o sutete."
33. Kurokawa, "Gei ka kekkon ka."
34. Ōki, "Shishunki ni tasshita," 80–81.
35. Misono-za Program, July 1957.
36. Ōki, "Shishunki ni tasshita," 80–81.
37. Akiyama, "Serifu no mazusa"; W., "Netsui ni wa kōkan"; "Otona ni natta shōjo kabuki," 45; Katsurada Shigeharu, "Tenkanki ni tatsu Ichikawa Shōjo Kabuki" [Ichikawa Girls' Kabuki Reaches a Turning Point], *Makuai* (October 1956): 82–83; Toshikura Yoshikazu, "Ichikawa Shōjo Kabuki" [Ichikawa Girls' Kabuki], Tōyoko Hall Program, March 1955, 3.
38. Akiyama, "Hanatakashi shōjo kabuki," 76.
39. Katsurada, "Tenkanki ni tatsu," 82–83.
40. Ichikawa Masujūrō, "ISKK," 6.
41. Katsurada, "Tenkanki ni tatsu," 82–83.
42. Ibid.
43. Ibid.
44. Akiyama Yasusaburō, "Sei ippai no butai: Ichikawa Shōjo Kabuki" [An Energetic Production: Ichikawa Girls' Kabuki], *Asahi shinbun* (evening), 9 November 1957. Akiyama appears to be employing the traditional Japanese counting convention whereby a baby's age is counted one at birth. Thus, even though Fukushō, Misuji, Baika, and Kobotan, were born in 1936, their age would be rendered twenty-two in 1957.

45. W., "Migotae aru 'Kagamiyama': Ichikawa Shōjo Kabuki" [Ichikawa Girls' Kabuki's Worthwhile "Mirror Mountain"], *Kyōto* (evening), 17 February 1957.
46. Kawatake Shigetoshi, "Hisashiburi no shōjo kabuki," 22.
47. "Hatachi ni natta Ichikawa Shōjo Kabuki" [Ichikawa Girls' Kabuki Turns Twenty], Misono-za Program, July 1957, 23.
48. Ōki, "Shishunki ni tasshita," 80–81.
49. Ichikawa Baika, follow-up phone interview, 9 March 2004.
50. Ōki, "Shishunki ni tasshita," 80–81. The article is dated 5 July 1958, which was technically several days after the Tokiwa-za engagement. However, based on the content of the article, it appears that the magazine was distributed a week or two before the printed date.
51. Ibid.
52. Ibid.
53. Ichikawa Baika, follow-up phone interview, 9 March 2004.
54. Ichikawa Misuji, "Shōjo kara onna e," 232; Akiyama Yasusaburō, "Yobimono 'Sannin sanbasō': Tokiwa-za no Ichikawa Shōjo Kabuki" [The Draw Is 'Three Person Sanbasō': Ichikawa Girls' Kabuki at the Tokiwa-za], *Asahi* (evening), 4 July 1958. See also Enomoto Shigetami, "Magari kado ni kakatta: Shōjo Kabuki" [Girls' Kabuki Turns a Corner], *Engekikai* (December 1959): 110–113.
55. Akiyama, "Yobimono."
56. Ichikawa Misuji, interview.
57. "Goaisatsu moshiagemasu" [May We Offer Our Greetings], Tōyoko Hall Program, April 1958, 30.
58. Ibid.
59. Ibid., 5.
60. Ichikawa Misuji, "Shōjo kara onna e," 232; Akiyama, "Yobimono."
61. Ichikawa Misuji, "Shōjo kara onna e," 232–233.
62. "*Wakashu kuzushi*" [The Downtrodden Chap], *Engekikai* (August 1958): 56–58.
63. Ibid., 58; Akiyama, "Yobimono."
64. The piece was excised and adapted from *Mata kokoni sugata hakkei*, a "transformational" (*henge*) piece first performed by Ichikawa Danjūrō VII in 1813. The famous dance "Ōmi no okane" is part of this piece. See "Danjūrō musume," in *Nihon buyō zenshū*, ed. Nihonbuyōsha (Tokyo: Buyōsha, 1982), 3: 695–700. This was the second time the troupe performed this piece.
65. Kurokawa, "Mi o sutete."
66. Ibid.
67. Ono, *Ono Haruyoshi*, 160–161.
68. Tsuchiya, "Shōjo kabuki no jūnen," 173.
69. Ichikawa Masujūrō, *KJ*, 162.

70. Tsuchiya, "Shōjo kabuki no jūnen," 173. *Pachinko* is a pinball game for which winners can receive cash prizes. Invented after World War II, the game is often claimed to be the most popular leisure activity in Japan.

9. THE FINAL YEARS

1. According to Ichikawa Baishō, the troupe came under Shōchiku at this time, but I found no written evidence of this. Ichikawa Baishō, interview.
2. Ichikawa Misuji, "Shōjo kara," 234.
3. Enomoto, "Magari kado," 110; see also "Ichikawa Shōjo Kabuki" [Ichikawa Girls' Kabuki], *Engekikai* (January 1961): 54. The 1961 article briefly documents the creation of the Ichikawa Girls' Kabuki Troupe, Inc., but it makes no reference to the fact that, by 1961, the troupe had changed its name to the Ichikawa Actress Company.
4. Enomoto, "Magari kado," 110.
5. Ibid.
6. Ibid.
7. Ichikawa Shōjo Kabuki Program, Tōyoko Hall, March 1959; Ichikawa Shōjo Kabuki Program, Shinjuku Daiichi Gekijō, December 1959. First built in 1904, the Shinjuku Daiichi Gekijō (earlier the Shin Kabuki-za) closed in July 1960. Waseda, ed., *EHD*, 3: 265.
8. Miyake Shūtarō, "Chikamatsu mono no shusaku" [Excelling with Chikamatsu Pieces], *Mainichi* (evening), 16 March 1959; Tsuchiya, "Shōjo kabuki no jūnen,"172.
9. Akiyama, "Ushinawanu kawai-rashisa"; Miyake, "Shōjo kara onna e"; Andō Tsuruo, "Masuyo ga migoto seichō" [Masuyo's Splendid Growth], *Yomiuri*, 18 December 1959.
10. Fujima Rankei, interview by author, 25 July 2004, Tokyo.
11. Miyake, "Chikamatsu mono"; Akiyama Yasusaburō, "Seijitsu na butai" [A Sincere Stage: Ichikawa Girls' Kabuki], *Asahi* (evening), 19 March 1959; Andō, "Buyō ni shinpo."
12. "Shinkyō Miseta Fukushō to Masuyo" [Fukushō and Masuyo Show Great Progress], *Kyōto*, 22 August 1959.
13. Tsuchiya, "Shōjo Kabuki no jūnen," 172–173; Enomoto, "Magari kado," 113.
14. Ichikawa Hisayo, interview by author, 2 April 2004, Tokyo; Ichikawa Kiyomi.
15. Akiyama, "Seijitsu na butai"; Akiyama, "Ushinawanu kawai-rashisa."
16. Enomoto, "Magari kado," 112; Miyake, "Shōjo kara onna e"; Akiyama, "Seijitsu na butai."
17. Ichikawa Joyū-za, Shinjuku Daiichi Gekijō Program, March 1960. Ichikawa Masujūrō and Kurokawa Mitsuhiro both stated that the troupe performed at the Shinjuku Daiichi Gekijō in May 1960, during which it took the new

name Ichikawa Joyū-za. I, however, found no written evidence supporting this claim. I located a program from the Shinjuku Daiichi Gekijō from March 1960, which states that it was during this production that the troupe took the name Ichikawa Joyū-za. Ichikawa Masujūrō, *KJ*, 181; Kurokawa Mitsuhiro, "37 nen, tsuni maku o hiku" [Closing the Curtain at Last in 1962], *Chūnichi*, 21 February 1984.

18. Both critics Toshikura Yoshikazu and Tomita Yasuhiko attributed the troupe's new name to Ōtani Takejirō, and Ichikawa Masuyo was quoted in the *Chūbu Nihon* as saying that the troupe's new name was decided by Ōtani. See Toshikura Yoshikazu, "Ichinin mae no da kara" [Because They Have Become Adults], Shinjuku Daiichi Gekijō Program, March 1960; Tomita Yasuhiko, "Shinkyō ichijirushii Masuyo" [Remarkable Progress Made by Masuyo], *Ōsaka*, 20 August 1960; "Konshū no shūyaku: Ichikawa Masuyo" [This Week's Star: Ichikawa Masuyo], *Chūbu Nihon* (evening), 6 June 1960.

19. Ono, *Ono Haruyoshi*, 160–161.

20. "Goaisatsu" [Greetings], Ichikawa Joyū-za Program, Shinjuku Daiichi Gekijō, March 1960, 1.

21. "Matsuda-buchō daijin mizu kara furugō" [Minister Matsuda Presents It Himself], Ichikawa Joyū-za Program, Shinjuku Daiichi Gekijō, 3 March 1960.

22. Ichikawa Sanpuku, interview.

23. Tobe Ginsaku, "Kono kotoba gozonji? Joyū-za" [Do You Know This Word? Actress Company], *Engekikai* (April 1960): 85.

24. Maeda Mitsuho, "Shōjo kabuki kara Joyū-za e" [From Girls' Kabuki to Actress Company], Ichikawa Joyū-za, Misono-za Program, June 1960, 8.

25. Toshikura, "Ichinin mae."

26. Maeda Mitsuho, "Shōjo kabuki," 8.

27. See Kano, *Acting Like a Woman*, 27–32, 219–230.

28. See "Ichikawa Joyū-za," Misono-za Program, June 1960; "Ichikawa Joyū-za," Mainichi Hall Program, August 1960; Ichikawa Baika, interview; "Mata kano 'Seki' no imyō" [Nicknamed "The Barrier" Again], *Kyōto* (evening), 15 August 1960.

29. Ueno, "Nagoya hiroen kōen."

30. Tomita, "Shinkyō ichijirushii Masuyo."

31. "Konshū no shūyaku."

32. Ichikawa Ebimaru, interview. Ichikawa Suzume, interview.

33. Copies of the scripts are preserved in the Ichikawa Shōjo Kabuki archive, Sakuragaoka Museum, Tokyokawa, Japan. VHS copies of the four films are housed at the Misono-za Library in Nagoya and in the Ichikawa Shōjo Kabuki archive.

34. Andō Tsuruo, "Ichikawa Joyū-za no kokaku" [Ichikawa Actresses Company Old Style], *Yomiuri* (evening), 19 February 1962; Ichikawa Umeno, interview.

35. Akiyama Yasusaburō, "Miseru gidayū mono: sannen buri no Ichikawa Joyū-za" [*Gidayū* Pieces For Show: Ichikawa Actress Company after Three Years], *Asahi*, 21 February 1962; Miyake Shūtarō, "Hisabiza no Ichikawa Joyū-za: bunan na 'Numazu'" [Ichikawa Actress Company after a Long Time: A Safe "Numazu"], *Mainichi* (evening), 20 February 1962; Andō, "Ichikawa Joyū-za no kokaku," *Yomiuri*, 19 February 1962; See Akiyama Yasusaburō, "Kakki no aru kyakuseki: Ichikawa Joyū-za kōen" [A Lively Auditorium: Ichikawa Actress Company], *Asahi*, 20 June 1962. The only evidence that I could find of the June 1962 Tōyoko Hall engagement was Akiyama's article; articles about the troupe, including Masajūrō's *KJ*, made no mention of it.

36. See, in particular, "Konshū no shūyaku," *Chūbu Nihon*, 6 June 1960; Tomita, "Shinkyō ichijirushii Masuyo," *Ōsaka*, 20 August 1960. See also "Ichikawa Joyū-za," Yomiuri Hall, September 1962.

37. "Konshū no shūyaku"; Tomita, "Shinkyō ichijirushii Masuyo." See also "Ichikawa Joyū-za," Yomiuri Hall, September 1962.The program roster is not entirely reliable; it seems that the troupe "padded" the program to include members, such as Ichikawa Hisayo, who had resigned previously. Ichikawa Hisayo, interview; Akiyama Yasusaburō, "Kaeru Fukushō no godan: Ichikawa Joyū-za" [The Acclaimed Fukushō's Five Roles: Ichikawa Actresses Company], *Asahi*, 27 September 1962.

38. Akiyama Yasusaburō, "Honkakuteki na dashimono" [Genuine Pieces on the Program], *Asahi*, 9 September 1962; Andō Tsuruo, "'Genpei nunobiki no taki' jōen no yūki" [Courage in Performing "The Genji and Heike at the Nunobiki Waterfall"], *Yomiuri*, 27 September 1962.

39. Andō, "'Genpei nunobiki.'"

40. Ibid.; Miyake Shūtarō, "Mezurashii 'Yoshikata yakata'" [A Rare "Yoshikata's Abode"], *Mainichi*, 28 September 1962; Onoe Umeno, interview.

41. Kurokawa, "37 nen." See "Ichikawa Joyū-za," Yomiuri Hall, September 1962. According to Andō, the troupe had been invited to Hawaii for one week to participate in the "Japan Show," a revue of performing arts. Misuji, Baika, Fukushō, and Suzume had been planning to perform *Danjō dōjōji*, a twist on *Maiden at Dōjō Temple*, and *Two Lions*. Ichikawa Baika said that the tour had been canceled, but did not elaborate on the reasons. Ichikawa Baika, interview. See also Andō Tsuruo, "'Genpei nunobiki no taki' nado ni wadai" [The Topic Is "Genji and Heike at the Nunobiki Waterfall"], *Yomiuri* (evening), 21 September 1962.

42. Andō, "Buyō ni shinpo"; Enomoto, "Magari kado," 111.

43. Sandra Buckley, "Television," *Encyclopedia of Contemporary Japanese Culture* (London: Routledge, 2002), 514.

44. See Kano, *Acting Like a Woman*, 32.

45. Matsushita Kahoru, interview by author, 7 June 2004, Tokyo. Ichikawa Suzume and Ichikawa Baishō voiced similar feelings (interviews).

46. Kurokawa, "37 nen."

47. Ibid.; Ichikawa Baika, "Terebi fukyū."
48. Ichikawa Ebimaru, interview.
49. Ichikawa Himeshō, phone interview by author, 27 April 2004; Kurokawa, "37 nen."
50. Ichikawa Baishō, interview.
51. Kurokawa, interview; Ichikawa Baishō, interview.
52. Ichikawa Misuji, interview.
53. Fujima Rankei, interview.
54. Ichikawa Masujūrō, *KJ*, 162.
55. Seki, *Ebizō soshite Danjūrō*, 14–15; Samuel L. Leiter, "Ichikawa Danjūrō XI," 40; Hayashi Kyōhei, interview by author, 2 August 2004, Tokyo.
56. Ichikawa Emiko, interview.
57. "Ichikawa Shōjo Kabuki sono go" [After Ichikawa Girls' Kabuki], in "Gendai butai haiyū" [Contemporary Stage Actors], special issue, *Engekikai* (September 1964): 223.
58. Ichikawa Baika, interview. A VHS recording of the documentary was given to me by Ichikawa Baika, who thought it had been broadcast on Nippon Hōsō Kyōkai (NHK). Ichikawa Suzume believed that it was broadcast on Nagoya Television. Unfortunately, the documentary is undated, and all production information is omitted. I assume that the documentary was filmed in 1964, because the narrator states several times that Baika, who was born in 1936, is twenty-eight years old. If Baika's age, however, was calculated using the traditional Japanese counting convention whereby a baby's age is counted one at birth, the date could have been 1963.
59. Ichikawa Masujūrō, *KJ*, 164, 181. See also See Ichikawa Baika, "Terebi fukyū"; Kurokawa, "37 nen."
60. Ichikawa Masujūrō, *KJ*, 163. Suzuki Tadashi (b. 1939) is one of Japan's leading contemporary theatre directors. He launched his famous Toga Village festival during the summer of 1976.
61. Nakamura Jakuemon IV, phone interview by author, 31 July 2004; Tokyo; Sawamura Tanosuke VI, interview by author, 18 August 2004, Tokyo. On the other hand, Nakamura Shikan VII said that he knew about the troupe and had met some of the performers, but never had the opportunity to see a performance, since he was so busy. His wife, Masako, who was working in the dressing room during our interview, however, chimed in that she saw the troupe perform numerous times, and seeing that I had brought photographs of the troupe, proceeded to identify each one of the leading performers by name. Nakamura Shikan VII and Nakamura Masako, interview by author, 18 October 2004, Tokyo.
62. Matsushita, interview.
63. Kurokawa, "37 nen."
64. Ichikawa Baika, "Musume kabuki hata-age" [Unfurling Girls' Kabuki], *Mainichi*, 29 March 1993.

EPILOGUE: KABUKI AS INVENTED TRADITION

1. See Eric Hobsbawn, "Inventing Traditions," in *The Invention of Tradition*, ed. Eric Hobsbawn and Terrance Ranger (New York: Cambridge University Press, 1983), 1–14.
2. Kabuki-za Program, September 2004, 40–41. The program was in honor of the stage debut of Nakamura Shikan's fifth grandson, Nakamura Yoshio. For the record, though, it should be pointed out that two of the boys stated that by day they each wanted to become a kabuki actor, but "by night a baseball player."
3. Ichikawa Ennosuke has performed with Fujima Murasaki (b. 1923), his wife and the well-known dance choreographer and teacher. She has danced opposite him, e.g., in the *michiyuki* scene of *Love Suicides at Sonezaki* and appeared in his troupe's production of *Setaigo*, a stylized musical dance piece about the succession of China's empress. In recent years, women have begun to perform jobs, once limited to men, in the offstage arena, from fitting costumes to designing scenery.
4. In 1978, Ichikawa Baika established the Satsuki school of kabuki-style Japanese dance. In more recent years, she has trained children in the Matsuo Juku Kodomo Kabuki Troupe.
5. Kurokawa Mitsuhiro, "Shisetsu: Nagoya Musume Kabuki no jūnen" [Personal Essay: Nagoya Musume Kabuki's Ten Years], *Engeki* [Theatre] 37 (1992): 48. On Danjūrō XII, see Laurence R. Kominz, *The Stars Who Created Kabuki: Their Lives, Loves, and Legacy* (Tokyo: Kodansha, 1997), 224–231.
6. Danjūrō XII's disciple Ichikawa Shinzō (b. 1956) performed in *Sumida River* with Ohka in the same program.
7. "Goaisatsu" [Greeting], *Ichikawa Ohka no kai* [Ichikawa Ohka's production] Program, Nagoya Nō Gakudō, 29 November 2007, 1.
8. Ibid; "Interview: Ichikawa Danjūrō Ichikawa Ohka," *Gamon*, November/ December 2007, 2–3.
9. Judith Mackrell, "The Kabuki Kid," *The Guardian*, 18 May 2006, http:// arts.guardian.co.uk/features/story/0,,1777362,00.html (accessed 26 May 2008).
10. Kurokawa, "Shisetsu," 50–51.
11. Ichikawa Masujūrō, "ISKK," 3.
12. Brandon, "Myth and Reality," 79. See also Mayo, "To Be or Not to Be," 291. Brandon. "Kabuki and the War," 19–39; Okamoto, *The Man Who Saved Kabuki*; Kamiyama, "Kumehachi no zanzō," 22–23.
13. Women performed on the Chinese stage before this ban. In fact, during the Yuan dynasty (1277–1367), women dominated the public stage. See Chou Hui-ling, "Striking Their Own Poses: The History of Cross-Dressing on the Chinese Stage," *TDR* 41:2 (Summer 1997): 130–152; Siu Leung Li,

47. Ibid.; Ichikawa Baika, "Terebi fukyū."
48. Ichikawa Ebimaru, interview.
49. Ichikawa Himeshō, phone interview by author, 27 April 2004; Kurokawa, "37 nen."
50. Ichikawa Baishō, interview.
51. Kurokawa, interview; Ichikawa Baishō, interview.
52. Ichikawa Misuji, interview.
53. Fujima Rankei, interview.
54. Ichikawa Masujūrō, *KJ*, 162.
55. Seki, *Ebizō soshite Danjūrō*, 14–15; Samuel L. Leiter, "Ichikawa Danjūrō XI," 40; Hayashi Kyōhei, interview by author, 2 August 2004, Tokyo.
56. Ichikawa Emiko, interview.
57. "Ichikawa Shōjo Kabuki sono go" [After Ichikawa Girls' Kabuki], in "Gendai butai haiyū" [Contemporary Stage Actors], special issue, *Engekikai* (September 1964): 223.
58. Ichikawa Baika, interview. A VHS recording of the documentary was given to me by Ichikawa Baika, who thought it had been broadcast on Nippon Hōsō Kyōkai (NHK). Ichikawa Suzume believed that it was broadcast on Nagoya Television. Unfortunately, the documentary is undated, and all production information is omitted. I assume that the documentary was filmed in 1964, because the narrator states several times that Baika, who was born in 1936, is twenty-eight years old. If Baika's age, however, was calculated using the traditional Japanese counting convention whereby a baby's age is counted one at birth, the date could have been 1963.
59. Ichikawa Masujūrō, *KJ*, 164, 181. See also See Ichikawa Baika, "Terebi fukyū"; Kurokawa, "37 nen."
60. Ichikawa Masujūrō, *KJ*, 163. Suzuki Tadashi (b. 1939) is one of Japan's leading contemporary theatre directors. He launched his famous Toga Village festival during the summer of 1976.
61. Nakamura Jakuemon IV, phone interview by author, 31 July 2004; Tokyo; Sawamura Tanosuke VI, interview by author, 18 August 2004, Tokyo. On the other hand, Nakamura Shikan VII said that he knew about the troupe and had met some of the performers, but never had the opportunity to see a performance, since he was so busy. His wife, Masako, who was working in the dressing room during our interview, however, chimed in that she saw the troupe perform numerous times, and seeing that I had brought photographs of the troupe, proceeded to identify each one of the leading performers by name. Nakamura Shikan VII and Nakamura Masako, interview by author, 18 October 2004, Tokyo.
62. Matsushita, interview.
63. Kurokawa, "37 nen."
64. Ichikawa Baika, "Musume kabuki hata-age" [Unfurling Girls' Kabuki], *Mainichi*, 29 March 1993.

EPILOGUE: KABUKI AS INVENTED TRADITION

1. See Eric Hobsbawn, "Inventing Traditions," in *The Invention of Tradition*, ed. Eric Hobsbawn and Terrance Ranger (New York: Cambridge University Press, 1983), 1–14.
2. Kabuki-za Program, September 2004, 40–41. The program was in honor of the stage debut of Nakamura Shikan's fifth grandson, Nakamura Yoshio. For the record, though, it should be pointed out that two of the boys stated that by day they each wanted to become a kabuki actor, but "by night a baseball player."
3. Ichikawa Ennosuke has performed with Fujima Murasaki (b. 1923), his wife and the well-known dance choreographer and teacher. She has danced opposite him, e.g., in the *michiyuki* scene of *Love Suicides at Sonezaki* and appeared in his troupe's production of *Setaigo*, a stylized musical dance piece about the succession of China's empress. In recent years, women have begun to perform jobs, once limited to men, in the offstage arena, from fitting costumes to designing scenery.
4. In 1978, Ichikawa Baika established the Satsuki school of kabuki-style Japanese dance. In more recent years, she has trained children in the Matsuo Juku Kodomo Kabuki Troupe.
5. Kurokawa Mitsuhiro, "Shisetsu: Nagoya Musume Kabuki no jūnen" [Personal Essay: Nagoya Musume Kabuki's Ten Years], *Engeki* [Theatre] 37 (1992): 48. On Danjūrō XII, see Laurence R. Kominz, *The Stars Who Created Kabuki: Their Lives, Loves, and Legacy* (Tokyo: Kodansha, 1997), 224–231.
6. Danjūrō XII's disciple Ichikawa Shinzō (b. 1956) performed in *Sumida River* with Ohka in the same program.
7. "Goaisatsu" [Greeting], *Ichikawa Ohka no kai* [Ichikawa Ohka's production] Program, Nagoya Nō Gakudō, 29 November 2007, 1.
8. Ibid; "Interview: Ichikawa Danjūrō Ichikawa Ohka," *Gamon*, November/December 2007, 2–3.
9. Judith Mackrell, "The Kabuki Kid," *The Guardian*, 18 May 2006, http://arts.guardian.co.uk/features/story/0,,1777362,00.html (accessed 26 May 2008).
10. Kurokawa, "Shisetsu," 50–51.
11. Ichikawa Masujūrō, "ISKK," 3.
12. Brandon, "Myth and Reality," 79. See also Mayo, "To Be or Not to Be," 291. Brandon. "Kabuki and the War," 19–39; Okamoto, *The Man Who Saved Kabuki*; Kamiyama, "Kumehachi no zanzō," 22–23.
13. Women performed on the Chinese stage before this ban. In fact, during the Yuan dynasty (1277–1367), women dominated the public stage. See Chou Hui-ling, "Striking Their Own Poses: The History of Cross-Dressing on the Chinese Stage," *TDR* 41:2 (Summer 1997): 130–152; Siu Leung Li,

Cross-Dressing in Chinese Opera (Hong Kong: Hong Kong University Press, 2003), esp. 29–64; Tian, "Male *Dan*," 78–81, 90–93.

14. Tian, "Male *Dan*," 92–93. See also Colin Mackerras, *Peking Opera* (Hong Kong: University of Oxford Press, 1997), 61–66; Siu Leung Li, *Cross-Dressing*, 198–199. The Communist Party's policy, formulated in the 1950s and 1960s, has been to permit the remaining male *dan* to perform, but not to allow the training of new male *dan*. Instead, women are trained to perform female roles.

15. Ann Thompson, "Forum: Gender in Shakespeare and Kabuki," in *Transvestism and the Onnagata Traditions in Shakespeare and Kabuki*, ed. Minoru Fujita and Michael Shapiro (Kent, CT: Global Oriental, 2006), 192.

Bibliography ∾

PRIMARY SOURCES

Signed Articles and Books about the Ichikawa Girls' Kabuki Troupe and the Naritaya House

Akiyama Yasusaburō. "Toki doki me ni fureru 'kusasa' " [Sometimes "Overdone" Acting]. *Asahi shinbun* (evening), 4 May 1953.

———. "Natsu kare fukitobasu saikō no iri" [The Highest Attendance Figures Blow Away the Dead Season]. *Asahi shinbun* (evening), 22 August 1954.

———. "Ichikawa Shōjo Kabuki tōjō" [The Entrance of Ichikawa Girls' Kabuki]. Tōyoko Hall Program, March 1955, 2.

———. "Seiketsu na Ichikawa Shōjo Kabuki" [The Pure Ichikawa Girls' Kabuki]. *Asahi shinbun* (evening), 12 August 1955.

———. "Hanatakashi shōjo kabuki: hachigatsu no Meiji-za" [The High-Nosed Girls' Kabuki: August at Meiji-za]. *Engekikai*, October 1955, 76–77.

———. "Serifu no mazusa ga ki ni naru: Ichikawa Shōjo Kabuki" [Concerns about the Poor Dialogue: Ichikawa Girls' Kabuki]. *Asahi shinbun* (evening), 15 May 1956.

———. "Sei ippai no butai: Ichikawa Shōjo Kabuki" [An Energetic Production: Ichikawa Girls' Kabuki]. *Asahi shinbun* (evening), 9 November 1957.

———. "Yobimono 'Sannin Sanbasō': Tokiwa-za no Ichikawa Shōjo Kabuki" [The Draw Is 'Three Person Sanbasō': Ichikawa Girls' Kabuki at the Tokiwa-za]. *Asahi shinbun* (evening), 4 July 1958.

———. "Seijitsu na butai" [A Sincere Stage: Ichikawa Girls' Kabuki]. *Asahi shinbun* (evening), 19 March 1959.

———. "Ushinawanu kawai-rashisa" [Not Lacking in Cuteness]. *Asahi shinbun*, 19 December 1959.

———. "Tasai de kigarui: Ichikawa Joyū-za, chikara no haitta 'Kawashō' 'Sendai hagi' " [Various and Lighthearted: Ichikawa Joyū-za, A Show of Strength in "The Kawashō Teahouse" and "Autumn Flowers of Sendai"]. *Asahi shinbun*, 21 March 1960.

———. "Miseru gidayū mono: sannen buri no Ichikawa Joyū-za" [Gidayū Pieces for Show: Ichikawa Actress Company after Three Years]. *Asahi shinbun*, 21 February 1962.

Akiyama Yasusaburō. "Kakki no aru kyakuseki: Ichikawa Joyū-za kōen" [A Lively Auditorium: Ichikawa Actress Company]. *Asahi shinbun*, 20 June 1962.

———. "Honkakuteki na dashimono" [Genuine Pieces on the Program]. *Asahi shinbun*, 9 September 1962.

———. "Kaeru Fukushō no godan: Ichikawa Joyū-za" [The Acclaimed Fukushō's Five Roles: Ichikawa Actress Company]. *Asahi shinbun*, 27 September 1962.

Andō Tsuruo. "Suitorigami no yosa, warusa: Meiji-za no Ichikawa Shōjo Kabuki" [The Good and Bad about Blotting Paper: Ichikawa Girls' Kabuki at the Meiji-za]. *Yomiuri shinbun*, 6 August 1954.

———. "Tadashii tehon o ataeyo" [Give the Correct Patterns]. *Yomiuri shinbun* (evening), 10 August 1955.

———. "Mō hitotsu migaki o: Tōyoko Hōru no Ichikawa Shōjo Kabuki" [Polishing One More Thing: Ichikawa Girls' Kabuki at Tōyoko Hall]. *Yomiuri shinbun* (evening), 12 November 1956.

———. "Sawayakana 'Kokaji' no Misuji" [A Fresh "Little Swordsmith's" Misuji]. *Yomiuri shinbun* (evening), 8 November 1957.

———. "Buyō ni shinpo: Tassha na Ichikawa Shōjo Kabuki" [Improvement in Dance: The Amazing Ichikawa Girls' Kabuki]. *Yomiuri shinbun* (evening edition), 11 March 1959.

———. "Masuyo ga migoto seichō" [Masuyo's Splendid Growth]. *Yomiuri shinbun*, 18 December 1959.

———. "Ichikawa Joyū-za no kokaku" [Ichikawa Actresses Company Old Style]. *Yomiuri shinbun* (evening), 19 February 1962.

———. "'Genpei nunobiki no taki' nado ni wadai" [The Topic Is "Genji and Heike at the Nunobiki Waterfall"]. *Yomiuri shinbun* (evening), 21 September 1962.

———. "'Genpei nunobiki no taki' jōen no yūki" [Courage in Performing "The Genji and Heike at the Nunobiki Waterfall"]. *Yomiuri shinbun*, 27 September 1962.

Carson, Robert A. "Teen-Age Kabuki Troupe of Girls Is Making Hit." *Nippon Times*, 13 February 1953, 4.

———. "*Onna* Kabuki Finishes Run at Meiji-za Today." *Nippon Times*, 7 May 1953.

Enomoto Shigetami. "Magari kado ni kakatta: Shōjo Kabuki" [Girls' Kabuki Turns a Corner]. *Engekikai*, December 1959, 110–114.

Fujino Yoshio. "Seichō miseta shōjo kabuki" [Girls' Kabuki Shows Improvement]. *Chūbu Nihon shinbun*, 11 December 1955.

Fukushima Shuji. "Shōjo Kabuki e no kitai to sunbyō" [Our Expectations, In Short, for Girls' Kabuki]. Naka-za Program, July 1955.

Goto (first name unknown). "Hatsu no Minami-za kōen: Ichikawa Shōwa Kabuki" [Minami-za Debut: Ichikawa Girls' Kabuki]. *Kyōto shinbun*, 16 June 1954.

Goto Akira. "Shōjo Kabuki no rikiryō" [Girls' Kabuki's Ability]. Minami-za Program, January 1955, 7.

Ichigawa Tsutomu. "Ai suru otome-tachi" [The Girls I Love]. Naka-za Program, March 1956, 6.

Ichikawa Ebizō. "Goaisatsu" [Greetings]. Tōyoko Hall Program, May 1956.

Katsurada Shigeharu. "Mezurashii 'Kagamiyama' tōshi" [A Rare Full-Length "Mirror Mountain"]. Naka-za Program, March 1956.

————. "Kiyō binbo e no kiken" [Danger of Being a Jack of All Trades and Master of None]. *Makuai*, October 1956, 82–84.

————. "Tenkanki ni tatsu Ichikawa Shōjo Kabuki" [Ichikawa Girls' Kabuki Reaches a Turning Point]. *Makuai*, October 1956, 82–84.

Kawatake Shigetoshi. "Sōshu o agete" [Offer Your Applause]. Mitsukoshi Gekijō Program, February 1953, 10.

————. "Hisashiburi no shōjo kabuki" [Girls' Kabuki after a Hiatus]. Tōyoko Hall Program, November 1957, 22.

Kimura Kikutarō. "Seijun na Ichikawa Shōjo Kabuki" [The Pure Ichikawa Girls' Kabuki]. *Makuai*, February 1953, 52.

Kōsei. "Shōjo kabuki to wa" [What Is Girls' Kabuki?]. Meiji-za Program, May 1953, 26.

Kusakabe Chitomeko [草壁知止子]. "Seitake no nobita shōjo kabuki" [The Girls' Kabuki that Has Grown Taller]. *Engekikai*, December 1957, 58–60.

Maeda Mitsuho. "Shōjo kabuki kara Joyū-za e" [From Girls' Kabuki to Actress Company]. Ichikawa Joyū-za Misono-za Program, June 1960, 8.

Masuya Jisaburō. "Ichikawa Shōjo Kabuki [Ichikawa Girls' Kabuki]. *Makuai*, August 1955, 91.

Miyake Shūtarō. "'Hara' no shūren: Mitsukoshi Gekijō no Ichikawa Shōjo Kabuki" ['Belly' Training: Mitsukoshi Theatre's Ichikawa Girls' Kabuki]. *Mainichi shinbun* (evening), 14 February 1953.

————. "Daigekijō ni deta shōjo kabuki: sono gei wa ko shite umareta" [Girls' Kabuki Appears on a Big Stage: How Their Art Was Born]. *Mainichi shinbun* (evening), 4 May 1953.

————. "Misuji no soshitsu, Fukushō no me" [Misuji's Aptitude, Fukushō's Eyes]. *Mainichi shinbun*, 9 August 1954.

————. "Shūsai Misuji ni nozumu" [Looking at the Genius Misuji]. *Mainichi shinbun*, 15 March 1955.

————. "Bunan na 'Shuzenji monogatari': Meiji-za no Ichikawa Shōjo Kabuki" [A Safe 'Tale of Shuzenji': Ichikawa Girls' Kabuki at Meiji-za Theatre]. *Mainichi shinbun* (evening), 10 August 1955.

————. "Seiseiki karyō no 'Roben sugi'" [High Marks for "Priest Roben"]. *Mainichi shinbun* (evening), 15 May 1956.

————. "Mazu ichio no seiseki: Tōyoko Hōru no Ichikawa Shōjo Kabuki" [A Fine Grade: Ichikawa Shōjo Kabuki at Tōyoko Hall]. *Mainichi shinbun* (evening), 13 November 1956.

————. "'Numazu' to odori: Tōyoko Hōru no Ichikawa Shōjo Kabuki" ["Numazu" and Dance: Ichikawa Girls' Kabuki at Tōyoko Hall]. *Mainichi shinbun* (evening), 13 November 1957.

————. "Chikamatsu-mono no shūsaku" [Excelling with Chikamatsu Pieces]. *Mainichi shinbun* (evening), 16 March 1959.

236 *Bibliography*

Miyake Shūtarō. "Shōjo kara onna e" [From Girl to Woman]. *Mainichi shinbun*, 16 December 1959.

———. "Hisa biza no Ichikawa Joyū-za: bunan na 'Numazu'" [It's Been a Long Time Ichikawa Actress Troupe: A Safe "Numazu"]. *Mainichi shinbun* (evening), 20 February 1962.

Noguchi Tatsuji. "Ichikawa Shōjo Kabuki no ayumi" [Development of Ichikawa Girls' Kabuki]. In "Gendai no kabuki haiyū" [Contemporary Kabuki Actors]. Special issue, *Engekikai*, December 1955, 134–136.

Ōe Ryōtarō. "Hamamatsu no Ichikawa Shōjo Kabuki" [Hamamatsu's Ichikawa Girls' Kabuki]. *Engekikai*, December 1952, 76–78.

Ōki Yutaka. "Shishunki ni tasshita: Ichikawa Shōjo Kabuki" [Ichikawa Girls' Kabuki Reaches Puberty]. *Shūkan Tōkyō* [Tokyo Week], 5 July 1958, 80–83.

Ōtani Takejirō. "Minami-za no nigatsu to awasete minasama ni onegai no koto" [February at Minami-za, and a Special Request for Everyone]. Minami-za Program, February 1956, 2.

Seki Itsuo. "Ichikawa Shōjo Kabuki ni tsuite" [About Ichikawa Girls' Kabuki]. Minami-za Program, February 1957.

Shimizu Fue. "Shōjo kabuki būmu." [Girls' Kabuki's Boom]. Misono-za Program, February 1955, 16–17.

Tobe Ginsaku. "Kono kotoba gozonji? Joyū-za" [Do You Know This Word? Actress Company]. *Engekikai*, April 1960, 85.

Toita Yasuji. "Ichikawa Shōjo Kabuki: kabuki no kuni no 'tensai shōjo'" [Ichikawa Girls' Kabuki: Kabuki World's "Girl Prodigies"]. *Geijutsu shinchō* [Artistic New Tides], July 1953, 70–72.

———. *Naki dokoro jinbutsushi* [People Who Hit a Nerve]. Tokyo: Bungei Shunjū, 1987.

Tomita Yasuhiko. "Tadashii seichō ni kyōdan: hōkensei daha Ichikawa Shōjo Kabuki" [Amazed at the Proper Dignity: Ichikawa Girls' Kabuki Breaks the Feudal System]. *Ōsaka nichi nichi shinbun*, 15 June 1953.

———. "Dōtonbori no kyōi: Ichikawa Shōjo Kabuki" [Dōtonbori 's Miracle: Ichikawa Girls' Kabuki]. *Ōsaka nichi nichi shinbun*, 7 November 1954.

———. "Azayaka na "Noriaibune" [A Lively "Ferry"]. *Ōsaka nichi nichi shinbun*, 5 February 1955.

———. "Misuji-san ni horebore, Masuyo no 'Dōjōji' hyōjo wa mane dekinu" [Enchanted by Misuji; Cannot Imitate Masuyo's Expression in "Dōjō Temple"]. *Ōsaka nichi nichi shinbun*, 7 July 1955.

———. "Tasai na kyōgen ni seichō shimesu" [Showing Growth in a Variety of Pieces]. *Ōsaka nichi nichi shinbun*, 10 July 1955.

———. "Netsuen to kyōwa no kesshō: hikaru Misuji, Masuyo no 'Tsubosaka'" [Enthusiasm and Harmony's Crystallization: Shining Misuji, Masuyo's "Tsubosaka"]. *Ōsaka nichi nichi shinbun*, 5 March 1956.

———. "Jitsu o musunda hachi nen no shūgyō" [Reaping the Efforts of Eight Years]. *Ōsaka nichi nichi shinbun*, 5 July 1957.

————. "Shinkyō ichijirushii Masuyo" [Remarkable Progress Made by Masuyo]. *Ōsaka shinbun*, 20 August 1960.

Toshikura Yoshikazu. "Hamamatsu no Shōjo Kabuki" [Hamamatsu's Girls' Kabuki]. *Engekikai*, October 1952, 34–35.

————. "Ichikawa Shōjo Kabuki" [Ichikawa Girls' Kabuki]. Tōyoko Hall Program, March 1955, 3.

————. "Kinkyō hōkoku" [Report on How Things Are Going]. *Engekikai*, October 1955, 49.

————. "Yonnen mae" [Four Years Ago]. Tōyoko Hall Program, May 1956.

————. "Ichinin mae no da kara" [Because They Have Become Adults]. Shinjuku Daiichi Gekijō Program, March 1960.

Tsuchiya Chikashi. "Shōjo kabuki no jūnen" [Girls' Kabuki's Ten Years]. In "Kabuki haiyū hyakka" [Directory of Kabuki Actors]. Special issue, *Engekikai*, December 1959, 172–173.

Tsukikata Ryūnosuke. "Nobi yo shōjo kabuki" [Grow, Girls' Kabuki], *Ōsaka nichi nichi shinbun*, 9 November 1954, 5.

————. "Fuan no kotoba" [A Word from a Fan]. February 1955, Misono-za Program, 13.

Tsumori Kenji. "Ichikawa Shōjo Kabuki junen" [Ichikawa Girls' Kabuki Touring]. *Asahi gurafu* [Asahi Graph], 25 September 1956, 42–43.

Uchiyama Tsuneo. "Hamamatsu to jūdaime Danjūrō: Ichikawa Shōjo Kabuki sodate no oya" [Hamamatsu and Danjūrō X: The Parent Who Raised Ichikawa Girls' Kabuki]. *Tōtōmi* [The Far Lake] 25 (March 2002): 9–18.

Ueno Chiaki. "Nagoya hiroen kōen: mada atarashii mono ni yowai" [Nagoya's Performance Celebration: New Pieces Are Still Weak]. *Chūbu Nihon shinbun*, 7 June 1960.

Ueno Senshu. "Ichikawa Shōjo Kabuki ni omou" [Thinking about Ichikawa Girls' Kabuki]. Misono-za Program, February 1955, 27.

W. "Netsui ni wa kōkan" [Favorable Impressions Regarding the Enthusiasm]. *Kyōto shinbun* (evening), 11 September 1956.

W. "Migotae aru 'Kagamiyama': Ichikawa Shōjo Kabuki" [Ichikawa Girls' Kabuki's Worthwhile "Mirror Mountain"). *Kyōto shinbun* (evening), 17 February 1957.

Watanabe Saburō. "Shōjo bakari no kabuki" [The All-Girls' Kabuki]. *Shūkan sankei* [Industrial and Commerce Weekly], 22 February 1953, 56–57.

Yamamoto, Yuki. "All Girl Kabuki Is a Smash Hit." *Nippon Times*, 17 August 1954.

AUTOBIOGRAPHIES/MEMOIRS BY MEMBERS AND STAFF ASSOCIATED WITH THE NARITAYA HOUSE

Ichikawa Baika. "Ōatari, shōjo kabuki" [Smash Success, Girls' Kabuki]. "Matsuba-botan no ki" [Journal of Miniature Peonies], *Mainichi shinbun*, no. 1, 11 January 1993.

Ichikawa Baika. "Honkaku gekijō de ronguran" [A Long Run in a Real Theatre]. "Matsuba-botan no ki" [Journal of Miniature Peonies], *Mainichi shinbun*, no. 2, 18 January 1993.

———. "Gonan, yobikomi, mimau aoitake" [Difficulties, Being Screamed at and Hit with a Green Bamboo Pole]. "Matsuba-botan no ki" [Journal of Miniature Peonies], *Mainichi shinbun*, no. 3, 25 January 1994.

———. "Shishō wa ichi-ryū mainichi shonichi" [The Master's Best: Every Day Is the First Day]. "Matsuba-botan no ki" [Journal of Miniature Peonies], *Mainichi shinbun*, no. 4, 1 February 1993.

———. "Shoen geidai-chū ni chichi no shi" [My Father's Death in the Middle of the Opening Program]. "Matsuba-botan no ki" [Journal of Miniature Peonies], *Mainichi shinbun*, no. 5, *Mainichi*, 8 February 1993.

———. "Maiko-san to ikitō" [Hitting It Off with Geisha Apprentices]. "Matsuba-botan no ki" [Journal of Miniature Peonies], *Mainichi shinbun*, no. 7, 22 February 1993.

———. "Bunraku de haragei oshierare" [Being Taught Gut Acting from Bunraku]. "Matsuba-botan no ki" [Journal of Miniature Peonies], *Mainichi shinbun*, no. 8, 1 March 1993.

———. "Terebi fukyū, heru danin" [Advent of Television, Dropping Members]. "Matsuba-botan no ki" [Journal of Miniature Peonies], *Mainichi shinbun*, no. 9, 8 March 1993.

———. "Musume kabuki hata-age" [Unfurling Girls' Kabuki]. "Matsuba-botan no ki" [Journal of Miniature Peonies], *Mainichi shinbun*, no. 12, 29 March 1993.

———. "Suzume hyaku made odori wasurezu" [Never Forgetting the Customs that One Learned as a Child]. "Matsuba-botan no ki" [Journal of Miniature Peonies], *Mainichi shinbun*, no. 15, 19 April 1993.

Ichikawa Kumehachi. "Geidan hyakuwa" [One Hundred Sayings about Art]. *Engei gahō* [Theatre Illustrated], April 1907, 79–86.

———. "Meika shinsōroku" [Discussions with People from Famous Families]. *Engei gahō*, September 1907, 107–122.

Ichikawa Masujūrō. *Kabuki jinsei* [A Kabuki Life].Toyohashi: Hōbundō, 1983.

———. "Ichikawa Shōjo Kabuki kōenkai: Ichikawa Shōjo Kabuki are kore" [Symposium on the Ichikawa Girls' Kabuki: Pondering Ichikawa Girls' Kabuki]. Lecture, Sakuragaoka Museum, Toyokawa, Japan, 7 May 1995. Transcript courtesy Sakuragaoka Museum.

Ichikawa Misuji. "Shōjo kara onna e no nayami" [Concerns (about Going) from a Girl to a Woman]. *Fujin gahō* [Ladies Illustrated], September 1958, 231–234.

Ichikawa Sanshō V. *Kyusei Danjūrō o kataru* [Talking about Danjūrō IX]. Kyoto: Suiko Shoin, 1950.

Ichikawa Suisen II. "Kagamijishi" [Mirror Lion]. In *Kagamijishi* [The Mirror Lion], edited by Hukusabro Horikosi [*sic*] [Ichikawa Sanshō V]. Kyoto: Unsō Shuppanbu, 1948, 13–63.

Ichikawa Suisen III. *Kudaime Danjūrō to watashi* [Danjūrō IX and Me]. Tokyo: Rikugei Shobo, 1966.

PRIMARY DOCUMENTS FROM THE SAKURAGAOKA MUSEUM AND HAMAMATSU CHŪO TOSHOKAN

Ichikawa Ebizō IX to Ichikawa Masujūrō. Letters. 23 February and 1 March 1956, no. 26 and 10, Ichikawa Shōjo Kabuki collection. Sakuragaoka Museum, Toyokawa, Japan.

Ichikawa Sanshō V to Ichikawa Masujūrō. Letters, 28 February 1953–6 January 1956, no. 1–25, 28, 30, Ichikawa Shōjo Kabuki collection. Sakuragaoka Museum, Toyokawa, Japan.

Ichikawa Shōjo Kabuki documents. Sakuragaoka Museum, Toyokawa, Japan.

Saitō Sadaichirō. "Hamamatsu jōen kabuki shibai kiroku" [A Record of Kabuki Plays Performed at Hamamatsu]. Unpub. scroll, Hamamatsu Chuō Toshokan [Hamamatsu Central Metropolitan Library], ref. no. 775:29: K, 1960.

Yoneko to Ichikawa Masujūrō. 17 February 1956, no. 29, Ichikawa Shōjo Kabuki collection. Sakuragaoka Museum, Toyokawa, Japan.

PROGRAMS CONSULTED FROM ICHIKAWA SHŌJO KABUKI PERFORMANCES/ICHIKAWA JOYŪ-ZA

Mitsukoshi Gekijō (Tokyo), February 1953, Ōtani Shōchiku Toshokan, Tokyo.
Meiji-za (Tokyo), May 1953, Ōtani Shōchiku Toshokan, Tokyo.
Bunraku-za (Osaka), August 1953, Ōtani Shōchiku Toshokan, Tokyo.
Bunraku-za (Osaka), November 1953, Ōtani Shōchiku Toshokan, Tokyo.
Minami-za (Kyoto), June 1954, Ōtani Shōchiku Toshokan, Tokyo.
Minami-za (Kyoto), September 1954, Ōtani Shōchiku Toshokan, Tokyo.
Naka-za (Osaka), November 1954, Ōtani Shōchiku Toshokan, Tokyo.
Misono-za (Nagoya), December 1954, Misono-za Toshokan, Nagoya.
Minami-za (Kyoto), January 1955, Ōtani Shōchiku Toshokan, Tokyo.
Naka-za (Osaka), February 1955, Ōtani Shōchiku Toshokan, Tokyo.
Misono-za (Nagoya), February 1955, Misono-za Toshokan, Nagoya.
Tōyoko Hall (Tokyo), March 1955, Ōtani Shōchiku Toshokan, Tokyo.
Minami-za (Kyoto), May 1955, Ōtani Shōchiku Toshokan, Tokyo.
Naka-za (Osaka), July 1955, Ōtani Shōchiku Toshokan, Tokyo.
Misono-za (Nagoya), 1955 December, Misono-za Toshokan, Nagoya.
Minami-za (Kyoto), February 1956, Ōtani Shōchiku Toshokan, Tokyo.
Naka-za (Osaka), March 1956, Ōtani Shōchiku Toshokan, Tokyo.
Tōyoko Hall (Tokyo), May 1956, Ōtani Shōchiku Toshokan, Tokyo.
Misono-za (Nagoya), August 1956, Misono-za Toshokan, Nagoya.
Minami-za (Kyoto), September 1956, Ōtani Shōchiku Toshokan, Tokyo.

240 *Bibliography*

Tōyoko Hall (Tokyo), November 1956, Ōtani Shōchiku Toshokan, Tokyo.
Minami-za (Kyoto), February 1957, Ōtani Shōchiku Toshokan, Tokyo.
Minami-za (Kyoto), June 1957, Ōtani Shōchiku Toshokan, Tokyo.
Naka-za (Osaka), July 1957, Ōtani Shōchiku Toshokan, Tokyo.
Misono-za (Nagoya), July 1957, Misono-za Toshokan, Nagoya.
Hamamatsu-za (Hamamatsu City), August 1957, Hamamatsu Chūo Toshokan.
Tōyoko Hall, November 1957, Ōtani Shōchiku Toshokan, Tokyo.
Misono-za (Nagoya), December 1957, Misono-za Toshokan, Nagoya.
Tōyoko Hall (Tokyo), April 1958, Ōtani Shōchiku Toshokan, Tokyo.
Hamamatsu-za (Hamamatsu City), May 1958, Hamamatsu Chūo Toshokan.
Tokiwazu-za (Tokyo), July 1958, Ōtani Shōchiku Toshokan, Tokyo.
Misono-za (Nagoya), December 1958, Misono-za Toshokan, Nagoya.
Tōyoko Hall (Tokyo), March 1959, Ōtani Shōchiku Toshokan, Tokyo.
Misono-za (Nagoya), August 1959, Misono-za Toshokan, Nagoya.
Minami-za (Kyoto), August 1959, Ōtani Shōchiku Toshokan, Tokyo.
Misono-za (Kyoto), December 1959, Misono-za Toshokan, Nagoya.
Shinjuku Daiichi Gekijō (Tokyo), December 1959, Ōtani Shōchiku Toshokan, Tokyo.
Mainichi Hall (Ōsaka), January 1960, Ōtani Shōchiku Toshokan, Tokyo.
Shinjuku Daiichi Gekijō (Tokyo), March 1960, Ōtani Shōchiku Toshokan, Tokyo.
Misono-za (Nagoya), June 1960, Misono-za Toshokan, Nagoya.
Minami-za (Kyoto), August 1960, Ōtani Shōchiku Toshokan, Tokyo.
Mainichi Hall (Ōsaka), January 1961, Ōtani Shōchiku Toshokan, Tokyo.
Ota-ku Minkaikan (Tokyo), May 1961, Sakuragaoka Museum, Toyokawa.
Tōyoko Hall (Tokyo), February 1962, Ōtani Shōchiku Toshokan, Tokyo.
Yomiuri Hall (Tokyo), September 1962, Ōtani Shōchiku Toshokan, Tokyo.
Kitazawa Kaikan (Suwa, Nagano Prefecture), October 1962, Sakuragaoka Museum, Toyokawa.
Tomokai Rakukan (Nara) n.d., Sakuragaoka Museum, Toyokawa.
Kyūshū tour, n.d., Sakuragaoka Museum, Toyokawa.

SELECT PROGRAMS FROM NAGOYA MUSUME KABUKI PERFORMANCES

Chūshō Kigyō Center (Nagoya), April 1985.
Nagoya Shimin Kaikan (Nagoya), September 1985.
Chūshō Kigyō Center (Nagoya), April 1987.
Chūshō Kigyō Center (Nagoya), April 1988.
Nagoya Shimin Kaikan (Nagoya), January 1991 (with members of Ichikawa Shōjo Kabuki).

Geijutsu Sōzō Center (Nagoya), July 1992.
Aichi-ken Geijutsu Gekijō (Nagoya), December 1992.
Nagoya Shimin Kaikan (Nagoya), June 1993.
Misono-za (Nagoya), December 1994.
Geijutsu Sōzō Center (Nagoya), April 1995.
Kokuritsu Gekijō (Tokyo), November 1995.
Artpia Hall (Nagoya), February 1997.
Artpia Hall (Nagoya), May 1997.
Artpia Hall (Nagoya), August 1997.
Artpia Hall (Nagoya), September 1997.
Nagoya Shimin Kaikan (Nagoya), September 1998.
Artpia Hall (Nagoya), November 1999.
Kita Bunka Gekijō (Nagoya), September 2000.
Nō Gakudō (Nagoya), December 2000.
World Music Theatre Festival, Netherlands and Belgium, April 2002.
Misono-za (Nagoya), September 2002.
Chiku-za Gekijō (Nagoya), July–August 2003.
Dan Dan Hōru (Taisha, Shimane Prefecture), September 2003.
Artpia Hall (Nagoya), September 2003.
Chiku-za Gekijō (Nagoya), July 2004.
Sunpotto Hall (Takamatsu City), August 2004.
Ichikawa Ohka no kai, Nagoya Nō Gakudō, 29 November 2007.

NEWSPAPERS

Asahi shinbun
Enshyu [sic] *shinbun*
Chūbu Nihon shinbun
Chūnichi shinbun
Guardian, The
Hamamatsu minpō
Jiji shinpō
Kyōto shinbun
Mainichi shinbun
Nippon Times
Ōsaka nichi nichi shinbun
Sangyō keizai shinbun
Shizuoka shinbun
Tōkyō nichi nichi shinbun
Tōkyō shinbun
Yomiuri shinbun

MAGAZINES AND PERIODICALS

Asahi gurafu [Asahi Graph]
Bunka seigatsu [Cultural Life]
Engekikai [Theatre World]
Fujin gahō [Ladies Illustrated]
Geijutsu shinchō [Artistic New Tides]
Kabuki
Makuai [Intermission]
Mainichi gurafu [Mainichi Chart]
Sandê mainichi [Sunday Mainichi]
Shūkan sankei [Industrial and Commerce Weekly]
Shūkan Tōkyō [Tokyo Week]
Shufu no tomo [Housewife's Friend]
Tōkai tenpō [Tōkai News]

INTERVIEWS

Fujima Rankei, interview by author, 25 July 2004, Tokyo.
Hayashi Kyōhei, interview by author, 2 August 2004, Tokyo.
Ichikawa Baika, interview by author, 4 March 2004, Toyokawa, Japan; follow-up phone interview, 9 March 2004.
Ichikawa Baishō, interview by author, 28 April 2004, Toyokawa, Japan.
Ichikawa Danjūrō XII, interview by author, 6 October 2002, Tokyo, Japan.
Ichikawa Ebimaru, interview by author, 16, 28 April 2004, Toyokawa, Japan.
Ichikawa Emiko, interview by author, 2 June 2004, Toyohashi, Japan.
Ichikawa Fukushō, interview by author, 30 April and 3 May 2004, Gero, Japan.
Ichikawa Himeshō, phone interview by author, 27 April 2004.
Ichikawa Hisayo, interview by author, 2 April 2004, Tokyo.
Ichikawa Kiyomi, interview by author, 20 April 2004, Tokyo, Japan.
Ichikawa Kobeni, interview by author, 4 May 2004, Yatomi Village, Japan.
Ichikawa Kobotan, interview by author, 29 April 2004, Gifu City.
Ichikawa Masuyo, interview by author, 23 March 2004, Tokyo, Japan.
Ichikawa Misuji, interview with author, 4 October 2004, Nagoya, Japan.
Ichikawa Sanpuku, interview by author, 5 April 2004, Toyohashi, Japan.
Ichikawa Suzume, interview by author, 5 April 2004, Toyohashi, Japan.
Ichikawa Toshie, phone interview by author, 27 April 2004.
Kurokawa Mitsuhiro, interview by author, 15 July 2004, Nagoya, Japan.
Matsushita Kahoru, interview by author, 7 June 2004, Tokyo.
Miyakoji Noburu, interview by author, 17 September 2004, Tokyo.
Nakamura Matazō, interview by author, 12 September 2004, Tokyo.
Nakamura Jakuemon IV, phone interview by author, 31 July 2004.
Nakamura Shikan VII, interview by author, 18 October 2004, Tokyo.

Onoe Umeno, interview by author, 20 August 2004, Tokyo, Japan.
Sawamura Tanosuke VI, interview by author, 18 August 2004, Tokyo, Japan.

FILM/VIDEO/DVD

Documentary on Ichikawa Shōjo Kabuki (title unknown). Producer unknown. CA. 1964, VHS courtesy Ichikawa Baika.

"Ichikawa Joyū-za Kabuki geki shirizu" (Kabuki Play Series, includes *Awa no Naruto, Kagamiyama kokyō no nishikie, Tsubosaka reigenki*, and *Koi bikyaku Yamato ōrai*). Ca. 1960. Produced by Ichikawa Joyū-za. Misono-za Theatre Library (Nagoya) and Sakuragaoka Museum (Toyokawa).

Kyōen yukinojō henge [Rival Performances: The Transformation of Yukinojō]. Shin Tōhō Eiga, 1957, DVD by Broadway Inc., Japan. Misora Hibari Collection, 180 min.

Mainichi News, undated footage. (ca. 1951–1952), VHS courtesy Ichikawa Baika.

SECONDARY AND TERTIARY SOURCES

Bach, Faith. "Breaking the Kabuki Actors' Barriers: 1868–1900." In *A Kabuki Reader: History and Performance*, edited by Samuel L. Leiter, 152–166. Armonk, NY: M.E. Sharpe, 2002 [1995].

———. "The Contributions of Omodakaya to Kabuki." Ph.D. diss., St. Anthony College, University of Oxford, 1990.

Bernstein, Gail, ed. *Recreating Japanese Women, 1600–1945*. Berkeley: University of California Press, 1991.

Birnbaum, Phyllis. *Modern Girls, Shining Stars, the Skies of Tokyo: 5 Japanese Women*. New York: Columbia University Press, 1999.

Brandon, James R. "Kabuki and Shakespeare: Balancing Yin and Yang." *The Drama Review* 43:2 (Summer 1999): 15–53.

———. "Kabuki and the War of Greater East Asia, 1931–1945." *Mime Journal: Theatre East and West Revisited* 22 (2002–2003): 19–39.

———. "Myth and Reality: A Story of Kabuki during American Censorship, 1945–1949." *Asian Theatre Journal* 23:1 (Spring 2006): 1–110.

Buckley, Sandra. *Broken Silence: Voices of Japanese Feminism*. Berkeley: University of California, 1997.

———. *Encyclopedia of Contemporary Japanese Culture*. London: Routledge, 2002.

Butler, Judith. *Gender Trouble: Feminism and the Subversion of Identity*. New York: Routledge, 1990.

———. "Imitation and Gender Insubordination." In *Inside/Out: Lesbian Theories, Gay Theories*, edited by Diana Fuss, 312–313. New York: Routledge, 1991.

Butler, Judith. *Bodies That Matter: On the Discursive Limits of "Sex."* New York: Routledge, 1993.

Carlson, Marvin. *The Haunted Stage: The Theatre as Memory Machine.* Ann Arbor: University of Michigan Press, 2001.

Chou Hui-ling. "Striking Their Own Poses: The History of Cross-Dressing on the Chinese Stage." *TDR* 41:2 (Summer 1997): 130–152.

Coaldrake, A. Kimiko. *Women's Gidayū and the Japanese Theatre Tradition.* London: Routledge, 1997.

Dalby, Liza. *Geisha.* Berkeley: University of California Press, 1983.

Davis, Tracy. "Questions for a Feminist Methodology in Theatre History." In *Interpreting the Theatrical Past: Essays in the Historiography of Performance,* edited by Thomas Postlewait and Bruce A. McConachie, 59–81. Iowa City: Iowa Press, 1989.

Dolan, Jill. *The Feminist Spectator as Critic.* Ann Arbor: UMI Research Press, 1988.

Dower, John W. *Embracing Defeat: Japan in the Wake of World War II.* New York: W.W. Norton, 1999.

Dunn, Charles and Bunzō Torigoe, trans. and ed. *The Actors' Analects.* New York: Columbia University Press, 1969.

Edelson, Loren. "Danjūrō's Girls: The Ichikawa Family and Women on the Kabuki Stage." Ph.D. diss., The Graduate Center, City University of New York, 2006.

———. "The Female Danjūrō: Revisiting the Acting Career of Ichikawa Kumehachi." *Journal of Japanese Studies* 34:1 (Winter 2008): 69–98.

———. "The Return of the Actress to the Public Stage." In *Gender and Law in Imperial Japan,* edited by Barbara Brooks and Susan Burns. Submitted to Ann Arbor: University of Michigan, Japan Series.

Engei Gahō, ed. *Nihon haiyū meikan* [Facebook of Japanese Actors]. Tokyo: Engei Gahō, 1910, 76.

Ferris, Leslie. *Acting Women: Images of Women in Theatre.* New York: New York University Press, 1989.

Fujii Kōsei. "Sengo no Nagoya geinō kōshi: Ichikawa Shōjo Kabuki to Fuji Kabuki o chūshin ni" [Postwar Nagoya Small Performance Movement: Focusing on Ichikawa Girls' Kabuki and Fuji Kabuki]. *Nagoya geinō bunka* [Nagoya Performance Culture] 1 (1992): 3–10.

Fujita Minoru, and Shapiro, Michael, eds. *Transvestism and Onnagata Traditions.* Kent, CT: Global Oriental, 2006.

Gerstle, Andrew C. "Eighteenth-Century Kabuki and Its Patrons." In *A Kabuki Reader: History and Performance,* edited by Samuel L. Leiter. Armonk, NY: M.E. Sharpe, 2002 [1987].

Gunji Masakatsu. *Kabuki no bigaku* [Kabuki Aesthetics]. Tokyo: Engeki Shuppansha, 1963.

———. *Zeami no zuihitsu: Zeami seitan roppyakunen ni* [Collected Writings on Zeami in Honor of His Six Hundredth Anniversary]. Tokyo: Hinoki Shōten, 1984, 18–19.

Hamamatsu Shōten Kairenmei, ed. *Hamamatsu shōten renmei setsuritsu sanjū shūnen kinenshi* [The Thirtieth Anniversary of the Hamamatsu Commercial Federation], Hamamatsu: Hamamatsu Shōten Kairenmen, 1 February 1979.

Haga Noboru et al., eds. "Gendai haiyū meikan" [Contemporary Actors' Directory]. In *Nihon jinbutsu jōhō taikei* [Japanese People Information Data]. Tokyo: Kōseisha, 1999 [1918].

Hasegawa Shigure. *Kindai bijin den* [Tales of Modern Beauties]. Tokyo: Sairensha, 1936.

Hasumi Seitarō. "Onna yakusha no hanashi" [Talk about Female Performers]. *Gendai no kabuki haiyū* [Contemporary Kabuki Actors]. Special issue, *Engekikai* [Theatre World], December 1955, 46–47.

Hattori Yukio. *Ichikawa Danjūrō dai dai* [Generations of the Ichikawa Danjūrō Line]. Tokyo: Kodansha, 2002.

Hibino, Kci. "Re-Constructing Japanese Theatre after the War: Mitsukoshi Gekijō and Its Activities." In *Rising from the Flames: The Rebirth of Theatre in Occupied Japan, 1945–1952*, edited by Samuel L. Leiter. Lexington Press, forthcoming.

Hobsbawn, Eric and Ranger, Terrance, eds., *The Invention of Tradition*. New York: Cambridge University Press, 1983.

Hume, Robert D. *Reconstructing Contexts: The Aims and Principles of Archaeo-Historicism*. Oxford: Oxford University Press, 1999.

Ihara Seiseien. *Meiji engekishi* [History of Meiji-Period Theatre]. Tokyo: Kuresu Shuppan, 1933.

———. *Kabuki nenpyō* [Kabuki Chronology]. 8 vols. Tokyo: Iwanami Shoten, 1956–1963.

Isaka, Maki [Morinaga]. "Women *Onnagata* in the Porous Labyrinth of Femininity: On Ichikawa I." *U.S.-Japan Women's Journal* 30–31 (2006): 105–131.

Ivy, Marilyn. *Discourses of the Vanishing*. Chicago: University of Chicago Press, 1995.

Iwasaki Eiji. "Mitsukoshi Geikijō engekishi: shōwa 21 nen kara 28 nen made" [History of the Mitsukoshi Theatre: 1946–1953]. Mitsukoshi shiryō shitsu, Tokyo, 1990.

Jiang Qing. "Revolutionizing Beijing Opera." In *Chinese Theories of Theater and Performance from Confucius to the Present*, edited and translated by Faye Chunfang Fei. Ann Arbor: University of Michigan Press, 1999.

Kamiyama Akira. "Kumehachi no zanzō: Onna yakusha to joyū no aidai" [Images of Kumehachi: Between Female Actor and Actress]. *Geinō* [Performing Arts] 34:9 (September 1992): 17–23.

———. "Kindai ni okeru kabuki no henyō" [The Transition of Kabuki in Modernization (*sic*)]. In *Kabuki: Changes and Prospects*, edited by International Symposium on the Conservation and Restoration of Cultural Properties, 159–170. Tokyo: Tokyo National Research Institute of Cultural Properties, 1996.

Kamiyama Masashi. *Shashinshū Hamamatsu: Meiji, Taishō, Shōwa* [Collection of Photographs of Hamamatsu: from the Meiji, Taishō and Shōwa Periods]. Tokyo: Kokusho Kankō, 1978.

Kano, Ayako. *Acting Like a Woman in Modern Japan: Theatre, Gender, and Nationalism*. New York: Palgrave, 2001.

Kobayashi Katsunojō. "Wasurareta haiyū-tachi" [Forgotten Actors]. *Engei gahō*, September 1940: 68.

Koike Shōtarō. "Daimyō nikki ga egaku aru Edo joyū" [An Edo Actress as Portrayed in a Daimyō's Diary]. *Rekishi to jinbutsu* [History and Individuals] 10:11 (1980): 214–218.

———. "Okyōgen-shi." In *Kabuki jiten* [Kabuki Encyclopedia], edited by Hattori Yukio et al., 2nd ed. Tokyo: Heibonsha, 2000.

Kominz, Laurence R. *The Stars Who Created Kabuki: Their Lives, Loves and Legacy*. New York: Kodansha International, 1997.

Kurokawa Mitsuhiro. "Shisetsu: Nagoya Musume Kabuki no jūnen" [Personal Essay: Nagoya Musume Kabuki's Ten Years]. *Engeki* [Theatre] 37 (1992): 46–54.

———. "Musume no oya-tachi wa geisuki datta" [The Girls' Parents Liked Performing Arts]. "Maboroshi no Ichikawa Shōjo Kabuki" [Phantom Ichikawa Girls' Kabuki], *Chūnichi shinbun*, no. 1, 6 January 1984.

———. "Ryōriya no nikai de keiko" [Practice on the Second Floor of the Restaurant]. "Maboroshi no Ichikawa Shōjo Kabuki" [Phantom Ichikawa Girls' Kabuki], *Chūnichi shinbun*, no. 2, 7 January 1984.

———. "Nomikomi no hayai onna no ko" [The Girls Who Learned Quickly]. "Maboroshi no Ichikawa Shōjo Kabuki" [Phantom Ichikawa Girls' Kabuki], *Chūnichi shinbun*, no. 3, 9 January 1984.

———. "Hatsu geiko de shishō mo zessan" [Praise Too from the Master at the First Practice]. "Maboroshi no Ichikawa Shōjo Kabuki" [Phantom Ichikawa Girls' Kabuki], *Chūnichi shinbun*, no. 5, 11 January 1984.

———. "Dai ikkai happyōkai wa daiseiko" [The First Recital Is a Success]. "Maboroshi no Ichikawa Shōjo Kabuki" [Phantom Ichikawa Girls' Kabuki], *Chūnichi shinbun*, no. 7, 23 January 1984.

———. "Nojuku mo shita nagaki jungyō" [Also Spending the Night Outside on a Long Tour]. "Maboroshi no Ichikawa Shōjo Kabuki" [Phantom Ichikawa Girls' Kabuki], *Chūnichi shinbun*, no. 8, 24 January 1984.

———. "Ise jungyō wa sansan na kekka" [Disastrous Results for the Ise Tour]. "Maboroshi no Ichikawa Shōjo Kabuki" [Phantom Ichikawa Girls' Kabuki], *Chūnichi shinbun*, no. 9, 25 January 1984.

———. "Ōatari, Hamamatsu-za kōen" [Smash Hit, the Hamamatsu-za Production]. "Maboroshi no Ichikawa Shōjo Kabuki" [Phantom Ichikawa Girls' Kabuki], *Chūnichi shinbun*, no. 10, 28 January 1984.

———. "Sōke ga Ichikawa no na o menkyo" [The Head Grants the Ichikawa Name]. "Maboroshi no Ichikawa Shōjo Kabuki" [Phantom Ichikawa Girls' Kabuki], *Chūnichi shinbun*, no. 11, 30 January 1984.

———. "Sōke ga kyōryoku ni atooshi" [The Head Powerfully Supports]. "Maboroshi no Ichikawa Shōjo Kabuki" [Phantom Ichikawa Girls' Kabuki], *Chūnichi shinbun*, no. 12, 1 February 1984.

————. "Zessan o haku-shita Tōkyō kōen" [Tokyo Production Receives Acclaim]. "Maboroshi no Ichikawa Shōjo Kabuki" [Phantom Ichikawa Girls' Kabuki]. *Chūnichi shinbun*, no. 13, 3 February 1984.

————. "Matsui sensei to no kōryū rokunen" [Six Years with Matsui-sensei]. "Maboroshi no Ichikawa Shōjo Kabuki" [Phantom Ichikawa Girls' Kabuki], *Chūnichi shinbun*, no. 14, 4 February 1984.

————. "Suparuta-shiki no mōgeiko" [Intense, Sparta-Like Training]. "Maboroshi no Ichikawa Shōjo Kabuki" [Phantom Ichikawa Girls' Kabuki], *Chūnichi shinbun*, no. 15, 6 February 1984.

————. "Watashi seigatsu mo kibishiku kisei" [Private Life Also Strictly Regulated]. "Maboroshi no Ichikawa Shōjo Kabuki" [Phantom Ichikawa Girls' Kabuki], *Chūnichi shinbun*, no. 16, 7 February 1984.

————. "Yoi shidōsha ni megumareru" [Blessed with Good Teachers]. "Maboroshi no Ichikawa Shōjo Kabuki" [Phantom Ichikawa Girls' Kabuki]. *Chūnichi shinbun*, no.17, 8 February 1984.

————. "Gei ka kekkon ka nayamu zain" [Troupe Members Worry: Art or Marriage]. "Maboroshi no Ichikawa Shōjo Kabuki" [Phantom Ichikawa Girls' Kabuki], *Chūnichi shinbun*, no. 18, 13 February 1984.

————. "Mi o sutete na o toru" [Throwing Away the Fruit, Taking a Name]. "Maboroshi no Ichikawa Shōjo Kabuki" [Phantom Ichikawa Girls' Kabuki], *Chūnichi shinbun*, no. 19, 20 February 1984.

————. "37 nen, tsuni maku o hiku" [Closing the Curtain at Last in 1962]. "Maboroshi no Ichikawa Shōjo Kabuki" [Phantom Ichikawa Girls' Kabuki], *Chūnichi shinbun*, no. 20, 21 February 1984.

Kyōdō Tsushinsha, ed. *Kabuki yonhyakunen ten* [Exhibition on Kabuki's Four Hundred Years]. Tokyo: Kyōdō Tsushinsha, 2003.

Laderrière, Mette. "The Technique of Female Impersonation in Kabuki." *Maske und Koturn* 27 (1981): 30–35.

————. "The Early Years of Female Impersonators in Kabuki." *Maske und Koturn* 35 (1985): 31–37.

Leiter, Samuel L. *New Kabuki Encyclopedia: A Revised Adaptation of Kabuki Jiten.* Westport, CT: Greenwood, 1997.

————. "Four Interviews with Kabuki Actors." In *Frozen Moments: Writings on Kabuki, 1966–2001*, edited by Samuel L. Leiter. Ithaca, NY: Cornell East Asia Series, 2002 [1966], 11–31.

————. "The Frozen Moment: A Kabuki Technique." In *Frozen Moments: Writings on Kabuki, 1966–2001*, edited by Samuel L. Leiter. Ithaca, NY: Cornell East Asia Series, 2002 [1967], 59–73.

————. "Kumagai's Battle Camp: Form and Tradition in Kabuki Acting." In *Frozen Moments: Writings on Kabuki, 1966–2001*, edited by Samuel L. Leiter. Ithaca, NY: Cornell East Asia Series, 2002 [1991], 157–182.

————. "Ichikawa Danjūrō XI: A Life in Kabuki." In *Frozen Moments: Writings on Kabuki, 1966–2001*, edited by Samuel L. Leiter. Ithaca, NY: Cornell East Asia Series, 2002, 32–43.

Leiter, Samuel L. "Gimme that Old-Time Kabuki: Japan's Rural Theatre Landscape." In *Frozen Moments: Writings on Kabuki, 1966–2001,* edited by Samuel L. Leiter. Ithaca, NY: Cornell East Asia Series, 2002, 257–294.

———. "From the London Patents to the Edo *Sanza*: A Partial Comparison of the British Stage and *Kabuki*, ca. 1650–1800." In *Frozen Moments: Writings on Kabuki, 1966–2001,* edited by Samuel L. Leiter. Ithaca, NY: Cornell East Asia Series, 2002, 297–320.

———. "From Gay to *Gei*: The *Onnagata* and the Creation of Kabuki's Female Characters." In *A Kabuki Reader: History and Performance,* edited by Samuel L. Leiter, 211–229. Armonk, NY: M.E. Sharpe, 2002 [2000].

———. "From Bombs to Booms: Kabuki's Revival in Tokyo during the Occupation." In *Rising from the Flames: The Rebirth of Theatre in Occupied Japan, 1945–1952,* edited by Samuel L. Leiter. Lexington Press, forthcoming.

Mackerras, Colin. *Peking Opera.* Oxford: Oxford University Press, 1997.

Mackie, Vera. *Feminism in Modern Japan: Citizenship, Embodiment, and Sexuality.* Cambridge: Cambridge University Press, 2003.

Matsumoto Shinko. *Meiji zenki engekironshi* [A History of Early Meiji Theatre Discussions]. Tokyo: Engeki Shuppansha, 1974.

———. *Meiji engekironshi* [A History of Meiji Theatre Discussions]. Tokyo: Engeki Shuppansha, 1980.

Mayo, Marlene J. "To Be or Not to Be: Kabuki and Cultural Politics in Occupied Japan." In *War, Occupation and Creativity: Japan and East Asia, 1920–1960,* edited by Marlene Mayo and J. Thomas Rimer, 269–309. Honolulu: University of Hawaii, 2001.

Mezur, Katherine. *Beautiful Boys/Outlaw Bodies: Devising Kabuki Female Likeness.* New York: Palgrave Macmillan, 2005.

Mine Takashi. *Teikoku Gekijō kaimaku: kyo wa Teigeki ashita wa Mitsukoshi* [The Opening of the Imperial Theatre: Today the Imperial, Tomorrow Mitsukoshi]. Tokyo: Chūkō Ronsha, 1996.

Miyake Saburō. *Koshibai no omoide* [Memories of Minor Theatre]. Tokyo: Kokuritsu Gekijo Geinō Chōsashitsu, 1981.

Molony, Barbara and Ueno Kathleen, eds. *Gendering Modern Japanese History.* Cambridge: Harvard University Asia Center, 2005.

Mori Yoshio. "Katabami-za wa dō shiteiru ka" [What Will the Katabami Troupe Do?]. In "Gendai Butai Haiyū" [Contemporary Stage Actors]. Special issue, *Engekikai,* September 1964, 198–199.

Morinaga, Maki. "The Gender of *Onnagata* as the Imitating Imitated: Its Historicity, Performativity, and Involvement in the Circulation of Femininity." *positions: east asia cultures critique* 10 no. 2 (2002): 245–284.

Morizui Kenjiki. "Ichikawa Kumehachi debunki I: Aru onna yakusha no kojitsu" [Rumors about Kumehachi: Things That Female Actor Said, Part I]. *Jissen bungaku* [Practical Literature] 42 (March 1971): 38–46.

Nagayama Takeomi, ed. *Kabuki-za hyakunenshi* [One Hundred Year History of Kabuki-za]. Tokyo: Shōchiku Kabushiki Gaisha, 1993.

Nakamura, Karen and Matsuo, Hisako. "Female Masculinity and Fantasy Spaces: Transcending Genders in the Takarazuka Theatre and Japanese Popular Culture." In *Men and Masculinities in Contemporary Japan: Dislocating the Salaryman Doxa*, edited by James E. Roberson and Nobue Suzuki, 59–76. London: Routledge/Curzon, 2003.

Nichigai Asoshietsu, ed. *Nihon seimei yomifuri jiten* [Japanese Family Names in Chinese Characters]. Tokyo: Nichigai Asoshietsu, 1990.

———, ed. *Geinō jinbutsu jiten: Meiji Taishō Shōwa* [Dictionary of Performing Artists from the Meiji, Taishō, and Shōwa periods]. Tokyo: Nichigai Asoshietsu, 1998.

Nihonbuyōsha, ed. *Nihon buyō zenshū*. Tokyo: Nihonbuyōsha, 1982.

Nihon Tōkei Nengan [Japan Statistical Yearbook]. Tokyo: Bureau of Statistics, Office of Prime Minister, 1955–1956.

Nojima Jusaburō. *Kabuki jinmei jiten* [Biographical Dictionary of Kabuki], 2nd ed. Tokyo: Nichigai, 2002.

Norizuki Toshihiko. "Okyōgen-shi to iu Edo no joyū" [The Edo Period Actress Called Okyōgen-shi]. *Geinō* [Performance], September 1992, 10–16.

Ōe Ryōtarō. "Shinpa no hitobito: Ichikawa Suisen no koto" [People in *Shinpa*: Things about Ichikawa Suisen]. *Engekikai*, May 1962, 86–87.

Okamoto Kidō. *Ranpu no moto nite* [Under the Lamp: Discussions on Meiji Theatre]. Tokyo: Iwanami Shoten, 1965 [1935].

Okamoto Shiro. *The Man Who Saved Kabuki: Faubion Bowers and Theatre Censorship in Occupied Japan*, translated and adapted by Samuel L. Leiter. Honolulu: University of Hawaii, 2001.

Ono Haruyoshi. *Ono Haruyoshi jidenshō mizube danwa* [Autobiographical Discussions by Ono Haruyoshi]. Kyoto: Shirakawa Shoin, 1978.

Ortolani, Benito. *The Japanese Theatre: From Shamanistic Ritual to Contemporary Pluralism*. Revised edition. Princeton: Princeton University Press, 1995.

Oshima, Mark. "The Keisei as a Meeting Point of Different Worlds: Courtesan and the Kabuki *Onnagata*." In *The Women of the Pleasure Quarters*, edited by Elizabeth de Sabato Swinton, 86–105. Worcester, MA: Worcester Art Museum, 1995.

Plath, David W. "Gempuku [*sic*]." *Kodansha Encyclopedia of Japan*. Tokyo: Kodansha, 1983.

Pflugfelder, Gregory M. *Cartographies of Desire: Male-Male Sexuality in Japanese Discourse, 1600–1950*. Berkeley: University of California Press, 1999.

Poulton, Cody M. *Spirits of Another Sort: The Plays of Izumi Kyōka*. Ann Arbor: Center for Japanese Studies, University of Michigan, 2001.

Powell, Brian. *Japan's Modern Theatre: A Century of Change and Continuity*. New York: St. Martin's Press, 2001.

———. "Communist Kabuki: A Contradiction in Terms?" In *A Kabuki Reader: History and Performance*, edited by Samuel L. Leiter, 167–185. Armonk, NY: M.E. Sharpe, 2002 [1979].

Pronko, Leonard C. *Theatre East and West*. Berkeley: University of California Press, 1967.

Richie, Donald. *A Hundred Years of Japanese Film.* Tokyo: Kodansha, 2001.
Rimer, J. Thomas. *Toward a Modern Japanese Theatre: Kishida Kunio.* Princeton: Princeton University Press, 1974.
Rimer, J. Thomas and Yamazaki Masakazu, trans. *On the Art of Nō Drama: The Major Treatises of Zeami.* Princeton, NJ: Princeton University Press, 1984.
Robertson, Jennifer. *Takarazuka: Sexual Politics and Popular Culture in Modern Japan.* Berkeley: University of California Press, 1998.
Rubin, Gayle. "The Traffic in Women: Notes on the 'Political Economy of Sex.'" In *Toward an Anthology of Women*, edited by Rayna Reiter, 157–210. New York: Monthly Review Press, 1975.
Sakuragaoka Museum, ed. "Ichikawa Shōjo Kabuki ten" [Exhibition on Ichikawa Girls' Kabuki]. Pamphlet, Sakuragaoka Museum, Toyokawa, Japan, 28 April–28 May 1995.
Schmidgall, Gary. *Shakespeare and Opera.* New York: Oxford, 1990.
Seidensticker, Edward. *Low City, High City: Tokyo from Edo to the Earthquake.* New York: Alfred A. Knopf, 1983.
Seigle, Cecilia Segawa. *Yoshiwara: The Glittering World of the Japanese Courtesan.* Honolulu: Hawaii, 1993.
Seki Yōko. *Ebizō soshite Danjūrō* [Ebizō and then Danjūrō]. Tokyo: Bungei Shunjū, 2004.
Senelick, Laurence. *The Changing Room: Sex, Drag and Theatre.* London: Routledge, 2000.
Shinhen Toyokawa-shi Henshū Iinkai, ed. *Toyokawa-shishi* [Tokyokawa City History], no. 9 Minzoku [Folklore]. Toyokawa: Toyokawa-shi, 2001.
Shino Yōdarō and Uchiyama Mikio. *Nihon koten geinō to genzai: Bunraku kabuki* [Japanese Classical Theatre and the Present: *Bunraku* and Kabuki]. Tokyo: Iwanami Shōten, 1996.
Shively Donald H. "Sumptuary Regulation and Status in Early Tokugawa Japan." *Harvard Journal of Asiatic Studies* 25 (1964):123–164.
———. "The Social Environment of Tokugawa Kabuki." In *Studies in Kabuki: Its Acting, Music, and Historical Context*, edited by James R. Brandon, William P. Malm, and Donald Shively. Honolulu: University of Hawaii Press, 1978.
———. "*Bakufu* versus Kabuki." In *A Kabuki Reader: History and Performance*, edited by Samuel L. Leiter. Armonk, NY: M.E. Sharpe, 2002 [1955].
Sievers, Sharon L. *Flowers in Salt: The Beginnings of Feminist Consciousness in Modern Japan.* Stanford: Stanford University Press, 1983.
Siu Leung Li. *Cross-Dressing in Chinese Opera.* Hong Kong: Hong Kong University Press, 2003.
Sugiura Zenzō. *Joyū kagami* [Actress Mirror]. Tokyo: Sugiura Shuppanbu, 1912.
Takarazuka Gekidan Shuppan-bu, ed. *Takarazuka Kageki gojūnenshi* [Takarazuka Revue's Fifty-Year History]. Takarazuka: Takarazuka Kagekidan Shuppan-bu, 1964.

————. *Takarazuka Kageki no rokujūnen* [Takarazuka Revue's Sixty Years]. Takarazuka: Takarazuka Kageki Shuppanbu, 1974.

Takasago En, ed. *Takasagoya: Sōritsu sanjūnen kinen: Sanjūnen no ayumi* [The Thirty-Year Anniversary of the Takasago Inn: A History of Thirty Years]. Hamamatsu: Oda Kogeisha, 1979.

Tansman, Alan M. "Mournful Tears and *Sake*: The Postwar Myth of Misora Hibari." In *Contemporary Japan and Popular Culture*, edited by John Whittier Treat, 103–133 Honolulu: University of Hawaii, 1996.

Thornbury, Barbara E. "Restoring an Imagined Past: The Kokuritsu Gekijō and the Question of Authenticity in Kabuki." *Asian Theatre Journal* 19:1 (Spring 2002): 161–183.

Tian, Min. "Male *Dan*: the Paradox of Sex, Acting, and Perception of Female Impersonation in Traditional Chinese Theatre." *Asian Theatre Journal* 17:1 (Spring 2000): 78–97.

Tschudin, Jean-Jacques. "Early Meiji Kabuki and Western Theatre: A Rendez-Vous Manque." In *Kabuki: Changes and Prospects*, edited by International Symposium on the Conservation and Restoration of Cultural Properties, 183–193. Tokyo: Tokyo National Research Institute of Cultural Properties, 1996.

Vaporis, Constantine N. "To Edo and Back: Alternate Attendance and Japanese Culture in the Early Modern Period." *Journal of Japanese Studies* 23:1 (Winter 1997): 25–67.

Walthall, Anne. "Peripheries: Rural Culture in Tokugawa Japan." *Monumenta Nipponica* 39:4 (Winter 1984): 371–392.

Waseda Daigaku Engeki Hakubutsukan, ed. *Engeki hyakka daijiten* [Theatre Encyclopedia]. Tokyo: Heibonsha, 1963.

Weinstein, Stanley. "Kinkakuji." In *Kodansha Encyclopedia of Japan*, edited by Itasaka Gen. Tokyo: Kodansha, 1983.

Yamagawa Kazuo. "Ichikawa Shōjo Kabuki" [Ichikawa Girls' Kabuki]. In *Sengo geinōshi monogatari* [Stories of Postwar Performance History]. Tokyo: Asahi shinbun Gakugei-bu, 1987, 76–79.

Yoshida Setsuko. *Edo kabuki hōrei shūsei* [Collection of Edo Kabuki Ordinances], vol. 1. Tokyo: Ōfūsha, 1989.

Index

264 *Index*